Rethinking Art History

Donald Preziosi

Rethinking Art History

Meditations on a Coy Science

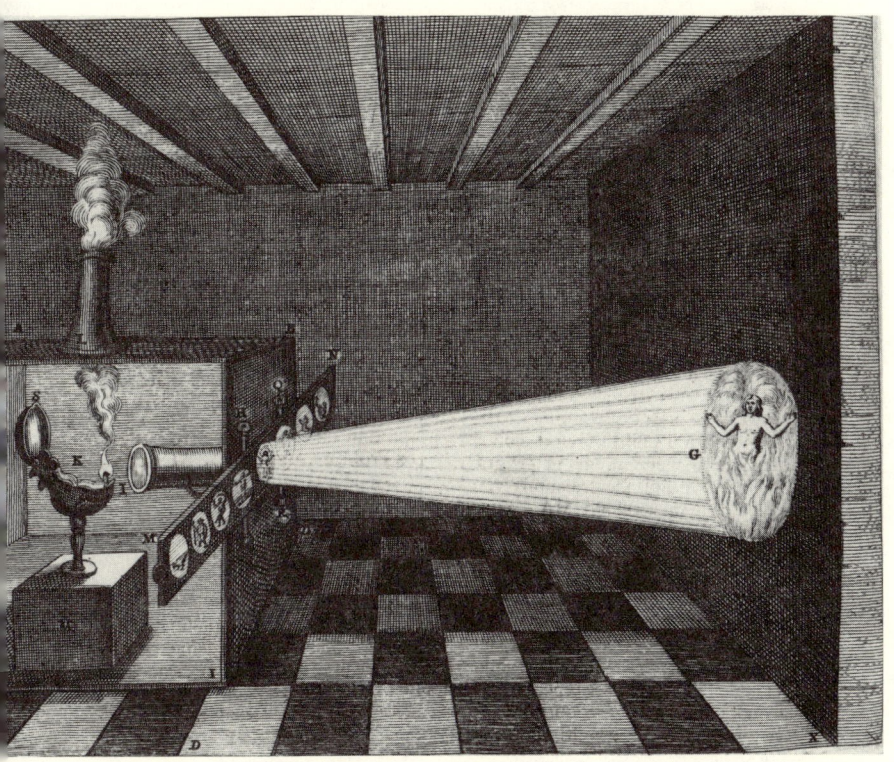

Yale University Press *New Haven & London*

Designed by Richard Hendel.

Set in Ehrhardt type by

Marathon Typography Service, Inc., Durham, North Carolina.

Printed in the United States of America by

Vail-Ballou Press, Binghamton, New York.

Library of Congress Cataloging-in-Publication Data

Preziosi, Donald, 1941 –

 Rethinking art history : meditations on a coy science /

Donald Preziosi.

 p. cm.

 Bibliography: p.

 Includes index.

 ISBN 0-300-04462-3 (alk. paper)

 1. Art—Historiography. I. Title.

N380.P68 1989

707'.2—dc19 89-30733

CIP

The paper in this book meets the guidelines for permanence and durability of the Committee on Production Guidelines for Book Longevity of the Council on Library Resources.

10 9 8 7 6 5 4 3 2 1

Frontispiece: An Early Lantern-Slide Projector.

(From Athanasius Kircher, *Ars Magna Lucis et Umbrae* [Amsterdam, 1671], p. 768.)

For, and because of, Meyer Schapiro

How far the perspective character of existence extends or whether existence has any other character than this; whether existence without interpretation, without "sense," does not become "nonsense;" whether, on the other hand, all existence is not essentially actively engaged in interpretation.
 —NIETZSCHE

I imagine you are asking me for my system on the arts today, and to situate it relative to those of my colleagues. I quake, feeling that I've been caught out, since I don't have anything worthy of being called a system, and know only a bit about two or three of them, just enough to know that they hardly constitute a system: the Freudian reading of the arts, the Marxist reading, and the Semiotic reading. Maybe what we should do is change the idea that has been clothed in the name of system.
 —JEAN-FRANÇOIS LYOTARD

Contents

List of Illustrations viii

Acknowledgments ix

Preface xi

Chapter One I
A Crisis in, or of, Art History?

Chapter Two 21
That Obscure Object of Desire: The Art of Art History

Chapter Three 54
The Panoptic Gaze and the Anamorphic Archive

Chapter Four 80
The Coy Science

Chapter Five 122
Reckoning with the World

Chapter Six 156
The End(s) of Art History

Notes 181

Bibliography 245

Index 265

Illustrations

An Early Lantern-Slide Projector frontispiece

Figure 1. *Bentham's Panopticon* 63

Figure 2. *Abri Blanchard Calendar Bone* 138

Figure 3. *Gontzi Tusk Calendar* 139

Figure 4. *Athens: Akropolis Reconstruction* 170

Figure 5. *Akropolis: Plan of the Propylaia* 174

Figure 6. *Propylaia: Anamorphic Resolutions* 176

Acknowledgments

So many persons have informed this study to its benefit that to preface the volume with a neat and orderly genealogy would be misleading. But there are some palpable landmarks on the way. The need for a focused discussion of many of the issues raised was first felt during graduate studies at Harvard that jostled together art history, anthropology, and linguistics. The feasibility of pursuing such a study became apparent in stages, in part through graduate seminars that I taught at Yale, the Massachusetts Institute of Technology, and the State University of New York at Binghamton; and in part thanks to participation a decade ago in a discussion group at Harvard known as the Philomorphs.

I am greatly indebted to two extraordinary institutions that provided me with space, time, and intellectual challenge in recent years: first, the Center for Advanced Study in the Visual Arts (CASVA) at the National Gallery of Art in Washington, D.C., where as a senior fellow during 1981–82 I began the present project in earnest; and second, the Center for Advanced Study in the Behavioral Sciences (CASBS) at Stanford University. A substantial part of the present volume began to take shape during my residency at Stanford as a research fellow in 1983–84, under the auspices of the Andrew Mellon Foundation and the National Endowment for the Humanities whose support I gratefully acknowledge.

At CASVA I had the good fortune to interact with a constant stream of art historical colleagues from around the world; during that time I profited from unfettered, dispassionate, and passionate dialogue on art historical and critical issues of the most diverse kind. Art history internationally owes a great debt to Dean Henry A. Millon and Associate Dean Marianna Shreve Simpson for actively opening up and nurturing an intellectual and material space for the discipline to reflect upon itself. At CASBS I had the opposite but reciprocal good fortune not to interact with art historical colleagues as I began to write, profiting rather from conversations and discussions in adjacent and distant areas of the human sciences that, as I was to discover, resonated with a number of the deepest concerns of my own discipline. The juxtaposition of these two institutional residencies within the space of three years contributed strongly to my understanding of, and ability to begin to articulate, many of the issues, questions, and problems raised in this work.

In and around these experiences, I have had the opportunity to discuss

these issues with friends, students, and colleagues in Berkeley, Berlin, Binghamton, Bloomington, Los Angeles, New York, Urbino, Vienna, and Washington within a variety of contexts — lectures, symposia, disciplinary and interdisciplinary meetings, and graduate seminars of which I was, ostensibly, the conductor. As the graduate students in my Binghamton seminars will surely understand, this book is a gift to them.

I especially want to thank Philip Armstrong, Deborah Cibelli, Alison Ferris, Sue Friedlander, Melissa Hall, Paul Ivey, Preminda Jacob, Amy Karlinsky, Lynne Kirby, Judith Sumner, Pam Toma, and Rosemary Welsh. For comments and criticisms on earlier versions of parts of this text, I am grateful to the following: Svetlana Alpers, Nancy Armstrong, Irene Bierman, Norman Bryson, Teresa de Lauretis, Michael Fotiades, Christopher Fynsk, Frederic Garber, Christine Hasenmueller, Michael Herzfeld, Ian Hodder, Wendy Holmes, Gregory Jusdanis, Rosalind Krauss, Alexandros Lagopoulos, Vassilis Lambropoulos, Sir Edmund Leach, Rob Nelson, Joseph Riddel, Thomas Sebeok, William Spanos, Maureen Turim, and Hayden White.

I also owe a great debt to the late Roman Jakobson for extended discussions on some of these issues in Cambridge and on Ossabaw Island, Georgia; and to Meyer Schapiro for long Saturday conversations on West 4th Street many years ago. In no small measure, my sense of what art history could be has derived from the latter.

Finally, I want to thank Judy Metro, senior editor at Yale University Press, for her ongoing encouragement and unfailingly good advice in bringing this project to completion.

Los Angeles
Summer 1988

Preface

Surveying the development of any modern academic discipline is not unlike trying to read a heavily palimpsested manuscript full of emendations, erasures, and marginalia, with innumerable graffiti added by different hands over time. Rereading the history of art history is, in particular, not an easy task. Its development is not simple, unilinear, progressive, or cumulative. The ramifications of its practices are often startlingly contradictory. Despite the accumulation of confident manifestoes, pronouncements, methodological protocols, and intricate supportive technologies, art history seems to go off in different directions at the same time or tends to dissolve and to blur as one tries to fix it in clear and steady focus. The reader often longs for a magic solvent that will disclose on the pages of art history some more coherent subtext, some clear and rational agenda that must surely be written somewhere, perhaps in invisible ink.

Indeed, one would think that for a discipline so perennially obsessed with the ultimate apt phrase and the poignant and penetrating bon mot, there might be some Olympian perspective revealing an orderly, rational, and progressive evolution.

There is no such perspective, despite what might be inferred from numerous primers. Journeying through the actual forest of art historical writing can be an unsettling experience and an unattractive task for any accustomed to viewing historical landscapes from the air or from angles (however anamorphic) that collapse the great complexity of the art historical terrain into an orderly and pedagogically neat booklet of road maps. There are certainly enough guides for the perplexed, but few guides to the discipline do more than beg the question as to why art history came into existence as an academic and critical practice, what its goals are or have been (apart from the usual missions cloned from other humanistic disciplines), and how the art historical enterprise relates to those of anthropology, sociology, history, or philosophy. And yet, this unsettling, tedious, and disconcerting journey—or, to use another metaphor, this archaeological campaign—must be undertaken if we are at all concerned with the fate of the discipline in this period of confusing transition and transformation.

What art historians do is changing—certainly too slowly for some and far too precipitously for others. Some would seem to lament that art historians today wander over a bleak and darkening landscape increasingly threatened

from below by the rumblings of new taxonomic technologies and from above by new theoretical developments hovering like lowering storm clouds, portending some idealist-materialist Armageddon. Others have viewed the same clouds as signaling blustery but bracing relief from long-standing intellectual drought and see the arrival of computerized systems as a remedy to the fetishized drudgeries of bookkeeping that for so long have pretended to the status of creative intellection in art historical research.

What is left of the art historical *hortus* within the humanities has understandably come to seem like a narrow, trackless, and weed-filled space with fewer and fewer comforting vistas apart from the silent quiddities of one's favorite objects. All the old road signs seem to have been effaced by adolescent graffitists or rewritten in extraterrestrial hieroglyphs by ivory-tower academicians whose heads swirl about in a starry semiological firmament.

These are extreme but not uncommon reactions to unsettling times in the discipline. Clearly, however, not all questioning of the transformations taking place in art historical practice has been sour, neoconservative w(h)ine in recycled bottles. And it is equally clear that not all those calling for accelerated change or reformation know whereof they speak, or speak in the same voice. It is surely as naive and ill informed to claim (as some have) that structuralism, semiology, psychoanalytic theory, feminist theory, social history, poststructuralism, or deconstruction are but different tentacles of the same alien or heterodox beast as it is to hold (as some do) that there is a singular and solid orthodoxy in traditional theory or practice. The complexity and rich diversity of historical and critical practice over the past century preclude any neatly written scenario. It is too easy and reductive to collapse that complexity into the neat packages of intellectual biography and theoretical genealogy *in vacuuo* so tediously characteristic of our discipline up to the present time.

The ocean of reticence once so ubiquitous in art history is drying up. This can only be a salutary development (as confusing as it may have become), for the submarine landscape now being uncovered in all its strangeness and bizarre morphology has long determined the currents of historical practice and the directions of critical thought. We are beginning to see in a clearer light some of the diverse circumstances, needs, and desires that have made art history possible and sustained it on its complex courses through the past century.

In short, we are learning how to remember art history, but in new ways. But lest we conclude too swiftly that what is being uncovered on that ocean floor represents some deeper or truer history of art history, we should remind ourselves that this increasingly (but still only partially) visible terrain of theory and metaphor has itself been shaped by the powerful and often

contradictory currents of practice both within and outside the discipline.

It is that fuller text that demands rereading today. With regard to that larger picture, the present text is itself a palimpsest.

The six chapters of this book represent several probes into the archaeology of art history—several test trenches beneath the rhetorical surfaces of disciplinary practice. These chapters overlap in a number of areas, and parts of their arguments can be seen as different facets of a set of related problems. The format of the book is neither linear nor cumulative; there is no set of simple conclusions at the end. Instead, each essay focuses upon a particular matrix of strategies in art history, which we take here as exemplary conjunctions of art historical knowledge and power. The focus of each has been suggested by certain kernel and persistent metaphors, theoretical assumptions, and rhetorical strategems. As the book attempts to clarify, each of these has served, over the past century, to strengthen, legitimize, and render natural or obvious several specific perspectives on the roles and functions of artistic production and construal. At the same time, the analyses will be sensitive to the ethical and moral orders projected and legitimized by art historical knowledge.

Chapter 1 sets the stage by discussing the crisis in the discipline as it has been portrayed and debated over the past decade, particularly in the United States. This large body of crisis writing has tended to be redundant, frequently shallow, and polemically aimed at often fictive targets. What is of interest to our discussion is its avoidance of history, or at least its scant willingness to look at the history of the discipline in its complexity and contradictoriness.

Chapter 2 is concerned with that often obscure object of desire, the art of art history, and the historical oscillation of disciplinary attention between the uniqueness of its objects of study and their apparently ordered sequences of appearance and diffusion over time and geography. What kind of analytic object has the art of art history been? What problems arise when, as in recent years, almost any conceivable object has been invested with museological or aesthetic status?

While chapter 2 deals with the identity and definition of the object domain of the discipline, chapter 3 considers some of the primary ways in which the objects of that domain are made visible—or rather, the disciplinary technologies for rendering the visible legible. Here it will be argued that—rather than being simple ancillary instrumentalities or supplements to the study of artworks *in vivo*—photographic technology, the practices of filmic isolation, projection, and the potential for instantaneous and universal juxtaposition of all forms of imagery provided the founding definitions of art historical prac-

tice as such. Comparable in some respects to microscopy and telescopy in the sciences, photography worked to render visible an imaginary and universal table or chart of exempla, and the analytic matrix of lantern-slide projector and blank surface provided art history with a paradigmatic frame within which to erect a universal "history" of art.

This supplement—what might be appropriately termed a certain cinematic sensibility—is, in fact, the technological metaphor for the entire art historical project, defining the nature of art historical study as well as the nature of its object domain. It established a panopticist model for disciplinary knowledge in art history, resonating with Bentham's Panopticon, that late eighteenth-century design for a perfect mode of surveillance that some have seen as a powerful paradigm for emergent scientific disciplines in the nineteenth century. This "panoptic gaze" necessarily works in tandem with a complementary technology—an archive—consisting of a network of slide and photographic libraries, art indices, electronic data-retrieval and data-storage systems, as well as a particular type of apparatus now commonly referred to as the art history survey text, in both its verbal and its architectonic (museum) format. In a manner complementary to the panoptic theater, the art historical archive works to situate the art historian in a carefully circumscribed position for the reading of images. Not unlike the various forms of anamorphic painting of the European baroque, the art historical archive projects very specific perspectives or sites from which the archival display locks into a telling and narrative order. In this way, the "anamorphic archive" works to define another disciplinary artifact, the art historian or critic.

Chapter 4 considers the historical role of various theories of meaning and signification in determining the matrix of disciplinary strategies constituting modern art history. A "coy semiology" from its very beginnings, art history has flirted with one or another facet of sign theory, from connoisseurship to iconology to modern visual semiotics, while remaining mostly true to a curiously eucharistic semiology running as a thread through theories of signification in the late nineteenth and early twentieth centuries—in contrast to a secular, Lockean perspective on meaning and signification, and in contrast to the more radical assumptions of some of Saussure's *sémiologie*. Similarities and differences between Panofsky's iconology and more recent structuralist semiotics are considered, along with connections between the semiology of Saussure and that of his erstwhile mentor, the historian and art critic Hippolyte Taine. Finally, we consider the relationships between contemporary art historical practice and various poststructuralist theories of signification.

Chapter 5 is devoted to the question of the origins of art and the simultaneous avoidance of the question by the discipline. Tacit assumptions regarding the origins of the activities that art history takes as its object domain

permeate many aspects of disciplinary practice, grounded as they have been in very particular concepts of human identity. As one of the primary defining instances of humanness, artistic creativity is characteristically seen as coterminous with the history of *Homo sapiens sapiens*. Increasingly, however, the study of Paleolithic cultures has come to problematize a number of traditional assumptions about artistic origins and about art itself, including certain conceptions regarding the integrity of the art object and of its modes of signification. The chapter examines some of the implications of this recent research for the future of the discipline, arguing that in one sense art history marginalized Paleolithic art because of the latter's challenges to certain foundational disciplinary assumptions.

Chapter 6 looks back at the probes we have made with an anamorphic eye so as to highlight some of the social-historical implications of the previous chapters. This leads to a consideration of the growth of a social history of art in Anglo-American academia, viewing it as a mixed, uneven, and at times internally contradictory series of enterprises, with as many meanings and implications as there have been practitioners and apologists. Rather than constituting a school of art history during the 1970s and early 1980s, the social history of art was a watershed between modernist and contemporary practices, at times complicit (especially in certain *Marxisant* modes of practice) with traditional paradigms, and at times innovative, forming an important part of what is loosely referred to today as contemporary critical theory. The book closes with an analysis of a particular art historical moment—the Mnesiklean Propylaia on the fifth-century B.C. Athenian akropolis—as an emblem of where the discipline has been and of where it might be going: a view beyond the Panopticon.

Throughout the book, we shall be sensitive to the contrasts presented by the modern discipline as seen from both the outside and the inside. From without, art history often shows a kind of utopic face: a world, as Pierre Bourdieu once wrote of art, like a "sacred island systematically and ostentatiously opposed to the profane, everyday world of production, a sanctuary for gratuitous, disinterested activity in a universe given over to money and self-interest, [which] offers, like theology in a past epoch, an imaginary anthropology obtained by a denial of all the negations really brought about by the economy."[1]

Yet from within, art history, as we shall see, is rather more heterotopic, juxtaposing in a singular disciplinary space a whole series of places that are assembled after the fashion of bricolage to project a kind of ironic unity, coherence, and singleness of mission. The more one explores the carpentry of this space, the more it comes to appear as a trompe-l'oeil rather like the

Trapezoidal Room of Adelbert Ames—a momentarily coherent perspective that on closer inspection is revealed as impossible and contradictory.

In this sense, art history could be seen as sharing with other heterotopic spaces within or constituting society—film, the theater, television, the ship, or even the vacation village or theme park—a programmatic projection both of illusion and compensation. There is a certain similarity in this regard between the discipline of art history and such institutions as the library or the museum: heterotopias of indefinitely accumulating time, accumulating everything, resonating with the will, as Michel Foucault once put it, to establish a General Archive, to "enclose in one place all times, all epochs, all forms, all tastes; the idea of constituting a place of all times that is itself outside of time and inaccessible to its ravages; the project of organizing in this way a sort of perpetual and indefinite accumulation of time in an immobile place."[2] By lashing together several nineteenth-century dreams of scientificity, art history has been paradigmatic of a certain modernist, panoptic sensibility: a factory for the production of sense for modern Western societies.

In attending to the contradictions and complexities that make up the modern history of art history, the following chapters may be seen as a kind of backwoods work—each attempting to open up pathways through the dense and confusing undergrowth of conflicting assumptions, rhetorical devices, analytic strategies, and technologies that have come to characterize the discipline in its modernity.

This book is neither an apologia nor a jeremiad. Its aim is to illuminate some of the issues that have been coy within the discipline of art history to date, particularly in its American manifestations; and to suggest some of the necessary means whereby a detailed and thoroughgoing archaeology of art history might be mounted. Nor do these essays purport to sketch out a complete historiographic history of the discipline; that is a task for the future. In a simple and literal sense, *Rethinking Art History* is a series of interlinked prolegomena, antecedent to a history that must be written if we are to have a realistic sense of where we might be going. The following chapters have the modest aim of foregrounding some of the primary metaphorical substructures of modern art historical practice: the rhetorical framings that have for so long delimited how we speak and think about the history of art history.

A Crisis in, or of, Art History?

*Alien spacecraft (rumored to bear the Air France emblem) have
been sighted over college campuses from Yale to northern
Alabama. Meanwhile, red-blooded young American scholars have
begun speaking a strange language thick with words like "semiotics,"
"prosopopoeia," "apotropaic," and "diacritical." Attempts
to treat the condition with bed rest and vitamin C have come to
naught.*
 —James Lardner

Il n'y a pas de hors-texte.
 —Jacques Derrida

1. Across the Ocean of Reticence

The 1982 winter issue of *Art Journal*, one of the official publications of the College Art Association of America, was devoted to the theme of "The Crisis in the Discipline."[1] Oddly, much of the writing in that special issue did not directly address the announced theme of disciplinary crisis. Of six articles, only one, by Oleg Grabar, explicitly dealt with the history of the discipline and its methodological prospects for the future. The questions implied in the title —namely, whether or not there was a crisis in art history, and, if there were, what it might consist of—were not explicitly posed or answered.

Indeed, a curious reticence drifted through the forty-six pages of text devoted to this theme. In an editorial statement, Henri Zerner wrote that the "complaints" by a "growing minority of art historians, especially of the younger generation" that art history has "fallen behind" and "deteriorated," having "reduced the thought of its founders, Morelli, Riegl, Wölfflin, and others, to an uninspired professional routine feeding a busy academic machine"[2] are "no longer a novelty . . . [having been] rehearsed often enough in the last ten or fifteen years." And whereas art history has been "reexamined, rethought, [and] restructured," there is "naturally, little or no agreement on how this is to be done." Zerner noted that "the authors who have accepted

the invitation to contribute essays . . . all have made an effort to indicate a direction rather than simply to complain about the state of affairs." As guest editor of this special issue, Zerner's "hope was only to obtain stimulating essays on methodological problems. These essays take various forms: speculation on the possible direction of the discipline, reinterpretation of basic texts, a test case, or a practical and positive critique of ideology. All of them, however, pose questions that transcend professional specialization."

From the collection of short essays, the editor discerned two concerns as especially important: the need to rethink the "object" of art history, and the "profound contradiction" embodied by a "history of style . . . [as] the attempt to establish a narrative or causal chain within the assumed autonomy of art." Indeed, Zerner's mention of them is a recognition that they constitute two of the most basic problems, or even dilemmas, of art history as a discipline—a recognition shared at the present time by art historians and others.[3]

At the risk of equivocation, it should be stated at the beginning that there both is and is not a crisis in art history at the present time. But the pertinence of this assertion has to do only secondarily with the question of whether those who believe there to be such a crisis are correct and their opponents wrong, or vice versa. As I see it, the problem goes beyond this. In order to begin to understand this complex and rather confusing period in the history of the discipline, it is necessary to look more closely at certain assumptions about the nature of art historical knowledge and at the perspectives on the history of the discipline characteristically promulgated by art historians and other humanists today.

Much of what might be termed crisis writing over the past decade and a half seldom deals directly with these issues,[4] and, arguably, a good deal of that has worked, certainly to a large extent unwittingly, to deflect or to postpone engagement with the more fundamental problems facing the discipline today. As I hope to make clear, much of the problem with current critical speculation has to do with the notion of crisis itself and the often hidden assumptions of historical development that the notion carries with it.

The quotation from the *Washington Post* at the beginning of this chapter is taken from a report on what is termed "a new brand of literary criticism [that] has scholars everywhere up in arms." Subtitled "Humanities vs. the Deconstructionists," the text is juxtaposed with a large cartoon showing an eggheaded, goggle-eyed, multilimbed, professorial alien monster whose eyes beam down death rays onto two humans (presumably academics or interested laymen) dropping books as they fall. The four arms of the monster grasp a book, a pad, a pen, and an unfortunate female in King-Kong-like fashion. The figure rises to mammoth proportions against the backdrop of a terrestrial city. In the dark sky above, three flying saucers in the form of academic

caps with flying tassels descend to earth, evidently bearing within them more such "deconstructive" monsters. At the top of the cartoon is the caption "Humanities Vs The Deconstructionists," the latter two words dripping blood as they march across the starry sky. One vividly imagines the imminent establishment of an alien Evil Empire on our tranquil, humanistic shores.

Yet the article (appearing in the Style section at the head of a subsection entitled Fashion/Gardens) assures us, albeit not without a certain anxiety, that there are freedom fighters at hand: "Dissolve to Cambridge, Mass., headquarters of the national resistance to just about everything that has happened in the criticism and teaching of literature over the last 15 years, for a word from the resistance leader, Walter Jackson Bate, Kingsley Porter university professor at Harvard." The writer goes on to note that "Bate and his allies indict deconstruction as nihilistic, whimsical, abstruse and incapable of distinguishing great literature from trash—and for spreading these maladies not only within the relatively small circle of avowed deconstructionists, but out among a far broader and more dangerous community of dupes and fellow travelers."

It may not be surprising or unexpected that the major newspaper in a national capital living under what the media refer to as a neoconservative political climate might report on this "War of the Words" in language virtually interchangeable with that found in reportage dealing with Central America or the Middle East. Indeed, one could almost change the names of the players and places and be left with a syntactically coherent article discussing the current regime's views of foreign policy. And anyone familiar with the present state of journalistic writing in the United States would not be surprised to encounter a report on deconstructionism not only remarkably belated but puerile and reductivist, even in the Style or Fashion/Gardens addenda to the news.

But precisely because of its context the report should be closely attended to (or not so readily dismissed as popular media rubbish) as a dim attempt to entertain the population of currently neoconservative Washington with yet another tempest in the liberal academic teapot. We could assume that we are to be amused at the latest antics of members of a profession "bombinating in a void" due to anger induced by a shrunken job market. Or perhaps the article might be read as yet another more ingenious way of playing out the more substantive rivalries of the annual Harvard-Yale football game.

To do so would be to miss a more important point about the article —namely, its ideological functions in a media market already saturated with the frequently vicious rancor and intolerance encouraged by the present political climate. It would be useful to elaborate on how the article works to whet agonistic appetites and to sharpen the fangs of players and audiences

("Harvard, Capital of Reaction, versus a thuggish Yalie Gang of Four").

We could begin after the manner of Roland Barthes commenting on yet another social or cultural *mythologie*.[5] Consider the significance that, in the image, male academic types are being eradicated by the laser-goggled eyes of the monster, while a slinkily dressed, high-heeled female academic is being snatched away by the alien deconstructionist: a story older than King Kong. Note that the alien invasion takes place in a large city (no doubt more megalopolitan than Sunbelt)—in inland American mythology, the perpetual hotbed of alien ideas, pestilence, sin, and barbarian passions. Observe that the alien craft "are rumored to bear the Air France emblem": Are these Parisian intellectuals perhaps a more exotic brand of extraterrestrials? Thereafter, we read that the "godfather" of deconstruction, Jacques Derrida, a "perpetual outsider," is in fact "a Jew in Christian society, a Frenchman in Algeria, a North African in France," one who at the age of fifty-one has "yet to receive a PhD from the French academic establishment."

What's going on here? Are these nattering nabobs of negativism really some sort of Arabs after all? The semantic density of these rhetorical slidings allows for multiple readings, according to the brand of paranoia subscribed to by different members of the potential audience: something for every bigot. If you're from Harvard, then these are Yalie thugs. If you're a red-blooded American humanist, then these are Parisian intellectuals. If you're a Christian, these are surely Jews. And if you're a red-blooded American Judeo-Christian, then these alien monsters can be nothing other than Arabs in mufti.

Deconstruction, we are told in the article, is considered "a dangerous gun in the hands of young graduate students" for one can "hardly walk through a [Yale] quad without hearing talk of self-consuming artifacts and works that unravel their own assumptions." Clearly, one must avoid sending offspring to New Haven to be educated: "The parents of a comparative literature student at Yale sent her a copy of Bate's article as a warning against slipping into the clutches of Yale's notorious 'deconstructionist mafia' or 'gang of four.'" As one probably suspected, this is a Sino-Sicilian plot.[6]

Presumably, however, the humanities in America need to worry about their own Star Wars defense, so parents need not worry about their daughters at Yale, and we all can rest securely about the progress of humane letters. One wonders if the female figure being snatched up in the cartoon by the alien monster might, after all, be an unfortunate Yale daughter cornered in a quad one grey New Haven morning by a self-consuming artifact—that fate worse than death.

We could also appeal to Poussin in his exhortation to Chatelou to "read the story first, then the tableau."[7] Consider the opening of the article: "It's the first horror movie about English teachers. It's called 'The Beast from the

Unfathomable' or, if you prefer, 'Humanity vs. the Deconstructionists.' It's in black-and-white and 2-D, but there are those who find it plenty scary just the same."

Note the word "humanity," not "humanities" as in the cartoon caption, which clearly raises the stakes in the struggle portrayed. In contrast to Walter Jackson Bate's call for the profession to rededicate itself to the "Renaissance ideal of humane letters," using the "great works of western literature as a tool for building 'that mysterious, all-important thing called character as well as the generally educated mind,'"[8] Barbara Johnson, a translator of Derrida, observes that Bate "uses the words 'human' or 'humane' all the time, but uses those words to mean 'anything that makes a white, dominant-class Harvard-affiliated male feel good about himself.'"

The problem in dealing with such a controversy, even if we were to see it as in some way paradigmatic of the current situation in art history, is that it becomes almost impossible to put aside the terms in which the game is played out or predetermined—the discursive frameworks already carpented by simplistic yet powerful dualisms. We are invariably swept up into the fray on one side or the other. This may well be the deeper ideological function of such articles in the first place—namely, to appeal to instincts that would impel us to take sides; to take up arms and pens against the enemy (whether deconstructivist or human[e]); or perhaps to simply shake our heads, rue the confusions, and lapse into quietism, thus rendering the issues marginal.

In no small measure, discourse on the disciplinary crisis in art history has been characterized by equivalent and similar rhetorical co-options and alienating lapses. To some, powerful orthodoxy in traditional practice tends to be opposed to some radical or less repressive or heterodox alternative, some utopic (or dystopic) vision or scenario for the future. This reflex toward binarisms, toward the erection of negative or oppositional theologisms, has worked in a variety of ways in the recent history of the humanities.

For example, in contrast to the "War of the Wor(l)ds" scenario of 1983, we might turn to a 1986 article in the *New York Times Magazine*,[9] entitled "The Tyranny of the Yale Critics," in which the once purely evil and alien deconstructionists are now portrayed as an Establishment tyrannizing those remaining unfortunates on the margins longing after some return to humane letters. One conjures up images of Star Wars freedom fighters living out troglodytic dreams of traditional humanism somewhere west of the Appalachians or south of Los Angeles, preparing to launch sallies against the Evil Empire now firmly established in our midsts.

It would be rash to conclude from this that the situation has changed fundamentally or that there are substantive differences in ideology between the salons of Washington and those of New York. The rules of the game have

remained intact, even if the capital of orthodoxy may have shifted south to Connecticut; the battle lines still betray the old geometries. This is evident in looking at the rhetorical strategems employed by various new breeds of freedom fighters in political or cultural life, from the Orwellian "moral majority" to the "newspeak" art criticism of the political magazine *New Criterion*. Both project a rhetorical space in which the majority of some true-believing population is tyrannized by a minority Establishment.[10]

What is most distressing about such a climate is not so much the crude sophistry promoted under the rubric of art criticism or cultural history, or the agenda that is so transparently political; rather, by repeating an older intolerance under new banners it affords yet another instance of avoidance—an avoidance and co-option of discussion and dialogue, a deflection away from more substantive attention to the fundamental problems facing art history and criticism at the present time.

The point here is less the correctness or otherwise of such opposed positions (whether in literary theory or art history) and more the sterility of perpetuating a view of the state of humane studies by means of simplistic dualisms, or within the discursive frameworks of a reductivist Hegelianism. Indeed, the very notion of disciplinary crisis is inextricably bound up with very particular ideas about history itself—ideas that appear to be shared, unquestioningly, on various sides of the question of crisis.

If the *Art Journal* issue discussed above was reticent on the subject of the nature of the disciplinary crisis (ostensibly its theme), it was completely silent on the implications of the very notion of crisis. And that silence accurately mirrored the situation in the discipline at large until fairly recently.[11]

2. *Ad Astra per Aspera*

> *To argue that a particular theory succeeds where another has failed is to write the history of . . . criticism as a History, a progressive overcoming of falsehood in which theory fulfills its destiny in coming to its truth in the fullness of time.*
> —*Andrew Parker*

> *A growing minority of art historians, especially those of the younger generation, are convinced that art history, which at the turn of the century seemed to be at the forefront of intellectual life, has fallen behind; that far from progressing it has deteriorated and reduced the thought of its founders.*
> —*Henri Zerner*

The appeal to authority in modern art history—a deference to the insights of teachers and scholars of earlier generations—is a fixture of practice that may or may not be more pronounced than in other areas of humanistic study. In many instances, our elders are implicitly portrayed as our intellectual betters. For Holly, "the majority of teachers and scholars of art historical methods are no longer preoccupied with the ultimate questions of meaning and mind that excited the imaginations of the architects of those methods."[12] And Zerner observes that the younger generation of art historians is convinced that the modern discipline has "reduced" these founders' thoughts and has "deteriorated" into a grey and lugubrious realm of academic specialization, a narrowness of spirit and attention.

Whether the present generation of younger art historians is convinced that the failings of disciplinary practice have to do with construing the thought of Morelli, Riegl, Wölfflin, and others too narrowly or rather all too thoroughly is perhaps a moot point. But the suggestion that there is little preoccupation with "ultimate questions of meaning and mind" in the discipline today patently falls far of the mark, if we are to take the remarkable proliferation of journals, symposia, and other fora for art historical and critical dialogue as symptomatic.[13] Indeed, there has rarely been a period as theoretically fertile as the present.

What is perhaps more pertinent to the present discussion is the tenor of these remarks and their more or less explicit suggestions that the current crisis in art history stems principally from a forgetfulness of the depth and insight of scholars who wrote during the golden age of art history. The implication is that, far from progressing, the discipline has declined and that one of our primary tasks today should be a closer and fuller attention to the writings of historians and critics at the dawn of the modern period.

Such implications carry with them a chain of presumptions: that the work of Panofsky (or Riegl or others) could be read as predicting subsequent theoretical developments or at least as anticipating them (thus, Panofsky could be read as anticipating contemporary semiology, or Riegl as anticipating the concerns of structuralism).[14] Another presumption is that contemporary attention to questions of theory simply repeats, but in a narrow way, questions raised by art historians at the turn of the century. To be sure, some of this reflects an understandable wariness of contemporary theoretical developments and new vocabularies or an impatience with those who appear more open to importing alien discourse on "meaning and mind" than to rereading what the history of the discipline has to offer—that is, its own very rich speculative tradition. But few have suggested rejecting the latter out of hand.[15]

Yet there is a great deal of confusion about these matters, and even among those who see the current state of the discipline as one of decline there are

strong differences on causes and cures. Others would see the crisis in the discipline as caused by an impasse among theoretical and ideological attitudes and perspectives, resulting in a certain disciplinary inertia or paralysis.

There is no decline, of course, except perhaps in manners, one of the more palpable changes in a discipline so long considered, with some justification, both excessively patriarchal and patronizing.[16] But whether there is some sort of theoretical and ideological gridlock is another and more complicated question. Strikingly distinct visions of art historical theory or practice have been in contention for some time; and these visions are often radically disparate in their implications for the place of the discipline among the human sciences or in the academic world, or for the proper social and cultural functions of the art historian.

The identity of the art historian and critic, and of the discipline itself, is clearly in flux; and yet this flux is taking place against a backdrop of disciplinary practice that in one sense has never been more secure and powerful, in part because of its ancillary but powerful connections to the commodity marketplace and its museological validating mechanisms.

It may be that fuller reading, discussion, and appreciation of the work of the great writers of the early modern period has tended to be low on a pedagogical agenda so oriented toward marketplace and museological professionalism. If that were universally true, it would indeed be lamentable. But the situation in American university departments and programs is more complex. The problem lies with the way in which our attention to this work is sited in a curricular sense.

More often than not, such study tends to be bracketed within the formats of advanced graduate study rather than being integrated at introductory levels, and the depth and theoretical variety more accurately reflecting the history of art history and criticism tends to remain hidden to all but the most advanced students, those who are already committed professionally. Almost without exception in American university curricula, undergraduate exposure to the history and development of art history is minimal, and curricular space is filled with historical surveys of art history, with varying degrees of chronological or geographical focus.[17]

Although exceptions exist, generally speaking there has traditionally been very little room for "Morelli, Riegl, Wölfflin and others" in art historical education in this country, and what space has been made tends to be belated and somewhat marginal. Within the characteristic structure of art historical pedagogy, the great controversies surrounding the nature and functions of art in history—whether social, cognitive, or psychological—have been frequently marginalized. And normally only a more privileged group of students (preprofessional graduates) has any extended exposure to such issues. To a

certain extent, this situation has been determined by a number of apparently extrinsic factors—an increased professionalism or careerism in the university atmosphere in general, or the necessity of many disciplines to compete for student audiences, resulting in curricular packaging that tends to defer or deflect all but the neatest and most economical self-imagery.

To raise such issues may also be reductive, for in another sense one could claim that academic art history can also be seen as a victim of its own pedagogical success at being well integrated into the academy, particularly as a visual analogue to the study of literature. Indeed, it may be recalled that one of the earliest formal appearances of art history in the American university system occurred in 1874 when the Harvard Corporation appointed Charles Eliot Norton Lecturer on the History of the Fine Arts as Connected with Literature.[18] Conflated with the success at academic integration was the growing sense of the discipline becoming a science complementary to other human and natural sciences, with all that that notion entailed in the last quarter of the nineteenth century.[19]

But even in its growth as a historical science, art history as a discipline remained closely aligned with a connoisseurial professionalism, and indeed the two continued to be mutually defining. By hindsight one might easily suggest that art history has always trod an uneasy line between humanistic philosophy and a certain applied professionalism. Even in this regard, however, the situation is rather complex, because there is no clear demarcation between art historical scholarship and its applications to the practices of the museum and the marketplace. It would be misleadingly simplistic to claim any clear opposition between a pure discipline and an applied practice or technology. The analogy is false for two reasons: first, art history is not an empirical or experimental science, despite claims to the contrary;[20] and second, such distinctions among the sciences themselves (upon which such an analogy might be said to rest) are fallacious and reductivist.

The opposition between pure and applied art historical practices cannot be justified, even if there are differences in practice between the museum or marketplace and the university; or even if there are often clear differences in personnel. The entire question centers around the orientation of research. Oriented research—that is, research programmed or organized in view of its utilization—might be said to characterize the professional activities of curators, gallery personnel, or advisors to private and corporate collectors: in short, all work that seems to have a palpable use or payoff.

And yet any such distinctions or demarcations are ultimately misleading, for implicit in them is a belief that academic research is in some sense basic, or inaccessible to constraints and conditioning by the pressures of the state or mercantile interests; that it is in some deep sense disinterested. The

implicitly hierarchical opposition or distinction between disinterested and oriented research is grounded in the old contrast between the free or liberal arts and mercenary art (*Lohnkunst*) explored at length by Kant,[21] or, at another level, between play and work; a hierarchized distinction, like that between mind and body.

The problem with maintaining such distinctions, however implicitly, is that it is impossible to distinguish the set of aims apparently embedded in these opposed practices. The course of basic academic research is not, and surely has never been, plotted in a vacuum hermetically sealed off from the needs of civil society or of the marketplace. This goes much deeper than the more obvious constraints upon research and writing induced by attentive awareness of thesis advisors to the current job market, or the strategems of launching oneself into the professional stream by attention to potential areas of study hitherto ignored (or mishandled) in previous doctoral dissertations. It implicates the entire scenography of academic research and writing in several ways.

The most obvious and palpable feedback upon research and writing in the discipline is the very weight of the commodity marketplace and its hierarchies of value and fashion. The very existence of a history of art centered on the diachronic parade of masterpieces insures the perpetuation of a system of comparable worth in academic attention. Or perhaps one should say insured, for at present the situation has become more complex because of the exponential expansion of art historical attention to the limits of the diachronic and diatopic horizons. For today, that picture is out of sync: "Nowadays there is no art so dead that an art historian cannot be found to detect some simulacrum of life in its moldering remains. In the last decade, there has, in fact, arisen in the scholarly world a powerful sub-profession that specializes in these lugubrious disinterments."[22] What gave rise to this journalistic lament was not merely a revolution in the wheel of fashion, or a downgrading of great masterpieces at the expense of trash (as these remarks might in fact suggest), but rather an across-the-board expansion of academic and mercantile attention in a disciplinary machinery that, resonating with economic theory and practice, can only survive by expansion.

The opposition between basic and end-oriented research, which is implicit in some of the lament about disciplinary decline, has but limited relevance. What is produced in academic research can always be used, and use value is a property more extensive than that which generates inflated profits for dealers or an increase in donations to museums. As a humanistic discipline, art history also produces, sustains, and perpetuates humanistic values, which are themselves marketable in direct ways and indeed provide an aura quite as manifest in a monetary sense as the commodity itself. To possess a Caravaggio

is perforce to possess a spirit, an age, a time, and a world.[23]

Despite protests to the contrary by some professionals, art history is an important and, in a number of ways, an essential practice in modern society, for it works to represent us to ourselves by reproducing the scenography of our most cherished social-historical mythologies. Indeed, the art of art history may have a function in modern society similar to that of the university as traditionally conceived — as a chance for reflection, a place to see seeing; an apparent mirror of the world, a prism refracting the chaos of life into a measured and measurable system or code: a history.

The more Olympian perspective often attributed to an earlier generation of great writers and scholars is an artifact of hindsight, the result of an understandable need to project backwards to a golden age of theoretical and methodological clarity. It is a retreat from the current confusion of diversity, complexity, and fragmentation. And yet a more thorough reading of the history of art history reveals how illusory any picture of a more gilded age must be. Over the past century, art history has mirrored deep ambiguities and contradictory claims about the status of its object of attention. There was never a time when the nature of the object domain or the roles and functions of art were uncontested. And "that obscure object of [disciplinary] desire" been obscure, perhaps never more so than when powerful assertions regarding its solidity and universality have been voiced.

The problems of the discipline are not adequately addressed by simply polishing up the totems of disciplinary ancestors so as to divine in their weathered details the answers to current issues. We need to reexcavate the entire disciplinary topography while at the same time sharpening our understanding of our motivations for doing so. And there may be no better place to begin than with a consideration of the notion of crisis itself.

3. The Crisis *in* the Discipline

The nostalgia for a golden age is deeply rooted in particular notions of history, art, and disciplinary history. These very notions are today in contention and are the sources of the decade-long debate about crisis.

One could say that the business of art history is the history of art, by which is customarily understood the developmental progress[ion] of the visual arts: differential articulations over time, space, biography, and ethnography. The business of the art historian has traditionally been to plot and to chart such transformations and articulations against the broader social and cultural changes accruing diachronically in different places. A founding assumption here, of course, is that there is an "it" that is a more or less universal

phenomenon manifested in transfinite articulations and changes over time and place. In the most generic sense, the disciplinary task is to trace the occurrences of the phenomenon from a variety of perspectives—that of the connoisseur, involved in delineating the minute signs of biographic and temporal identity, a semiological task of great skill; that of the iconographer, involved in the semiological task of delineating networks of signifiers and signifieds and their morphological and referential transformations over time and place; or that of the social historian, concerned with the signs of the various roles played by artwork in simultaneously generating, sustaining, and reflecting broader social, cultural, and historical processes.

There is a deep sense in which, for the art historian, art has always been a historical event or phenomenon, a sign of its times, an index of historical, social, cultural, or individual growth, identity, change, or transformation. It is fair to say that even at its most formalist or idealist moments, this perception has been a given in the discipline. And this is clearly implicit in all forms of disciplinary practice, even if more direct confrontation with fundamental issues regarding the actual nature of such relationships has customarily tended to be deferred.[24]

And yet it is that very deferral that has caused some degree of anxiety and impatience among those aware of recent and complementary discussions in other areas of the humanities and social sciences. There has been for some time a very palpable impatience that fundamental issues in this area continue to be deferred or buried under the weight of pedagogical and museological needs and constraints. And there is a feeling among some that the discipline as presently constituted has little space or interest in pursuing basic questions of signification.

To no small degree, the discipline has been unaccustomed to dealing directly with such issues in a sustained manner over the past generation or two, and there may be some justification in arguing that the enormous institutional expansion of art history since World War II has, paradoxically, made the discipline more inward-looking.[25] In this sense, the revival of questions of signification and of the relationships of artwork to the social and historical circumstances of its production and reception may have seemed like (extraterrestrial) importations from elsewhere (history, literary criticism, semiotics, and so on) rather than a continuation of prewar discourse.[26] Indeed, it seems clear that what some have meant by the crisis in the discipline stems from the shock and apparent suddenness of this revival—a seemingly alien agenda threatening to upset what many would have considered a fairly tight and smoothly running academic ship.

Yet a longer view of the situation will reveal that over the past decade and a half two interrelated developments have come to prominence. In the first

place, there has been a powerful external stimulus to considerations of signification due to the growing awareness of complementary discussions in other disciplines (notably literary theory, linguistics, and semiotics), a stimulus that has significantly fueled a revived interest in infradisciplinary discourse on the subject and an interest in rereading the history of art historical writing on this and related subjects.

Although the term *crisis* has been used in various senses in recent writing,[27] the kernel implications appear to be those of impasse or a turning away (real or imagined) from some previously set course of disciplinary development or progress. Common to both of these senses is the implication of directionality (which is impeded or is threatening to change): a certain notion of the history of the discipline as linear, directional, developmental, or progressive.

The discourse on disciplinary crisis is moreover doubly barbed, conflating notions about disciplinary history and art history, the latter grounded in metaphors of linearity or recurrent circularity. By this metaphor, the history of the discipline is construed as a developmental evolution, a progressive refinement of theory, method, or practice in general—in short, (theoretical or methodological) position, negation of that position, negation of the negation of that new position, and so forth. Within such a Hegelian, historicist framework, art history is often seen to progress by clarifying the nature and details of artistic or aesthetic evolution or development. The scenario resonates with the usual image we have of artistic behavior among pot makers and pot painters in the ancient Kerameikos of Athens: a densely packed *quartier* of artisans vying with one another for the luxury market through constant and continual one-upsmanship in technique, style, or virtuosity—allowing us (by hindsight) to reconstruct an evolutionary progress in representation and refinement.

The history of the discipline is frequently imagined, implicitly, in a similar fashion—as one of progressive problem solving, of thesis and antithesis, of the laying aside of one methodological system by newer and more powerful refinements. This scenario is substantially grounded in anterior notions regarding the history of art itself as in a sense evolutionary—a progressive chain of problems addressed and solved or a progressive unfolding of human presence. Or it may be an ongoing series of revelations of a universal entity that is art, which is itself construed as a revelation of Being, of a Truth that is already present.[28]

The developmental scenario of the history of art history, itself an echo of a nineteenth-century historicism within which art was framed, necessarily supports any notion of crisis. In short, unless history has a direction of some sort (to change, to continue, or to lose in aimless wandering), it cannot have a crisis.

That art history as a discipline has long been deeply grounded in some variant of historicism is patent, if we take Mandelbaum's definition as exemplary: Historicism is "the belief that an adequate understanding of the nature of any phenomenon and an adequate assessment of its value are to be gained through considering it in terms of the place which it occupied and the role which it played within a process of development."[29]

Compare this with the definition of the art historian's task spelled out by Kleinbauer: "Art historians aspire to analyze and interpret the visual arts by identifying their materials and techniques, makers, time and place of creation, and meaning or function—in short their place in the scheme of history."[30] The operant term, of course, is *scheme*—the implication that history has (or even is) a scheme, the notion that history has a code, as Lévi-Strauss once observed, namely that of chronology.[31]

One might argue that art history has mostly put aside a more obvious form of historicism with a capital *H*—that is, in Mandelbaum's sense, of history as progressive or developmental. Yet, while such terms as *archaic* or *classic* have come to lose many of their older evaluative connotations, historicism more broadly understood (as any view that holds history to be linear) still constitutes the basic schema of the discipline on the various horizons of contemporary practice. Indeed, as Derrida has noted, "the word *history* has no doubt always been associated with a linear scheme of the unfolding of presence, where the line relates the final presence to the originary presence according to the straight line or circle."[32]

In other words, the schema retains its metaphysical and teleological aura: The line invariably implies directionality (whether or not that directionality is overlain with evolutionary or developmental connotations) out from some origin, some originary source or presence. And the line itself is construed as an array of points of presence or Being: The diachronic is the sum of synchronic moments.[33] It is not without pertinence, moreover, that the historical origin point, the Paleolithic *Ansatzpunkt* of human art, is continually marginalized and obscured.

The terms *line* and *point* here are generic ones, for the disciplinary focus on synchronic moments has always been a sliding one, alternately narrow or wide, ranging from the individual object to the *vita* to the period or period style. And, of course, the disciplinary focus on temporal development is similarly flexible, ranging from individual biography to the multiplicity of chains and diachronic networks of influence constituting the history of art in a place, society, or period. Nevertheless, the essential geometries remain through all these complexities. Conjoined in the disciplinary business of history—that is, chronology and genealogy—periodicization and directionality imply, often despite the best intentions (as Jameson observes),[34] a

"seamless web of phenomena each of which, in its own way, 'expresses' some unified inner truth—a world view or a period 'style' or a set of structural categories which marks the whole length and breadth of the 'period.'"

The history of the discipline could conceivably be viewed as the ongoing and continually refined writing out of this implicit program—the confabulation of an ever more detailed chronology with the implied goal of representing (in the sense of re-presenting) presence, the fullness of human time, the fullness of Being in all its signs and indices. Only within such a perspective would the notion of programmatic or disciplinary crisis have any pertinence. The varied labors of stylistic analysis, connoisseurship, iconography, and both what one standard primer serenely refers to as intrinsic and extrinsic facets of research[35] have long been oriented toward this end. Indeed, it would appear inescapable that all forms of modern disciplinary practice are deeply grounded in this task of re-presenting the unified inner truth of a universal phenomenon (art) in all its variety and multiplicity over human time. Such a scheme is metaphysical in nature, and the very notion of disciplinary crisis only makes sense if the history of art history, and the history of art history's art, are conceived in teleological terms. And the undermining of historicism amounts to an undermining of the very thought of crisis.

In the previous section, the question of art historical research as oriented toward various ends was raised, in connection with observations on the lament by some that the disciplinary crisis consisted of a turning away from "fundamental questions of meaning and mind" toward the narrow specializations supported by the museum and the marketplace. It was suggested that distinctions between pure or basic research and goal-oriented work were fallacious, for a variety of reasons. It is also evident that the disciplinary orientation—or, more properly, the orientation of all practice addressed to art and its history, whether in the university, the museum, or the marketplace —has been in the direction of supporting and maintaining a certain notion of the aesthetic as a defining instance of the Human, the Kantian bridge between Nature and Spirit.[36] Necessarily, this task has been a deeply important one and proceeds in connection with the disciplinary business of maintaining and legitimizing the notion of Art itself or of the aesthetic as an ontological object in its own right. To no small degree, the task is sustained by the scenography of disciplinary knowledge itself, which works to engender distinct object domains according to complementary criteria: Art history is but a brick in this edifice.[37]

Coincident with the implicit notion that the work of art is in some way a revelation of Being or of a Truth that is already present (in the mind, in culture, and in society) is the notion that the artwork's modus operandi is that of saying: The work reveals, expresses, re-presents some prior meaning

or content. Indeed, as we shall see, the art of art history is inextricably grounded in a logocentric paradigm of signification,[38] and the business of the discipline is addressed above all to the task of reading objects so as to discern produced meaning, to hear the Voice behind what is palpable and mute.

And yet upon this notion is erected a curiously double disciplinary postulation: that the true meaning of an artwork can be translated (into discourse) and that the true meaning of the work of art is untranslatable. This is more than a matter of an oscillation between two options in the historical time of the discipline; indeed, this double postulation can be seen to coexist within the same discursive frameworks.[39] The implications here for claims of scientificity for the discipline are obvious, for this contradiction resonates with yet another one—art history's self-image as a science of singularities or unique artifacts that at the same time are construed as tokens of a class, exemplars of the multifarious forms of *tekhnē*.[40]

Disciplinary practice has rested upon a series of metaphors and tropes that remain grounded in classical theories of signification and representation. Such rhetorical protocols, as we shall see, have tended to be held in common by seemingly distinct schools of theory and methodology in art history. However much they might contrast with each other in programmatic ways, iconographic analysis, Marxist social history, and (structuralist) visual semiotics, among others, have shared basic assumptions on how artworks mean and how they appear to reflect social and historical processes. To a large extent, the divisions among art historians at the present time go deeper than what might be inferred by surface rhetoric, and, in fact, such differences cut across all of the current "party lines."

What is increasingly evident to many art historians and critics is the apparent incompatibility of the discipline's foundational and supportive assumptions during its older, modernist period with the contemporary postmodern critique of representation and historicism. As one writer recently observed, the open question is whether the latter critique "can be absorbed by art history without a significant reduction of its polemical force, or a total transformation of art history itself."[41] In other words, can the implications of postmodern practice be accommodated by a discipline theoretically grounded in an apparently different paradigm of art, history, and signification? Can it in fact be accommodated *at all?*

4. The Crisis *of* the Discipline

Art history might seem today, at times, like a Homeric battlefield of conflicting theories and methodologies, of ideologies and personalities

jockeying for rhetorical authority and territorial dominance. If one follows closely the debates, smouldering and overt, in various contemporary journals, in recent books and monographs, and occasionally in the pages of those two or three newspapers in the United States that have not yet relegated the visual arts to Sunday supplements called Style or Living, one might conclude that the interrelated practices of art history, museology, connoisseurship, and art criticism are in great ferment and even in profound and unsettling crisis. One might even discern deep and unresolvable differences among professionals who align themselves under banners labeled formalism, stylistic analysis, connoisseurship, biographical and psychoanalytic theory, social history, iconography, neo- or post-Marxisms, semiotics, structuralism, poststructuralism, hermeneutics, feminism, or deconstruction.

But one might also come away with the impression that these various modes of practice really represent a tedious oscillation of rhetorical poses — an intensely played bead game wherein the players and the style of pieces might differ over place and time, with the rules and protocols of the game remaining largely the same. All of the clashes of positions and personalities might even come to seem like a parade of fashions in which what really matters is change and novelty for its own sake — playing the preppie to some hippie only to be punked and yuppied in turn.

In a very real sense, both of these impressions are partly correct. Much of what passes for intense philosophical or theoretical dispute is often rhetorical gamesmanship related to individual authority, the projection of the self into a space of being *dans le vrai*.[42] One seeks rhetorical and institutional positions in which one's pronunciamentos have a ring of legitimacy, naturalness, and truth. The struggles are nonetheless very real and substantive, and in the final analysis what is at stake is more than abstract (or rather all too palpable) academic ego.

The ostensible terms of the debates have not always adequately or accurately represented the real issues, which go deeper than the surface rhetoric of one school or position against another. What may appear from outside the discipline as a rough and irascible pluralism of approaches comes to seem like an academic fiction once one crosses the ocean of reticence and looks at the scrim of disciplinary power and authority lit from other angles. Such a fiction (of rough pluralism) is not benign, for it works to promote the false impression that there are widespread agreements in the discipline over fundamentals and that all the fuss is over secondary issues — for example, as to which methodology might be pertinent or productive in a domain of study itself taken for granted.

It is that domain, however, that is at stake today, and, in consequence, so is the nature of the discipline as a discipline. Indeed, the principal divisions

among historians, critics, and others have less to do with whether to expand a canon, taken for granted, to include aboriginal imagery or Shaker furniture as with the nature of canon formation as such: what constitutes the object of study as opposed to that object's exempla.

A principal difference among art historians and critics today concerns whether there is a crisis *in* the discipline or *of* the discipline. The difference in locution is more than stylistic and signals distinct attitudes toward historical and critical practice as such. Indeed, rather than there being some uniform and tacit agreement about the domain of study, with disagreement about modes of study, there exists a deeper and more fundamental division among many practitioners (and, to be sure, even in the same practitioners)[43] regarding the essential identity, goals, and purposes of the discipline.

These divisions emerge more clearly when such salient issues as the following are addressed:

1. notions regarding the proper domain or object of study of art history—the boundaries of the discipline and the criteria for discerning or establishing these;
2. the manner whereby artworks (or visual artifacts as such, whether or not the object of study is coterminous with the latter) produce signification or reflect meaning or content; or how they generate certain effects for and among viewers or users;
3. the relationships (whether of contrast, similarity, or identity) between art history and art criticism; and
4. the relationships between the latter and artistic practice, between creation and interpretation.

Positions on these issues cut across all of the schools, modes of practice, or methodologies that one might list as extant among historians and critics. Indeed, there may be deeper congruences on these questions between many formalists and some social historians or semioticians than between groups of art historians hastily assembled under one of these methodological or theoretical umbrellas. One might reasonably contend that divisions within the discipline today center more deeply around an opposition between idealist and materialist assumptions. But this would make the situation more clear-cut than has historically been the case; certainly, the picture emerging from an examination of the contemporary theoretical landscape should be balanced with a rereading of the historical development of the discipline over the past century, including earlier modes of practice and speculation. That larger picture is far from clear or simple.

Our primary concern below will be with the ways in which positions on these four issues have been built into the disciplinary framework, and how

such orientations work to determine art historical theory and critical practice. It will be shown that this very framework is a theoretical and ethical machinery. Both the art of art history, and the history of art history's art are prefabrications resulting from the historical networking of disparate disciplinary technologies, including material formats of study and analysis, habitual modes of explication and proof (how the discipline predetermines "sense"), and the organization of research—indeed, the entire panoptic machinery and its ancillary devices.[44]

In noting the distinction between the locutions "crisis *in* the discipline" and "crisis *of* the discipline," it was suggested that they signal often radically different attitudes toward what is at stake today in art history. But the differences do not clearly correspond to some purported differences between a traditional practice and contemporary or new art history.[45] That would be to reduce the very palpable tensions between contemporary theory and the traditional of art historical study to a mere generational conflict between two modes of thought that happen to hold the stage at the same time. If the conflicts implicated here were merely temporal, they would be of limited theoretical interest, "a passing squall in the intellectual weather of the world,"[46] a lugubrious parade of rhetorical fashion. As a careful rereading of the history of art history will show, these conflicts reflect contradictory perspectives on art and history that antedate the institutionalization of the discipline and have been built into it from its academic beginnings.

The implications of the latter are far-reaching and propel us beyond the terms of the current debates on disciplinary crisis. More particularly, these implications may cue an awareness of, and sharply highlight, the metaphorical and rhetorical scaffolding within which we have been characteristically constrained to view the discipline and its history. Metaphor is never neutral or innocent: It invariably frames and fixes the terms of debates, orients the course of discussion, and not infrequently predetermines or prefabricates resolutions.

Typically, we have been used to dealing with the situation in the discipline by implicitly viewing it as a space (a "Homeric battlefield" for some) contested by opposing theoretical and methodological factions or practices. But we may be dealing with a space *defined by* the juxtaposition of contending and frequently contradictory practices.

The former metaphorical scenario is congruent with, and indeed supports, the historicist attitudes discussed above, and necessitates speaking of a crisis *in* art history. Moreover, the scenario implies that art history is an independent entity to which things happen, like an edifice that weathers over time due to forces external to it. The latter scenario suggests that as a discipline art history is necessarily sustained through the very tensions engen-

dered by the contradictions and opposing forces that have perpetually consti-
tuted its theoretical scaffoldings; that its modus vivendi is precisely one *of*
crisis built into it from its beginnings. Consonant with the latter—an image,
perhaps, of a suspension bridge rather than of a masonry edifice—would be
a view that what has been referred to as a "resistance to theory"[47] is inherent
in a discipline that by its very nature is a theoretical enterprise.

From such a perspective, the series of tensions, resistances, and discursive
oscillations seemingly in the discipline may in fact be what generates its
apparent solidity. And the simultaneous legibility and ineffability of its objects,
or the equally historical and ahistorical nature of its focus may well constitute
the disciplinary power of art history.

The terms of the current debates on crisis and the state of the discipline
have invariably been situated on a horizon that validates historicist perspec-
tives or fosters an impression of parochial squabbling over secondary rather
than fundamental issues or that reduces the issues at stake to a generational
dispute that simply repeats the perennial compulsion toward periodicization.
On such a horizon, the debates are not resolvable in the terms played out
over the past fifteen years.[48]

We need to change our focus to a deeper level—to the very language of art
history and its metaphorical geometry. It is there that we may begin to form a
more substantial picture of what is at stake in the discipline today.

That Obscure Object of Desire
The Art of Art History

A work of art can be defined as a man-made object of aesthetic significance, with a vitality and reality of its own. Regardless of the medium of expression, a work of art is a unique, complex, irreducible, in some ways even mysterious, individual whole.
—*W. E. Kleinbauer*

1. Lust for Life

ust for Life, the 1956 Hollywood film biography of Vincent van Gogh, included several scenes in which the eye of the camera was coincident with the eyes of the artist looking at various landscapes, interiors, and persons. In each case, after a momentary pause and a quick flash to the intensely concentrated face of the tortured artist, the scene dissolved into one of van Gogh's famous paintings.

This is no mere decorative flourish. The use of cinematic dissolve here embodies and performs the derivation and provenance of the finished aesthetic image before our eyes. In so doing, the technique highlights two predominant concepts: that of artwork in the West since the Renaissance as a formal transformation or translation of originary sensory perception; and a still current concept of art historical and critical practice—namely, the detection of an originary view of an artist that is transformed in a metamorphized vision by the artist. At the same time, the cinematic device performs for a lay audience the exegesis of measuring and appreciating that artistic vision.

This is truly extraordinary. In the twinkling of an eye, *Lust for Life* sets out for its viewers the dominant thrust of speculation on the nature and processes of aesthetic creativity in the visual arts over the past four centuries, since its paradigmatic foundations in the work of Vasari.[1] Moreover, this demonstration is mythomorphic, (that is, it approximates the form of which it speaks) twice over:[2] in the forward motion of aesthetic production and in the backwards motion of the mode of art historical reconstruction.

The former process is given a rather miraculous aura, as if the artist's

brush were a wand transforming an optical array into a new reality. The spectator never sees the actual process of painting in the film, even though Vincent is occasionally shown applying daubs of paint to canvas. Nor does one see the historian or critic at work; only the results of that labor of detection and exegesis are apparent.

The artist-hero (the ostensible protagonist, for I would argue that the actual hero of *Lust for Life* is the discipline of art history) is also revealed as a filter or aesthetic mediator, refracting the prose of the world into poetry; he is a distillator of the Essential from the world in which we live. In this refractive regime, the artwork is framed as a record or trace of the artist's originality and individuality. Indeed, the film indicates that the measurable difference or distance between painted image and encatalyzing scene is isomorphic with the artist's degree of difference from the mundane world of the ordinary mortal—an iconic sign of artistic genius. As that distance changes, so too does that genius change and grow. Vincent's life is presented as a journey of growth from realism or naturalism to abstraction: a quest for an essential or higher reality increasingly different from the ordinary.

And yet here is the problem. As a *fabula metrologica*, *Lust for Life* indicates that that distance may also be a sign of increasing removal from sanity, a journey into madness. The film depicts the agony and madness of the artist-hero as a measured (and measurable) distance from an objective (camera-eye) real world.[3] The resultant artworks stand as eloquent testimony to that madness and marginality. As time passes in the cinematic narrative, the increasing madness of Vincent is made to be seen as congruent and commensurate with an increased irreality in his art. To be sure, there are occasional remissions into euclidean lucidity, but the essential vector remains constant.

A closer scrutiny reveals that this cinematic biography performs important ideological work for art history and criticism, despite the popular format easily denigrated by professional practitioners. Apart from the attempt of the film to marginalize modern nonfigural artwork along a dangerous boundary between sanity and madness, it is primarily concerned with establishing and exemplifying art historical practice as a benign therapeutic operating within a carefully circumscribed and neutral frame. The art historian or critic[4] is the implied practitioner or operator of a revelatory machinery, working at the recuperative task of reconstituting for a lay audience an originary fullness of meaning and reference, a semiologically articulatable presence of real being.[5]

We are made to understand that the historian-critic of today is one who with patience, fine cunning, and with a certain behind-the-scenes modesty will restore the original substance of "what Vincent saw." Indeed, he has already done so—hence the film as an example of narrative realism, assuring

us that we are looking at a biographic record; a true *istoria*, a projection through an Albertian window.[6] As a tracer of lost person(a)s, the analyst is a forensic detective, whose de-tect-ion (literally and etymologically) removes the opaque roof from the labyrinthine chambers of the artistic mind.

At the same time this is a daring and dangerous metrology, for the distance between some original state and its filtered, altered, post hoc record or trace is both negative and positive. We are made vividly aware of those villainous art critics of Vincent's time who, taking the distance from optical illusionism (photographic realism) in the canvases as a negative measure, see a sign of separation from sanity.

Yet *Lust for Life* assures us that the same quantity may be read more properly and truly as a positive measure of creativity and originality, as a sign of heightened aesthetic Vision. For, by art historical hindsight, Vincent is aesthetically *dans le vrai*:[7] His work is a pointer toward a more enlightened and sophisticated art historical future. He is like a Gregor Mendel who understood the evolutionary "line" of art history's art before the time of his professional critics and colleagues. In effect, the historian-critic possesses a measure that can be used both to remedy and to poison—a true *pharmakon*.[8]

The film presents critical dispute only in terms of the progressive evolution of aesthetic morphology—the sometimes gradual, sometimes abrupt evolution of a visual logic. It thus works to hypostatize the implicit social Darwinism of the survival of the best and brightest among that company of artistic seers to which Vincent belongs. *Lust for Life* works to justify the diachronic canon monumentalized in the corpus of art history textbooks that synoptically survey the genealogies of that object termed art.[9] Indeed, it works to legitimize and to naturalize the idea that this object has a history of its own—that there is a *vie des formes* somehow semiautonomous from the lives of men and women and their interrelations and social determinations. In this grey and lugubrious history (so patently a metaphor for free-market capitalism and its entrepreneurial violence), form is all, and any work of art incorporates traces of its own funicity—a memory of previous aesthetic problems and solutions,[10] which the astute art historian is equipped to read. Ultimately, the subject of Vincent's painting is art history itself—here construed as a history of form.

The film succeeds in affirming two things. First, it makes it clear that Vincent's genius eventually was recognized by critics and historians—albeit too late, perhaps. And in this regard, *Lust for Life* stands as an object-lesson for the contemporary critic and historian. In short, it is made clear that there is a true history of art, a real developmental progression, which will survive the tests of time. Second, the film shows samples of Vincent's grounding in traditional representational technique—the fact that he could "really draw" and produce images that were fully naturalistic (that is, photographic); this

was a great comfort to a popular audience in the fifties, no doubt uneasy about the associations of abstraction in art and marginal and beatnik life styles. Indeed, Vincent is revealed as a child of orthodoxy, a revelation strengthened by periodic references to his religiously conservative upbringing and familial roots. This is an astute recuperative device, intended to have the audience believe that in a theologic order there are higher realities that may not resemble the realities of sensate and mortal life. Vincent's paintings might very well indicate, then, in their altered Vision, some deeper or higher truths than those of the camera. True to his individualist visions, Vincent touches a deep chord in modern American mythology. And at the same time, there is nothing but a profound religiosity about our hero. He is, of course, a saint, in the same celestial ring as Edison and Buckminster Fuller.

Van Gogh's aesthetically orthodox training is thus presented as providing the basis of a certain permissable liberty—a license to take representational (illusionist) liberties in the pursuit of his ostensible goal of indicating a truer world, a deeper reality. He is no weekend beatnik with the soul of an accountant but a competent draftsman exploring the more sophisticated realms of artistic expression.

In presenting us with a truer world, however, *Lust for Life* also situates a future world for us in a curious way: Art history is nowhere to be seen but will later emerge. The history of art is here revealed not as a mere random vector in time but rather as progressive and directional—a teleological quest. In its historical context, the film worked vigorously to suggest the reality of a progress not only in art but also in the scientific and technological products of a progressive market economy. It is of no small interest that the film was made during the Cold War when the United States had begun to successfully market its culture industry abroad; and it is now common knowledge that one of the more astute instruments in that contest was formalist abstract painting.[11] But the pertinence of the film goes beyond this.

While the film displays van Gogh's license to produce the images he did (prefiguring in a certain sense the culmination in abstract expressionism), it also performs a kind of morality play demonstrating that liberties have limits and embody certain civic responsibilities. Boundaries are suggested beyond which artistic vision dissolves into madness and arouses social opprobrium. Although *Lust for Life* validates Vincent's forward-looking vision, it indicates that there are absolute limits in its accelerational capacities. At the same time that the film validates a teleological scientificity, it tells us that progress and change should be conservative, coming about best in graduated stages: Too much too soon is madness. To strain the machinery in reaching toward an art historically inevitable future may lead to mental disintegration. The film stands as a "guide for the perplexed" at different

crossroads of individual and collective life. It is, after all, about lust.

These cinematic accomplishments, however, raise some art historical problems and point to at least one major contradiction in the picture of historical criticism constructed by the film. Indeed, there is a scandal being masked here: the essential ambiguity of critical standards as such; the fact that they are always, everywhere, instruments of power. In short, there is a contradiction in the narrative, which is cleverly treated. The exhibition of Vincent's fine abilities as a draftsman, scattered as mementoes over many episodes (often his earlier, more naturalistic work is shown pinned on the studio walls), is the result of a palpable tension regarding the ambivalence of critical norms and standards—the fact that the same norms may have distinct and even opposed meanings. In the first place, a distance from a figural, realist ground is a sign of madness and aesthetic (and consequently social) deviancy. On the other hand, it is a measure of originality and genius, a mark or trace of a deeper, more real Vision. It is a measure with two opposite or opposed meanings. In effect, this ambivalence erases the distinction between the positive and negative axes of a Cartesian geometric grid, leaving us with no absolute standard or frame of reference, because it allows for the existence of a quantity with antithetical referents.

The contradiction is elided in the film by appealing to the real or true history of artistic evolution; the problem is given a historical denouement that reveals which application of the standard is right and which is wrong. In other words, it is resolved in teleological or ideal time, as the result of a synoptic perspective to which the art historian (of the future) is privy. In short, the contradiction is resolved outside of history, in some ideal and ahistorical realm.

By decomposing the opposition, the film also works to mask another contradiction, for the audience potentially faces the problem—and the further scandal—that taste and critical norms are themselves artifacts of historical and social development and change. In other words, it is made apparent that aesthetic standards are conventional and arbitrary and not neutral, absolute, or independent of institutions, classes, or social ideologies. In short, they are instruments of power—the power of the villainous critic to inter the genius of Vincent beyond the pale of the canon, the power of the enlightened critic to rescue that genius and to enshrine it properly in the growing pyramid of human creativity and worth.

Again, this contradiction is elided in a theocratic and metahistorical manner: Some critics are right, period. And that right(eous)ness is proved by the subsequent, validating synopticism of the art historical textbook of the future, that Domesday Book in which all names are inscribed, all is justified, and all the now-hidden linkages of a true history are charted.

This is extraordinary, a remarkable sleight of hand, an optical illusion of fine cunning and cinematic brilliance. And *Lust for Life* performs for us the trick of stepping aside from these nicely woven double binds, echoing disciplinary practice itself. The problem is that if (a) the standards of an age and place can change, often abruptly, over time, and (b) even within the same time and place standards can differ among presumably competent historians and critics, then the promise of the existence of absolute limits and norms is a recuperative illusion. However, by portraying nay-saying critics as obsolescent dunderheads behind their time, we are shown that certain critical perspectives and evaluations must be better, in some intrinsic way, than others. And of this set of better judgments, only one can be correct and true.

This is a doubly effective movement, indicating that better judgments are historically grounded (in terms of the evolutionary line of aesthetic progress) and (presumably if the spectator is unwilling to buy this completely) that they are outside and beyond mere historical fluxion. And the film makes clear what the criteria for the latter—that is, for absolute critical standards—would be. In short, that critical stance is true and right that is restorative of narrative fullness, sense, and order—a composed picture of "the-man-and-his-work" precisely as a "unique, homogeneous, complex, irreducible, in some ways even mysterious, individual whole," to repeat Kleinbauer's definition of "a work of art."[12] The critical restoration of Being, then, is shown as operating in a scientistic manner, purporting that the simplest, most economical, most scientifically elegant solution is necessarily the truest. True science is a real art. This is perforce a Gestaltist geomancy, a fixing of the artist-hero on the sunlit stained-glass window of a homogeneous Selfhood.

But should the spectator, viewing a film made at least half a century after Freud, still have qualms, *Lust for Life* offers more: the implication of a *droit des artistes* for a certain contrariness and biographic messiness (not, however, a deep contradictoriness or disorder). This is couched in the allusory trope of the license of the great artist-genius to be contrary and idiosyncratic. Ultimately, however, the beginning and middle of the film work inexorably to a theatrically composed end, for this is a tamed idiosyncracy wherein the-man-and/or-his-work can be "in some ways even mysterious" while remaining as a homogeneous "individual whole." This may be a fuzzy set, but it is still a set. *Lust for Life* works to recenter a potentially and dangerously decentered subjecthood:[13] The-man-and-his-work must be thought of as the-man-as-a-work.

Thus the film engenders and produces the-man-as/and-his-work as itself a work of art and indicates to us that only such a regime of critical history can be acceptable as true. Consequently, only the critic-historian who uses the apparatus of his discipline, his own draftsmanly instru-

ments, to compose such a life can, in fact, be *dans le vrai.*

So, despite the fact that "the judgments of the art historian are not correct or incorrect in the way a hypothesis in science is . . . they are illuminating for the time and place in which they are made." It will be understood additionally that "art historians may approach art and work around it, but they can never penetrate its mysterious core in the way a scientist seeks out the truth of his theories and hypotheses." We therefore are warned in advance of the following: "The art historian . . . shuns the tendency of the scientific historian to empty works of their aesthetic significance and drain away their aesthetic integrity."[14]

It is thus clear that false vitae would be those whose composition of the-man-and/as-his-work are architectonically heterogeneous or internally contradictory and poorly carpented. Poor carpentry, craftsmanship in which the joints and seams of the hero's life are not finely fitted, is to be avoided. The outer must match and reflect the innermost; any gaps in the logical and rhetorical carpentry will invariably lead to leakage—the draining away of spirit and integrity.

Such joining cannot hold: In this architectonic rhetoric, a loosely fitted seam inexorably leads to the promiscuous insertion of interrogative wedges that may pry this temple of the spirit apart. It is best to burn all blueprints and preliminary sketches, all traces of the chisel, in this Praxitelean pragmatics—in short, all traces of art historical and critical grounding in time, place, and social process. Art history is to be written in such a manner as to suggest that its story composes itself, authorless, in the third person singular.[15]

2. Dreams of Scientificity

History does not therefore escape the common obligation of all knowledge, to employ a code to analyze its object, even (and especially) if a continuous reality is attributed to that object. The distinctive features of historical knowledge are due not to the absence of a code, which is illusory, but to its particular nature: the code is a chronology.
— *Claude Lévi-Strauss*

The data of the art historian are unique, while those of the scientific historian are specimens of a class, cognate occurrences under a law.
— *W. E. Kleinbauer*

Lust for Life presents itself as a kind of paradigmatic framework for art historical criticism and stands as an exemplar, a tableau vivant both of

the-man-and/as-his-work and of the-historian-and-his-work, replicating, in a mythomorphic manner, a Vasarian *auteurist* ideology. This cinematic biography only makes sense (a) if its format is infinitely extendable to any aesthetic moment, genre, period, or person; and (b) if it is but one case study, one cassette taken from the shelves of a universal archive.

But this archive could be no random aggregate of vitae: It assumes the existence of a given domain of like phenomena that can be systematically attended to so as to capture and articulate the transfinite variety of tokens of a type or class. The objects within this constant and uniform domain will necessarily be a subclass within the entire set of artifactual creations of a society or period. This domain, in other words, is construed as not coterminous with the material culture, the made world, or the built environment of a time or place. Not everything may be subsumed within this framework, and objects belonging to this class must not be indistinguishable from mere commodities or productions.

Thus, a primary condition for the scientificity of a discipline incorporating such objects would be a domain that is clear, coherent, and consistent, with boundaries that are articulatable and distinct. Consistent definitions of proper objects must be made so as to distinguish them from other phenomena in the artifactual universe. We might assume that characteristic definitions would include certain properties, such as medium; mode of perceptual address;[16] a certain evident constancy of subject matter or perhaps content; the predominance of certain themes, modes of reading, and reception; or even characteristic orientations and sitings within given built environments.[17] Beyond such a set of properties (however delimited), objects cannot share the same properties or cannot share them to an equivalent extent. Indeed, art could not exist by degree, any more than one can be only a little pregnant. Such a situation, however, raises many epistemological and practical problems.

This domain would be a measured and measurable world. For norms and standards to be operable at all, they must perforce be absolute, transtemporal, and beyond the vagaries of momentary taste and fashion. Presumably those artworks that endure and have aesthetic pertinence for the ages justify their inclusion in the canon—a tricky proposition, as *Lust for Life* should indicate.

Moreover, within this domain of attention, everything about the objects must be significant in some way, but not everything can be significant in the same way. In addition, everything cannot be significant in every way: The historian and critic (not to speak of the lay viewer or user) are not free to assign any set of meanings, referents, or associations in an artwork. Although the range of associations encatalyzed by an artwork might multiply to infinity, that range must be oriented or grounded, perhaps in some common core of percepts. Viewing artwork cannot, at base, be an occasion for infinite semio-

tic bricolage or free play. As the film makes clear, some interpretations must necessarily be truer than others, closer to originary intention or programmatic purpose. And criticism would be an apparatus and discursive practice for insuring fidelity to authorial intention.

All of this would mean, of course, that the disciplinary analyst is dealing with a code of determined and determinate formations and contents. And herein lies the tip of the problematic iceberg.

In the first place, there is an essential contradiction between a domain of objects that are unique and irreducible and a domain of objects that are tokens of a type or class of like phenomena. Either we are dealing with an order of monadic unicums or with a constant and variably articulated class of phenomena. If the former is the case, there is no possibility of a disciplinary science in the ordinary sense of the phrase; if the latter, then art cannot strictly be a kind of thing, but rather a term useful in denoting a certain way of attending to a variety of morphologically distinct things. The pertinent question as regards the latter would not be "what" is art, but perhaps, as Nelson Goodman once said, "when" is art.[18]

If there is to be a disciplinary science of art history, then we might expect that three broad premises should govern it: (1) that artworks say (express, reveal, articulate, project) something determinate; (2) that such determinacy be grounded ultimately in authorial or artistic intention—what the *maker meant* to express or convey about a view of the world or about the truth of some internal or emotive state; and (3) that the properly equipped analyst could mimetically approximate such determinate intentionality by producing a *reading* that, it must be assumed, similarly trained and skilled experts might agree possesses some consensual objectivity.[19]

Such fixity of determination clearly underlies the cinematic performance of *Lust for Life*, and a corresponding determination to fix meaning characterizes the activity of critical history interwoven through the narrative fabric of the film. We are given a certain measure of such fixity in the morphological distance between optic view and artistic, transformative vision, revealing the latter as grounded in and encatalyzed by the former. The historian-critic (in the person of the cinematic apparatus itself) works to render morphological opacity semiologically transparent. Within the code of artistic practice developed by van Gogh, meaning is reduced to reference in a complex heuristic manner, which might be understood as follows.

First, it is granted that van Gogh's paintings refer to a given view of the natural world or, more broadly, his experiential world, which comprises the subject matter or content of the work. Second, it is implied that the historian-critic works to establish the intentions of the artist by a variety of means, most notably by a comparative method or *combinatoire* wherein the corpus of works

is examined to reveal a certain constancy or invariance of pattern (whether in form or in content). These telltale signs of constancy, or so-called style,[20] are assumed to be arrayed along (that is, they align themselves so as to project) a plane or table of distinctive features characteristic of the artist's corpus. This grid of features might then be employed, by hindsight, as a criterion for judging whether certain works are attributable to the artist in question.[21] Needless to say, the features may refer to morphology pure and simple (assuming for the moment that there is a reality to the notion of form apart from its obvious status as an analytic artifact); or they may indicate other kinds of constant patterning—thematic, semantic, tropic, and so forth.[22] (Such features might also be used to distinguish other aspects of the artist's corpus.)[23]

These two categories might be taken as distinct axes of signification, say, a vertical axis in the first case and a horizontal axis in the second. Such a grid might be understood, according to the implications of the film, as projecting a disciplinary apparatus that works to decode or to decipher the system of formation and signification comprising the artist's oeuvre, rendering the visible legible as signs within an aesthetic system, structure, or code peculiar to an artist, period, or place. Indeed, it would necessarily follow that the aesthetic code of our artist-hero is but one of a large number of partly idiosyncratic, partly shared codes of practice. The meanings of the artist's work would therefore be taken to represent a personal and original inflection of a wider code or system of artistic practices—an idiolect within a *Kunstwollen*, something recognizably van Gogh. Moreover, each of the distinctive features of this particular code of practice must in some way be mutually implicative and mutually defining: Each must in some way mesh with all others so as to engender and to exemplify that stylistic code in a unified way.

Such a set of circumstances depends for its pertinency upon a further set of assumptions. For the entire system to work at all, it must be assumed that there is an epistemologically legitimate division between form and content (or, in modern terms, between a formation that signifies and a content or meaning or reference that is signified). The purpose of the formation would be to convey a meaning from a maker to a user or beholder, who may very well be the maker himself. One might assume, then, that each of these facets could form the basis of two semiautonomous disciplinary objects with histories of their own—a history of the signifier (a *vie des formes*) and of signifieds (a *Geistesgeschichte*). Each might appear to evolve or undergo diachronic or diatopic change; and each might have a "life" of its own.

These two facets of art historical signification recall, in fact, the two faces of the traditional sign inherited from medieval scholastic philosophy up through its Port-Royal and Lockean extensions and transformations to the culminative work of Saussure three-quarters of a century ago.[24] Indeed, this

comprises the essential outline of the notion of the sign in its traditional or structuralist mode.

The semiological framework of stylistic analysis as implied by *Lust for Life* (and forming the tacit base of the discipline of modern art history) hinges on one major assumption: an isomorphism of the significative elements of the entire system, code, or oeuvre of an artist (and, by extension, of a time or place),[25] which is grounded in a deeper belief in a homogeneity of Selfhood on the part of the artist.

It is clear that the entire system makes sense only if we assume that the-man-and/as-his-work is a well-formed system,[26] displaying a constancy of patterning (morphologically and thematically) across every instance of the corpus of objects; and that each artwork, both in its totality and in all its details, is a trace or testimony of an organic wholeness, a constant self-identity of the Subject through all its transformations.

The system, in short, is teleological, grounded in a conflation of the-man-and-his-work and the-man-as-a-work (of art). Once again, to recall the previous discussion, the disciplinary apparatus works to validate a metaphysical recuperation of Being and a unity of intention or Voice. At base, this is a theophanic regime, manufactured in the same workshops that once crafted paradigms of the world as Artifact of a divine Artificer, all of whose Works reveal a funicity, a set of traces oriented upon a(n immaterial) center. In an equivalent fashion, all the works of the artist canonized in this regime reveal traces of (that is, are signifiers with respect to) a homogeneous Selfhood and are proper(ty) to him.

This system, then, would situate the art historian and critic as sacerdotal semioticians or diviners of intentionality on behalf of a lay congregation. We would seem to be dealing with a disciplinary apparatus that, in delimiting a domain of attention, equally specifies what would constitute proper historical criticism or exegesis. Both the art of art history and the art historian of art history come into complementary alignment as mutually defining and supportive artifacts of a disciplinary machinery. The protagonist of *Lust for Life* and the implied historian-critic are not historical figures as such but rather characters projected by its narrative machinery. Let us consider some of the implications of this fictional regime.

The art historical canon includes classes and types of objects that both have and do not have "authors." As indicated from the preserved traces of the visual environments of historical societies, the overwhelming bulk of this artifactual world is clearly anonymous with respect to known authorship. The art historical archive, however, works to rectify this anonymity by means of an encyclopedic system of nominalizations (the master of X; the school of Y; circa 2150–2050 B.C., and so on), which may or may not include a proper

name but invariably include some form of diachronic and diatopic attribution or provenance. In short, it incorporates markers of fixity within a projected universal space-time grid of appearances. For much of its modern history, the discipline has been deeply involved in attribution in various senses of the term, assigning works to loci of generation: a concern for authen-tication. Within this framework, the phrase "circa 1865" is as much a proper name as "42nd Street," and for a similar reason: Both serve to denote a spatial positioning within a grid.

Such a practice goes well beyond mere attribution of an artwork to a given individual, however. Its purpose is, in fact, to construct "the rational entity we call an author," as Foucault reminds us. He notes further that "these aspects of an individual, which we designate as the author (or which comprise an individual as an author) are projections, in terms always more or less psychological, of our way of handling texts."[27]

In the tradition of biblical exegesis as codified by St. Jerome,[28] the author is understood as (1) a consistent standard of quality (distinguishing him from inferiors or imitators); (2) a field of conceptual or theoretical coherence (with regard to the articulation of a system of doctrine); (3) a certain stylistic uniformity (exhibiting certain characteristic morphological elements); and (4) a definite historical figure in which a series of events converge (thereby eliminating works of a different time or place).

Foucault, in referring to literary analysis, observed that modern criticism presents a number of striking similarities to these exegetical strategies and that St. Jerome's criteria "define the critical modalities now used to display the function of the author."[29] It is evident that the criteria for reconstituting the visual artist performed by *Lust for Life* (as exemplary of critico-historical practices in the discipline of art history over the past century)[30] are fundamentally the same as these. "The artist" explains the presence of elements in a corpus of work—which is to say that the artist operates as a principle of unification for an oeuvre: "The author also constitutes a principle of unity in writing where any unevenness of production is ascribed to changes caused by evolution, maturation, or outside influences."[31]

In addition, the artist function serves historical and critical discourse as a device to neutralize contradiction. It is one of the functions of critical discourse to do so, by appeal to authorial self-identity in all works.[32] Picasso must always be himself in his paintings, ceramics, whimsical sculptures, personal letters, and signed receipts (not to mention the "essences" marketed by his daughter Paloma's perfume company). And governing all this "is the belief that there must be—at a particular level of an author's thought, of his conscious or unconscious desire—a *point where contradictions are resolved*, where the incompatible elements can be shown to relate to one another or to

cohere around a fundamental and originating contradiction.[33]

The disciplinary involvement with artistic attribution and recuperative justification goes very far beyond a dispassionate librarianship concerned with archival order and system for its own sake.[34] The discipline is grounded in a deep concern for juridico-legal rectification of what is proper(ty) to an artist and is thereby involved with the solidity of the bases for the circulation of artistic commodities within a gallery-museum-marketplace system. At the same time, it works toward the legitimization and naturalization of an idealist, integral, authorial Selfhood without which the entire disciplinary and commodity system could not function. The concern for fakes and forgeries, then, is no mere marginal curiosity: It is in one respect a key matrix wherein disciplinary, legal, and commercial lines of power converge and support each other—the keystone, perhaps, of disciplinary rhetoric. Not only must the property of different artists (or places, periods, or ethnicities) be clearly distinguished from each other, but the artist must be true to himself in all his works.[35] He must always be self-identical, and his work over time must be woven together as a coherent fabric.

And we need not be reminded that this notion of Selfhood is consonant with ethnic and national self-identity. Indeed, they are mutually supportive and coimplicative. It is not without pertinence that the discipline came to crystallize as a systematic technology, a *theatrum analyticum*, during a century increasingly obsessed with ethnic self-identity and national statism.[36] From its beginnings, art history was a site for the production and performance of regnant ideology, one of the workshops in which the idea of the folk and of the nation state was manufactured. Today, the extension of its disciplinary horizons to all places and times essentially continues this program of identifying, manufacturing, and sustaining Selfhood and solidarity. For both the Palladian villa and the Benin bronze, the same lines of disciplinary power and knowledge converge in the quest for authorship and homogeneous Selfhood.

3. The Palm at the End of the Mind

The palm at the end of the mind,
Beyond the last thought, rises
In the bronze decor,

A gold-feathered bird
Sings in the palm, without human meaning,
Without human feeling, a foreign song.
—Wallace Stevens

The Vasarian programmatic apparatus—the method grounded in medieval principles of biblical exegesis—sets forth protocols for erection of temples of the spirit in the modern discipline. More Roman than Greek, more Pantheon than Parthenon, the disciplinary edifice has been less a sculpted block of solids than an articulated mass or frame defining and bracketing an ineffable void: a material lust for an adjacent, metonymically contiguous, mold-negative, intangible life. It carves out of airy nothingness a local habitation, an obscure object of metaphysical desire. The art of art history, to echo Wallace Stevens, is "the palm at the end of the mind."

And like the Pantheon, the discipline is a vast aggregate of materials, methods, protocols, technologies, institutions, social ritual, and systems of circulation and inventory: some visible, most hidden, all interlocked into a machinery for engendering and sustaining a central Truth, a void made so palpable as to appear solid. Let us look at some of this machinery.

Currently, the discipline of art history seems like a kind of department store of methodological options from which we might choose or mix and match, according to the dictates of personal taste, selecting particular instruments suited to interlock with the configurations of perceived problems.[37] Indeed increasingly, institutional departments have come to portray themselves as such, both by inclusion as well as through strategic exclusions of certain methods (anything but formalism, anything but Marxism, anything but theory). To be sure, such apparent diversity normally masks an implicit and tenacious hierarchy of methods as well as an apparently widening rift between art history as a form of history and art history as a form of art—or between (not always the same thing)[38] a secular practice and a metaphysical one.

Yet this seemingly innocuous pluralism is but the equally extreme polar correlate of an opposite reductionism wherein everything is treated as a nail because all we possess is a hammer. The views illuminated by, or revealed through, the apparently differently crafted windows of heuristic attention under such rubrics as iconography, connoisseurship, stylistic analysis, semiology, critical theory, social history, deconstruction, and so on are neither different perspectives on the same objects, nor differentiated facets of some uniform master instrument.

Any methodology is a set of explicit and implicit stage directions for taking up declamatory, analytic positions—positions from which to make statements that are *dans le vrai*, from which certain kinds of questions are natural or pertinent or poignant. The self-identities of professional practitioners derive in no small measure from just such an epistemological scenography the function of which is to validate and naturalize and centralize certain kinds of discursive protocols while simultaneously marginalizing others. The

disciplinary strategy, by no means unique to art history, is not merely to carve up discursive fiefdoms related as equals in some broad disciplinary commonwealth, but rather to make it appear that other forms of discourse and other methodologies are heterodox. The language of art history has traditionally been intensely agonistic and even, at times, theocratic. But this should not be surprising in a field in which the force of personality reigned supreme and the individual insight was accorded heroic status, nearly equal to the depth of vision accorded the artist herself as the author of masterpieces.

If we attend very closely to the language of the discipline in modern times, and in particular to the topography of metaphor forming the basis of that language, it will become apparent that much of the dispute among competing methodologies today collapses into a rather different picture than what might be read off the surface of critical discourse. In the disciplinary task of rendering the visible legible, there are deep metaphorical assumptions which link together often apparently distinct methodological and theoretical approaches.

One of the most persuasive and tenacious tacit structures of the modern discipline is what may be termed the instrumentalist metaphor, a paradigm that has worked as a validating and naturalizing scaffold for many aspects of art historical and critical practice. In seeing methodologies as tools for analysis, we tacitly legitimize an empiricist modality that by its very terms—its implicit euclidean geometries—situates the analyst behind a glass wall, apart from objects or analysands. This binary, subject-object topology serves to reify the phenomenon in question [art], investing it with a pregiven ontological status, an otherness that is and must be autonomous of the analyst-subject. And it clearly resonates with the programmatic landscape of empiricist science; as H. I. Brown notes, "We must understand that scientists are trying to understand a reality which is objective in the sense that it exists independently of their theories."[39]

In investing this *Gegenstand* with ontological status, the object to hand ("the palm at the end of the mind") is necessarily loosened or bracketed away from its modes of production and reception and social determinations in order to align it with classes of objects perceived and defined as homologous or isomorphic on formal, thematic, or functional lines.[40] Such an instrumentalism works to encatalyze a wide variety of chains of deponent propositions and consequent paradigms, almost inevitably rooted in spatial metaphor. One of the more obvious consequences of presuming that such objects have a life or reality of their own is a temporal one—that they possess a history of their own,[41] which is somehow legible in objects, as the history of the earth may be read in geologic formations and fossils.

The space of instrumentalism is a descendant of the space of a certain

panopticism that has served as the dominant nuclear metaphor during the establishment, institutionalization, and systematization of the disciplines of Western education and professional life since the Enlightenment. Michel Foucault's classic discussion of the importance of Jeremy Bentham's Panopticon model for the ideal prison or institute of surveillance is worth recalling.[42] For our purposes, it will suffice to note that the observation site in Bentham's circular prison confers upon the observer an invisibility and detachment from the objects of surveillance. The position is clearly analogous to the epistemological and synoptic position of the art historical and critical (or in general disciplinary) subject. Indeed, the panoptic prison, in its topology, also can be seen as providing a systematic ground for the disciplinary archive as such:[43] Each backlit cell is the extension of the Vasarian frame and a prefiguration of the cinematic logic in our *Lust for Life*. It is also an extension of a metaphysical and theologic order, connected with an earlier Renaissance perspectivism.[44]

The illusion fostered here is that the site from which subjects observe objects is detached and neutral, a locus inhabitable by anyone with proper credentials, a position that remains constant despite changes in personnel. The complementary illusion fostered by a panoptic instrumentalism is that objects of surveillance are understandable through removal from their social and historical contexts. What is occluded is the fact that what are taken as data are, in fact, *capta*. Such a fragmentation and bracketing necessarily gives priority to the formal, morphological, and surface characteristics of the observed objects.

In abstracting phenomena from their contexts — indeed, from their textuality as such[45] — instrumentalist metaphors work to establish bracketed objects on a lattice or grid of formal homologies. Objects are necessarily fixed as tokens of a reified type, related to other tokens as inflected instances of a general class. At the same time, particular notions of context are equally and reciprocally fixed. For every text there must then be an apposite and opposed con-text, and an important recuperative movement is set in motion so as to connect or relate the given artwork or class of objects to their historical, social, or biographical grounds.

What is of interest here is the language of such a movement. More often than not, these operations are couched in the language of euclidean spatial geometry. Relations between object and context, between art and its grounds, are articulated as linear or multilinear connections: The object is staged as a resonance or reflection of historical or social situations, conceived invariably as external to the object in focus.[46] The thicker the web of connectivities and the more richly embedded it is in its time and place, the more confident we are of practicing serious social history rather than mere formalism. The

artwork is necessarily construed as a sign of its time or place or a distillation of the spirit of an age or personality.

While there is a great deal of variation in the specific language of such operations, from the reflectivities of older formalisms to the signifier-signified relations of more recent structuralist semiologies, underlying much of this variation is an invariant notion of reintegration of some purported fullness, the reconstitution of the latter serving as the ostensible goal of study—"what Vincent saw" or "what Manet's Olympia meant" at the time of its appearance. Little thought is given to the further implications of such reconstitutions, to the steps beyond establishing what is blithely construed as a fixity of meaning.

Within the discipline today, there is a good deal of ambivalence about the problematic of contextual reintegration and its methodologies. These range from the mechanical practices of iconographic text matching[47] to more recent versions of social history and to formalist connoisseurships and the current challenges to the latter brought about by work in "aesthetic scanning" and "shape grammar,"[48] from various metaphysical Marxisms[49] to the Rube Goldbergesque contraptions of certain forms of artistic psychobiography.[50]

One might assume that if one hand of the discipline dissects, the other must sew up the patient after the operation; and it may seem reasonable to envision the discipline as a corporation of practitioners each with separate tasks to perform in assuring that all parts of the machinery are well oiled and meshed together with occasional clumsiness but with ultimately good intentions. It is less obvious, but I think clear after a certain amount of circumspection, that this is an illusion manufactured by the very geometry of disciplinary knowledge as such—the idea that, like the parallels of Euclid, the various lines of subdisciplinary practice work in parallel toward an ideal future where the strands will be tied together by our betters, by masters with a more synoptic vision to match those of our idealized masters of some golden disciplinary age two or three generations ago.

There is no central control tower in the disciplinary shunting yards of research. To imagine that there is or should be would be to continue the ideological program of idealization and mystification that has engendered and reified artwork as an instrumentalist Object in the first place. It would be more to the point to rearticulate the blueprints that have engendered and sustained the metaphorical landscapes within which we practice our craft. Metaphor, never in any way innocent, always orients research and prefabricates and fixes results.[51]

At various times in the history of art history, certain images persist almost as prefabricated material capable of assimilation to a wide variety of rhetorical and methodological protocols. A close rereading of the history of the

discipline's retentions and transformations of its guiding tropes reveals a picture of disciplinary development that is rather different from that found in most prominent histories of art history. By attending to the detailed mechanisms by which tropes, paradigms, and metaphorical images operate, we may get closer to some of the ideological presuppositions that double-bind us. Such bonds operate with remarkable heightened power at the most elementary constitutive syntactic levels in art historical writing.

To understand the ideological double bindings that legitimize the discipline's operational protocols, it is necessary to attend to the fact that language is never transparent, neutral, or value-free. To employ a disciplinary language (from the jargons of formalism to those of semiology) is to enter into a composed and prefabricated world, a tapestry of ontological patterns. Often, an illusion of greatest freedom and idiolective bricolage masks precisely those sites of declamation that are most controlled. The observer in the disciplinary panopticon, while hidden and separated from the system of objects under observation, is himself in a prefabricated position or locus, captive in a device that delimits and defines what may be seen at all. Both seer and seen are components of this apparatus.

The instrumentalist metaphor is precisely an apparatus for the manufacture, maintenance, and naturalization of a particular family of related ideologies. Within its frame, it comes to appear inevitable, for example, that any artwork or any object of attention is either fully accountable by comparison with other equivalent objects of attention or fully accountable only by certain absences. Both positions are co-implicative. In the latter case, "that which is absent" is construed as anything from spirit (of a time, place, people, or person) to social or historical or economic forces determining anything from the object's morphology to its functions or use value. The hypostatized object is akin, within this framework, to a gnarled tree on a windswept coast, whose very form is a function of a constant but invisible wind.

An obsessional formalism which sees the task of the historian-critic as complete in a verbal paraphrase of its visuality is nonetheless a subspecies of a reintegrational perspective, if only in situating the object as a testament or lack thereof of artistic genius. In all versions of disciplinary praxis, the object is invariably a sign, a signifier of something signified: an artifact of some previous mentifaction. While it is obvious that art objects are invariably the result of some prior assemblage of materials (whether manufactured or appropriated from a given built environment)[52] and are thus in some sense an effect of activity, within an instrumentalist metaphor the cause-effect relationship is characteristically skewed so as to privilege the prior state. The latter is commonly envisioned as situated internal to the maker or as external—as in the case where the maker is reduced to an instrument of

extrinsic forces of various kinds (economic, social, cultural, and so on). In short, instrumentalism, both in its formalist mode and in its structuralist semiological facets, raises questions about a confusion of final, proximate, or efficient cause.[53]

It is clear that the metaphor is dependent upon some theory of semiosis in various theoretical or methodological guises. And yet the version of semiosis on which much of these variations rest is more akin to that inherited from medieval scholasticism than from any more recent poststructuralist versions. And in particular, the theories of the Port-Royal grammarians loom large as a determining background.[54]

To return to the question of the situational geometries of instrumentalism: If every methodology is construed as oriented toward some domain of attention, every perspective equally implicates a near side or inside of the analytic window. It incorporates a viewing from somewhere, a perspective whose apex is at the locus of the analyst, the wielder of tools. It is not without significance that this view *from* is characteristically occluded or taken for granted in art historical and critical writing. The position of the analyst, in this panoptic regime, is a tacit space (that may be filled by similarly equipped or invested persons)—an ideally neutral Cartesian zero point, as divested of its own history, sociality, and conditions of investment and establishment as its analysand. Just as the analytic isolation of the object of study serves to generate and to naturalize illusions of completeness or closure (the artwork as an object or unicum in its own right) and evokes or elicits deponent chains of metaphorical imagery in validation of such closures, so it may be observed that the antisymmetric isolation of the analyst produces similarly powerful consequences.[55]

In the discussion of *Lust for Life* and its implied art historian, the art object and the art critic were seen as co-implicative and mutually defining functions of the cinematic apparatus. The subject established in relation to an object was himself subjected to the particular constraints of the instrumentalist machinery. These constraints are manifested in two ways: (1) in the specific regime of visibility permitted by the apparatus, which constructs a position from which, and only from which, the object (oeuvre, vita, genre, or period) is readible or legible; and (2) in a system of linguistic protocols whereby declamation by the subject is acceptable primarily in a historical, narrational, third-person mode. The latter (shared more broadly by the historical and sociological disciplines) involves a practice carried out in an enunciative regime, in Benveniste's sense of that term.[56] The former is a species of anamorphism—the channeling of vision into the singular point from which a scene reveals itself as veridical. Anamorphism is the basic design principle of the entire disciplinary apparatus,[57] from panoptic instrumentality to the

organization of the art historical archive and constitutes one of the principal guiding metaphors linking together formats for analysis, theories of visual representation (a theory is literally a perspective or *view*), and definitions as to acceptable and proper forms of declamation.

In this manner, any form of disciplinary knowledge is a panoptic, anamorphic apparatus: what is visible is legible only from a particular perspective that both reveals objects of a domain and occludes other objects and other possible domains. In the case of art history, the geometry of the apparatus determines the nature of both the analysand and the analyst as well as the sense of any analysis.

4. The Wickerwork of Time

It may suffice to note that any rewarding use of the notion of an historical or cultural period tends in spite of itself, and often despite the best intentions, to foster the impression of a facile totalization, a seamless web of phenomena each of which, in its own way, "expresses" some unified inner truth — a world view or a period "style" or a set of structural categories which marks the whole length and breadth of the "period" in question.
—F. Jameson

As we have seen, *Lust for Life* performs and validates a notion of the life and work of an artist as an ordered unicum, an artwork in its own right, characterized by an essential homogeneity and self-identity. It was clear that the film biography derived its own naturalness from the implied existence of a universal archive of equivalent vitae. And it was also suggested that the vita functions as a paradigm for other kinds of lives — those of a people, race, nation, or period — and that in so doing, it operates as a microperiod in the diachronic evolution of art as such. The Vasarian framework of the-man-and-his-work resonates with and evokes larger unities on a diachronic scale and leads us necessarily to a consideration of one of the central problematics of the discipline — the notion of periodicization.[58]

It is not difficult to understand the manner in which the paradigm of the individual vita operates as a nuclear metaphor aligning chains of consequent paradigms and metaphors. On the dual axes of space and time, the individual vita is the model both of the art historical period and of an ethnic or national style or spirit. The greater bulk of art historical and critical writing in the modern period has been devoted to the establishment, refinement, and justification of such unities. Indeed, the history of art history might be

plausibly written as the ongoing and ever refined writing out of this implicit programmatic,[59] just as the history of the museum could be reasonably portrayed as a history of the performance of that programmatic in an imaginary space.[60]

As noted previously, art history in its formative phases in the latter half of the nineteenth century, was one of the important sites for the manufacture, validation, and maintenance of ideologies of idealist nationalism and ethnicity, serving to sharpen and to define the underlying cultural unity of a people as distinct from others. In this regard, the emergent discipline was one facet of a broader movement that included the resuscitation (or invention) of national or folk art, architecture, and literature, contributing to the justification of a people's self-identity through the erection of genealogies stretching back through the mists of time.[61] Various versions of national histories of art came to be systematized and codified according to contemporary paradigms of evolution. But apart from the more obvious biological models to hand at the time, there were closer and more directly pertinent models to inform the epistemological foundations of the emerging discipline of art history—notably, philology and, in particular, glottochronology.[62]

The latter is one of the primary parallels for an art historical formalism that assumed an intrinsic or internal aesthetic evolutionism—the perspective that art forms exhibit a largely autonomous growth and evolution according to laws largely independent of external conditions (barring Visigothic or Mongolian invasions). The glottochronological model of language change, focused specifically upon diachronic changes in the signifier (in this case phonemic and acoustic configuration), held that there could be shown to exist certain inexorable laws of change and transformation in linguistic form that operated independently of meaning, context, or social usage. The elucidation of such laws could therefore serve, reciprocally, as standards against which to assess the relative ages of linguistic texts of hitherto unattributable date.

Glottochronology was a facet of nineteenth-century philological science addressed to the origins and formation of linguistic families. In the late eighteenth century, this study achieved a major breakthrough by painstakingly demonstrating that the ancient sacred language of the Rg Veda, Sanskrit, was in fact a cognate of classical Greek and Latin as well as a cognate of other languages of the European group (which came to be known alternately as the Indo-Germanic or Indo-European family), such as Celtic, Germanic, Armenian, Slavic, and Persian.[63]

This work should be seen in the broader context of the intense eighteenth-century concern for natural evolution, which stressed the study of geology and the notion that the earth bore within it traces of natural hieroglyphs, sediments, and strata indicative of cataclysmic upheavals of past eons. The

latter, a focus of an interesting genre of European painting discussed recently by Stafford,[64] provided one of the correlative metaphors for philological research, eventually serving as a theoretical ground for the philological subdiscipline of glottochronology.

This is not to suggest simply that art historical formalism in its diachronic mode was a direct linear descendent of such paradigms (even if in some cases art historical evolution in the early modern period was conceived of as a direct analogue of glottochronology);[65] rather it may be affirmed that the former grew up within a certain epistemic framework of which linguistic and natural evolution were correlative paradigms. In other words, it would be more realistic to see the situation as one of mutual implication and interwoven metaphorical naturalization. In the case of linguistic evolution, it is quite clear that in no small measure such work served, both implicitly and overtly, important ethnic and nationalistic agendas. The development of aesthetic history served equivalent if not identical aims.

In an important sense, early art history and glottochronological phonology operated from a common set of assumptions, chief among which was the notion that the spirit of a people was manifested—and could be systematically traced through—every morphological detail of a cultural artifact system. That is to say, everything about any detail of formation will—indeed, logically should—reveal something of the basic nature of a people at various stages in its evolutionary development. The trick was to learn to read the traces astutely.

Clearly, the assumption is that there exists such a unified nature, an "it" that changes slowly or abruptly over time or that is manifested through regional inflections over geography: The corpus of Englishness or Hellenism (when construed as being more than an artifact of analysis or ideology) is pictured spatially as a grid or lattice whose coordinates define greater or lesser combinations of a matrix of distinctive features. So much of modern art history has been devoted to the plotting of relative distances among such clusters of distinctive features without reference to the bases for the assumption of the corpus itself. To a great extent, this avoidance is built into the pedagogical formats of art history curricula, which, despite occasional variations, rarely deviate from patterns inherited from nineteenth century historicist agendas.

The panoptic, anamorphic apparatus of the discipline, with its built-in instrumentalism, exhorts the art historian to construct the text of history so as to render it internally consistent and coherent. This exhortation extends to the larger chronological picture as much as to the individual vita or to the individual artwork. Ambiguity, internal incoherence, or contradiction are to be gradually eliminated as the historian or critic comes to elaborate hypothe-

ses that can account for and render mutually coherent the greatest number of elements in the work, in the life, or in the period.

In short, the guiding question behind disciplinary activity—What time is this place?—pervades all levels of analysis, and the need to suppose that persons, periods, or works of art either do or should constitute harmonious wholes is rarely itself questioned.

These perspectives are one with the principles governing the framing of individual vitae, within which the artist is revealed in every facet of his material production in a manner harmonious with all facets of his personal life—the-man-and/as-a-work (of art). It is equally apparent that the notions of periodicization commonly assumed by the discipline are grounded in the same metaphor of homogeneity and unity. This is not to deny *tout court* that differences between specific historical styles might not be historically valid in some general way, at least if one looks at a period through the frame of a specific place (say, classical Greece through the eyes and products of the city of Athens). Rather, the point is that with few exceptions the justificatory assumptions guiding such framings tend to be couched in a metaphorical rhetoric that is metaphysical at base and at one with a broad ideological program of ontotheological validation[66] linking together a large number of practices and methodologies of which art history, as a disciplinary form of knowledge, is itself a facet. We are dealing with what is surely an ethical praxis, dependent upon very particular notions of Selfhood inherited from certain areas of Western theology.

A great deal of recent art historical writing works in such a way as to isolate and to privilege an element in a totality such that the element or class of elements—forms, forms of belief, or formats of social interaction or ritual —serves as a master code or essence capable of explicating other elements of the totality in question; as something to measure other elements against (again, the spatial or visual metaphor). It has been precisely this reificational movement that has lent the history of art history's art its characteristic fictionality. At once reductionist and scientistic, the projected history of artworks occludes complexity and contradiction, producing a curiously aestheticized version of social and cultural history.

The discipline manufactures this ideological fiction at a variety of sites[67]—in textbooks, libraries, verbal and cinematic biographies, university curricula, the establishment of appropriate fields of research for professional as well as doctoral candidates, the formats of journalistic reviewing and art criticism, as well as in the erection and maintenance of a class of imaginary spaces-as-history: museums.

If the "history" of art history's art has too often been to history as Disneyland is to the history of the United States, it may be because, like the latter, it has

worked to engender and maintain a heterotopic vision of what it might be comforting to believe about ourselves and our history. But this is not to oppose the history of art history's art to some truer history or to imply that the perspectives on history manufactured and naturalized by formalist instrumentalism are fictive only because they might be rather clumsy synopses or distorted refractions of a fuller and more complex history. There is no history that is not uninvested ideologically: At issue is the question as to whether any history articulated within a discursive framework based upon centrality, homogeneity, or the continuity of self-identity can be other than oppressive. While art history today may have gone beyond an earlier obsession with masterpieces or with the paraphernalia used by dominant classes to signal status, wealth, and power in various media, the question remains open as to its capacity to move beyond the paradigms of history that have been part and parcel of that paraphernalia.

Opening up the question of history as a discursive practice and a genre of writing brings us up against one of the most deeply seated metaphors for art in the history of art history.

5. Speak to Me Only with Thine Eyes

He walked Broadway like an active, transitive verb amidst a rabble of adverbs, prepositions, and other insignificant parts of speech.
—attributed to Stanford White

The notion of art objects as communicative tokens or forms of message material, in short, as language, is a metaphor that has risen like a phoenix from the ashes of nearly every methodological framework in the history of the discipline and deeply pervades the entire history of writing about art in the West. Transcending many diverse and otherwise opposed theoretical perspectives, its more recent variants have been Panofskian iconology and its apparent apotheosis, structuralist semiology. Indeed, the notion of art as language seems at times the cornerstone in the disciplinary edifice.[68]

Within such a framework, broadly construed, aesthetic activity is pictured as a nonverbal correlate or analogue of the speech act or enunciative event, the three primary constituent elements of which are a speaker, a message, and a listener. The speaker is taken to correspond to the designer, maker, or artist; the made object (anything from a saltceller to an entire urban fabric) is likened to a message or text; and the viewer, user, or beholder (singular or plural) is taken to be an addressee, receiver, or consumer of such message objects.

Despite a great many rhetorical variations, the geometry (or more appro-

priately, the *topology*) of relationships among the three constituent elements of the paradigm has essentially remained constant. And what seems to be constant in the history of art history, particularly over the past century, is a strong resistance to seeing this metaphor as anything but natural or inevitable. It has been so taken for granted in the discipline that, most of the time, it is invisible.

Indeed, what could be more natural than a view of art as a form of social communication? For surely, art objects can with good reason be spoken of as conveying a certain content—intellective, emotive, social, cultural, and so on—to a certain audience. It is true that formations are made and used and that in particular societies at particular times, maker and user are distinct individuals, classes, groups, or professions. And, unquestionably, makers and users do indeed construe artifactual formations as communicative in some fashion. To greater or lesser degrees, made formations are taken as autonomous or semiotically complete, closed, or finished, or else as coordinated components in broader sociocultural transmissions, which may or may not include formations in the same or in other media. Some of the latter (if one takes up a perspective from painting—and what modern art historian can avoid that stance?) may be architectonic, verbal, musical, tactile, or olfactory. One may imagine the iconographic program of a medieval church or a modern museum as necessarily including the building itself as well as the performative rituals oriented around a scenography.[69]

To construe made formations as meaningfully communicative in some way may or may not be generically pertinent or historically apt. But to construe them as always communicating, or as always communicating in the same or equivalent ways over time or context, is quite another matter. Included in that idea is invariably the notion that the art object has a message in itself and that we may interrogate it so that it may speak to us. It is this idea that has been commonplace throughout the history of the discipline. In this century, the idea has been foregrounded by iconology and has been even more privileged by the advent of visual semiotics.[70]

We are confronted, in this class of paradigms, with an essentially transitive and linear chain of events wherein the object in question is taken as a trace of the intentions of an active fashioner, whose intentions and conditions of production are to be reconstituted by users, viewers, or beholders—in short, to be read. In this chain of assumptions, the artwork is construed as a reflection of re-presentation of originary mentifaction—the signifier of some set or class of signifieds. That which is signified is assumed to have existed at some conscious or unconscious level in the mind of the maker. The canvas is a delivery van, conveying meaning to the customer.

What tends to remain constant behind all of the variations in imagery

designated is the topology of relations among maker, object/message, and viewer (or among producer, product, and consumer). If we look at the paradigm more closely in the history of the discipline, we can identify five constituent elements that play a role:

A. maker/artist
B. processes of production
C. object
D. processes of reception
E. user/viewer

There have been many metaphorical variants for each of these positions or functions, among which the most prominent have been:[71]

A. inspired articulator of collective or class values; privileged servant of a social order; prophetic or bohemian rebel dissidently marginal to conventional society; independent manufacturer freely offering private products to amenable audiences; worker-engineer or bricoleur on a fraternal footing with an audience; God;
B. manufacture; revelation; inspiration; play; labor; reflection; reproduction (of originary mentifaction or intention); fantasy;
C. product; process; practice; medium; symbol; epiphany; gesture; icon; index; message (in a personal or collective, real or imaginary code);
D. consumption; magical influence; ritual; participatory (or indirect) dialogue; passive reception; spiritual encounter; translation; divination; cryptanalysis;
E. reader; consumer; receiver of a transmission that may or may not have been aimed at her; critic; connoisseur; worshipper.

Close attention to art historical writing reveals fewer metaphorical variants for *E* than for any of the other component terms in the paradigm, for by and large the viewer has been seen largely as a passive reader or consumer of images: the end of the line, so to speak, the targeted audience or inadvertent interceptor of a transmission.

This logocentric paradigm[72] is given a characteristic slant or trajectory so as to privilege the maker or artist as an essentially active, originary force, in complementary contrast to the essentially passive consumer or reader of works. It involves no great leap of the imagination to see that the paradigm simultaneously serves as a validating apparatus to privilege the role or function of the historian or critic as a legitimate and invested diviner of intentionality on behalf of lay beholders.[73] The position is at the same time sacerdotal and secular, with the historian or critic inevitably [wittingly or not] representing the interests of a certain class, group, or collective in

the rectification of reading—that is, in interpretation.

In the imaginary space of the metaphor, the historian-critic occupies a position athwart D (we may call her D_1), serving as an exegetical grid. Indeed in one sense, D_1 is the engine of the machinery—the enabling device that gives life and direction to the entire system. And although individual readers might be free to actualize the text of the work in different ways, employing it as a site for the evocation of personal associations, the viewing of artworks cannot ultimately be an occasion for idiosyncratic bricolage or freeplay. There are two constraints upon this: an arbitrary prejudice inherited in part from Gestalt psychology regarding the need to integrate discrete perceptions into an intelligible whole,[74] and a second stabilizing, fixing reflex—the question of intentionality to which the critic-historian is professionally privy. Some meanings must needs be closer or truer to originary intentionality, and it is the traditional task of the art historian to elucidate such meanings and references. In short, pictorial imagery must be some kind of code and by definition must be conventionally grounded, with determinate and determinable signifieds.

It is clear that we are dealing with an essentially re-presentational paradigm wherein the art object is construed as a vehicle through which the intentions of the maker are transported to the mind of the beholder through the medium of artifactual articulations. The object is a form of conveyance for a particular absent content in the same manner that words carry meanings or references. The paradigmatic apparatus may be seen as working to support reflectionist notions of artwork consonant with those of instrumentalist formalisms. For the lay beholder, the subtext of the message is invariably the same—the genius [or lack thereof] of the artist as yet another trace of human creativity in all its ineffability. The artist is a chip off the divine block.

Historically, this absent content has been conceived in spatial terms and has been characteristically positioned on one of two axes:

1. externally, in the direction of a *Zeitgeist* or *Kunstwollen* or of ethnicity in general; or of social, economic, or historical forces of which the maker is but the instrument of transmission; the ghostwriter, so to speak; or
2. internally, in the direction of creative or libidinal impulses or energies of which the maker is often unconscious and for which, again, she may serve as an instrument.

With regard to the first, the logocentrist paradigm is connected to assumptions regarding periodicization and ethnicity in the sense discussed above; in the second case, it is grounded in Romanticist notions of a homogeneous Selfhood, all of whose products are to be construed as evidence for psycho-

biographic unity or self-identity over time and circumstance. It is patent that both axes serve as an armature on which accrues the praxis of the art commodity marketplace: to possess a work by X is to possess, dually, the spirit of X and of X's time and place.[75] Value is translated into the singularity of the artist in his creative gestures, and it is the appropriation of artworks as signs that legitimizes their economic and social power. The value of the artwork is equated with its genealogical value—the signature and aura of its successive transactions, its pedigree.

This goes beyond the use of artworks as mere signals of power and social status: Just as the cycle of successive gifts in primitive societies charges the object with ever more value, so the artwork circulates from inheritor to inheritor, creating not merely profit but legitimacy. In this regard, the modern public museum does not simply remove works from a private, parallel marketplace to some sort of collective ownership (thus guaranteeing their authentic aesthetic functions); rather, the museum functions like a gold bank, as a fixed reserve guaranteeing the bases for private exchange, an agency transmuting economic exchange value into sign exchange value. This entire potlatch system is grounded in, and is legitimized by, the logocentrist metaphor and its fabrications of Selfhood.

The linguistic or communicational paradigm in all of its metaphorical variants is not only idealist in the extreme with regard to its picture of language as such, occluding all but the most simple one-on-one interpersonal locution[76] but is also deeply metaphysical, deriving from a metaphor of the world as the artifact of a divine Artificer. It privileges Voice over its representations or material traces. Logocentrist paradigms of artistic activity are deponent metaphors oriented upon a core ontotheologism, one of whose historical manifestations was the coordination of Vision and Voice in Renaissance iconology.[77]

The metaphor of art as visual language, then, is no mere innocent or neutral analogy, even if that metaphor has been largely secularized in modern times. It is, in fact, the very warp on which the disciplinary weft has been carried in its historical development over the past century. In short, the discipline is by and large committed to a view of language (or of signification) that is reductivist in the extreme. Suffice it to say, the bulk of the current disciplinary crisis has been concerned with the urgency of revising our notions of signification, as we shall see below.

To return to the topology of the communicational paradigm, in addition to de-emphasizing the viewer or user of artworks, there is also a marginalization of interest in the intermediate terms of the paradigm and a relegation of attention to these processes to external or extrinsic status in the discipline, to use Kleinbauer's terms. Both *B* (circumstances and processes of production)

and *D* (processes of reception) are relegated to psychology, despite a continuation of interest in these issues among art historians who began their work prior to World War II (notably Ernst Gombrich or Rudolf Arnheim)[78] or among current scholars whose recent work has been exemplary (in particular, Baxandall, Clark, Fried, and Krauss).[79] Much of this more recent work has focused on problems of reception and construal, issues brought again to the forefront by the contemporary interest in (or rather revival of interest in) signification theory. Disciplinary awareness of problems in perceptual and cognitive psychology remains minimal and has all but ceased, following the heyday of Gestaltist work in the 1930s, as has attention to the important question of how children learn to mean nonverbally.[80]

In no small measure, the discipline has maintained its focus upon the "what" of signification to the near exclusion of the "how"—the historical circumstances of artistic work, and the complex mechanisms whereby meaning is engendered. This persistence stems from a perspective on art as representation in a narrow sense[81]—art as a second reality alongside the world in which we live day to day, rather than as one of the powerful social instruments for the creation and maintenance of the world in which we live. The former focus invariably legitimizes art as essentially a mode of private entertainment, a dreamworld to soften the jarring complexities and contradictions of the present and the past.

The response to the tedious Michelangelism still prevalent in the discipline—the obsessive fetishism of the-man-and/as-his-work—need not be a repetition of the logocentrist double bind in reserve, the undue privileging of addressees or decoders; a casting of the question into an arena of completely idiosyncratic bricolage; or an opening up of the artwork to the transfinite multiplication or eternal polysemy of signification. Such a movement would amount, in fact, to a kind of negative theology as theocratic as that which is rejected and would do little but maintain the severance of subjects and objects from their social, historical, and ideological circumstances. To do so would be to continue to practice an idealist and mystifying prioritization with a different hand but with the same deck of cards. To fetishize the viewer simply reverses an older fetishism of the artist.

A reversed logocentrism would work to obscure the psychic complexities of individual subjects, as logocentrism itself obscures those of makers. Subjects, rather than consuming or passively decoding artworks, in fact appropriate, maintain, and transform the artifactual world in all its facets in meaningful, dynamic, and not infrequently contradictory ways. In so doing, they might be said to transmit to themselves and others certain information regarding the dynamic and changing nature of such appropriations. I use the term *information* here in Gregory Bateson's sense as "news of difference," and the

term *reckon with* is preferable to *read* precisely because of its double meaning of "coping with" and "thinking with." Whatever the sources of artifactual production, the user is always an active, complicit, constru(ct)ing subject.

It might be thought that of all disciplines, modern art history would know a great deal about the ways in which viewers construe artworks. But the fact remains that collectively we know very little about this. There has been little place in the academic discipline for engagement with such issues and only a minimal awareness of potentially comparative work in other disciplines or areas of research. To be sure, the problems raised for disciplinary practice by postmodernism and poststructuralism have brought such issues to the fore-ground among a small number of professionals, but the implications of the latter for the discipline have been minimally examined.

Yet the implications in a general sense are suggestive. Artworks—like any group of cultural artifacts—afford positions for subjects in signifying practice. The maker of an object is at the same time an addressee of her own activity. Any articulation is necessarily directed both towards oneself and some other(s). Indeed, it may be said that one articulates to oneself from the place of an Other.[82] It is clear that any form of significative activity, whether verbal or visual (for the sake of this argument, these may be kept apart), involves not merely the transfer of information from A to B but equally the very establishment and maintenance of the subject in relation to its Other, and the internalization of the Other in the formation of the self.

Moreover, all signifying activity is, in varying degrees, referential, self-reflective or autotelic, allusory, territorial or phatic (signaling various degrees and levels of individual or collective identity), emotive or expressive, and didactic, directive, or conative.[83] Varying degrees of dominance among these dimensions might be attested in the reconstructed intentions of makers as well as (and thus not necessarily in identical ways) in the reckonings of users with respect to the same work. And in addition, such significative dimensions necessarily change over time and circumstance: It need hardly be said that a painting of a Madonna and Child in a fourteenth-century church may be materially identical to itself when removed to a foreign museum, but it is surely not identical aesthetically (being prized more for its morphological or historical value than for its role as an *imago agens* in a religious iconographical program) or culturally (having become part of a new and different icono-graphical program for a modern museum).

Precisely because visual artifacts have a certain degree of object-permanence (in contrast, say, to unrecorded speech acts) and may remain perceptually available over long periods of time, they are necessarily subject to major changes in significative appropriation by different users or by the same users at different times and in diverse circumstances.

Such complexities may be multiplied easily, and it becomes clear that the differences between verbal language and visual artifacts may be more pertinent than their purported homologies, as I have argued elsewhere.[84] The point to be made here is that it is necessary to attend to the entire set of processes whereby artifacts used as artworks are produced and reckoned with in the engenderment and sustenance of individual and collective realities (that is, ideologies), if we are to (1) see the logocentrist and instrumentalist paradigms in a clearer and more enhanced light; (2) reverse the parochialism of focus so endemic in the modern academic discipline; and (3) reconnect the contemporary discipline with its prewar engagement in important philosophical, cognitive, and psychological issues.

And in attending to the "how" of such processes, we shall be in a better position, in my view, to understand why certain rhetorical tropes and guiding metaphors have informed the growth and development of art history as a discipline—how, in other words, all that seems natural and inevitable about art and art history has been historically fabricated for a variety of social ends. This is not to say, however, that we shall escape the forest of ideological symbolism into some neutral clearing. To imagine that we might would be to fall precisely into a prefabricated trap.

In its long and complex history, the discipline of art history has been dominated by a number of recurrent metaphors, including those of genesis, origins, continuities, resemblances, evolution, and periodicization. The corpus of art historical and critical writing has spoken of dualities and binarisms, among them notions of primitivism versus sophistication; fine art versus craft; simplicity versus complexity; monumentality versus ordinariness; uniqueness versus replication. Our discourse is deeply imbued with notions of invention, metamorphosis, problem solving, the gradual (or abrupt) emergence of one visual logic or style out of or against another or others, as well as various versions of geometric, spatial, or topological theorems for the mapping of relationships between objects and surrounds or systems of social, cultural, ethnic, or individual value.

As a discipline, art history presupposes very specific systems of value pertaining to the nature of history, sociality, production, consumption, exchange, perception, cognition, and origins. Historically, the discursive protocols of the discipline have been bent toward making specific (and specifically post-Renaissance Western) ideas about art as an object in its own right inevitable and natural.

We have seen something of how the metaphorical apparatus of the modern discipline works to establish and to position artwork and art historian relative to one another as functions within a panoptic, anamorphic machinery. It has

been suggested (and I believe this to be correct in its general outlines) that the discipline also serves to project or to validate a certain kind of viewing Subject: ideally, passive consumers, and, in more contemporary contexts, educated and discerning cryptographers—but receivers of messages all the same. At the same time, art history has been a powerful system of investiture of certain professional groups—historians, critics, connoisseurs, curators, dealers, and archivists—with interpretative, semiotic, or exegetical power. In this regard, of course, it shares with other humanistic disciplines (perhaps most closely with literary studies) a highly complex and self-perpetuating analytic theater of power and knowledge, a discourse always written in the third person singular.

In sum, the discipline of art history has been a complex apparatus for the ongoing manufacture of certain forms of ideology as knowledge. Its forms of power and control, however, do not emanate from some central office or *comité*, despite a latent tendency towards heroicization, but are diffuse and diverse, as anonymous as a machine or a work of art whose mode of address is "To whom it may concern."

Art history has all too commonly been a coy semiology in the service of a theologism masquerading as a humanism. While it has always lived, since its academic institutionalizations over a century ago, within an enchanted realm of the dream of scientificity, it, in fact, functions more obviously as an ethics. Surrogate definitions and descriptions of the ideal human have pervaded nearly all definitions of art in the corpus of art historical and critical writing. And as a semiotic enterprise, art history has operated as a system of metaphors, the metaphoricity of which has been forgotten.

It always seems as if the discipline is trying to put back together again a Humpty-Dumpty fragmented by the instrumentalism of its own discursive apparatus. Within such a space, that obscure object of desire of art history can only remain obscure. Nor will the situation change substantially merely by replacing old disciplinary contents or subject matters with new ones if the same discursive formats and protocols remain unchanged or unquestioned —as indeed happened during the 1970s with the rise of a "social history of art." Art history, despite claims to the contrary, has never been the name of a science. It is a form of cultural practice necessarily interwoven with other forms of social and cultural practices, inexorably linked to social and ideological needs and desires. Its future survival as a discipline will be read in its ability to understand its own complex and contradictory history.

In its various traditional disciplinary formats, art history was an instrument for the manufacture of ideology as knowledge, one whose modus operandi has always been strongly cinematic. In the words of Stephen Heath, "An important—determining— part of ideological systems . . . is the achievement

of a number of machines (institutions) which move, which *movie* the individ-
ual [as Subject], shifting and placing desire, the energy of contradiction, in a
perpetual retotalization of the Imaginary."[85]

After more than a decade of debate and discussion of disciplinary crisis, it
is perfectly clear that art history knows what it does. And it frequently knows
why it does what it does. What it knows less well, however, is what *what it does*
does.[86] The pursuit of that understanding, which entails the re-membering
of the lines of rupture and contradiction papered over by art history as it
perpetually misreads its own history, is surely our most pressing task.

The Panoptic Gaze and the Anamorphic Archive

Spaces are born and die like societies; they live, they have a history. In the fifteenth century, the human societies of Western Europe organized, in the material and intellectual senses of the term, a space completely different from that of the preceding generations; with their technical superiority, they progressively imposed that space over the planet.
—P. Francastel

Bentham was the complement to Rousseau. What in fact was the Rousseauist dream that motivated many of the revolutionaries? It was the dream of a transparent society, visible and legible in each of its parts, the dream of there no longer existing any zones of darkness, zones established by the privileges of royal power or the prerogatives of some corporation, zones of disorder. It was the dream that each individual, whatever position he occupied, might be able to see the whole of society.
—M. Foucault

1. The Theater of Geomancy

The setting is a wide, shallow auditorium in the museum at Forest Lawn Cemetery in Glendale, California, not far from central Los Angeles. The lights are low, and an atmosphere of solemn expectancy pervades the theater on this New Year's Day. The visitors, having just viewed reproductions of all known Michelangelo sculptures in the bright haze of the cemetery gardens outside, welcome the cool, dark comfort of the theater. Gradually, the lights dim, and organ music fills the auditorium. Beyond the music one can sense something imminent: A low rumble announces the dramatic opening of the world's largest curtain, followed by a few moments of silence and complete darkness. Suddenly, the music swells, and the darkness is pierced by a small spotlight illuminating a group of figures wearing biblical garb. A deep voice emerges through the music to begin a narration of events leading up to the Crucifixion. The

audience is about to travel through the world's largest painting.

For the next forty-five minutes, spotlights roam the vast dark space, illuminating each successive episode in the religious drama. Passing episodes recede into darkness. The spotlights suddenly punctuate the screen unpredictably—fifty feet to the left, twenty feet up and back to the right, at dead center, and in the far margins. The painting by Jan Styka—which seems hundreds of feet wide and at least a hundred feet high—becomes transformed into a sequenced narrative made up of stills of Roman soldiers, the Holy Family, apostles and followers, Mary Magdalen, the Hill of Golgotha, Pontius Pilate, and good and evil characters: the whole Crucifixion story laid out as spotlit stations of the cross.

The performance ends with a full and dazzling illumination of the gigantic painting. In the last minutes of illumination and tragic musical crescendo, the entire landscape of crucifixion is before us: The whole temporal framework of the religious drama, the whole dramaturgic journey, is captured in a single space. Following another pause in the darkness, one views the story of the Resurrection similarly performed across the world's second largest painting. The musical score and voice-over, however, are rather more upbeat.

What at first glance might seem a grotesque apotheosis of the art history classroom is in fact a re-presentation of the discursive space of the modern discipline *tout court*. One immediately recalls the virtuoso performances of professional colleagues entrusted with teaching large surveys of art history in auditoria large enough to allow them to flash four or six images on the screen at once, thus brilliantly orchestrating historical narratives.

The scenography of such a performance is grounded in a number of assumptions and is made possible by a technology, both material and metaphoric, with Renaissance roots. Moreover, the proper use of this technological apparatus not only gives us the object of study—that is, makes it visible—it also works to analyze objects in their very morphology. And beyond this, the resultant morphology (or syntax) also performs the mental judgments taken as coincident with that process of analysis.[1] In short, the discipline operates a discursive machinery—a practice of manipulating signs (that is, thinking) —that positions the analyst with respect to an object or series of objects, thereby simultaneously defining the nature of proper objects and constructing a proper distance between subject and object.

Such a discursive order, which Timothy Reiss terms "analytico-referential discourse,"[2] had a variety of manifestations at the time of its emergence in the sixteenth century. Its principal metaphors were those of the telescope (eye–instrument–world) and of the voyage of discovery (self-possessed port of departure–sea journey–country claimed as legitimate possession of the discoverer).[3] The basic premises of this discursive order included the notion

that the syntactic order of semiotic systems (particularly language, but in a coordinate fashion also the new perspectival realism in art)[4] was coincident with both the logical order of reasoning and the structural organization of a world given as exterior to both of those orders. The relationships were taken to be not simply ones of analogy but of identity. As Reiss observed, the exemplary formal statement of this set of relationships is *cogito-ergo-sum*.[5] He goes on to note that

> simultaneous with this claim of logical identity, various devices are elaborated enabling a claim for the adequacy of concepts to represent objects in the world and for that of words to represent those concepts. The outcome is that the properly organized sentence (a concern dominant among grammarians of the second half of the century) provides in its very syntax a correct *analysis* of both the rational and material orders, using elements that *refer* adequately through concepts to the true, objective nature of the world.

The metaphor of the telescope was of prime importance in these developments, representing the emergence of a new kind of conceptualizing practice: Signs always fall within the space of the telescope itself. For Galileo, knowledge was always a sign-manipulating activity. Thus, the star observed through the instrument is not the same object as the star observed with the unaided eye: Changing the length of the telescope gives us a different instrument and therefore a different object.[6]

Discourse, in this Galilean paradigm, stands equally for a distance between subject and object, as well as an exchange between the division of mind and matter. In contrast to the medieval period in which, as Reiss argues, the sign had been in all ways the equal of the thing,[7] the word had now become a means of *visualizing* the object: the mark of, but also a bridge over, a new space between the intellect and the world. This new discursive order produces a system that will prove a more powerful instrument than what preceded it: the paradigmatic instrumentality of the scientific method,[8] in all its transformations up through the end of the nineteenth century, climaxing in the "telescope" model of Freud.

The complex courses of Reiss's arguments are beyond the scope of the present discussion. We shall instead attend to the configurations of discursive practices that Reiss does not address (despite occasional references to Panofsky)[9]—those of the visual arts and their interpretation.

As discussed previously, the discipline of art history has traditionally addressed the task of making the visible legible. In other words, it is apparent that the disciplinary apparatus has evolved as a means for reading objects. In this way, the analytic theater of art history parallels the perspectival,

re-presentational art of the Renaissance wherein the painting, sculpture, or building became a means of rendering the world as legible. Moreover, one might suggest that traditionally the modern discipline has functioned precisely to hypostatize the discursive, sign-manipulative activity of the new art of the Renaissance itself.[10]

Indeed, in a powerful way, the analytic theater of art history operates as a metaphor of the scenographic logic of perspectival realism. The historian-analyst occupies a discursive position of centrality analogous to the perspectival eye of painting as a single, central view. Recall Alberti's discussion of the picture plane: "Painters should only seek to present the form of things seen on this plane as if it were of transparent glass. Thus the visual pyramid could pass through it, placed at a definite distance with definite lights and a definite position of center in space and a definite place in respect to the observer."[11]

The plane of the canvas or panel corresponds to the conjunction of two pyramids at their bases. The pinnacle of one pyramid corresponds to the imaginary vanishing point, and that of the other, to the imaginary subject whose place we propose to fill.[12] While the Renaissance painting displays a scene, it simultaneously puts us in our place, fixing us as subjects for certain meanings. In the words of Nichols, "The painting stands in for the world it represents as we stand in for the singular but imaginary point of origin; we recognize the identification marks of the world re-presented while this very identification marks our position, our capture and appropriation."[13]

It should be noted that the cost of such fixed centrality is a marginal distortion resulting when the observer's eye is not correctly positioned in the center of the perspectival projection. The recognition and exploitation of such potential distortion characterizes anamorphic art—for example, paintings (such as Holbein's *French Ambassadors*) in which the center of projection is oblique to the picture plane rather than perpendicular to it, as in strict linear perspective. In an anamorphic image, the realistic illusion locks back into place once the proper position is found.

Galileo abhorred these perversions of "normal" vision[14] developed during the sixteenth century. Yet it can be argued that such curious liberations from the fixities of central-point perspective nonetheless ceaselessly confirm the importance of steady, center position. The wit of anamorphism is a constant reference to a rational and stable system that it assumes in the very moment that is parodied or questioned.[15] In short, anamorphism functions both as a critique of the discursive apparatus of linear perspectivism and as its support: an oblique validation of its power and naturalness. Anamorphic painting displaces the viewer to another locus, one not directly opposite the vanishing point of the perspectival work (hence, not perpendicular to the picture plane);

in that displacement, the laws of linear perspective nonetheless apply.

Alberti condemned those painters who, because they wished their work to seem abundant in detail or because of some *horror vacui*, fail to practice composition, instead scattering everything about in a confused fashion, rendering the narrative disordered rather than enacted ("*sed confuse et dissolute omnia disseminant, ex quo non rem agere sed tumultuare historia videtur*").[16] Composition is conceived here not merely as morphological unity but as a unity of theme and information. As Baxandall has shown, many of these crucial terms are taken from the humanist theory of the time, grounded in Ciceronian rhetoric.[17]

The discursive space of the Albertian ideal painting is composed of a unity of form and theme (*compositio*), wherein the body of the viewer is reduced to a punctual site of reading. That this is an ideal locus is clear: It depends, in fact, upon a foveal centrism in relation to a *veduta* that, contrary to the circumstances of actual vision, is rendered totally clear and distinct even at its margins. In other words, the entire field of vision is measurable and visible.

The system incarnates a viewer, rendering him tangible and measurable: a Subject in a composed space, not merely a random witness. Subject and Object are captured and fixed along the centric ray passing back and forth between point of view and vanishing point. The distance between the two is a fully articulated space, rendered either explicitly or implicitly as architectonic —the chessboard of the urban stage, as Damisch has observed,[18] a word-bound scenography.

The gaze thus established is, as Bryson notes, rather like that of Argus, "with a thousand foveae held motionless to a thousand points on the canvas."[19] The actual "fragmented *durée* of viewing, which labours to build an eventually total scheme of the image and to comprehend the composition *im Augenblick*,"[20] is assimilated and buried beneath a dream of instantaneous and timeless painting.

All this forms a background to the discursive space of the modern discipline of art history, but not as a simple teleological determinant. Indeed, the position of the art historical analyst necessarily assumes this background; but it is not sufficient, for the discipline arose within historical frameworks carpented out of more recent metaphorical material, and a more recent hypostatization of that background: the discursive space of the Panopticon. It is the latter, curiously ignored equally by Reiss in *Discourse of Modernism* and Bryson in *Vision and Painting*, that provides us with a more adequate opportunity to understand the architectonic logic of art history's *theatrum analyticum* as fundamentally mythomorphic, approximating the form of which it speaks.[21]

2. The Eye(s) of Power

Experiencing Styka's *Crucifixion* at Forest Lawn recalls John Locke's description of the workings of the mind as a kind of *camera obscura*: "The understanding is not much unlike a closet wholly shut from light, with only some little openings left, to let in external visible resemblances, or ideas of things without: would the pictures coming into such a dark room but stay there, and *lie so orderly as to be found* upon occasion, it would very much resemble the understanding of a man, in reference to all objects of sight, and the ideas of them."[22] Images appear at various positions within the dark closet of the auditorium. The task of the apparatuses of voice, music, and spotlights is to cause such "pictures" to "lie orderly" so as to com-pose understanding. In an equivalent manner, the apparatus of the modern discipline composes understanding by causing the history of artworks to lie orderly as a history of aesthetic form.

But beyond mere form, the unit pictures of this history comprise a sliding scale from individual *taches* (say, the earlobes of Caravaggio) to the-man-and/as-his-work (the Vasarian frame)[23] to times, periods, places, or ethnicities. Everything from the semiological enterprise of connoisseurism to the architecture of stylistic and intellectual history is made to lie orderly. Indeed, the different views projected by various disciplinary tasks or methods come to be subsumed in a common frame.

These would lie orderly, and lie, orderly: as fictive, ideal compositions of pictures enacting a genealogy construed as a history, a teleological destiny —*dessin* as *destin*. "Would but the pictures . . . stay there," as Locke observed: The task of the discipline is to cause its objects of desire to "stay" within a domain erected to encompass the encyclopedic history of aesthetic form, to "*lie so orderly as to be found*."

The position of the art historian in this theater of memory and illusion is also akin to that of the user of Giulio Camillo's Memory Theater in the sixteenth century,[24] regarding which Viglius stated:

> He calls this theatre of his by many names, saying now that it is a built or constructed mind or soul, and now that it is a windowed one. He pretends that all things that the human mind can conceive and which we cannot see with the corporeal eye, after being collected together by diligent meditation may be expressed by certain corporeal signs in such a way that the beholder may at once perceive with his eyes everything that is otherwise hidden in the depths of the human mind. And it is because of this corporeal looking that he calls it a theatre.[25]

Viglius also notes, in the same passage, Camillo's "zeal in imitating Cicero" in this theatral fantasy. As Frances Yates argues, Camillo's Memory Theater represented a confluence of a variety of theories of memory, from the ancient Greco-Roman practices prescribed by Cicero and Quintillian to a Christianized cabalism mixed with Hermetic elements. In essence, Camillo's theater was a version of the ancient Vitruvian semicircular theater, on whose tiers were fixed all manner of symbolic figures drawn from antiquity, serving to index an entire system of world knowledge. In short, as Yates noted, this was "the Idea of memory organically geared to the universe":[26] a reduction and compression into symbolic figures of world knowledge composed as a theatrical filing cabinet.

As such, Camillo's Memory Theater is a late Renaissance instance of a Western concern for data storage and retrieval, as well as a sort of apotheosis of Greco-Roman rhetorical praxis with an admixture of Cabalism and Neoplatonism. But what for the ancient orator striving to memorize long arguments was a technique of visualizing thematic material along an imaginary architectonic topography became, in the sixteenth century, an articulated Space for the Subject to inhabit.[27] Although Yates discusses the materialization of the Thomist Summa in the actual construction of church iconography by painters such as Giotto (relying on *imagines agentes* or strikingly naturalistic imagery in ecclesiastic contexts),[28] the connection between these practices and the Albertian discursive space is not made.

And yet the connections seem patent, in the sense that the Albertian apparatus and the Camillan theater have two topological aspects in common: the identity of the position of user or beholder, and the equivalencies between the perspectival space constructed by the new painting and the receding hierarchical tiers of the mnemonic scenography. It may be reasonable, then, to suggest that the Camillan theater was an instance of the new discursive spaces of the Renaissance that had begun to elaborate determinate and determinable positions for subjects and objects: yet another enactment of a metaphor of knowledge and vision of which Galileo's telescope and Alberti's *pittura* were equally powerful exempla.

Of course, the Forest Lawn theater treats the episodes of the vast painting as various *vedute* or stations in a religious history in precisely the same way that the disciplinary apparatus summons up individual artworks as *vedute* upon a vast history of aesthetic formation. Objects are conjured up (in the dark) to "lie orderly" in a projected domain of objects. The disciplinary apparatus incorporates parallel technologies as well—the historical survey text and the museum or gallery being most notable among these.[29] Furthermore, the Forest Lawn theater re-enacts the discursive space of the academic discipline; despite the grotesque size of its apparatus, an identical topology of

relations between constituent elements is in place. And in both cases, highlights of a vast memory theater are evoked: In the one case, the point of reference is a religious biography; in the other, the great diorama of human creativity in all media.

And yet salient differences exist between these two constituents and the topology of relations exemplified by Galileo's telescope, Alberti's Window,[30] and Camillo's Memory Theater. In other words, there is an element of difference between these latter and the discursive space of the modern discipline: That difference is the situation of the analytic Voice, the locus of narration. In the Forest Lawn apparatus, as in the disciplinary machinery at large, the Voice of the historical narrator, emanating through the darkness from a set of electronic speakers, stands apart.

The narrator is thus a component in a cinematic apparatus, an invisible or dimly perceivable source that the beholder projects upon the screen. The image speaks to us and seems to narrate itself. This disembodied Voice in the disciplinary technology is precisely analogous to the enunciative modality in the art historical written text, which is narrated in the historical third person. In short, the invisible Voice animating the progression of imagery is equivalent to the use of the third person in historical writing: a voice of authority and authorization.

In addition, this Voice becomes the exegetical filter of aesthetic signification: It assumes the position of interpretation or analysis lying athwart the transitive conveyance of meaning by the artwork to classes of viewers.[31] This is perforce a coy Voice, emanating from the dark, projected, moreover, *into* that imagery (as we project voices from a movie-theater speaker into the lips of characters on the screen) as if to conjure up the Voice of the work. The work speaks to us of its history, circumstances of production, and sense ("what Vincent saw" or "what Manet's *Olympia* meant).

This Voice coyly speaks in a historical mode in the textual practice of the discipline, fostering an impression of naturalness, authority, and legitimacy. In short, the disciplinary apparatus maintains a constant topology of relationships among the elements of sense and meaning—in the academic or pedagogical machinery (the lecture hall or seminar room), in the archive of analytic writing (the survey or biographical text), and in the heterotopic architecture[32] of cultural institutions (the museum). All of these technological apparatuses work to maintain a coordination of vision and voice, a rectitude wherein, in Locke's words, things "stay" and "lie orderly."

The scenographic carpentry of Alberti's Window; the analytico-referential discourse of the scientific method of which Galileo's telescope comprises a metaphorical diagram and enabling device; the mnemonic architecture of the theater of Giulio Camillo—all of these comprise the expanding horizons

in the modern discipline of art history since its emergence during the final quarter of the nineteenth century. But none of these alone is capable of accounting for the particular discursive architecture of the conflation of power and knowledge within the discipline. By the time of the institutionalization of art history as an academic discipline, those practices had been subsumed in a powerful metaphorical framework for all forms of disciplinary knowledge, engendered by the design at the end of the eighteenth century for a house of surveillance—Jeremy Bentham's Panopticon.[33]

The late Michel Foucault suggested the existence of a powerful epistemological connection between the architectonic logic of the Panopticon and the formats of modern disciplinary knowledge.[34] Foucault's arguments on this score have been persuasive in general, although I hope to make clear that the particular logic of the discursive apparatus of art history presumes a powerful formative role for Renaissance perspectivalism, memnotechnics, the architectonics of scientific methodology, as well as for a certain logocentrist[35] construal of semiosis or signification. Let us first examine the Panopticon itself (fig. 1).

Bentham's design for the Panopticon consisted of a ringlike building of several stories surrounding a central tower. The tower was pierced by windows opening onto the inner side of the peripheral mass of rooms or cells. These openings were aligned with those of the individual cells, each of which had two windows, an inner one and a large outer one. The entire cell was backlit by the large outer window; this backlighting allowed an observer in the tower to survey fully the inhabitants of each cell—madmen, criminals, patients, or schoolboys. Like so many small theaters, each cell contained an individual actor, "perfectly individualized and constantly visible."[36] The format, in effect, reversed the situation of the older dungeon—that swarming, dark place of communal confinement, contagion, and conspiracy.

In such a theoretical setting, everything is surrendered to perfect visibility, which is now the ultimate trap. This visibility is axial—subject to the hidden gaze of the supervisor(s) in the central tower—and complements a lateral invisibility: There is no communication possible between inhabitants of individual cells and thus a guarantee of order.

Great pains are taken, simultaneously, to render the supervisor invisible to those being surveyed. Bentham envisaged not only venetian blinds on the windows of the tower, but, on the inside, partitions intersecting the hall of observation at right angles. Moreover, there were no doors between quarters in the observation hall, only zigzag openings (as in old-fashioned photographic darkrooms). The reason for this is patent: Any slight noise or gleam of light would betray the presence of the supervisor. Power, in this regime, is both visible (in the anonymous mass of the central tower seen from each cell)

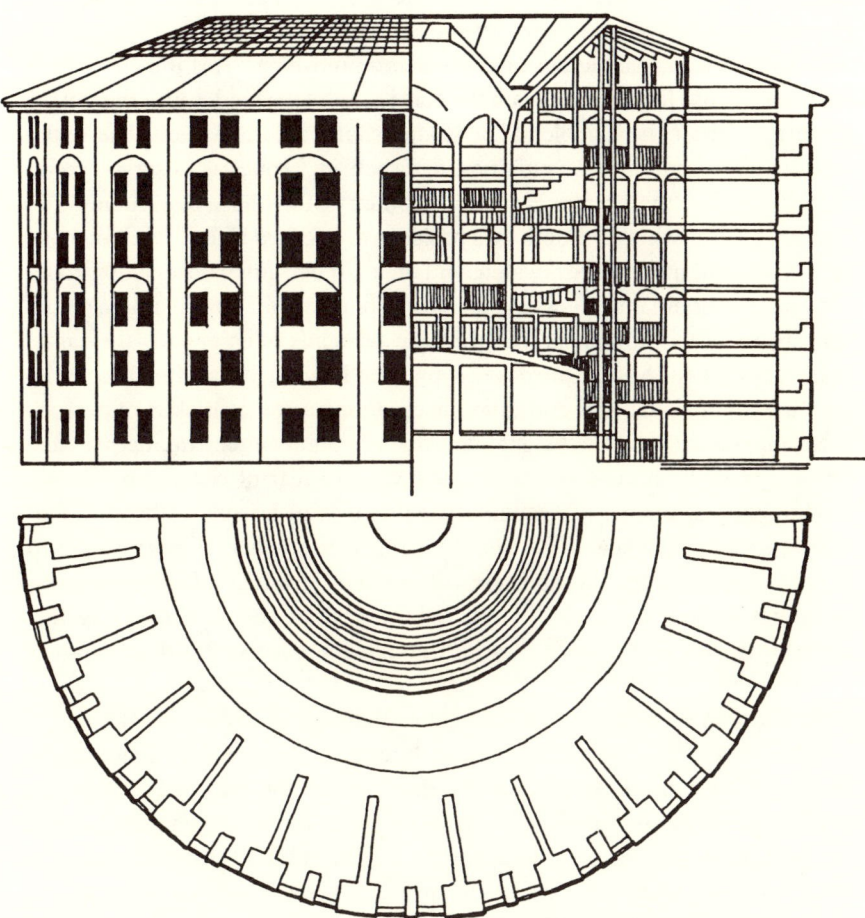

FIGURE 1. *Bentham's Panopticon.* (Adapted from Bentham, *Panopticon*, pl. 2.)

and unverifiable (in that the inmate can never know exactly when or how he is being observed).

The effect is precisely that of the contemporary electronic surveillance camera mounted over the entrances to some buildings: a sign of anonymous surveillance. As Foucault observes, "The Panopticon is a machine for dissociating the see(ing)/being seen dyad: in the peripheric ring, one is totally seen, without ever seeing; in the central tower, one sees everything without ever being seen." Note also that "consequently, it does not matter who exercises power. Any individual, taken almost at random, can operate the machine: in the absence of the director, his family, his friends, his visitors, even his servants. Similarly, it does not matter what motive animates him: the

curiosity of the indiscreet, the malice of the child, the thirst for knowledge of a philosopher who wishes to visit this museum of human nature, or the perversity of those who take pleasure in spying and punishing." It is thus no longer necessary to use force to constrain the convict, calm the mad, cause the worker to work, motivate the schoolchild be studious, or make the patient observe the rules of an institution. The old "house of security," Foucault observes, could be replaced by "the simple, economic geometry of a 'house of certainty.' "[37]

It is not clear whether Bentham's project was inspired by Le Vaux's menagerie of animals at Versailles (which contained an octagonal observation room with circumferential windows); it is known, however, that by Bentham's time this structure had disappeared.[38] But the principle is essentially the same. What is pertinent for our purposes is that the Panopticon made possible the drawing up of similarities and differences among a constant class of persons in an immediate, rapid, efficient, and quantifiable manner. Among patients, one could track the courses of diseases without fear of contagion. Among schoolchildren, one could examine the progress of lessons without fear of copying and influence. One could quantify the signs of normalcy and abnormalcy, measure the aptitudes of workers in such a factory (thereby making it possible to justify differences in wages), or assess character against a norm. In short, one could classify through the observation of juxtaposed instances of a constant class of phenomena, or, in a similar fashion, compare different classes of phenomena and educe their distinguishing marks.

In this sense, the Panopticon is an architectonic apparatus for enacting the discursive logic of the chart, the table, the diagram, the taxonomic list, or the memnotechnical theater of knowledge — in short, the entire paraphernalia of the human and natural sciences. Foucault rightly observes that this apparatus was, in a sense, much more than a dream building (as much as it might owe to the utopic architectonics of the eighteenth century):[39] It was a diagram of a mechanism of power reduced to its ideal form, "a figure of political technology . . . detached from any specific use." As Bentham himself said, it was applicable "to all establishments whatsoever, in which, within a space not too large to be covered or commanded by buildings, a number of persons are meant to be kept under inspection." It is, moreover, "a great and new instrument of government . . . ; its great excellence consists in the great strength it is capable of giving to *any* institution it may be thought proper to apply it to."[40]

Power, in such a framework, is not a heavy constraint, but is subtly present in the fabric of life through what he termed "a simple idea in architecture." This is, moreover, a fully transparent space in which the exercise of power may be supervised by society as a whole, repeating, in a remarkably efficient way, the Rousseauist dream of a "transparent society" in which each individual "might be able to *see* the whole of society."[41] It was Bentham's

opinion that the increase in power established by his panoptic regime of visibility carried no risk of degeneration into tyranny, for he envisaged the disciplinary mechanism democratically controlled and accessible to all.

Foucault notes that the panoptic schema was destined to spread throughout the fabric of the entire social body, to become a generalized function. It came to program the basic functions of society penetrated through and through by disciplinary mechanisms. It amplified power, but in a special sense — by strengthening social bonds, increasing productivity, developing the economy, raising public morality, and formatting public education as a universal instrument of the social commonwealth.

Bentham's apparatus is best viewed not as an invention totally reforming a view of the world but rather as representing a kind of technological breakthrough that worked to subsume, collect, and amplify diverse strands of perspectives on knowledge and power copresent in the seventeenth and eighteenth centuries: a milestone in the ongoing loosening of the disciplines from their kinship with traditional religion.

Foucault argues that after the beginning of the nineteenth century society is defined in increasingly disciplinary ways; and yet "'discipline' may be identified neither with an institution nor with an apparatus; it is a type of power, a modality for its exercise, comprising a whole set of instruments, techniques, procedures, levels of application, targets; it is a 'physics' or an 'anatomy' of power, a technology"[42]—a technology that may be taken over by specialized institutions (such as the penitentiary) or by institutions that use it as an essential instrument for specific ends (the hospital and the university).

Bentham's Panopticon stands Janus-like between the modern era and the ancien régime and partakes of both. It was one product of the age of revolution in a century of Enlightenment that would have banished all darkness in man. His vision prescribed a regime of power that might have been construed as the diametric opposite of monarchy. It stood deeply entrenched in the attitudes of an age that, as expressed in the preoccupations of the revolution, wished to prevent wrongdoing by eradicating the desire to do wrong.[43] It sought in a utopian fashion to banish, ultimately, the need for punishment and to redress the wastefulness of monarchical forms of punishment wherein the judiciary arrested only a portion of criminals so as to frighten others through spectacular displays of punishment, torture, and execution.

Bentham's project held interest for its time because of its concise formulaic nature — the promise that it might be applicable to almost any conceivable domain of social life. It promised power through transparency, a space of exact legibility. But it was inspired by already existing forms of discipline: In fact, the idea for the Panopticon originated with Bentham's brother, who in 1751 had visited the Ecole Militaire in Paris.[44] In addition, the designs by

architect Claude-Nicolas Ledoux for the salt plant at Arc-et-Sedans gave effects similar to those of Bentham's Panopticon.[45]

In the course of his discussion of Bentham's Panopticon, Foucault observed that this "architectural apparatus" would be "a machine for creating and sustaining a power relation independent of the person who exercises it; in short, that the inmates should be caught up in a power situation of which they are themselves the bearers."[46] Yet while this may indeed have been the case for Bentham's apparatus, it should also be said that any architectural "apparatus"—indeed, any urban fabric—could be claimed as functioning in equivalent ways. Cities do, in fact, sustain power relations as well as engendering and naturalizing them, and a similar claim can be asserted for artifactual systems in the broadest sense, from the paraphernalia of material culture in general to the fine arts of painting and sculpture (an assertion to be explored in chapter 4). For the moment, however, it may be said that Bentham's Panopticon offered its age and the modern period in general a particularly focused paradigm of the conflation of knowledge and power.

In that sense, the Panopticon resonates with Camillo's Memory Theater as an *imago agens* of a generalized paradigm—a strikingly vivid and exemplary model of a discursive space that positioned subject and object in a specific topology of relationships, permitting information and knowledge to be evoked. The Panopticon and the Memory Theater function in equivalent ways on several fronts: (1) in siting the observer in a position of centrality vis-à-vis an ordered array of phenomena; (2) in rendering that array completely visible—in the former, as individual cells peripherally arranged on several vertical stories; in the latter, as stepped tiers of information packaged as compressed symbolic *figurae* indexing distinct inflections of knowledge and wisdom; and (3) in allowing comparison, distinction, contrast, and variation to be instantaneously legible.

But the two also differ in several ways. First, the Memory Theater is what we might term today a passive information store, while the Panopticon is a more active program for the creation and evocation of information: a machine for generating knowledge rapidly and economically. Second, the *figurae* in the tiered space of Camillo's Theater are statues, while those in the Panopticon are living individuals: Camillo's statues speak to us of what is more or less complete, finished, closed; in the Panopticon, the inmates behave.[47] Third, the two differ particularly with regard to the visibility of the observing subject: In the theater, visibility is not an issue; in the Panopticon, the subject, as well as the locus of seeing, is invisible, hidden from reciprocal observation.

Furthermore, let us note that the invisibility of the panoptic observer-analyst in relation to living objects of study can be seen as equivalent to the stance of detachment of the modern disciplinary analyst vis-à-vis his or her domain of study. This is the glass wall of instrumentalist empiricism,[48] the

fabricated naturalism of an objective, realist stance, a modality for elucidating knowledge taken as existing in an object. As was made clear in chapter 2, this instrumentalist stance works to legitimize the domain of the history of art as ontologically pregiven. The Eye of Power is the enabling device of the dream of scientificity and an archetypal image within that dream.

3. Lares et Penates: The Art Historical "I"

The "before" and "after" inscribed within the space of the photo reveal that time is inscribed in any spatialization, that otherness disrupts identity, that no present is full and complete in itself but contains traces of the past and the future within it (as it becomes a part of another present in which it is trace rather than presence). This is true of any photograph, any portrait. . . . To read a photograph is to produce a double series (at least) of discourses around it (before and after) and generating from it; it is to inscribe it in an intertextual synchronic-diachronic network and to open up its arbitrary frame or border to the differences of society and the times of history (a conflictual plurality).
—David Carroll

The function of ideology is to fix the individual in place as subject for a certain meaning. This is simultaneously to provide individuals with a subject-ivity, and to subject them to the social structure with its existing contradictory relations and powers. The subject in ideology has a consistency which rests on an imaginary identification of self. . . . The consistent subject is the place to which the representations of ideology are directed: Duty, Morality, and Law all depend on this category of subject for their functioning, and all contribute as institutions to its production. . . . The individual thus lives his subject-ion to social structures as a consistent subject-ivity, an imaginary wholeness . . . the individual produces himself in this imaginary wholeness, this imaginary reflection of himself as the author of his actions.
—Rosalind Coward and John Ellis

The realism of the Albertian Window, the perspectivalism of artistic practice inaugurated during the Renaissance and constituting the mainframe of aesthetic praxis up into the modern era, was perforce an ideological fabrication. It was a powerful format of representation that a

society gave to itself, fixing the relationships by which individuals would represent themselves in their world of objects, their signifying universe. As an ideology, it functioned by putting the individual at the center of structures, making this subject the place where ideological meanings were revealed.

The imaginary wholeness of the subject recognized in the aesthetic *veduta* is an artifact of the perspectival orderliness of that object: both a mirror of the world and a mirror of the self. Alberti's Window, in this sense, may be said to be an instance of what Lacan would call the "imaginary" wherein the construction of the self takes place through a process of imaginary identification (of self) as a united whole in a "mirror" stage of ego development.[49] In Lacanian terms, this identification is retained as the prototype for all self-identifications as the child enters into social and cultural formations (symbolic systems)[50] as a language-using (that is, generally signifying) subject. All such identifications made by the individual in the process of producing itself in discourse are always already *in* ideology.[51]

The positionality prescribed in perspectival realism as it evolved during the Italian Renaissance serves to define and de-limit the Subject as a site for the predication of sense. Meanings exist for the Subject who functions as the place of the intention of those meanings, commencing with the separation of subject and object. As Kristeva has noted, "The position of the imaged 'I' introduces the position of the object, itself separated and signifiable."[52] As the infant is forced to situate its identity in separation from objects, so is it the case that the specular image makes up the prototype for the world of objects. And the subject is constructed by means of its acquisition of signifying practices from the place of the Other. In Lacan's terms, the Other is "the place where the signifying chain is, which controls everything that will be able to be *presented from* the subject" (italics mine).[53]

It is the misrecognition of the ideological ficticity of this positionality that projects as natural the Cartesian *cogito* and the Albertian *veduta*, with their positing of a Subject completed and finished in its identity and essence, transcending all transformations. Claude Simon, remarking on the integrity of each family's past, noted that this is "as if the same model with the same pensive, pitiless and disabused countenance posing for the same painter had put on at some theatrical costumer's their successive garments, reincarnations, sporadic reappearances of a single character repeated down through the centuries in the same perfidious and weary attitude."[54] The family history with its origin in the portrait is seen as nothing but a continuous series of portraits and the voices that could be anchored in them.[55] Each portrait indexes all others, as the terms *mother, father, sister,* or *brother* refer to relationships within a system of kinship.

It might be said that one of the primary functions of the art museum in its

modern history[56] has been to install the Cartesian self in a hall of mirrors (Albertian *vedute*) in which that Subject can be re-cognized. Indeed, it might be suggested that the art museum reduces all installable objects to positions of predication in an Albertian subject-predicate frame, wherein the composed object is made to work to reflect the beholder's Subjecthood. It could hardly be otherwise in an institution that situates Caravaggio and Duchamp on perfectly equivalent pedestals: All must "stay" and "lie orderly," preserving and projecting a fixity of meaning so as to capture in their gaze the gaze of an integral self. Challenged to find and locate the unity in works, we inevitably find our own unity. Even if—indeed, especially where—certain works refuse unity and fixity of meaning:[57] The power of the museum lies precisely in its ability to elide alternative signifying practices.[58] In this regime, the beholder is invited, in Sylvère Lotringer's words,

> to confront the diverse sections (of the text), to uncover the correspondences, to note the similarities and differences, to describe relations, in brief, to constitute a Summa, a Monument of Sense. A procedure which is eminently classical. . . . One always ends up completing a puzzle. All it takes is enough time. Disorder is never remediable: it constitutes only a simple moment of hesitation in the service of an operation of mastery. The dispersion of pieces never ceases to proliferate under the reassuring image of an original totality which is hidden only in order to be reestablished in all its rights. . . . Each piece of the puzzle holds "its place" from all eternity. It is enough to identify it and to assign to it, according to its own configuration, the site that belongs to it. The puzzle, in its closed, restrained economy, is a secure game. Meticulously closed in on itself, completely framed. The game of science and the game of meaning. The game of the science of meaning.[59]

Everything takes place in the museum in some eternal contemporaneity; all diachrony, all difference, all multivocality is enframed in synchronicity. As a heterotopic space, the art museum orchestrates difference and contradiction into a single visible field and in a focus that is always deep enough in a cinematographic sense to include everything in its ken. In this sense, the frames always operate so as to disappear out of focus.[60]

In short, the museum functions on the same principles as the Albertian Window, reducing to perfect visibility all points of view, in two senses. First, the museum situates all objects within viewing spaces that evoke and elicit a proper viewing stance and distance. Artworks are spaced, arranged, and composed so as to permit the taking up of proper stances: positions for the subject. Second, it composes a narrative, historical space made up of episodes (early Netherlandish painting, Impressionism, Greek vases, the

world of Tutankhamen; or, equivalently, the Sackler Collection, the Mellon Bequest). In every instance, the visitor is released into an imaginary space (in both the literal and Lacanian senses of the term) in order to make sense of the puzzle palace; and, ultimately, to make sense, to story oneself in the semiological labyrinth of the history of culture presented as a genealogy of art.[61]

The art museum is thus a panoptic apparatus that decomposes and rearranges the elements of Bentham's Panopticon into a cinematic journey made up of *vedute* topologically equivalent to the views of individual cells in the house of surveillance. The defining instance of this process, the ideal type to which museums of the present either refer back to or anticipate, is the Guggenheim Museum, the Panopticon of Fifth Avenue.[62]

Unlike its panoptic prototype, however, the modern art museum does not render the observer invisible. Indeed, the visitor is supremely visible, circulated through a choreographic landscape made up of interactions with other visitors—the latter always present, always ignored (except choreographically). The observer is always observed—by other visitors, by guards, by sensing devices that may be triggered by crossing the prescribed distances between subject and object, and by remote cameras. The viewer is in a very concrete sense as fixed to positions (and in some instances to exact itineraries)[63] as the objects on view—or as the inmates of the Panopticon. The entire space of the museum is articulated so as to render this process efficient, economical, natural, and legitimate.

As a heterotopic space, the museum is also a theater of geomancy—an ideal topography wherein the proper siting of objects and subjects works to insure the preservation of certain essential values, a certain essential spirit: a magical practice designed to evoke the spirits of ancestors,[64] to have them "stay" and "lie orderly." So that their spirits will remain serene and untroubled, all the lares and penates must be fixed in proper places, sequences, and kinship alignments: a veritable Bible of begatting.

It is not by accident that the modern art museum tends to have the flavor of a well-kept contemporary suburb, with its stopped-time quality, its genteel banishment of dirt, disarray, and disorder, its air of being Williamsburgered.[65] All history is perforce a production—a deliberate selection, ordering, and an evaluation of past events, experiences, and processes. Any museum, in incorporating selections and silences, is an ideological apparatus. In addition, every museum generates ways of not seeing and inhibits the capacity of visitors to imagine alternate histories or social orders, past or future.

The various spaces of the discipline resonate with each other as transformations or variant instances of a nexus of common themes—the fixity of signification, the integrity of the subject and object, the confabulation of

proper distances between analyst and analysand. To speak of the art historical auditorium is perforce to speak of the museum; to speak of both elicits the art historical textbook and the disciplinary archive; to juxtapose all of these evokes the identity and positionality of another disciplinary artifact, the historian or critic.

Threaded through all of these is a palpable panopticism—a thread spun out of Albertian, Camillan, and Galilean materials, supporting an ideology of representation as re-presentation, as a re-presencing of absent Spirit and Voice: a logocentrist metaphysics and a secular theologism. In Bentham's Panopticon, the centermost apparatus supports God, both literally and metaphorically: At the top of the central observing tower was to be a chapel, visible to all inmates. The hidden and invisible observers in the central tower stand beneath the gaze of the invisible, all-seeing God and, we might say, stand for that divine gaze. As we have seen previously, just as the art object is situated as akin to the artifact of a Divine Artificer, so also is the Artist assimilated to an analogous position.[66]

In chapter 2, it was argued that the chain of signification passing from the artist to the beholder through the medium of the object replicated a paradigm of language as communication—active construction of signs complementary with passive construal or consumption of signs. Furthermore, the position of the historian or critic lay athwart the fourth term in that paradigm, namely the processes of construal (D_1). Looking at the situation from the present perspective, it may be seen that the historian or critic's position is spatialized in yet another sense as coincident with the viewpoint opposite the vanishing point of the painting.

To extend the metaphor, we might say that the critic assumes a stance visà-vis the object which is coincident with the stance of the artist. Finding the proper stance could be said, then, to be equivalent to discovering what the artist saw ("what Vincent saw" in the terms of chapter 2)[67] in all senses of the term. In this regard, interpretation is analogized to the creative act of making, but in a curiously deflected way. The historian or critic cannot, in this regime, occupy precisely the same plane of creativity as the artist, for interpretation is traditionally construed as elucidation, not as fabrication. And yet the creativity of the critic is dis-placed to the afterglow of exegesis: One witnesses creativity with a small *c*, the astuteness and insightfulness of rendering the complex and opaque lucid and transparent.

This is an ambiguous realm, that of the demigod or the heroic as opposed to the divine and the laic. Ordinary mortals may aspire to this position with proper training and the acquisition of proper credentials—always assuming, of course, that they have the right stuff to be disciplined in the first place. One requisite is a certain aptitude or taste invariably understood as more

innate than acquirable. This ineffable quality of insight is characteristically signaled by nonverbal means. Michael Innes, the English literary historian and novelist, succinctly captured the atmosphere of this realm:

> The gallery was crowded—presumably with persons interested in the progress of the arts. Half of them were seated on several rows of chairs facing the farther wall; a few had been accommodated, after the fashion of a platform party, with rather grander chairs facing the other way; the remainder were standing in a huddle about the room. Appleby, whose business had for long been the observation of human behaviour, saw that while all had the appearance of following Mervyn Twist, a large majority was in fact exclusively concerned with disposing and maintaining the facial muscles in lines suggestive of superior critical discrimination. Some put their faith in raised eyebrows, thereby indicating that while they approved of the speaker's line as a whole, they were nevertheless obliged, in consequence of their own fuller knowledge, to deprecate aspects of it. Others had perfected a hovering smile, indicative of discreet participation in some hidden significance of the words. Yet others contented themselves with looking extremely wooden, as if conscious that the preserving of a poker face was the only safe and civil way of receiving observations which their uninhibited judgment would be obliged to greet with ridicule. Appleby found the spectacle depressing. Gavin Limbert had perhaps been lucky, after all. He had died young and untouched by disillusion—ignorant or careless of the oceans of twaddle and humbug which constitute the main response of the Anglo-Saxon peoples to any form of artistic expression.[68]

4. The Anamorphic Archive

The powerful network of apparatuses constituting the modern discipline of art history presupposes the existence of photography. Indeed, art history as we know it today is the child of photography: From its beginnings as an academic discipline in the last quarter of the nineteenth century, filmic technologies have played a key role in analytic study, taxonomic ordering, and the creation of historical and genealogical narratives. Lantern-slide projection entered the field very early, establishing the formats of study, analysis, and comparison of images.

And yet the entire disciplinary apparatus as it exists in the twentieth century would be unthinkable without a correlative technology—that of the cinema. In a number of important respects, modern art history has been a

supremely cinematic practice, concerned with the orchestration of historical narratives and the display of genealogy by filmic means. In short, the modern discipline has been grounded in metaphors of cinematic practice to the extent that in nearly all of its facets, art history could be said to continually refer to and to implicate the discursive logic of realist cinema. The art history slide is always orchestrated as a still in a historical movie.[69]

In 1895, the same year in which cinema was invented, the first modern university art museum opened in this country, the Fogg Art Museum at Harvard.[70] This new foundation was designed to do more than house a collection of artworks; indeed, this was but one of its functions, and to a certain extent a secondary one. Beyond this, the Fogg was designed to incorporate what constituted at the time the entire disciplinary apparatus: classrooms, laboratories, offices, and archival materials.[71]

The income from the Fogg bequest was devoted to the purchase not of artworks but rather of reproductions, chiefly in the form of photographs and slides, as well as some casts of sculpture. The museum was not explicitly designed for the exhibition of original works of art,[72] unlike the present Fogg Museum (which opened in 1927).[73] The original Fogg, erected some twenty years after the beginning of art history instruction at the university, reflected a paradigm of disciplinary study hitherto unique in this country. Other American university campuses had housed the collections of benefactors earlier in the century (for example the Trumbull Collection at Yale); and some instruction in the history of the fine arts had existed prior to the appointment of Charles Eliot Norton at Harvard in 1874. Nonetheless, the original Fogg was the first attempt to house the entire discipline in one space.[74]

The building, designed by Richard Hunt, was not, strictly speaking, a panopticon.[75] And yet it served panoptic ends with regard to orchestrating a variety of disciplinary technologies in a single space. The design provided four distinct apparatuses for making the history of the visual arts legible: lecture classrooms, fitted with projection capacities; space for the display of photographic reproductions in sequence; a library of textual material on the fine arts; and an archive of slides and photographs. Each of these, in slightly different ways, established stances for reading objects and articulating historical and genealogical narratives, relating these, in the words of Harvard historian George H. Chase,[76] to "the history of civilization" such that these monuments "should be interpreted as expressions of the peculiar genius of the people who produced them."

The business of the Fogg, then, could be summarized as orchestrating the domain of study into an encyclopedic and common history. Traces of that history were formatted in several ways—in the bibliographic orders of the Fogg library, in which texts were arranged by subject matter, medium, genre,

authorship, period, or artistic biography; in the archive of lantern slides and photographic reproductions, comprising data organized chronologically and geographically; in a collection of plaster casts of sculpture and architectural models; and through changing displays of artworks from an archive that by 1896 included thirty thousand prints as well as engravings, loaned examples of Greek vases, and so on.[77]

Compared to the Panopticon, the Fogg Museum was a more active machine for the dispersion of information into a variety of theaters for the construction of narratives. Rather than using a singular format for exhibition, the Fogg, unlike the traditional art museum, incorporated multiple analytic theaters and a multiplicity of stages for rendering the history of art visible. It was, in effect, a factory for the production of sense, a site for the manufacture of meaning in numerous dimensions: morphological, semantic, ethnic, and social. By circulating bits of information from its constantly expanding archives, one could compose narratives of "slices" of artworks—for example, the use of color or line compared in works of other times and places, or throughout the works of one artist.

As a factory for the production of meaning, the Fogg could be employed to generate all manner of patterns in time and space: As in the use of a natural language, one could generate a seemingly transfinite set of significant "texts" out of combinations of smaller morphological entities. One could, perhaps, but it seems evident that one did not, for overriding this capacity were the determinations of a variety of relatively stable genres, expressed most concretely in the series of courses offered in the museum by instructors. In the university catalogues of the time, a pattern had been set that was to continue, with some expansions and emendations, for some time: By 1881, the curriculum included Fine Arts 1 (principles of delineation, color, and chiaroscuro), Fine Arts 2 (principles of design in painting, sculpture, and architecture), Fine Arts 3 (ancient art), and Fine Arts 4 (Roman and medieval art), plus occasional advanced courses.[78] By the early 1900s, many courses had been added in architecture, landscape design, Greek and Roman archaeology, the history of the printed book, Renaissance art, Florentine painting, Venetian art, and Chinese and Japanese art. In 1912–13, the university offered the first survey course (as we now know it), which attempted to cover the whole history of art in one year. Again in 1913, the first "modern" course was offered, Modern Art and Its Relations to the Art of Earlier Times.[79] The progenitor of the entire curriculum was The History of the Fine Arts and Their Relations to Literature, the course offered in 1874 by Charles Eliot Norton. Norton had been appointed that year by the Harvard Corporation as Lecturer on the History of the Fine Arts as Connected with Literature.[80]

The Fogg curriculum established the ways in which the archive was to be

employed in the construction of historical and genealogical narratives, fixing historical, geographic, and media boundaries. In short, the evolving system was grounded in a notion of periodicization metaphorized after the Vasarian framework of the-man-and/as-his-work.[81] This paradigm simultaneously provided a key for unlocking the archive itself, a stance from which that mass of data could appear in a telling, narrative order, and a point at which anamorphosis is resolved into perspectival realism.

Viewed from a proper perspective, there emerges a striking visibility—a legibility—to everything. A given portion of the data mass becomes legible when com-posed according to the perspectivalism projected from a unary position on that material. The business of the Fogg was to orchestrate such positions, and it operated according to two related principles of organization or signification. The first of these principles is that of *anaphora* in which a given portion of a data mass acquires significance by referring (both metonymically and metaphorically) to other portions of the archival mass. Each informational unit (be that a text, a cast, a photograph, an artwork, or a slide) is in an anaphoric position, cueing absent others, establishing resonances with like objects, serving as an index wherein signification emerges through contiguity. The meaning of any unit in the archival mass lies, in short, in its relationship to another or others. The object is a sign of difference, and meaning is deferred to the system of contiguities and separations comprising the archive. The interest of the discipline lies in elucidating the principles of that system, which is analogized to a history or genealogy by a series of kinship relations. The pertinence of *kouros X* lies in its relations within a spatiotemporal grid to adjacent *kouroi*—both *kouros W* and *kouros Y* on a temporal axis, and, on a synchronic axis, to a series of contemporaneous *kouroi* $(X_a, X_b, X_c, \ldots X_n)$.[82]

Within the multidimensional environment of the archive is a potential for multidirectional connectivity, not merely morphological, of course, but also thematic. Indeed, the potential resonances may be legible on a wide variety of levels—material, textural, chromatic, functional, semantic or iconographic, and so forth. In principle, the entire data mass of the archive is implicated from any one unit point, and disciplinary practice continually reviews connectivities so as to elucidate potential genealogical and historical relations. Operating normally through simple juxtapositions of archival material, usually slides or photographs (a practice established by Wölfflin a century ago),[83] any search may be endless.

And yet, of course, it is not so open-ended in normal practice, for the archive is never not oriented; it is unlike the mythic Net of Indra, that vision of the universe made up of an infinite number of elemental units resembling perfectly reflecting pearl-like atoms, each perfectly reflecting all others. The

disciplinary archive not only has spatiotemporal mass, but its systemic structure is already aligned.[84] This brings us to the second principle governing the formation of the archive: anamorphosis.

Complementary to anaphora, anamorphism is an organizational device whereby relationships among units in a data mass are visible—in this sense, legible—only from prefabricated positions or stances vis-à-vis the archive. The user of the archive is cued toward certain positions from which portions of the data mass achieve coherence. This privileged viewpoint is established by a number of fabricated *vedute* within which, and only within which, a portion of the data mass locks into place as a composition according to the laws of one-point perspective.[85] The *vedute* are various and, in the modern history of the discipline, change over time. Among the most powerfully determining is that of the period or period-style, grounded in a belief that all of the principal examples of artworks at a given time and place must exhibit a certain uniformity of patterning. Normally, this is largely morphological in character, but it may also include certain consistent uses of materials, compositional methods, routines of production and of consumption, and perceptual habits,[86] as well as a consistency of attention to certain genres, subject matters, or patterns of patronage and formats of display.

The notion of the period or period style is complemented by another *veduta*, that of biographic unity—the Vasarian paradigm of the-man-and-his-work as the-man-as-a-work—grounded, as we have seen, in an idealist metaphor of homogeneous Selfhood supporting a logocentrist theologism. The archive in general is a metaphoric structure that shapes the routines of access to it by prescribing viewpoints as keys to signification. It is a system that contains only differences (anaphoric relations) and yet at the same time incorporates oblique points of access (anamorphic relations). In other words, the archival system is akin to a language (or a signifying or semiotic system in a general sense) in which the potential of endless tautology, the incessant slippage of any unit into all others, is counterbalanced by a positionality or directionality that fabricates meaning for and by a subject, a structuration that is manifest only insofar as it is incorporated as part of an active articulation.[87]

These privileged or anamorphic points at which the direction of the signifying chain is established recall the *points de capiton* of Lacan's theory of signification in relation to the signifying Subject.[88] Only insofar as the archive is used by a Subject who intends meaning within a signifying practice does it possess a certain fixity. The *point de capiton*, the "upholstery button" that pins down a mass of signifiers to a fixed signified, is located in the diachronic function of the *veduta*, in that meaning is only insured retrospectively, with the locking into place of a perspectival composition.[89] And at the same time,

the Subject's own identity is stabilized by the same process of differentiation. This process consists of marking out separations between himself and his surroundings so that he may find himself a place in the signifying chain.[90] In short, the Subject must recognize himself in the organizing structures of the signifying chain. The place one assigns oneself in knowledge is what makes possible communication and meaning.

The positionality that characterizes any signifying system—in which meanings exist for a Subject who functions as the place of the intention of those meanings—commences with the separation of subject and object.[91] Within the discursive space of the discipline, this distance is articulated both physically and verbally: physically, through the establishment of proper stances (in the museum or gallery, by a minimal space between subject and object; in the art history auditorium, by a standing aside from object projections); and verbally, in the use of a historical third-person mode of enunciation (allowing the object to "speak itself").

The problematic around which the old Fogg was designed (and which came to concern the modern discipline in the twentieth century) is thus that of perspective. In no small measure because the Fogg Museum incorporated an archive that was foreseen as expanding indefinitely [constituting, thereby, a filmic archive of the contents of all museums and visual environments],[92] the dilemma is apparent: There is no *one* position from which to see this totality. As David Carroll notes:

> Perspective distorts as much as it makes visible; it hides as much as it uncovers. This is perhaps most evident . . . in terms of the problem of focus. To concentrate on one element or form or one program linking together the various elements constituting form—colors, shapes, patterns, etc.—is always to leave other elements out of focus or to suppress them from the frame constituted by the particular perspective. These out-of-focus elements, traces of forms or colors are never totally eliminated, however, but act as a ground against which the distinct and purely "visible" features of the form that *is* in focus take form.[93]

This is also the problem of framing discussed by Derrida in *La Vérité en peinture*, where he analyzes how Kant attempted (and failed) to put the whole question of art itself within a closed frame, to delimit an inside from an outside, the *para* from the *ergon*.[94] The frame, as Carroll notes, is precisely the problem: "What is always a little out of focus is the frame itself and the operations defining it and those against which it defines itself."[95]

The problem is elided in the discursive space of the discipline (and in the Fogg Museum, which is taken here as a paradigmatic instance of the discipline's modernity) by the *multiplication* of foci; by staging a kind of a migratory

perspectivism circulating through various anamorphic sites—the lecture auditorium, the collection of artworks, the archive of slides, photographs, and other reproductions, the library of texts—assembled in a single architectural space. This is a fluid focus, which institutes an endless search. We are outside the space of the Panopticon and in the space of the cinematic theater: The Subject is on the move and is "movied,"[96] set out on a task that can never fully be finalized, a journey of shifting and re-positioning desire, of displacement, placement, and further displacement.

Within this regime, anaphora and anamorphism work toward complementary ends in the orchestration of desire and the fabrication of sense, of grids of intelligibility. The *mise-en-scène* is always a product of a *mise-en-séquence*. The space and time of reading the archive involve an activity of repetition and rememoration—a process, in Freud's words, of "remembering, repeating, and working-through," of opening avenues through, and thereby inventing, the archive as text.

This anamorphic archive is like a holographic plate: In normal light one sees only a blurred mass; in directed or laser light, a three-dimensional *figura*. What's more, it is a holographic movie, a sequencing together of Albertian Windows put into motion by the directionality of narrative realism that comprises the history of art.

The discursive space of the discipline of art history enframes an *ars memorativa*—a system of protocols for elucidating knowledge, and a prescriptive grammar for the composition of historical narratives. All, as Bentham might have remarked, "by a simple idea in architecture"—that is, by the formatting of data into a multiply accessible mass in several dimensions. It has been suggested here that the modern discipline operates as an anamorphic archive keyed by a panoptic gaze, a metamorphosis of Bentham's Panopticon, Camillo's Memory Theater, the perspectivalism of Renaissance realist painting (and scenography),[97] and the discursive instrumentalism of analytico-referentiality symbolized by the Galilean telescope, into the epistemological format of the modern cinema. Modern art historical practice has woven together these varied historical practices into a supremely cinematic discursive space.

What is accomplished in the Forest Lawn auditorium is essentially an emblem of disciplinary practice within the frame of a single (albeit gigantic) object of analysis, a composition of a historical narrative through a decomposition of an object into its component episodes or semantic syntax. The painting is an occasion to tell a story. As art history, it is synecdochal: Despite the extraordinary technologies mustered together to cause the object to speak, it presents us with but a slice of the object—its referentiality—and it

tells us nothing about the logic of its formal composition, modes of production, or iconographic background. Styka's *Crucifixion* (or *Resurrection*) might well be a photograph of a *tableau vivant* or a diorama in a natural history museum.[98]

Nonetheless, the performance mounted by the Forest Lawn auditorium encapsulates essential elements of the discursive practices of modern art history: The apparatus could be focused upon any other aspect of the object and remain intact as an exemplar of disciplinary protocol. It rests upon precisely the same network of historical practices as the Fogg Museum and derives its efficacy from the metaphorical power of those practices.

The *artes memorativae*, as Yates has so astutely indicated,[99] became transformed into one of the primary bases for the new scientific method in the seventeenth century. It passed from being a series of methods for memorizing the encyclopedia of knowledge to a set of aids for investigating the encyclopedia and/of the world with the object of discovering new knowledge.[100] Francis Bacon was well versed in the memory arts and proposed to use them so as to hold matters in ordered form in the mind for further investigation.[101] And Descartes himself proposed a major reform of the memory arts wherein memory would be reorganized on the causes of connections between things.[102] The numerous meditations on method in the seventeenth century were in various ways focused upon the search for a *clavis universalis*, a unitary methodology for the elucidation and augmentation of knowledge.[103]

The latter clearly prefigure the architectonic logic of the modern house of art history and that of the modern disciplines in a general sense. The panoptic gaze and the anamorphic archive at the foundation of modern art history during the last quarter of the nineteenth century repeat, with new and more powerful technological instruments, an older preoccupation with making legible the encyclopedia of the world. In its more recent guises, art history is grounded in the same metaphorical substratum: in metaphors whose metaphoricity has been forgotten.

The Coy Science

In Eudoxia, which spreads both upward and down, with winding alleys, steps, dead ends, hovels, a carpet is preserved in which you can observe the city's true form. At first sight, nothing seems to resemble Eudoxia less than the design of that carpet, laid out in symmetrical motives whose patterns are repeated along straight and circular lines, interwoven with brilliantly colored spires, in a repetition that can be followed throughout the entire woof. But if you pause and examine it carefully, you become convinced that each place in the carpet corresponds to a place in the city, and all things contained in the city are included in the design, arranged according to their true relationship, which escapes your eye distracted by the bustle, the throngs, the shoving. All of Eudoxia's confusion, the mules' braying, the lampblack stains, the fish smell is what is evident in the incomplete perspective you grasp; but the carpet proves that there is a point from which the city shows its true proportions, the geometric scheme implicit in its every, tiniest detail.

It is easy to get lost in Eudoxia: but when you concentrate and stare at the carpet, you recognize the street you were seeking in a crimson or indigo or magenta thread which, in a wide loop, brings you to the purple enclosure that is your real destination. Every inhabitant of Eudoxia compares the carpet's immobile order to his own image of the city, an anguish of his own, and each can find, concealed among the arabesques, an answer, the story of his life, the twists of fate.

An oracle was questioned about the mysterious bond between two objects so dissimilar as the carpet and the city. One of the two objects, the oracle replied, has the form the gods gave the starry sky and the orbits in which the worlds revolve; the other is an approximate reflection, like every human creation.

For some time the augurs had been sure that the carpet's harmonious pattern was of divine origin. The oracle was interpreted in this sense, arousing no controversy. But you could, similarly, come to the opposite conclusion: that the true map of the universe is the city of Eudoxia, just as it is, a stain that spreads out shapelessly, with

crooked streets, houses that crumble one upon the other amid clouds of dust, fires, screams in the darkness.
—*Italo Calvino*

1. Forms and Contents

We might read Calvino's parable about the city of Eudoxia with the following remarks by Raymond Williams:

> The replacement of the disciplines of grammar and rhetoric (which speak to the multiplicities of intention and performance) by the discipline of criticism (which speaks of effect, and only through effect to intention and performance) is a central intellectual movement of the bourgeois period. . . . From the description of a theory of perception, aesthetics became, in the eighteenth and especially the nineteenth century, a new specializing form of description to the response to "art". . . . What emerged in bourgeois economics as the "consumer"—the abstract figure corresponding to the abstraction of (market and commodity) "production"—emerged in cultural theory as "aesthetics" and the "aesthetic response." All problems of the multiplicities of intention and performance could then be undercut, or bypassed, by the transfer of energy to this other pole. Art, including literature, was to be defined by its capacity to evoke this special response.[1]

Williams's observations were made in connection with a discussion of the impact of recent reader-response criticism in literature upon earlier formalist approaches to meaning.[2] In his view, formalism was historically a notational variant of response-oriented criticism, involving a shift in emphasis (during the nineteenth century) from "the perception of beauty" to "the perception and contemplation of the 'making' of an object, its language, its skill of construction, its 'aesthetic' properties."[3] His remarks astutely shift the ground under recent popular wisdom regarding response-oriented theories of meaning as somehow transcending older formalist perspectives in which the object itself encapsulated fixed and stable significations: Both, as he reveals, share a common sense of the autonomy of art, and both participate in a mystification of the relationships of art with history and with social life, albeit in different ways. Williams suggests that if reader-response criticism and response-oriented theories of meaning are to achieve a significant break with the bleak formalisms of the past, then that transformation would require exploration of "the specifics of reception as a socially and ideologically determined process," a "coming to grips with the question of artistic *production.*" As Mary Louise Pratt has put

it, "Obviously it is not in the slightest degree necessary for reader-response criticism to exclude questions of production from the domain of literary studies. To say that a text can be made to mean anything by readers does not *require* one to deny the text's existence as a historically determined product."[4]

For Pratt, arguments raised against the affective fallacy might equally apply to the intentional fallacy with similar force: "Just as textual reception can be shown not to be the private personal exercise in semantic promiscuity that it was feared to be, so it can be shown that textual production is not simply a matter of individual authors acting out inscrutable intentions, personal prejudices and private anxieties. Just as the subject who reads a text must be seen not as an autonomous, self-consistent, essential self but as constituted by its social reality, so must the same be said for the subject who produces a literary text." She remarks further that "the intentional fallacy is no longer a sufficient excuse for failing to treat literary works as historically determined human productions, any more than the affective fallacy is sufficient grounds for failing to treat literary interpretations as historically determined human productions."[5]

What does all this have to do with art history?

The modern discipline of art history might be viewed in one sense as a reaction, within the frameworks of the nineteenth-century dreams of scientificity,[6] to the Romanticist entanglements with the double binds of the intentional-affective fallacies, resulting in a displacement of the problematics of production and reception beyond the purview of the new formalist, historicist science. The purpose of such a discipline (as Hayden White observed regarding the transformation of historical studies in the nineteenth century into a discipline)[7] would be simply to determine the facts of art history, by which to assess theoretically and epistemologically the objectivity, veridicality, and realism of the various contested philosophies of art inherited from the Romanticist era of aesthetic discourse. It might be suggested that the emergent disciplinary apparatus acquired its cogency and power at the expense of aesthetics and of the problematics of production and reception precisely by marginalizing such issues beyond its analytic purview.

Such issues, however, were not merely banished: The strategy would have been one of containment within a new discursive space, a suspension of the problems within the frameworks of a more urgent mission — the elaboration of a historical science grounded in the facts of the history of art through analytic comparative methods adapted from philology. But as we have seen,[8] the problematics of reception and production remained as mystified as ever.

Consider the profile of the new emergent discipline: a domain of analysis, a *theatrum analyticum* for the study of an ontologically pregiven class of phe-

nomena over time. These phenomena could be classified, compared, and contrasted as traces of the cultural history of individuals, groups, societies, and ethnicities. Within this panoptic framework,[9] the task of the new historian-critic would be to fix meaning or significance by locating members of the data mass relative to each other within an encyclopedic archive.[10] The procedures evolved were pre-eminently formalist in the sense that each object would be classified primarily according to its morphological or stylistic properties, and such properties could be grouped together as criteria to discriminate different artists, area or period patternings, or the signs of different national or ethnic groups.[11] The procedures allowed both synchronic and diachronic taxonomies and discerned evolutionary, progressive, or cyclic patterns over time.[12]

Within this new discursive space, objects for analysis emerge as objects of contemplation (in its root sense of semantically isolated or autonomous) and explication: The analysand is construed as semantically dense, complex, and by and large opaque. The task of the analyst is to ex-plicate that density —literally, to "un-fold" it—and to render it transparent to sense by rendering it legible. The artwork is invariably taken as autonomous and unique —a bafflingly intricate poetic text to be read.

Interpretation, within this regime, is established as the supreme critical-historical activity. The network of new disciplinary technologies[13] operates to suspend the analysand in a discursive space as an essentially communicative token, as a medium through which an author (or, in a broader sense, a society) speaks: Its mode of existence becomes primarily that of saying.[14] At the same time, the instantiation of the discipline works to legitimize the existence of a professionalized class of interpreters with the exegetical authority to make pronouncements that are *dans le vrai*.[15] Through the marginalization of the problematics of aesthetic reception and response, the new class of professional historians reserves the right to make pronouncements and value judgments by virtue of possession of the historical facts.

The new discipline of art history endeavored to demonstrate that its practice was as disciplined and rigorous as any other academically instituted science (for example, the study of literature)[16] by mounting a discourse that was tough-minded, logical, detached, objective,[17] and grounded in expertise. From an empirical point of view, the field intended to demonstrate that the objects in its domain were in some sense stable entities with determinable significations. Building upon the universally accepted premise that artworks were significant objects in the first place, the strategy was to naturalize the notion that artworks say, express, or reveal something determinate (with respect to which a certain indeterminacy or ineffability was to be construed as a species of determinacy).[18] Logically, then, certain conditions and assumptions needed to be made:

1. that such determinacy was grounded in authorial intention—what the maker meant;
2. that the properly equipped (that is, professional) analyst can mimetically approximate such determinacy; and
3. that the expert could produce a reading of the object that (it must be assumed) other similarly equipped experts might agree possesses some manner of facticity or objectivity.

These three assumptions necessarily depended upon the following conditions:

A. *everything* about an artwork was significant in *some* way;
B. not everything about an artwork could be significant in the *same* way; and
C. not everything about an artwork could be significant in *every* way.

Condition A specifies that there could be no semantically null or meaningless parts of an artwork: All parts must be understood as contributing in important ways to the overall significance and signification of the work. Indeed, this condition might be employed as a criterion for distinguishing quality in works or even for distinguishing what might be art from what is not: in the "fine" object, everything works together to com-pose a morphologically and semantically homogeneous wholeness or even purity.

Condition B specifies that the contributions of the various components of an artwork are varied and disparate: The whole forms a system or structure[19] or "text" wherein not all parts are of equal semantic weight. The third condition (C) specifies that there must be limits to the semantic field projected or cued by each component part: Everything cannot mean everything or anything, or there would be no firm ways of discriminating among artworks or of distinguishing artworks as a class from other artifactual products of societies. This condition, it should be noted, also provides a way of avoiding the semantic promiscuity attending private, personal response to objects by the lay population.[20]

These conditions are important in another respect. An essential task for the new discipline would be to substantiate a claim that artworks were substantively or even ontologically distinct from the entire class of products comprising the material culture of a society—that railway stations were importantly different from train sheds; that the fine arts were substantively different from quilt making or from the images on Sicilian donkey carts or Swiss town clocks. The task, in short, is to justify a separation of intrinsic properties from extrinsic properties—a program, of course, older than Kant and the discourse of aesthetic philosophy.[21]

We need not review the various justifications for the distinctness of art-works that have circulated inside and outside the discipline of art history;[22] many such arguments are invariably circular or simply beg the question. Some common threads in this vast and extended discourse, however, might be alluded to. Together with a presumption of a certain unparaphrasability of the semantic content[23] of artworks, there is additionally a criterion of cogni-tive or perceptual complexity in both the construction and construal of works—an appeal to a greater depth of (aesthetic) experience—as well as a certain purity of aesthetic cognition or perception.[24]

From a disciplinary perspective, the criteria are brought together in the perfectly unremarkable and ordinary definition in Kleinbauer's primer: "A work of art can be defined as a man-made object of aesthetic significance, with a vitality and reality of its own. Regardless of the medium of expression, a work of art is a unique, complex, irreducible, in some ways even mysterious, individual whole."[25] This simple definition is also remarkably astute, when read against the nineteenth-century historical background of aesthetic dis-course, for it circulates contradictory perspectives on signification within the same discursive space. In other words, artworks are simultaneously significa-tory and ineffable. The strategy is in one sense simple: To defend the scientificity of the new discipline, one beats science at its own game. By declaring aesthetic objects ontologically distinct from artifacts in general, and the meanings of art historical research ontologically separate from (and by implication superior to) the objects of scientific research, art history establishes itself as a disciplinary science of a higher order. Moreover, the materials dealt with by the professional analyst (attitudes, feelings, and inter-pretations) might be legitimized as having the status of eternal truths —universals of human nature, just as scientific laws are seen as the universals of physical nature. Equivalent disciplinary justifications can be found articu-lated for literary studies, as a perusal of Brooks and Warren will reveal.[26]

As discussed previously,[27] it was the metaphor of art as a form of language —specifically, as a type of communication—that constituted the new disci-pline as a cogent and coherent disciplinary enterprise. Indeed, the notion of language as com-municative is itself metaphoric:[28] a metaphor drawn from the visual world. Art history came to make its place within this web of circular metaphorics.[29] It had to show that artworks were not significant merely in a random way but rather were examples of the operation of a code: "Form" had laws, and the task of the professional was to illuminate such lawful systematicities. Individual objects would relate to one another in systematic ways as inflections or transformations of an underlying code. The artwork was in some way an individual *parole*, and the disciplinary mission in its deepest sense was to uncover the essence of its underlying *langue*.[30] Reduced

to their essentials, the Wölfflinian and Morellian enterprises worked to assimilate art into contemporary paradigms of linguistic signification: Complementary in their objects and aims, both projects reflected a long history of attention to the nature and operations of the sign and its distinctive features and reinstalled cryptography at the heart of the human sciences.[31]

There are clearly two sets of assumptions guiding disciplinary justification and institutionalization:

A. aesthetic objects are to the totality of the artifactual world as poetry is to the totality of language activity; and
B. the domain of art constitutes, for given times, places, and peoples, a systemic code with languagelike properties.

In short, art is simultaneously a special use or instance of artifactual codes and an autonomous code in its own right. The history of inflections on these assumptions constitutes the history of art historical theory. And the history of the discipline constitutes a series of strategies to maintain these contraries in play: The discursive space of art history is thus a contradictory, illusory, or imaginary space, precisely like a Necker Cube illusion in which alternate perspectival logics coexist within the same object.[32] And each of the objects in the disciplinary analytic theater invariably becomes, itself, a temple of entelechy, like that described in Calvino's parable of Eudoxia.

In situating the contemplative art object as an object of knowledge, as a thing that means, then reading, interpretation, and explication—in short, cryptography—become the essentially distinctive disciplinary activity. The establishment of the modern discipline, as discussed in the previous chapter, involved the subsumption and intercalation of a variety of metaphorical paradigms for signification, production, and reception in play since the elaborations of analytico-referential paradigms in the Renaissance.[33]

The art historical program of making the visible legible subsumed various arts of interpretation, including methods of scientific knowledge and natural philosophy elaborated during the Renaissance for breaking the codes of nature and in reading the book of nature scripted by an immaterial God.[34] The enterprise was carried forward within the rhetoric of nineteenth-century empirical science, one of the great jewels in whose crown was the study of language. We have already seen something of the relationships between the new art history and the assumptions and methods of glottochronology.[35] But the art historical enterprise may have been conceived as an analogue to linguistic study in other areas as well, particularly with regard to its attention to the problem of signification as such, through its concern with elucidating the codelike properties of its object domain.

As we shall see, art history sought to contribute to the writing of an

abcedarium culturae while simultaneously marginalizing and retaining a metaphysics of quiddity.[36] We need to turn our attention to the kind of signifier required by the new disciplinary attention to interpretation: How precisely are artworks to be understood as meaning?

2. *On Signe Ici*

The maintenance of the rigorous distinction — an essential and juridical distinction — between the signans *and the* signatum, *the equation of the* signatum *and the concept, inherently leaves open the possibility of thinking a* concept signified *in and of itself, a concept simply present for thought, independent of a relationship to language, that is of a relationship to a system of signifiers. By leaving open this possibility . . . Saussure . . . accedes to the classical exigency of what I have proposed to call a "transcendental signified," which in and of itself, in its essence, would refer to no signifier, would exceed the chain of signs.*
—*J. Derrida*

Francis Bacon's house, Gorhambury, included a gallery of painted-glass windows depicting various beasts, birds, and flowers, so that "his Lordship might use them as topiques for locall use."[37] The connection between the cinematic panopticon of the art history classroom and the medieval Gothic cathedral with its stained-glass windows illuminated by daylight is, of course, historically fortuitous. Yet, in a sense, the former has subsumed the latter by way of Bacon's Gorhambury: The modern disciplinary apparatus operates as a memory theater of "topiques" rendered transparent to meaning by the illumination of a theory of the sign inherited from Christian theology. The disciplinary strategy has been to establish an array of visible objects, situating the analyst in a position from which this array is legible as an encyclopedic system of signs.

What was the nature of this sign, and what are its relationships to the concepts of the sign elaborated during the nineteenth century by linguists and philologists?

It has become an almost unconscious reflex in recent writing to begin any consideration of sign systems, codes, or semiology with the work of Ferdinand de Saussure, the Swiss linguist credited by many with reviving the old notion of a science of signs in modern times.[38] There are, however, important historical reasons why the student of theories of signification in art history should not begin with Saussure — despite an appreciation of the fact that

Saussure's work was the culmination of a long tradition as well as an inauguration of that tradition into the twentieth century.[39]

For one thing, it is now evident that nearly all of the elements of Saussure's theory of signification were present (in some cases, identically expressed) in the writing of the French art critic, philosopher, and historian Hippolyte Taine, regarded by his contemporaries as the dominant intellectual figure during the last forty years of the nineteenth century.[40] Today, one hardly hears of Taine, a remarkable situation given his profound influence not only on subsequent theories of signification generally but on the philosophy of art and of the history of art. In the 1880s, Nietzsche referred to Taine as the greatest living historian; it has furthermore been suggested that Nietzsche's concept of value was explicitly taken from Taine.[41]

For the generation of scholars coming to maturity after 1865, Taine was seen as the first popular and successful critic of the spiritualist eclecticism and introspective philosophy that had ruled France during the previous generation under the influence of Victor Cousin.[42] In reaction to the prevailing intellectual climate, Taine proposed to apply the methods of the natural sciences to the human sciences and found suggestions for such a new method in the principles developed in natural history by Cuvier and Saint-Hilaire.[43] From the former's studies in comparative anatomy, Taine developed his conception of synchronic structuration; and from Saint-Hilaire, he elaborated a theory of diachronic or historical transformation ("la liaison des choses simultanées" and "la liaison des choses successives"). Saussure, in his *Cours*, introduced the terms *synchronique* and *diachronique* after observing that the various human sciences need to pay closer and more systematic attention to the axes on which objects of analysis occur ("l'axe des simultanéités" and "l'axe des successivités").[44]

At times Taine referred to himself as a follower of Condillac, and his contemporaries counted as one of Taine's greatest services to modern thought the fact that he restored respect for and interest in the philosophers and *idéologues* of the late eighteenth century, whose work, seen by many as the foundation of the French Revolution, had been suppressed and reviled by academic forces of reaction during the earlier part of the nineteenth century.[45] Saussure's *sémiologie* was developed within this new intellectual climate in Paris, a climate alive with renewed appreciation for the philosophies of signs and signification dating back to Condillac and Locke. Many of the commonplaces of Saussurian theory, as Aarsleff observed recently,[46] including the notions of the arbitrariness of the sign and of the linearity of speech, were basic principles of language study for Condillac and his eighteenth-century contemporaries.

The most complete explication of the principles of synchronicity and

diachronicity occurs in Taine's *Philosophie de l'art*, the general title of a two-volume work[47] that brought together five series of lectures given by him at the *Ecole des Beaux-Arts* beginning in 1865. His *De l'Idéal dans l'art*, delivered in 1867 and published in the second volume of his *Philosophie*, introduced and developed the concept of *valeur* as a feature characteristic of an epoch in the history of art. For Taine, changes in *valeur* in different art historical periods create new systems. And the full meaning of an artwork, including its value, is always a function of the cultural system in which it occurs.

Taine, who continually argued against the sort of history that was an unordered mass of anecdote and miscellaneous data, saw it instead as "a problem of psychological mechanics." In his program for what was later called *histoire totale* or *histoire des mentalités*, he outlined a history that embraced all of the social and collective manifestations of human life. And he saw these manifestations as structured and systemic—terms that constantly recur in his writings: "In any civilization we find that religion, philosophy, family life, literature and the arts form a system in which any change entails a general change, so that an experienced historian who studies some limited portion of it discerns in advance and almost predicts the quality of the rest."[48]

Taine's enterprise set him apart from the strict positivism of Auguste Comte (whose work Pasteur had rejected as harmful to science)[49] as well as from the spiritualist philosophism of Victor Cousin and his followers. And, according to Durkheim, he had replaced mere rationalism or empiricism with "what one could call rationalist empiricism."[50]

For Taine, the physical world is always invariably reduced to a system of signs: As with Locke, he held that sensation does not reveal substances, but rather the signs we take for facts. In his major philosophical work, *De l'Intelligence* (1870),[51] he argued that the mental component of thinking is composed of signs; and in addressing the philosophical problem of how physical and mental events connect, he argued that these are not different events but rather a single event known under two different aspects. He observed that "as soon as they are reduced to a single event with two aspects, it is clear that they are like the *verso* and *recto* of a surface, and that the presence or absence of one incontrovertibly entails that of the other. We have a single event with two faces, one mental, the other physical."[52]

This notion, the metaphor employed by Taine, recurs again in Saussure's *unité à deux faces*, in his *entité linguistique* or linguistic sign, composed of a purely mental *signifié* (or signified) and its invariably linked *signifiant* (or signifier): "Language can also be compared to a sheet of paper: thought is the recto and sound the verso; we cannot cut one side without also cutting the other. So also in language, sound cannot be isolated from thought, or

thought from sound."[53] For Saussure, the linguistic sign is a psychic entity with two sides, and there are no preestablished ideas, for nothing is distinct before the appearance of language.[54]

Although both Taine and Saussure believed that the full range of signs included more than the system of verbal language, they concentrated on words as the chief mental image. There is, nevertheless, little doubt that for Taine the full significance of an artwork (like that of a word) involved its functions in a system of cultural signs. In *Histoire de la littérature anglaise*, he identified three basic facets that the historian must consider in analyzing works:[55] race, milieu, and moment. Race comprises a given "interior" force, milieu an "exterior" force, and *le moment* is the sum of the effects accomplished by the previous two forces: "For in addition to the interior and exterior forces, there is the work those forces have already done together, and this work itself plays a role in the making of the one that follows; along with the permanent (racial) thrust and the given (environmental) milieu there is the acquired speed."[56]

The perspectives brought together in the study of cultural signs involve (as they did for Saussure) a study of the material in a given state (*à un moment donné*) and the study of features in time and change. Saussure's distinction between *langue* and *parole*—that is, between the social, collective *langue* that forms a structure *où tout se tient* and the individual manifestation that occurs in *parole*—follows from his insistence on system and structure. Both Saussure and Taine felt that changes in the cultural system or transformations of its underlying structure are initiated in the *parole*. Thus, for Taine, one of the principal tasks of the cultural historian is the focus on the individual object and an attention to *les petits faits*—those telltale, minute details that signal historical changes in the system.

3. Zadig's Method

Long before I had any opportunity of hearing about psychoanalysis, I learned that a Russian art-connoisseur, Ivan Lermolieff, had caused a revolution in the art galleries of Europe by questioning the authorship of many pictures, showing how to distinguish copies from originals with certainty, and constructing hypothetical artists for those works of art whose former authorship had been discredited. He achieved this by insisting that attention should be diverted from the general impression and main features of a picture, and by laying stress on the significance of minor details, of things like the drawing of fingernails, of the lobe of an ear, of halos and such unconsidered trifles which the copyist

> *neglects to imitate and yet which every artist executes in his own*
> *characteristic way. I was then greatly interested to learn that the*
> *Russian pseudonym concealed the identity of an Italian physician*
> *called Morelli, who died in 1891. It seems to me that his method of*
> *inquiry is closely related to the technique of psychoanalysis. It, too, is*
> *accustomed to divine secret and concealed things from despised or*
> *unnoticed features, from the rubbish-heap, as it were, of our*
> *observations.*
> *—Freud*

In 1880, in a series of lectures publicizing the discoveries of Darwin, Thomas Huxley defined as Zadig's Method the divinatory and cryptographic procedures common to history, archaeology, geology, astronomy, and paleontology.[57] He might well have included medicine, graphology, and the techniques of connoisseurship in art history set forth two centuries earlier by the chief physician to Pope Urban VII, Giulio Mancini,[58] a member of the Lincei Academy along with Galileo.

Mancini, famous for his brilliant and rapid diagnoses, was the first to attempt the establishment of what would later be termed "connoisseurship."[59] His book entitled *Some Considerations concerning Painting as an Amusement for a Noble Gentleman, and introducing What Needs to be Said* was directed at the noble amateur rather than at painters, at those dilettanti who attended the annual exhibition of old and new paintings held at the Pantheon on March 19 of every year.[60] The text dealt with "a certain experience in recognizing the painting of particular periods, just as antiquarians and librarians have for scripts, so that they can tell when something was written."[61]

Mancini's interest was in teaching the amateur to identify detailed elements in a painting that were impossible to imitate, thereby establishing criteria for distinguishing the work of masters from that of mere copyists. The master's hand

> can be detected especially where it would take much effort to sustain the imitation, as in hair, beards, or eyes. Curls and waves of hair, if they are reproduced exactly, will look too laborious, and if the copyist fails to get them right they will lack the perfection of the master's version. And these parts of a painting are like strokes of the pen and flourishes in handwriting. The same care should be taken to look for particularly bold or brilliant strokes, which the master throws off with an assurance that cannot be matched; for instance in the folds and glints of drapes, which may have more to do with the master's bold imagination than with the truth of how they actually hang.[62]

He made analogies between painting and writing on both a general level (the period) and an individual level (the particular writer or painter), and his reference to scripts alludes to the methods then being worked out by the Vatican librarian Leone Allaci for the dating and recognition of individual "hands" in Greek and Latin manuscripts.[63] And taking a cue from the ancient Hippocrates, Mancini argued that it would be possible to deduce from deeds the soul's "impressions," which derive from the "features" of an individual's body. He was in all probability referring here to the writings of a contemporary Bolognese physician, Camillo Baldi, whose 1622 treatise *Trattato come da una lettera missiva si conoscano la natura e qualità dello scrittore* was termed by Carlo Ginzburg the first significant European text on graphology.[64] Baldi deemed the characters of a letter to be a sign of the character of the individual.

The term *caratteri* occurs in either a literal or analogical meaning in the writings of Galileo, who was concerned with the insubstantial characters that the physicist can read in "this great Book, which Nature keeps open to everybody [who] has eyes in his forehead as well as in his brain."[65] The metaphor links the works of Galileo with those of Allaci, Baldi, and Mancini by defining one of the principal methodological strategies in diverse discursive or disciplinary theaters. However, Galileo's aims, which served to delimit the course of modern physics as a discipline, were distinct from those of the art connoisseur, the paleographer, or the graphologist: The latter were concerned with reading signs of individual traits, while the former attended to the construction of the typical in diverse individual physical exempla. As Ginzburg observes, these distinct yet complementary approaches served to define the subsequently different disciplinary trajectories of the human and natural sciences. Only much later, as we have seen previously in this chapter, had the two approaches combined in the development of the humanistic and social disciplines. Both approaches are nonetheless grounded in complementary uses of the same metaphor and in an equivalent notion of the sign.[66]

It was the systematic collection and collation of what Winckelmann called "little insights"[67] (one of the major bases of the fresh formulations of ancient knowledge during the eighteenth century) that provided one of the stimuli to the growth of various modern disciplines. Aphoristic examples of divinatory or cryptographic insights abounded in Europe from the sixteenth century on, however, and one of the most long-lived of such stories made its debut in a collection by Sercambi. The tale subsequently appeared in an Italian text (purported to be translated from Persian by an Armenian named Christopher), which was published in Venice in midcentury under the title *Peregrinaggio di tre giovani figliuoli del re di Serendippo.* By the eighteenth century, the story of the three sons of King Serendippo had been translated into most

European languages and was so popular that in 1745 Horace Walpole coined the new term *serendipity* to describe the making of unexpected yet insightful discoveries "by accident and sagacity."[68] Voltaire knew the work in French translation and reworked the theme in *Zadig*. In attempting to prove his innocence of a charge of theft, Zadig describes in great detail a bitch and a horse he has never seen, but whose appearance he is able to reconstruct with amazing concreteness by inference from tracks, marks, and furrows in the sand left by the passing animals.[69]

In the generation after Voltaire, the great anatomist and founder of the new science of paleontology, Georges Cuvier, linked the success of his new science to the divinatory sagacity of Zadig-like methods, while demonstrating that paleontology provided "more certain evidence than all of Zadig's clues."[70] The fact that the name of Zadig had come to represent so much led to the perceptible epistemological linkages between certain disciplines made by Huxley in 1880, and his reference to this commonality of analytic procedures as Zadig's Method.

Ginzburg weaves many of these threads into a composite historical cloth and links Zadig's Method to the extraordinarily popular nineteenth century detective story genre. Emile Gaboriau's great detective hero Monsieur Lecoq restlessly ran across a snowy landscape marked with the tracks of criminals, a landscape like "a vast white page on which the people we are searching for have left not only their footprints and traces of movement but also the prints of their innermost thoughts, the hopes and fears by which they are stirred."[71] And a case can be made for a palpable linkage between the art connoisseur Morelli and the detective novels of the physician-writer Arthur Conan Doyle, whose uncle Henry Doyle, appointed director of the Dublin Art Gallery in 1869, knew Morelli. Henry Doyle edited the 1890 *Catalogue of the Works of Art in the National Gallery of Ireland* according to principles laid out in the 1887 reworking of Kugler's manual by Layard, which was overseen by Morelli.[72] Anyone familiar with Conan Doyle's story "The Cardboard Box,"[73] in which Holmes receives in the post a box containing two severed ears, will recognize the similarities of detective deduction to "Morelli's Method." Conan Doyle also published an earlier article in *The Strand Magazine* with an illustration of possible shapes of ears, an illustration remarkably like that used by Morelli in his *Italian Painters*.[74]

Morelli's work was the subject of some criticism during the last decades of the nineteenth century among art historians who considered his approach mechanical, crudely positivistic, or materialistic. Later, Longhi suggested that Morelli's "materialistic indications" rendered his method "shallow and useless from an aesthetic point of view" and claimed that Morelli "either badly lacked the feeling of quality, or perverted it under the impulse of his

connoisseurship."[75] Croce also criticized his "sensualist appreciation of details taken out of their context."[76] On the other hand, more recent appraisals of Morelli's enterprise have taken a less polemically aestheticist line, thanks to the modern revival of interest in Morelli's seminal place in the development of the discipline of art history begun by Edgar Wind[77] and continued with great insight by Zerner and Ginzburg.[78]

As Morelli himself said, in response to his critics, "My adversaries are pleased to call me someone who has no understanding of the *spiritual content* of a work of art, and who therefore gives particular importance to external details such as the form of hands, the ear, and even, *horribile dictu*, to such rude things as fingernails."[79] The phrase "spiritual content" in the quote (my emphasis) may itself be taken as a clue to a deeper agenda in the work of Morelli's art historical and critical colleagues, an issue discussed previously and one to which we shall return.[80]

That Morelli's writings were significant for Freud's development of modern psychoanalysis has been explored elsewhere, as has the connection between the methods of Freud and Sherlock Holmes.[81] And it is of interest that when Freud was asked by Theodor Reik about the evident parallels between Freud's procedures and those of Conan Doyle's hero, Freud's response involved an expression of admiration of *Morelli's* expertise as a connoisseur.[82] It was clear that for both Freud and Morelli, trivial details "beneath notice" furnished keys to the unconscious. One should also note that Freud, Doyle, and Morelli were members of the medical profession and inheritors of a long and rich tradition of diagnostics and semiology dating back to Hippocrates.[83]

The connection between the reading in small unremarkable details of larger patterns of character, milieu, and period briefly outlined here and the *petits faits* of Hippolyte Taine's system of cultural and artistic signs is obvious. The latter's ideas began to unfold in the course of his lectures at the Ecole des Beaux-Arts in the mid-1860s, and Morelli's writings date from the following decades. Although there is no obvious trace in Morelli's work of explicit application of Taine's principles, and while none of Taine's later work exhibits any direct reference to Morelli's Method, it is clear that they share a complementary concern and a parallel procedure—a procedure not merely "in the air" in the late nineteenth century in some abstract way but, as Huxley argued in 1880, fundamentally common to a diverse set of disciplinary discourses.[84]

In considering the nexus of metaphors and protocols connecting the methods of Morelli, Zadig, Holmes, Freud, seventeenth-century art connoisseurs, and Galileo,[85] it is clear that our concern has been with complementary approaches to the problem of signification—the question of the nature and status of signs. Taine's *petits faits* and Morelli's earlobes were construed as signs in

the common sense of the term. But precisely what kind of signs were these?

For the most part, we have been concerned with indexes in the contemporary sense of the term—a sense whose modern usage stems from the work of the nineteenth-century American philosopher Charles Sanders Peirce, a contemporary of Morelli, Freud, Taine, and others we have considered above. For Peirce, the index was one of three generic sign types (the others being the symbol and the icon). Considered today as one of the great founders of modern semiotics,[86] Peirce continued a tradition of inquiry dating proximately to John Locke and elaborated during the eighteenth century—part of a larger tradition that Peirce's contemporary, Taine, revived after its early nineteenth-century academic and political repression.[87]

In turning to that tradition and, in particular, to its linguistic facets, it can be argued that the notion of the sign inherited by the new discipline of art history in the late nineteenth century was a very specific concept. But as we shall see, art history inherited not one such particular notion but two signs, each diametrically opposed to the other and each inherited from diametrically opposed theoretical, political, and religious traditions. And the modern discipline installed both within its disciplinary apparatus, like the oscillating perspectives of an optical illusion.

4. Signifier and Signified

"What a beautiful book could be composed, telling the life and adventures of a word. . . . Is it not true that most words are dyed with the idea represented by their outward form? Imagine the genius that has made them! . . . The bringing together of letters, their forms, the figure they give each word, trace precisely, according to the genius of each nation, unknown beings whose memory is in us. . . . Is there not in the word 'vrai' a sort of supernatural rectitude? Is there not in the terse sound it demands a vague image of chaste nudity, of the simplicity of the true in everything? . . . Does not every word tell the same story? All are stamped with a living power which they derive from the soul and which they pay back to it by the mysteries of action and the marvellous reaction that exist between speech and thought."
—the character Louis Lambert in Balzac

If attempts to relate meaning to form in a good deal of modern art history often resemble the more arcane and ingenious attempts by eighteenth-century divines to find a place for their God in a clockwork universe, the resemblances may not be totally fortuitous. Indeed, in one

sense art history is part of the same intellectual and philosophical tradition. Like remarkable Rube Goldbergesque contraptions, both seem to rely for their cogency upon the internal logic of purely syntactic relations that, once you try to envision their operations, are seen to defy the laws of gravity and sense. The great wit of Rube Goldberg lay in his astute juxtaposition of the two contradictory orders within the same frame;[88] the genius of the discipline of art history often seems to consist of continually redesigning frames so that contradictory notions of sense and meaning might circulate and co-exist in suspension at different [or even the same] rhetorical moments, rather like the alternating perspectives in a Necker Cube.[89] Indeed, it may very well be that the power and efficacy of the modern discipline has rested in no small measure precisely on this heterotopic ability to continually displace meaning (and the issue of signification in general) to different loci in its discursive space, thereby reinforcing the singular and relatively modern notion that the primary mode of existence of the art object is "to mean."[90]

During the nineteenth century, comparative philology came to be the model humanistic discipline. As Aarsleff observes, "Factual, descriptive, classificatory, empirical, and comparative, the new philology appeared to satisfy every article of scientific—or rather academic—faith in objectivity and disengagement from ideology."[91] And yet during the first half of that century, an important alliance was effected between philology and science to sustain arguments for Final Causes and for the assurance of a Creator's presence in Creation. The alliance revived the doctrines of essentialism that had been dismissed by philosophers of the eighteenth century—notably Locke and Condillac. The study of language was one of the main stages of the intense battles over the uniqueness of Man.

Seventeenth-century philosophical discussions on the nature of man were deeply tied to the problem of the origins and nature of human languages as well as to the relationships between words and things. The key reference point in these debates was the biblical personage of Adam. The most widely held view of the time was a doctrine purporting that in spite of their great multiplicity and disorder, all modern languages retained traces of some original perfect language created by Adam, who, before his Fall, established a nomenclature for the animals in his world. Languages were thought to be, of necessity, in fundamental accord with nature and yet retained the Divine nature of their common origin. In short, human languages were construed as being divinely inspired, rather than human or social conventions. And the authority of scriptural revelation was held to ensure that language, at base, was a nomenclature and that all words ultimately named essences and species.

The doctrine was, in effect, innatist and essentialist and served obvious ends in supporting a particular religious perspective on the world of human

knowledge and experience. In effect, this "Adamic doctrine" was an inevitable outcome of what were then held to be basic theologic truths: If one accepted the basic tenets of the Judeo-Christian religious tradition and the narratives of the Bible as true, and if, in consequence, the tale of Adam in his Eden had to be factual, then the origin and nature of language were self-evident.

Within such a discursive framework, the authority of language was immense, for in one sense the study of language could be seen as a more secure pathway to the true knowledge of nature than mere observation of the world, dependent upon the imperfections of sensory perception and mortal reasoning. And one of the chief instruments in the quest to reveal hidden truths in man and nature was the discipline of etymology.[92]

The critique of this perspective and its implications, in the form of John Locke's *Essay Concerning Human Understanding*,[93] laid the foundations for the modern study of language. Locke observed that speakers commonly believe words to be as good as things (as if a name carries with it knowledge of a species or its essence) and make the safe and simple assumption that language is an inventory of the world of experience. Words, argued Locke, are about ideas, not about things: There is not necessarily a "double conformity" between ideas and things.[94] But Locke's argument about the illusion of this double conformity was aimed less at the common habits and assumptions of speakers than at the serious support given this illusion in the contemporary Adamic doctrines with their commitment to innate notions.

The philosophy of language elaborated by Locke, in effect, turned the entire question around and situated imperfections in language rather than in the human capacities for knowledge, asserting that God had willed man to possess sufficient capacities to learn and to know what was necessary for the conduct of mortal life. Locke argued that language was neither divinely inspired or natural but constituted a social institution reflecting the particular experiential world of a language community. Contrary to the central assumption of Adamic doctrines, he asserted that the relationships between signifier and signified are conventional and arbitrary, however firm, strong, and natural such linkages might appear in communication. Words were to be seen rather as knots or bundles tying together a nexus of ideas that would not have existed without this tagging.

In short, Locke's analyses identified the supreme importance of signs in all facets of human life and experience, and in the final section of his *Essay* he establishes a three-fold division of knowledge into natural philosophy, ethics, and a third, which he termed *semeiotike*: "the business whereof is to consider the nature of signs the mind makes use of for the understanding of things, or conveying its knowledge to others. For, since the things the mind contemplates are none of them, besides itself, present to the understanding,

it is necessary that something else, as a sign or representation of the thing it considers, should be present to it; and these are ideas."[95] Locke was seeing the need for the elaboration of semiotics, a need equally reflected in the work of Charles Sanders Peirce and Ferdinand de Saussure in the modern period.[96]

Even within the related enterprises of these three men, there is a notable conformity between the project of Saussure and that of Locke in terms of criticizing the doctrines of innateness and essentialism. And between the eras of Locke and Saussure, a similar critical concern was voiced by Wilhelm von Humboldt. Saussure's famous chapter on the nature of the linguistic sign opens with these words: "When reduced to its essential principles, language is for some people a nomenclature, that is a list of terms that correspond to as many things. This conception is open to criticism in several respects. It assumes that ready-made ideas exist before words . . . and it suggests that the link that unites a name and a thing is a very simple operation, which is far from being true." Humboldt makes a similar observation: "The entire manner of the subjective perception of objects is necessarily carried over in the formation and use of language. For the word originates precisely in this perception, it is not a copy of the object itself, but of the image it creates in the mind. . . . With objects man lives mainly according to the manner in which language brings them to him."[97]

Although the critiques of essentialism to be read in Locke, Humboldt, and Saussure necessarily have differing historical motivations, the conformity among them resonates with similar arguments among philosophers, historians, and linguists over the past three centuries and contributes to the deeper understanding today of the ideological issues at stake.

In the case of Locke (writing within what was still a very powerful and omnipresent religious milieu), his motivation in opposing essentialism clearly involved making certain that all claims to truth be argued on open and public grounds rather than private and esoteric ones. As Aarsleff astutely notes, Locke was painfully aware from his own experience—and from that of contemporary advocates of the new sciences—of the potential tyranny (intellectual, religious, and political) of any doctrine of innateness. The grand passion illuminating all of his work was his desire for toleration, open discussion, and the kind of free, responsible, and mutually respectful discourse that he and his contemporaries were to see housed by the new Royal Society and its prototypes.[98] Regarding some individuals' claims to know innate principles, he observed that

it put their followers upon a necessity of receiving some doctrines as such . . . in which posture of blind credulity, they might be more easily governed by and made useful to some sort of men, who had the skill and

office to principle and guide them. Nor is it a small power it gives one man over another to have the authority to be the dictator of principles and teacher of unquestionable truths, and to make a man swallow that for an innate principle which may serve to his purpose who teacheth them.[99]

Locke laid out the fundamental principles of the modern study of language on a complementary firm dismissal of the naturalness of words, asserting that the meaning of a word has nothing to do with its sound and bears no innate relationship to things: "*Words* . . . come to be made use of by Men as *the Signs of* their *Ideas*; not by any natural connexion, that there is between particular articulate Sounds and certain *Ideas*, for then there would be but one Language amongst all Men; but by a voluntary Imposition, whereby such a Word is made arbitrarily the Mark of such an *Idea*. The use then of Words, is to be sensible Marks of *Ideas*; and the *Ideas* they stand for, are their proper and immediate Signification."[100]

To some writers in the first half of the nineteenth century, John Locke seemed to be the all-pervasive evil genius whose *Essay* informed the rationalist secularism of eighteenth-century science and philosophy. Carlyle's words seemed to summarize what to some in the nineteenth century was the great enigma of the man: "Locke, himself a clear, humble-minded, patient, reverent, nay, religious man had paved the way for banishing religion from the world."[101] In contrast to the previous century of philosophical discourse centered around issues raised by Locke and Condillac, the early nineteenth century erected an immense fabric of misunderstanding and vilification of Locke,[102] which was only unraveled much later in the century, notably in the writings of Taine.[103]

The reasons for the misreadings of Locke (and of the philosophers and scientists of the eighteenth century) are not obscure. They were largely the result of a general obsessive fear, exhibited in all facets of social life, of anything that might be construed as revolutionary thought. By 1800, the French Revolution appeared to many as a near apocalyptic event that had threatened to annihilate the past. The fear of "free thinking" led to repression, censorship, and more encyclopedic control over the details and formats of education. Increasingly insidious forms of quiet academic submission to authority came to be masked, as Aarsleff accounts, by strident claims of objectivity and freedom of inquiry.[104] Napoleon made it deliberate policy to favor the age of Louis XIV, and France virtually proscribed Greek studies because of a suspicion of republican or democratic ideas, resulting in a lament by Parisian scholars of the 1830s that the country had lost an entire generation of Greek scholarship. Complementary to such proscriptions, schol-

arship on the imperial period of Roman history and on the Middle Ages was raised to official eminence.

The motivations were essentially simple: Eighteenth-century philosophy, concentrated in the philosophy of language that contained definitions of man and the promise of progress (Condillac) and in the perfectibility of the human condition by human means (the program that the *idéologues* at the end of the century tried to fulfill), was identified by the forces of reaction under Napoleon with the root causes of the Revolution. And the nature of language was one of the principal grounds on which the reactionary crusades were to be mounted in the coming decades.

During the first half of the century, it appears that a massive campaign against Locke and his philosophy took place in both England and France; the debate drew into its orbit many prominent thinkers of the time, including Coleridge and William Hazlitt.[105] Specific strategies varied over time and place, and portions of Locke's work were held up for derision for different reasons.[106] Many unsympathetic and factually unfounded interpretations of Locke found their way to a wider public audience in both countries, partly because of an extraordinarily vehement series of lectures delivered by Victor Cousin in Paris before 1829.[107] At the end of the 1820s, Thomas Carlyle had made Locke responsible for all of the spiritual disasters of the age. And all during this period Coleridge became the chief exponent of a German transcendentalist dislike of and contempt for Locke, beginning with his letters of 1801 to Josiah Wedgwood.[108] Cousin's history of philosophy, translated into English in 1852, and his lectures on Locke, published in England and the United States in 1834, became set texts in several universities.[109]

The history of these vigorous and in some cases astoundingly off-base debates is too complex to be followed here. For our purposes, it may suffice to note that, thanks to Cousin especially, Locke had come to be seen as a "sensualist," as characterized by "the negation of all the great truths which escape the senses, and which reason alone discovers."[110] Cousin had also taken Locke to task for his opposition to "enthusiasm," a concept of great pertinence to that generation of Romanticist writers and critics: For Cousin, enthusiasm was "a state of reason which listens to itself and *takes itself as the echo of God upon earth*, with the particular and extraordinary characters which are attached to it," having its place "in the order of natural facts and in the history of the human mind."[111]

A close examination of the terms of these debates reveals that the issues being considered were construed as being essentially connected to more fundamental religious and ideological questions. But it would be wrong to conclude that the terms of the debates were couched within a rhetoric of religion versus rationalist science. Victor Cousin may have fought his crusade

against Locke and the eighteenth century with a wobbly spiritualism patched together from glimpses of contemporary German thought that he ill-understood;[112] but science was drawn into a supportive role on both sides.

In 1795 one of the most popular scientific thinkers of the age, Georges Cuvier, began to introduce the principles of his comparative anatomy in Paris. By 1800 his first volumes appeared, published under that title; in the following decades he lectured on the subject at the Museum of Natural History to audiences so large that tickets were frequently unobtainable.[113] His new discipline was founded on the principle of structure or the correlation of parts, which made it possible in a systematic fashion to reconstruct whole animals from sparsely preserved details. In this regard, Cuvier's work continued essential parts of a practice referred to earlier as Zadig's Method.[114]

But Cuvier was an opponent of the idea of evolutionary transformation in the biosphere current at the time and insisted on the absolute fixity of species and types. Indeed, in his view, species had been permanently fixed since the moment of Creation, for to think otherwise would render his views of natural history impossible. In such a science, observation, description, and classification sufficed. Speculation was unnecessary and irrelevant, for natural history pronounced what he referred to on many occasions as "sublime oracles."

For many, comparative anatomy as developed by Cuvier had become the very model of contemporary science. And in all his writings he continually referred to language study as supportive of his anatomic findings. But by rejecting the sliding scale in the great chain of being, his science allied itself with concepts of essentialism and final causes in language study and religious philosophy—concepts that had been dismissed as incompatible with the aims and method of the study of nature by Locke and the broader eighteenth-century philosophical and scientific tradition.

One of the most enthusiastic supporters of the essentialist perspectives of Cuvier was William Whewell, a master of Trinity College, Cambridge. His "Aphorisms concerning Ideas," from the 1840 volume *Philosophy of the Inductive Sciences*, is worth citing here:

> We take it for granted that each kind of things has a special *character* which may be expressed by a Definition. . . . If (Scientific) Natural History were introduced into education, men might become familiar with the fixation of the signification of words by Types; and this agrees with the common processes by which words acquire their significations. . . . The assumption of a Final Cause in the structure of each part of animals and plants is as inevitable as the assumption of an Efficient Cause for every event. The maxim that in organized bodies nothing is *in vain*, is as necessarily true as the maxim that nothing happens *by*

chance. . . . The Palaetiological Sciences point backwards with lines that are broken, but which all converge on the *same* invisible point: and this point is the Origin of the Moral and Spiritual, as well as of the natural world.

The identity of this "same point" or Origin need not be spelled out at length. In his small book *Indications of the Creator*, Whewell gave language a central place in his argument, basing his reasons on Cuvier.[115] During his mastership of Trinity, Cambridge became the home of anti-Lockean philosophy, a situation that lasted into the 1860s.[116] Later in the century, the philologist Max Müller took up some of the same essentialist arguments, asserting that it was not in the power of any man to produce or to change language, that everything in language is natural, that there is no historical change, and that language is independent of political history:[117] key points in the ideological opposition to the work of his own contemporary, Charles Darwin.

Language was central to these debates precisely because, according to the discussions of the time, it came closest to proving the great argument about firm boundaries between man and brute and about the divine origins of the order of things. Language study, comparative anatomy, and scientific method in general joined forces to reassert the religious essentialism that eighteenth-century philosophy had worked patiently to circumvent, also in the name of reason and science. The issues at stake had wide and deep ramifications for all aspects of human knowledge and for the justifications of particular ideological perspectives on society, individuality, origins, and history.

What do all these issues have to do with art and art history? To tie these threads together, we need to return briefly to the seventeenth century and to readdress the question of signification. We will then situate ourselves back in the last quarter of the nineteenth century, the time of the institutionalization of the art historical discipline.

5. *Hoc est Corpus Meum*

John Locke's *semeiotike* was elaborated during a time in which the French philosophers and theologians of Port-Royal were developing a general grammar and logic according to a theory of signification that examined the relationships between God and man.[118] This work was not fully translated into English until 1752, but Locke became familiar with it during his sojourns in Paris and possessed the original French writings in his collection.[119]

Although the Port-Royal theologians developed a comprehensive theory of

language in general, they only indirectly considered the central problem of the sign, and then only by way of simple and apparently unproblematical illustration. A prime example given of a sign is the Eucharist and its enunciation, *hoc est corpus meum*. But as Louis Marin and Milad Doueihi have recently argued,[120] this almost offhand example, in fact, constitutes the very foundation of the Port-Royal ideas about signification and representation—to the extent that the problem of the Eucharist, from a Christian perspective, is the essential problem of signification in its most general sense.

The problem, in outline, is this. The Port-Royal grammarians had to derive a formula that would capture God's Word in its material manifestation —one that would express and illustrate the presence of the Divine Word as the realization of a perfect exchange between Spirit and matter, between the world of the infinite and the world of mortal finitude. Such an exchange is both invoked and exemplified by the existence of the Eucharist.

What was needed in effect was a formula making it possible to think the unthinkable—the idea of a perfect, pure, and transparent signifier. Such a signifier would have to be visible and material so as to articulate a signified; and at the same time invisible and immaterial in order not to obstruct the presence of the signified itself. The sign would perform actively and efficiently the ideal and perfect interchangeability of object and sign.

In the case of the Eucharist, the religious prescription is that the object cannot merely be a symbol of the presence of the body of Christ or merely a palpable memory of the Hidden God. In some way it must be affirmed as the very body of the God: It must *be* Christ's body, not a simulacrum. With its millions of daily reinforcements in the ritual of the Mass around the world, the Eucharist (and its enunciation) must be the absolute proof of the possibility of a transparent substitution and exchange between thing and word.

Thus the Eucharist, as an object in the material world, is a sign, yet not a sign—not literally the body of Christ, yet also assuredly the very body of Christ. The universal and infinite cannot exist in the finite universe, yet it must somehow at the same time be present. Nor is it behind the thing, it *is* the thing.

The outlines of a solution to the dilemma can be seen in the overall structure of signification mounted by the Port-Royal grammarians.[121] Consider the phrase of enunciation again: *Hoc est corpus meum. Hoc* (this) is a gesture of indication: an index, signifying an X. And yet in the case of the Eucharist, *hoc* must more than indicate something absent: It signifies a palpable here and now, a concrete object. Hence, it is more than merely a re-presentation, it is a presentation: a presence. This really *is* Christ's body (*corpus meum*). In effect, the object is assimilated to the signified; it does not really stand for or stand in for what is absent, as any ordinary sign in

language. Thus, that which cannot be represented because of its divinity and infinity is here presented in *hoc*.

In other words, that which is exterior to the semiotic system constituting language is accommodated as an innerness, an interiority within that system: At the heart of the system of signs is a mysterium, a fleshed Spirit. The realm of Spirit is simultaneously totally outside the system of signs and at its innermost point. Spirit is both totally Other and totally within the here and now. And *est* refers to an object of designation, both more and less than a sign. In the Eucharist, the signifier *is* the signified.

The problem of the Eucharist clearly resonates with the problem of the relationships between the human soul and the human body: immortality within mortality. We see, then, that the problems of signification and representation necessarily implicate profound issues, for the possibility of justifying a spiritual or immaterial realm hinges on a perspective of signification and on the entire theory of semiosis. In short, if there could be shown to be a "place" for the immaterial within the realm of the material—and in a way that goes beyond the metaphorical—then an essentially real place for a divine or religious order could be demonstrated. Thus, the problems wrestled with by the Port-Royal grammarians clearly center around the role played by theories of signification and representation in the justification of the existence of a spiritual world.

More was at stake during the seventeenth century, however: the question of absolute monarchical power and the status of its representations vis-à-vis the person of the king. It was Pascal who discovered that the representations of the king—that is, his portraits—were essentially parodies of the Eucharist. In *Trois Discours sur les conditions des Grands* as well as in *Pensées*, he offers a penetrating critique of the processes of legitimation of absolute royal power, which involve a sort of hallucinatory series of transformations and substitutions carried out by representation:[122] a royal hocus-pocus.

We may begin to discern the force of the hysteria directed against the eighteenth-century philosophies of language and signification in the post-Revolutionary period. In their (mis)readings of Locke, Condillac, and others, proponents of essentialism in language and in the sciences and arts could very well believe that Locke "paved the way for the banishment of religion," in Carlyle's words, or even that earlier philologists and natural philosophers were somehow responsible for the cataclysmic disintegration of the eternal verities and fixed truths of the social order of the ancien régime.

Locke's *Essay* was not written as a rejoinder to the principles of signification and representation of the contemporary Port-Royal grammarians; his aims were more modestly limited to epistemological problems concerned with understanding language. Yet, he understood that the ideological implications

of his own work, and the work of his colleagues, stood in opposition to theories of innatism and essentialism, which, during his own time, could be seen as invariably justifying absolutist and dictatorial political regimes and repressive theological orthodoxies.[123] He saw quite clearly that those who "suppose their Words to stand also for the reality of Things"[124] would never, as scientists, be "chemists" but always remain "alchymists."

Georges Cuvier, as a comparative anatomist, never carried his new science all the way back to the First Cause: He merely took his audiences far enough to see no other possibility than a Divine Origin (within a Judeo-Christian framework). His relationship with his public was little short of charismatic. (In this area he may have resembled Taine and Saussure who, later in the century, were also immensely popular lecturers. Closer to our own time, one thinks of Lévi-Strauss and Foucault in Paris.) But Cuvier was one version of the sort of distinguished popular academic or man of science or letters whom John Holloway once called the "Victorian Sage."[125]

The sage invariably had a distinct style; what gave his views life and meaning lay in his actual words and in his unique use of language, not in what might survive summarizings of his content. Holloway's archetypal sage was Thomas Carlyle, who "does not wish to be thought of as explicitly allotting his own senses to these words, but as discovering what really they mean already, what their existing present use both depends on, and perhaps conceals."[126] In Holloway's view, Carlyle replaced rational discourse with the evocation of the true meaning of words, pointing to meanings that were deeper than their common senses—the premise being that such deeper meanings were somehow naturally available to the thoughtful reader. Someone, in short, like Carlyle himself.

The Victorian Sage functioned rather like a lay evangelist for conservative intellectual orthodoxies and, as Aarsleff observed, their primary weapons were often philology and etymology. Words were endowed with charismatic realities; they were not merely arbitrary signs but living powers. Balzac, who had an uncanny grasp of the classificatory verbalisms so rampant during the century, brilliantly lampooned the figure of the sage in his *Livre mystique*; in the person of young Louis Lambert, Balzac revealed the archetypical repertory and manner of the conservative sage conflating science, philology, and mystical theology (see quotation, sec. 4, this chapter).

If Lambert's perspective on signification seems to resonate with the problematic of the Fathers of Port-Royal, that resonance is not wholly accidental or fortuitous: Both represent facets of a tradition in sign theory that antedates Christianity and yet remains in some ways powerfully present in contemporary discourse, particularly in its structuralist aspects.[127]

And if, by replacing in Lambert's account the term *word* with the term

painting, that account might recall some familiar art historical and critical discourse, we may be ready to return to the time of Taine and the assimilation of that discourse into the modern academy.

6. *Abcedarium Culturae* versus the Metaphysics of Quiddity

For Balzac's Louis Lambert, each word was a temple of the spirit, a temple of entelechy—the articulated, palpable result of a vital force. Like a gnarled tree bent landward on a windswept coast, Lambert's *vrai* was "dyed with [an] idea" and in the combination of its phonemes was truly a "supernatural rectitude." Paraphrasing Balzac's young scholar, could we not also say, "Does not every *painting* tell the same story? All are stamped with a living power which they derive from the soul."

Is, then, the task of the art historian and critic one of "discovering what really they *mean already*"? The life and meaning of the artwork inhere in every daub of the brush or trace of the chisel, and the vital force that is the character of the artist can be read by the "thoughtful reader" in the *caratteri* of the work, in all *les petits faits*, and even (*horribile dictu*) in unregarded "rude things." Yet, are not such practices—that is, those characterized as sensualist both by Cousin in contesting Locke and by Croce in deprecating Morelli —incapable of leading the reader to "an understanding of the *spiritual content* of a work of art"?

William Whewell's treatise against Locke's philosophy of signification, entitled *Indications of the Creator*, was written in reaction to a treatise by his contemporary Chambers entitled *Vestiges of Creation*.[128] In the contrast between *Indications* and *Vestiges*, we may see an emblem of the issues at stake. If the word (or any artifact) provided an index of the spirit of the Divine (or human) Author—if, that is, such a spirit was in some way present in the thing—the basic task of the analyst consists of evocation (of what it "really means already"). But if the word or thing is a vestige of some other thing (whether that be a force in the most general sense or an activity on the part of an individual author or, by extension, of a society), then the analytic task becomes something strikingly different. The analyst must, in this case, construct an account of the causal connections among phenomena in the world, wherein the object or work may relate to an absent cause by any number of semiotic relationships—not only indexical, but iconic and symbolic as well (to put it for the moment in Peircean terms).[129]

The former perspective (emblematized by Whewell) reduces signification

to indication and to a single, transitive, unilinear orientation, however broken the lines of connectivity might seem at first. The signifier is assimilated to the signified in a tight play of interactive force—an apparently secularized version of Eucharistic meaning.[130] Let us call this a "metaphysics of quiddity."

The latter perspective (suggested by the enterprise of Chambers and the Lockean tradition on the subject of signification) allows for a wider variation in how signification may be construed, and even, in the case of both Chambers and Locke, permits the Creator to work in myriad ways, affording Its creatures multiple pathways back to Itself. Not only does the God of the Enlightenment somehow seem smarter than the God of the nineteenth-century fundamentalists, but It seems also to have a greater respect for the intelligence of Its creatures. And Its creatures (our analysts) exercise their talents (in reaching for God, or more simply in reaching for some sensible account of causalities in the mortal world, in a proximate sense) in constructing what we might call here an *abcedarium culturae*—a system of culture (in Taine's sense)[131] of which art and language are facets.

We might also refer to the former perspective as eucharistic in its assumptions regarding signification and representation. In such a discursive space, "every word [painting, sculpture] tell[s] the same story." And the latter, noneucharistic perspective is a facet of what Reiss called "the discourse of modernism,"[132] which we discussed in the previous chapter.

Yet the boundaries between these apparently contradictory and opposed semiotic traditions are not hard and fast: We have seen above how the two were conflated in the reaction against the eighteenth century,[133] and we shall see further something of the ways in which the discourse of modernism has been construed by some critics as inherently complicit with the former.[134]

Articulating this opposition puts into higher relief the two extreme perspectives on semiological issues constituting the modern discipline of art history over much of the past century and emphasizes once again a point made in various ways throughout this volume—that as a discipline, art history has traditionally encompassed both perspectives, two antithetical notions of signification and representation. As we have seen on a number of fronts, the disciplinary apparatus has worked as a "system of flotation" to suspend these antithetical semiologies.[135] The discursive space of the discipline may also be likened to our familiar Necker Cube analogy—the same object, with alternating ways of construing the figure that comprises the object. It has been suggested that this alternating figuration is the very emblem of disciplinary strength, the emblem of its self-presentation as a comprehensive science. And the often-invoked Kleinbauer definition is a medallion of this flotation: the (man-made) object is of "aesthetic significance" while at the same time "irreducible, even mysterious."

The artwork is, thus, a part of a cultural system of aesthetic signification, and yet, because it harbors a mystery, is simultaneously outside of culture and autonomous: both a part of the passing parade of cultural systems, social history, and ideologies and a spectator on the sidelines. As Pascal discovered, the portrait of the king is a parody of the Eucharist.

Yet within the modern discipline, both eucharistic and modernist practices do converge in agreeing that the function of the artwork is *to mean* and that the function of the historian-critic is *to interpret* or to read the work, to ex-plicate its aesthetic complexity and density. The two perspectives diverge more obviously, however, on how artworks mean or signify and, to a lesser extent, on what constitutes an adequate reading—where does analysis fittingly conclude? In short, the two perspectives proceed from divergent semiotic assumptions as to the nature of signification at play in aesthetic objects.

It will be clear that these divergencies undercut the apparent differences ascribed to various disciplinary methodologies, whether formalist or social-historical, iconographical-structuralist or psychoanalytic. As we have discussed above, such methodological differences are largely secondary to a more fundamental series of differences among practitioners as to *how* artworks signify. Indeed, it can be reasonably argued (as I think it has been) that the modern discipline of art history has but one general method: a tradition of practice historically elaborated out of a late nineteenth-century empirical science that subsumed a variety of sixteenth-century cryptographic technologies.

And yet, of course, to claim that there exists such a thing as the method of art history in and of itself would be misleading. As will have been made clear from this chapter and the two preceding ones, the modern discipline comprises a discursive space within which an extended family of versions of art historical method are set in play—now Zadig's, now Bentham's, now Camillo's Memory Theater, now that of Holmes, Freud, Taine, or Saussure. It's not a question of precursors or biological genealogies fixed in place for all time: Every stance taken up, every mode of practice rewrites other positions and perspectives. To write a fixed genealogy of art historical method is to beg the question and to extend the reifications of periodicization from the realm of artworks to that of interpretations. Indeed, to stabilize an opposition between the latter two is to fall prey to the same trap.

The trap is what constitutes the discursive space of the discipline—the alignment of analyst toward analysand, the orienting of the panoptic gaze upon an anamorphic archive. The method of art history is, in older terms, a method of loci—a technology of spacing or formatting knowledge so that inevitably entities such as subject and object are visible as distinct and have, as it were, an exteriority relative to each other. In short, the method of art

history is *method itself* (in all of its variations since Vasari and Alberti)—which is to say, metaphor.

I have asserted that the modern discipline deals with metaphors "whose metaphoricity has been forgotten." In a sense, that assertion is both true and false. It is clearly correct in that many disciplinary practices and theoretical perspectives (to distinguish between these two momentarily for rhetorical purposes) rest upon assumptions that appear self-evident or natural because we have forgotten their histories or their original ideological, religious, or philosophical motivations. But it would be incorrect to conclude from that aphorism that metaphor stands in opposition to some literal or nonfigurative set of circumstances. The aphorism does not exhort to uncover a single, fixed, or true disciplinary history that in the alexandrianism of the present time we can no longer see. It is rather an ironic emblem of the fact that to purport to remember a state of knowledge which is nonmetaphoric is largely ironic. No metaphor is innocent, least of all when metaphor presents itself as a tangled forest out of which we (metaphorically) might step.

In chapter 2, we saw that one of the pervasive metaphors for the art object was anthropomorphic—that qualities attributed to the well-made artwork invariably resonate with organic characteristics of the Western individual. It was suggested that within a Vasarian framework there was a conflation of the-man-and-his-work with the-man-as-a-work (of art) and that the converse was implicated—the artwork was like a man.[136] And like the man, the work was entelechal—containing a vital force; a temple of the Spirit.

Deriving from this core metaphor are various chains of assumptions regarding the characteristics of the work of art—its relative autonomy and uniqueness, as well as a certain inner spirit, which might be read in the *caratteri* of its physiognomy. Certainly, what I have termed the eucharistic tradition of criticism in art history situates itself along these complex chains of assumptions. And yet, what I am referring to as the modernist disciplinary tradition is, in a sense, also complicit in this anthropomorphism, but at a different level, and seemingly more indirectly. This concerns, once again, the assumptions regarding the nature of signification in the discipline, and in particular notions of the sign.

It is rarely remembered that, in addition to his famous sheet of paper, Saussure had another example to illustrate his view of the sign in language. This was the individual, composed of body (the signifier) and soul (the signified). While it might be tempting to consider Saussure's illustration as simply an analogy intended to aid in understanding something similar, such a metaphor was almost inevitable, for it is a reflex of a long tradition to which Saussure saw himself in opposition and yet to which he could not *not* conform. He says: "This two-sided unity has often been compared to the unity

of the human person, composed of a body and a soul. The comparison is hardly satisfactory."[137]

The metaphor, which is "hardly satisfactory," suggests that form—the palpable corporeality of a thing or body—is opposed to meaning or significance as its complement. The sensible is distinct from the intelligible, yet it is through corporeality that we infer concepts. Similarly, the significance of man rests in the nature and quality of his spiritual essence, his soul.

Saussure's dilemma involved a double assertion: on one hand, an assertion of the inseparability of signifier and signified, and on the other, a maintenance of a rigorous distinction between the two, with an equation of the signified with the concept. The difference between the signifier and the signified corresponds to the difference between the sensible and the intelligible.[138] Or, in the everyday language of art history, between form and meaning. The problem, as Derrida has shown, is that the concept of the sign cannot be used in an absolutely novel and an absolutely conventional way.[139]

By leaving open the possibility of an opposition between signifier and signified, between an equation of the signified with the concept, Saussure allows the possibility of construing signifieds as simply present for thought, independent of a relationship to language. And signifieds (or concepts) in that autonomy, that independent existence beyond the chain of signifiers, can be construed as having a life and history of their own.

The body-soul analogy thus remains: Souls are not merely insubstantial or immaterial; they are (in the Western Christian tradition) also immortal, having a life of their own beyond the life of the body.

In the common language of art history, meanings too have this additional essence: Both the Saussurian sign and the form-content dyad make inevitable a view of signification as communication—a transmission of the identity of a signified object, meaning, or concept that is rightfully separate from the signifying operation, from the signifier. The artwork remains a medium through which pass concepts, intentions, meanings, or signifieds. We are back to the transitive communicational model of artistic signification discussed in chapter 2,[140] with all that the metaphor entailed.

This model is also the discursive apparatus of the structuralist tradition for which Saussure paved the way and within which art history in this century has situated itself, equally in its eucharistic and modernist voices. This progression leads us, necessarily, to the problem of Panofsky.

7. Archimedes *am Scheidewege*

Intrinsic meaning or content . . . may be defined as a unifying
principle which underlies and explains both the visible event and its
intelligible significance, and which determines even the form in which
the visible event takes shape.
—*E. Panofsky*

Panofsky, not Wölfflin, was the Saussure of art history.
—*G. C. Argan*

There has recently been a revival of interest in the methodologi-
cal writings of Erwin Panofsky. This interest has been sparked principally by
two things: a burgeoning of attention within the discipline to explicitly theo-
retical and semiotic questions, and an increasing concern about the disci-
plinary history of art history. The motivations for these interests are varied,
but at base all are part of a general reaction within the discipline to the
impact of aspects of semiological theory on contemporary disciplinary
practice.[141] One major effect of this increased interest has been a closer
attention to problems of what in the common parlance of American art
history is termed "theory and method."[142]

The work of Panofsky on this front had loomed large in American aca-
demic practice for a variety of reasons. Among the most important were his
deservedly great reputation as a teacher and lecturer and the relative accessi-
bility of his major theoretical writings[143] (which appeared directly applicable
to the pragmatic formats of graduate research). In the postwar years, Panofsky's
iconography quickly came to define those very practices (at least for students
involved in earlier parts of the history of Western art) and to fill the volume of
academic discursive space with a formulaic program for active research and
teaching.

And yet, even before his death nearly two decades ago, his theoretical
reputation suffered a decline; indeed, his own theoretical and methodologi-
cal interests do not seem to have found fertile ground in the American
university system that housed him. Two poignant observations might be cited
in this regard:

[The iconographic method seems to] accumulate information of the
sort that allows a freshman instructor to utter some statement of dis-
placement such as "The dog in the Arnolfini portrait is not really a dog;
it stands for marital fidelity."[144]

Because his followers lost sight of his theoretical preoccupations (which he himself appears to have neglected more and more as time went on), the discipline he created has been transformed into a mere technique of deciphering . . . and, what is worse, iconographical deciphering has too often taken the place of meaning.[145]

The renewed attention to Panofsky's theoretical work seems to have been short-lived. The trajectory of that interest might be subtended by an arc springing from G. C. Argan's assertion in 1975 that Panofsky was the veritable "Saussure of art history" and coming to earth (after an important major colloquium held in Paris several years ago)[146] with W. J. T. Mitchell's 1986 *Iconology*, which barely mentions Panofsky at all. (The most notable reference was to Panofsky's anxieties about his iconology becoming rather like a new astrology.)[147]

Have we learned all there is to learn of relevance to contemporary theoretical and critical interests in Panofsky's work? To some, today, that oeuvre offers little: The work often seems theoretically weak, internally contradictory, and distressingly stuck in the lugubrious labyrinth of pro-, anti-, and para-Kantian rhetoric among Germanophone art historians of the early part of the century. And Panofsky's attempt to construct an Archimedean Lever or *Ansatzpunkt* to catapult the discipline out of its metaphysical circularities[148] resembles a quaint, early modern episode in trying to deal with the hopeless form-content double bind from within precisely that (neo-Kantian) metaphysical paradigm designed to maintain that metaphorical apparatus firmly in place. Moreover, Panofsky's Lever—the iconographical method—seems to have failed to transcend the old procedures of rote cryptography and to have resulted in entrenching that practice more deeply in disciplinary practice. In fact, it made it more systematic, efficient, and pedagogically useful.

If the arc of interest in Panofsky described above were to hold in place in the coming years, and if the interest in Panofsky's theoretical work were to remain as but a decade-long fashion to be buried deeper in the disciplinary closet, that would be unfortunate indeed. The failure of his enterprise is of more intrinsic interest to our understanding of the history of the discipline and to the development of art historical theory than are many other less tragic enterprises.

A cogent contemporary account of Panofsky's theoretical work has yet to appear; all that we have before us are models of what not to do. An example of the latter, and a poignant reminder of the existing need to situate Panofsky's work in relationship both to its historical contexts and to the contemporary discourse in the discipline on theory and method is a 1984 volume by M. Holly entitled *Panofsky and the Foundations of Art History*.[149]

It seems rather remarkable, given that the revival of interest in Panofsky

resulted from a burgeoning of interest in the possible relationships of iconological theory to the modern development of semiology, that the book has so little to say about this problem. In addition, what is said is so off-base and uninformed as to leave the reader to assume that an awareness of the issue was rather an afterthought, hastily patched in to appropriate parts of the argument.[150] Moreover, in explicit comparisons of Panofsky's iconological task with Foucault's archaeology,[151] Holly reduces the latter to a form of traditional intellectual history of precisely the sort Foucault himself worked against, as is clearly well known:[152] The "congruences," as Holly calls them, are superficial, and the reader is left with the feeling that the author indiscriminately swept through Foucault's works to pick up phrases that would match some of Panofsky's own.

The author's motivation in aligning Panofsky's work with contemporary theoretical and historical writing, in part, may be a reaction to recent statements citing a need to rebuke the impression that "most of the recent critical impulses have come from 'outsiders' (in respect to the mainstream of academic history of art)," in Kurt Forster's words.[153]

According to Holly, "Iconology, like early semiotics, was devoted to exposing the existence of the conscious and unconscious rules of formation that encircle a language and make possible its sudden emergence—both visual and linguistic—on the surface of human history. . . . Panofsky clearly conceived of the visual arts as a nonlinguistic language whose expressive forms are laden with meaning."[154]

Yet the paradigm of art as language, as we have seen, is as old as the hills, and the metaphor has been employed in the justification of a diverse set of ideological, philosophical, and religious agendas. And the notion of a "sudden emergence . . . on the surface of human history" (of visual and linguistic language) recalls a specific theological perspective critiqued by the long tradition of discourse on semiotic problems as early as Locke in the eighteenth century;[155] to attribute it blithely to "early semiotics" is remarkable. Peirce's observation that "every material image is largely conventional in its mode of representation"[156] has been said to corroborate "a fundamental tenet of much of the iconological program." Such a suggestion, however, misrepresents both Peirce's intentions and Panofsky's metaphysical program by conflating the two through some vague idea of words being like artworks because both are parts of larger contexts.

Again, the motivations behind Holly's assertions may become clear elsewhere in the book. Hard upon her paragraphs on Saussure and Peirce, and after a passing remark that we can "hypothesize but not prove" that Panofsky was "an attentive student of their works,"[157] because of some supposedly shared epistemological predispositions, she mentions that "art history was

sometimes demonstrably in the vanguard of contemporary thought, and the ideas that historians of art formulated while contemplating their artists and artifacts became relevant for other fields as well." This statement should be read with another on the same page: "We may suspect—like Wölfflin, who thought that 'the influence of one picture upon another is much more effective as a stylistic factor than anything deriving directly from the observation of nature'—that Riegl's, Wölfflin's, and Warburg's histories of art were more effective as historiographic influences in the development of Panofsky's art history than anything deriving directly from other fields of study."[158]

The statements, taken together, are interesting and represent a fairly common disciplinary impulse to assert the relevance of the discipline for other fields of study while at the same time exhorting the art historian to apply Wölfflin's analytic formalism to historiographic study: The true history of theoretical speculation constitutes an infradisciplinary genealogy. In other words, while early modern art history (in the person of Panofsky) reveals some "shared epistemological predispositions" with (in this case) early modern semiology, we need not concern ourselves more than momentarily with the latter because of its exteriority to the discipline.[159]

The catch in this is the following: Panofsky's own theoretical evolution did, indeed, appear to limit its contemplation to infradisciplinary models (apart from the example of his erstwhile mentor Cassirer). Panofsky is thus absolved from responsibility of attention to contemporary writers in other fields working on equivalent or identical problems—or on problems of signification in more general terms—and we may rest securely on confining our attention to the Germanophone antecedents of Panofsky's art history, which is precisely the limit-focus of Holly's book.

This Rube Goldbergesque rhetorical move is as significant for its referential content as for its phatic or territorial significance. That is to say, while appearing to justify a genealogical closure on Panofsky's theoretical evolution by appeal to specific historical and infradisciplinary influences, the statements serve an important territorial agenda in justifying a sort of disciplinary purity and autonomy. The move does a disservice to the intelligent reader as well as to Panofsky himself, as any familiarity with his own intellectual biography and its rich weaving together of many infra- and extradisciplinary sources can attest.

It may indeed be true that Panofsky was unfamiliar with the contemporary discourse on semiology within language study and philosophy. And it appears that elements in Cassirer's work that might have pointed Panofsky more explicitly in that direction were not, as far as we know, pursued.[160] But it also seems he was unfamiliar with the contemporary discourse on semiotics within art history and aesthetics, and that void remains rather inexplicable.

We do not know, for example, if Panofsky knew of the writings of one of his contemporaries in the 1930s, Jan Mukařovský, a member of that remarkable Prague Circle of linguists, philosophers, and aestheticians who played so seminal a role in developing the courses of semiological research in many fields in this century.[161] It was the art historian and critic Mukařovský who in 1934 wrote in his "Art as Semiotic Fact":

> Lacking a semiotic orientation, the theorist of art will be inclined to regard the work of art as a purely formal structure or, on the other hand, as a direct reflection of the psychological or even physiological states of its creator or . . . of the ideological, economic, social or cultural situation of the milieu in question. This train of thought will lead the theorist either to treat the evolution of art as a series of formal transformations or to deny evolution completely (as in the case of certain currents in aesthetic psychology) or, finally, to conceive of it as a passive commentary on an evolution exterior to art. Only the semiotic point of view allows theorists to recognize the autonomous existence and essential dynamism of artistic structure and to understand [the] evolution of art as an immanent process but one in constant dialectical relationship with the evolution of other domains of culture.[162]

The statement, from a paper delivered in French at the 1934 International Congress of Philosophy in Prague, concisely sums up the epistemological dilemmas with which Germanophone art history had been wrestling over the past half century—the same dilemmas being dealt with by Panofsky, who published his iconological solution five years later. Yet the difference between Mukařovský's perspective and that developed in *Studies in Iconology* is striking. Apart from the fact that the paragraph above could serve as a map of contemporary art historical positions (which one could pin with the names of Wölfflin, Riegl, Dvorak, Warburg at appropriate points), Mukařovský's perspective signals a possible shifting away from the transitivity of immanentist philosophies of art,[163] as well as from the "circularist" version of immanence elaborated by Panofsky.[164] The signal is the term *dialectical*, which breaks the metaphysical circularity of neo-Kantianism by its implication that even (in Mukařovský's words) the "immanence" of the artwork and its "autonomous existence and essential dynamism" are (however palpable in the existential confrontation with a work) social, cultural, and historical *productions*. The work serves to produce or to present immanent qualities, that is, as much as it reproduces or represents them.

If this seems familiar, it should be: It resonates with the perspective of Taine in his 1865 lectures at the Ecole des Beaux-Arts. And it conforms with the semiological perspective of Saussure, whose linguistic theory, as we have

seen, owed so much, in content as well as in form, to Taine's philosophy.[165]

There is, moreover, an implication in Mukařovský's remarks that corresponds to Taine's insistence on the importance of *les petits faits* as the site where evolutionary change occurs. In contrast to the rampant metaphysicalisms of contemporary art historical theory, in which art seems to evolve only as the corporeal reflections of some *Geist, Wollen,* or *istoria,* the structuralist perspective of Mukařovský was more temperate, more conservative, more thoughtful.[166]

Panofsky, while sensitive to many of the ramifications and implications of Cassirer's project, maintained a concern for the individual artwork as a temple of entelechy. And his Archimedean Lever, so to speak, eventually lifted the discourse only somewhat out of its routines of mystical cryptography.

Yet if Mukařovský might be seen today as having glimpsed the outlines of a more secure path out of the metaphysical form-content bind, he was unable, during the 1930s or 1940s, to move beyond a certain verbocentrist paradigm of the sign itself. Further on in the passage quoted above, he writes that

> the work of art bears the character of a sign. It can be identified neither with the individual state of consciousness of its creator nor with any such states in its perceiver, nor with the work as artifact [that is, not wholly with any of these three]. The work of art exists as an "aesthetic object" located in the consciousness of an entire community. The perceivable artifact is merely, by relation with this immaterial aesthetic object, its outward signifier; individual states of consciousness induced by the artifact represent the aesthetic object only in terms of what they all have in common.

For Mukařovský, every artwork was an autonomous sign composed of (1) an artifact functioning as perceivable signifier; (2) an aesthetic object registered in the consciousness of a community functioning as signification; and (3) a relationship to a thing signified—to the contextual sum of the social, philosophical, religious, political, and economic fabric of any given historical milieu.[167] From this perspective, the task of the art historian or theorist was the fullest possible accounting of this nexus of relationships within which any artwork necessarily stands and from which it derives its significance.

Like his research colleagues in the arts, letters, and philosophy at the Prague Circle (such as the linguist Roman Jakobson, who, along with a number of other colleagues, emigrated to the United States at the same time as Panofsky), Mukařovský was fully familiar with the work of the Swiss Saussure, the American Peirce, the German "sematologist" Karl Bühler, as well as with the tradition of Russian Formalism (brought to Prague by Jakobson). And like all his colleagues, he was vitally interested in problems of

meaning and representation in a wide variety of cultural fields—cinema, theater, literature, art, and architecture.[168] It was the perspective on the relationships between linguistics and poetics developed in the Prague Circle that is echoed in the statement of Ernst Gombrich in *Art and Illusion*: "Just as the study of poetry remains incomplete without an awareness of the language of prose, so, I believe, the study of art will be increasingly supplemented by inquiry into the linguistics of the visual image."[169] Mukařovský's writings on architecture during the 1930s, and in particular on the various levels of signification in buildings (which he termed "functional horizons"), provided the outlines of what was to become, in the writings of Jakobson twenty years later, the multifunctional paradigm of communication.[170]

That Panofsky was aware of the dilemma of the form-content paradigm is of course clear; yet in his search for an Archimedean Lever, he placed his enterprise within the pre-Lockean limitations of an iconology inspired by Cesare Ripa's 1593 *Iconologia* and within what Damisch has referred to as Ripa's logocentrist metaphysics of the sign.[171] Yet Mukařovský's work, situated in the Lockean tradition subsumed by the later work of Peirce, Taine, and Saussure, retains a logocentrist thrust in some ways complementary to that in Panofsky's paradigm.

The basic stumbling block to the elaboration of a thoroughgoing semiology of art was the problem of the sign. "The work of art," Mukařovský writes, "bears the character of a sign." His reference point, during the 1930s, could not *not* be the linguistic sign, and indeed in his essay he refers specifically to the enterprise of extending the results of linguistic research to other domains of sign usage, including art. In the passage quoted above, he is clearly extending Saussure's *langue-parole* distinction to art, with a sensitivity to a Peircean tripartite division of sign types.[172]

But Mukařovský is ambiguous about the status of art as an autonomous system of signs (vis-à-vis the entire range of artifactual systems in a society: Is there to be a "linguistics of the visual image," to use Gombrich's phrase, that helps define the "language of art"?). Moreover, he was ambivalent about the individual artwork itself, and his remarks oscillate between construing the object as a nexus of relationships with ties to the entire system of culture and seeing it as a medium or intermediary between creator and audience. Art objects, he notes, have the power to characterize and to represent the age: but more so than other cultural artifacts? Or do they do so with greater complexity and incisiveness? They constitute a reality perceivable by the senses whose function is to evoke another reality: They are external signifiers for which, in the collective consciousness, there are corresponding significations ("aesthetic objects").[173]

Mukařovský's sign is caught midway between several perspectives on semi-

osis (or the processes of signification) that derive from Saussurian linguistics and traditional art history. Ultimately, his "artwork as sign" is a metaphor from verbal language and from a perspective on language that remains essentially wed to a communicational metaphor: The art object is a medium or intermediary in a transitive transfer of information from artist (addresser) to beholder-addressee).[174]

Once again we are on familiar territory, where, as we have seen above, the function of analysis involves interpretation or explication of an artwork (whether signifier or not)—the reading of the object-as-text, an object whose mode of existence is "to mean."[175] Thus the art historical semiotician, if we follow Mukařovský, has as her task the process of making manifest the work's immanent sense. Pragmatically, then, the task is equivalent to that of the Panofskian iconographer, for whom the work of art, often seen as a sentence or emblematic proposition, is approached within the same discursive framework.[176]

There is yet another way in which Mukařovský's artwork-as-sign conflates with the traditional artwork: Both are interpreted as in one sense semiotically [or semantically] autonomous. The motivations for this autonomy, however, are distinct in an important sense. For Mukařovský, the individual art object has the autonomy of a lexical item in a sentence. This is a more relative autonomy than that of the Panofskian art object, in which the individual artwork is essentially irreducible, a "mysterious, individual whole," to echo Kleinbauer's definition. Even though, for Mukařovský, that "autonomous existence and essential dynamism" might be a dialectical product of the evolution of other domains of culture, it is approached, like an analysand, in a manner ultimately equivalent to the Panofskian artwork.

Panofsky's analytic framework is logocentrist in a slightly different way. In considering the art object as a "bundle" of distinctive features or motifs, the task of the analyst is to match such motifs or figurative patterns to a class of similar patterns over time and space. Yet what guarantees a secure matching (or conformity as members of the same iconographic class) is an identifying textual reference, which alone is the final determinant in ambiguous cases. As such, the class of motifs (say, Hercules with his club) comprises a sum of figural variations or interpretations of a (normally textual) source.[177]

Regarding the problem of basic units of meaning or semantic entities in artworks, Mukařovský is silent, apart from alluding to the sign-character of the artwork. Yet he does not clarify how this assertion is to be taken or exactly how it might serve as a basis for expansion. Are we to construe any individual art object as a semiotically complete entity or unit? As an analogue to a lexical unit such as a word in language, is the artwork then decomposable into

smaller phonemic entities? And do various systems of distinctive features underlie these?

Although it is evident how the linguistic analogy might be interestingly extended (indeed, there were some clues in Ripa's *Iconologia*, but Panofsky does not explore these in any substantial way),[178] Mukařovský does not take us much farther. I suspect that the stumbling block for Mukařovský was the fundamental problem of the relationship of art as a semiotic system to other systems of cultural artifacts. Gombrich astutely recognized the problem when, in the quotation above, he referred to the metaphoric paradigm of language. The analogy is simply this:

$$\text{poetry} : \text{prose} :: \text{art} : X$$

Thus, if poetic language constitutes a special instance of language in general (call this prose), then art could be construed as a special instance of—what? The entire artifactual system of a society at a given time or place? The comparison recalls Nelson Goodman's allusion to the *when* of art, and an answer could possibly be given within that framework. Just as poetry is prose language when certain conditions obtain—say, a certain use of language in a certain way or in certain perceptual or cognitive contexts—then it would seem a simple extension to see a visual art as a certain use of visual articulation in certain contexts.

The problem with realizing the program for a would-be semiotics of art is emblematized by Gombrich's own phrase: The complement to the prose of verbal language would be, in his words, "a linguistics of the *visual image*," which was, for Gombrich, a primary preoccupation in his research into visual illusion, caricature, and visual perception.[179] No small part of the problem is, of course, the nature of this visual image, and the entire issue has been confounded with other problems of representation in Western figural art. Bryson's critique of what he termed Gombrich's "perceptualism" in his recent *Vision and Painting* astutely identified the problem but did not suggest programmatic ways out of the morass.[180] We will return to this issue in chapter 5, but it is worth mentioning that the problem has been insightfully addressed by Joel Snyder in his recent critique of Panofsky's essay on "Perspective as Symbolic Form"—referred to by Holly as his most "proto-semiotic" work.[181]

The problems have always been more clearly delineated in architecture, and indeed there has been a rich tradition of semiotic research on that subject from the 1950s to the present. Some of the early research took its cue from Mukařovský's work in that area.[182] Indeed, Mukařovský's visual semiology was destined to expand and to continue in the areas of architectural history and theory rather than, immediately, in the study of *art mobilier*.[183]

Much of this now seems like ancient history. The present intellectual and critical climate, both in the humanities and within sectors of art history,[184] is so firmly and explicitly attentive to issues of signification and representation, under the encompassing term *theory*, that many of the old debates often seem to have little immediate relevance or import to present disciplinary concerns.

A specifically semiotic "method" has not arisen within the discipline to take the place of older semiological methodologies such as iconography or connoisseurship. To describe the history of art history in such terms would be to seriously misconstrue the actual complexity of that evolution. The situation today is more complex. The contrast between a semiotic art history and a nonsemiotic discipline is a false one. As the discussions in this chapter will have indicated, the discipline has from its foundations been a semiological enterprise in the full sense of the term. The more pertinent contrast has been between a eucharistic and a (post)modernist semiology.

Today, a wide variety of more self-consciously semiotic discourses have come into play among art historians in many areas, and with that sea change has come an increasingly altered *mentalité* that has allowed professionals to engage in broader dialogue within the humanities and social sciences on common and complementary problems of meaning, representation, and signification. The situation at present resonates in a curious way with the atmosphere of early Renaissance humanism, as evidenced by a proliferation of communication networks connecting once disparate spheres; in addition, there has been a burgeoning of provisional metalanguages in an attempt to come to grips with the complexities of a new world.[185]

For some, this decade-long situation has seemed like a crisis. For an increasing number of others, it has been an opportunity to reengage practice with the complex and often forgotten traditions of the discipline and to reopen dialogues fossilized since the war by the academic mechanisms of the disciplinary apparatus. The dialogues have been further frozen by that vast, constant, and convoluted labor both within and outside academia to condition whole generations to read a massive corpus of objects (almost every one of which was created in particular relationships to political, religious, social, and historical circumstances) through an optics that renders the latter as dim, invisible, or extraneous; as marginal and vulgar marks of the anti-aesthetic—those unfortunate but isolable aspects of some work's content that detract from their immanent aesthetic value—rather than as indispensible conditions of any object's possibility *as* aesthetic.[186]

The glimmerings in Mukařovský's writings of fifty years ago were glimpses of the possibility of understanding the latter. So too were Panofsky's writings: We need to reread his work from an anamorphic perspective, as it were, so as to highlight his own poignant glimpses of the paths we have subsequently

taken. If we question his writings as if they were oracular, they will only ever reflect the double binds of the questioner, as in Calvino's parable of the carpet in Eudoxia.[187] It is time to begin to read Panofsky in a manner that transcends the frameworks of his purported protosemioticisms. This would entail a rereading of his projects both with and against the grain not merely of Kant, Hegel, or Saussure but, most especially, of Nietzsche.

In that regard, we could take a cue (inadvertent though it might be) from Karl Jaspers:

> [Nietzsche's] contradictions show us what he is driving at. Existence both provides and is a product of exegesis. It is regarded as a circle that renews itself constantly while seeming to annul itself. It is now objectivity and now subjectivity; it appears first as substance and then as constantly annulled substance; though unquestionably there, it is constantly questioning and questionable; it is both being and not-being, the real and the apparent.[188]

Such a (re)reading of Panofsky's iconology—to grill him through the grid of Nietzsche, so to speak—could very well do him justice at last. Such a step remains to be taken.

Reckoning with the World

For much imaginary work was there;
Conceit deceitful, so compact, so kind
That for Achilles' image stood his spear,
Grip'd in an armed hand; himself behind,
Was left unseen, save to the eye of mind:
A hand, a foot, a face, a leg, a head,
Stood for the whole to be imagined.
—Shakespeare

1. Time out of Mind

The 1986 summer issue of *October*, arguably the most prominent journal of contemporary theory in art history in the United States, was devoted in part to the writings of André Leroi-Gourhan, one of the greatest of modern prehistorians, who died earlier that year.[1] Born in 1911, Leroi-Gourhan is credited by many as having revolutionized the study of Paleolithic cave art: He redefined the methodological enterprise of the prehistorian with the introduction of structuralist perspectives into the interpretation of the earliest forms of artistic practice. He served as director of the Musée de l'Homme in Paris in addition to his post as professor at the Collège de France from 1968 on. According to Annette Michelson, who translated two of his essays and wrote an opening encomium in the issue, Leroi-Gourhan's research, "while correcting a certain hermeneutical hubris characteristic of a preceding generation of scholars . . . offers a chastening model for art history of all periods, and for none more urgently than that of modern painting, in view of recent attempts to impose upon the corpus of painting a traditional and highly impertinent iconography."[2]

Michelson's title referred to Leroi-Gourhan's innovation in archaeological techniques during the early 1960s, when, in connection with the establishment of a model laboratory of archaeological research at Pincevent, near Fontainebleau, he rotated his "axis of inquiry" from the traditional vertical stratigraphy of the past to a more horizontal or "planographic" analysis of whole surfaces. Michelson observed that the minute and encyclopedic analy-

sis of complete layers or surfaces of habitation sites, accomplished by a painstaking cutting away of millimetric layers across a site, "facilitated the reading of a terrain in terms of its inner relationships" and "articulate[d] those inter-relationships which form the text of paleolithic culture." Leroi-Gourhan's "exact and concrete grounding of theory in praxis . . . rehearses for us that privileging of synchronic over diachronic in relational analysis of cultural texts which characterizes the structuralist enterprise." Michelson further noted that "the sense of rigor and illumination generated by these readings marks them as significant documents of the era which saw the adoption of the linguistic model as central to that analysis."[3]

The fragmentary and often haphazard nature of Paleolithic research did, in fact, yield to more comprehensive and systematic methodologies only a quarter of a century ago, and Leroi-Gourhan was indeed prominent in this movement. But the course of this transformation, and of the subsequent fate of Leroi-Gourhan's structuralist perspectives, is a very complex story—one that needs to be outlined in order to assess Michelson's assertion, somewhat remarkable at this late date, that Leroi-Gourhan's work "offers a chastening model for art history of all periods."[4] To rephrase the issue, is Leroi-Gourhan's perspective part of a solution for current art history or part of the problem of the discipline today?

Leroi-Gourhan's accomplishment can be succinctly stated. He elaborated a perspective that as early as 1958[5] overturned the prevailing interpretations of Paleolithic cave art dominated by the theories of his equally prominent predecessor in the field, the Abbé Breuil,[6] wherein animal imagery represented an art of sympathetic hunting magic.[7] As Margaret Conkey wrote in her lucid summary of the state of Paleolithic research, "The prevailing monolithic interpretation of the art as sympathetic hunting magic . . . was based on the assumption that the depictions (particularly those on cave walls) were random in placement. The chosen subject matter was, of course, presumed to have related directly to species or features (e.g., traps) important in the hunt and depictions were placed on 'sacred' locales."[8]

Leroi-Gourhan assumed that there was formalized planning in the selection and placement of subject matter in wall art and demonstrated this to some extent.[9] In short, he proposed (and in some cases his proposals remain generally accepted today) that the placement of visual images was not random —that each image was an element in what might be termed an iconographic program comprising a "text" spread over the surfaces of a cave gallery, much like the iconographic program of a medieval church.

His perspective shifted attention away from an "isolated masterpiece" approach (a projection backward of our own common attitudes toward individual canvas paintings) toward a more contextual approach. And bypassing a

strictly iconographic perspective, he elaborated a structuralist framework for his assumptions—namely, that the cave text was organized according to principles of binary oppositions among deeper-level valences. These principles concerned an opposition between male and female animals or figures (or pictographic symbols of gender, often accompanying images whose gender was not immediately apparent), as well as a multidimensional network of gendered animals positioned across the surfaces of a cave gallery.

From this perspective, an entire system of relationships could be read in the gallery text: oppositions in placement between male and female images wherein female animals were found to occur with greatest frequency in central or recessed portions of a cave wall, with male animals occupying peripheral positions relative to the latter—to the sides or on protruding portions of walls (and sometimes near the entrances of cave galleries).[10] Leroi-Gourhan's analyses rested on an intensive study of scores of individual caves together with statistical surveys of the occurrences of particular motifs.

One of the problems encountered by prehistorians studying this material had been that of relative dating of images, and, indeed, few reliable indications were apparent. The Abbé Breuil and others of his generation attempted to apply the techniques of art historical connoisseurship in distinguishing among different artistic hands in particular images. Coupled with such determinations were other indicators of stylistic development, so that works of much greater realism or more sophisticated modeling technique might be assumed to be later than sketchier or cruder images.

Nevertheless, none of these approaches yielded a body of conclusive results. The problems were complicated by the fact that in many caves numerous images were superimposed over previous ones. In addition, a great proportion of the imagery was apparently nonfigural—lines, meanders, seemingly random hatchings, outlines of latticelike forms that could be either huts or traps, and so on. Complicating the problems of interpretation was the question of the relationships between wall painting and *art mobilier*—the very large and diverse set of portable objects ranging from animal bones or tusks with occasional scratches to "palettes" engraved with images of animals to three-dimensional figurines (often of human females).

The effect of Leroi-Gourhan's proposals was rather like that of changing a television image from snowy and static-filled to clear and sharp: Suddenly, the entire field had a structure and shape, and the prehistorian had a key to unlocking the system of that structure. And like the discoveries of the phonemic regularities underlying the acoustic shapes of verbal languages, Leroi-Gourhan's new perspective seemed to make the muddled continuum of Paleolithic visual imagery snap into focus as an ordered set of relationships. The core insight here was the relational properties of the analysand—that it could

be analyzed into a stable network of relationships conforming to a series of elemental oppositions and contrasts: male versus female, centrality versus marginality, recession versus projection, and a whole series of oppositions among species of animals (such as bisons occurring where horses do not).

Needless to say, Leroi-Gourhan's theories met with strong opposition among many wedded to older interpretations of isolated images as symbolic indices of hunting or other forms of magic or primitive religion; the expression of collective psyche; records of hunting; or illustrated stories for the education of adolescent hunters. Yet he was not alone in his structuralist theories (as he himself records)[11]: As early as 1957, in a doctoral dissertation for the Sorbonne, Annette Laming-Emperaire vigorously challenged the traditional views and in her own research elaborated upon a similar structuralist position, outlined in her 1962 volume, *La Signification de l'art rupestre paléolithique.*[12]

There were, nonetheless, eventual challenges to Leroi-Gourhan's proposals as other researchers began to test his theories by applying similar methods to other materials or to materials Leroi-Gourhan had previously studied. Scholars disagreed with his interpretations of male and female valences attributed to certain animals, as well as their positions within parietal texts. In part, the challenges were based on the ambiguous gender markings of particular animals and on the sheer difficulty in simply reading many images. And on some points, Leroi-Gourhan's own views evolved as a result of these dialogues among prehistorians. The general subject was addressed at a 1972 international conference (known as the Santander Symposium) held in Spain; the proceedings reflect the variations in interpretation accorded both to Leroi-Gourhan's theses and to the materials under question.[13] In his most recent major book, *Dawn of Prehistoric Art*, Leroi-Gourhan de-emphasized the semantic content once attributed to apparent gender differences and topographic placements and stressed the study of the patterns themselves for what he termed their "mythogrammatic" properties for making and placing images.

At present, Leroi-Gourhan's (and Laming-Emperaire's) theses regarding the nonrandomness of parietal imagery seem secure and generally accepted in the field, and it is widely acknowledged that there is order and patterning in cave art.[14] The patterns appear to be regular and predictable in a general sense, although disagreements remain on the interpretation of particular subject matter. In addition, researchers have pointed out that the portable objects display an equivalent and consistent concern for formalized patterning, notably in a certain design congruence among figures of a given class (for example, the proportions of female figurines).[15]

Yet work during the past two decades has further revealed that artisans of the upper Paleolithic employed a variety of design principles in various

media, making it evident that although systematicity and patterning pervade the corpus of Paleolithic materials, there are no universally applied systems.

In one sense, this picture is predictable, given that the corpus of materials of the upper Paleolithic spans almost twenty thousand years and extends from southwestern Europe to the Russian steppes, with materials of similar date having been found in Africa and Australia as well. Moreover, the chronological horizons have been pushed back by more recent discoveries and reinterpretations of materials already known but not thoroughly studied. And unlike the bulk of parietal imagery, portable objects found in stratified contexts can be more securely dated, allowing for a more refined sense of developmental complexity and its relationship to other facets of social and cognitive organization. The diversity readable in this fuller record has permitted researchers to consider the differential trajectories of local and regional communities in a more concrete sense.

Currently, Leroi-Gourhan's work can be seen as spanning two eras. On one hand, in the 1960s and early 1970s it served to loosen the study of Paleolithic artwork from the art historicist binds that had offered few alternatives to the tradition of individual-image interpretation. By introducing a new slant on the study of parietal art, the understanding of Paleolithic art was set on a strikingly new course that seemed to overturn older vitalistic assumptions.[16] And yet, Leroi-Gourhan's accomplishments were circumscribed by a certain static or monolithic perspective common to some anthropological structuralism. In a way, Leroi-Gourhan's project reflected facets of Lévi-Strauss's work in its adoption and use of linguistic paradigms and in a tendency to focus on the synchronicity of the systems of patternings uncovered to the detriment of a vertical or diachronic dimension. In addition, parietal artwork (in contrast to portable artifacts) provided few easy clues as to historical variation. But it is unlikely that the social contexts that brought visual imagery into the human cultural repertoire could have persisted unchanged for twenty thousand years. Indeed, as more recent investigation has shown, this was not the case.

The parietal art of the upper Paleolithic, confined largely but not exclusively to southwestern Europe,[17] is but one component in a vast, highly complex, and diverse montage of cultural practices with inter- and infra-regional variations both spatially and temporally.[18] Moreover, there are few clues as to why parietal art was confined to certain areas and absent from other similar environments. The links between Leroi-Gourhan's structuralist approach and the approach of his predecessor Breuil are as strong as the differences, and the former's revolution now seems not quite so thoroughgoing as it did twenty years ago. The link involves a congruence between their assumptions. Both assume a continuous stylistic evolution grounded in a

single underlying cause: a meaning common to the twenty-thousand-year span of painting. They differ in the identification of what that single underlying cause or meaning was.

Breuil believed the parietal art of the upper Paleolithic to be the art of a society dependent upon hunting for its sustenance. The extraordinarily dynamic and vivid images of animals were read as manifestations of hunting magic or ritual—attempts to evoke the spirit of the potential or actual prey and to assert control over the animal's power. On the surface, Breuil's proposal had a simple elegance: When a hunting economy disappeared, so too did the magical art of the caves. Both are replaced by the agricultural revolutions opening the Neolithic or new stone age, circa 10,000 B.C. The evolution of parietal art, in Breuil's view, reflected assumptions common to his time about how art ought to evolve—from simple to complex, from monochrome outline to rich and complex polychromy.

Leroi-Gourhan's approach, while under the umbrella of an anthropological structuralism sensitive to the systematicity of patternings across synchronic contexts, ultimately rested on an equivalently singular semantics: the dynamism of sexual dualism. For Leroi-Gourhan, this was an art of sexuality, with the same underlying theme played out across many particular variations for twenty thousand years. He saw a homogeneity of formal patterning and semantic reference during the entire upper Paleolithic, and his four-stage chronology of stylistic evolution was ultimately a refinement of the two-stage simple-to-complex genealogical framework of Breuil.[19]

Leroi-Gourhan's perspective changed over time, and by 1972 (the time of the Santander Symposium) he had reassessed his earlier sexual model and replaced it with what he called a mythogrammatic perspective. In the new explanatory schema, the parietal art of the upper Paleolithic was the result of a set of spatiotemporal formulae (mythograms) representing a mythic order of the world. The texts of the Paleolithic caves repeated this representational symbolism of a mythic world order over and over again through countless individual variations, like stupas from Sanchi to Borobudur.

The congruence between Breuil and Leroi-Gourhan rests on an assumption of homogeneity in human social life during the upper Paleolithic, a homogeneity transcending specific climatic and environmental circumstances. Both scholars also assumed social and cultural equilibrium. In effect, then, Leroi-Gourhan perpetuated what Conkey recently termed a utopianist view of human society before the upheavals marking the agricultural revolutions,[20] characterized by stability, social harmony, universal consensus on values and institutional arrangements, and an almost leisured way of life. In the views of one recent writer, the peoples of the upper Paleolithic were the original affluent society.[21] As Conkey astutely points out, nearly all of the interpreta-

tions of "Why art?" at this time assume an equilibrium model of Paleolithic society.

In view of previous discussions, it may become evident that much of the discourse on Paleolithic art replicates the problematics of periodicization within the disciplines of art history and literary history.[22] Indeed, many of the chronological issues concerning Paleolithic art continue to be subsumed under questions of period style or stylistic development, and a perusal of the archaeological literature will reveal many of the same conundrums found closer to our own discipline. Not only is parietal art frequently treated as full-blown; it is also presented as a simple unilinear stylistic development with a common thematic—whether that be hunting magic, sexual dualism, or cosmological or mythogrammatic structuration.[23]

The situation recalls one discussed here in connection with the art of Vincent van Gogh; now, however, the Vasarian paradigm of the *auteur*, the-man-and/as-his-work, is expanded to encompass twenty thousand years.

2. Constru(ct)ing the Origins of Art

Why, indeed, in the face of increasing evidence to the contrary, does a picture of Paleolithic parietal art as reflective of a homogeneous, harmonious, almost utopic society prevail in the scholarly and popular literature? Why are variations and divergences in that one medium often glossed over and downplayed? And how is it that the Leroi-Gourhan revolution has seemed to reinstall, perhaps with greater persuasiveness, a uniformitarianism not very different from that of Breuil?

In one sense, given discussions in previous chapters, the answers may not be so mysterious. What is at stake in the literature of prehistory is the identity of *Homo sapiens sapiens* as fully distinct from earlier versions of ourselves. The parietal art of the upper Paleolithic is the measure and mark of that identity and distinctness and a key to understanding human origins.

Or is it? The evidence is indeed far from clear today. Several developments over the past quarter century have deeply altered our understanding of the place that the art of the upper Paleolithic may have had in human social and cognitive evolution. And a growing number of important discoveries have come to problematize many basic assumptions regarding the origins of aesthetic practice, including those of Leroi-Gourhan.

For one thing, it is now understood that remarkably advanced artifactual behaviors (speaking parochially from a modern historical perspective) long preceded the emergence of *Homo sapiens sapiens*. During the same years that Leroi-Gourhan was developing his structural analyses of parietal tableaux,

the French archaeologist Henri de Lumley was excavating a site called Terra Amata within what is now metropolitan Nice.[24] Terra Amata was a *Homo erectus* seasonal camp near the shore of the Mediterranean, with an approximate date of 300,000 B.C. The major artifact at Terra Amata was a building essentially identical in form to many found today in various parts of the world: an ovoid hut made of upright sticks apparently bent inward and possibly tied together overhead to form a roof.[25] Within were four large centrally aligned posts that likely supported a ridgepole running longitudinally, which in turn supported the inwardly inclining wall members. Between the two innermost upright posts was a hearth or firepit slightly below grade, bounded on the north side by a line of stones; the latter may have served as a windbreak for the fire or as a support for objects (such as skewers) used in cooking, or both.

The hut was rebuilt every year for twenty years along identical lines. De Lumley's painstakingly detailed excavation revealed that at the end of what was evidently an annual fishing season, the hut remains were covered over; a new hut was built over the remains the following year, the new hut floor superimposed over the remains of the old. The structure varied in size from year to year, within a range of 26 to 49 feet in length and 13 to 20 feet in width. The entrance in every case was through a gap in the wall on the western short end.

The artifactual evidence from within the hut is rather scanty: occasional sticks of red ochre, the remains of pebble and flake tools, and an imprint in the sand floor suggesting a rounded vessel, perhaps a wooden bowl or large shell. The hearth comprised a bed of small pebbles forming a circular surface, set slightly below the median level of the hut floor. The excavators also found several circular areas bounded roughly by chips and flakes, suggesting the debris of individual toolmakers: The clear space within the debris would appear to indicate where the toolmakers sat.

Judging from the size of the structures, the Terra Amata huts may have been the yearly camps of a small band or extended family whose cold-season dwellings may have been further inland in the nearby hilly terrain.

Aside from these traces and the general inferences that can be reasonably made about the inhabitants, little is known with certainty. Yet a good deal can be inferred about Terra Amata if one considers the nature and organization of the structures themselves.

For one thing, Terra Amata is no random aggregate of materials. It is a highly complex, regular, systematic object — systematic in the simple sense that it is composed of parts designed to interact in a fully integrated way, each serving differential functions: support, cohesion, bounding, separation. Each for, in other words, reflects and is modified by the presence of other forms.

The structure is bounded by a line of uprights of roughly identical size and configuration, dug into the sand and forming a continuous and regular ovoid. Moreover, a row of stones of varying size placed along the outer edge of this line of sticks provides an effective buttressing system to prevent the uprights from shifting outward in the sand.

The structure is a carefully organized and complex object. It is well suited to its situation, providing at the same time needed shade from the sun and, because of the draftiness of its construction, interior cooling and ventilation. In size, it is ample enough to allow for diverse activities—cooking, tool preparation (most likely simple harpoon spears and choppers), sleeping, and social congregation.

The construction is both an object and a mark—in short, a complex sign. Each year the Terra Amatans returned to precisely the same spot on the beach. The place may have been marked for the coming year's returning band by the remains of the previous hut, or, if the latter were totally covered over, by some indexical sign such as a pile of stones or sticks. It is not known why the group stopped coming here after twenty years, nor is it known where they camped before or after.

While enigmatic in a number of respects, Terra Amata nonetheless provides us with evidence of a cognitive or semiotic capacity seemingly remarkable when one considers its date—a quarter of a million years before the parietal and portable art of the upper Paleolithic. And in a sense, there is a certain conceptual resemblance between the structure and the imagery of the later caves. For example, both are built up of elements whose meaningfulness is a function of a total system. Just as the individual elements of an animal engraving or painting—lines, patches of colors, hatchings, and so on—might be of ambiguous significance until orchestrated in a system of relationships, whereupon they assume referential status as component parts of an image, so, too, do the parts of the Terra Amata building acquire referential status when orchestrated to compose an artifact that is at once an object and the mark of that object. A stick becomes an element of a wall; a pebble, arranged with other pebbles in an intentional relationship, becomes part of a hearth.

An object, or cluster of sensory signals, becomes a reference item in its own right. In order to become a referential item, it has to be cut loose from its original context. As von Glasersfeld writes in a recent study of verbal signing and toolmaking, "An analysis of toolmaking shows that it requires the operational capacity, in the active organism, to isolate recorded clusters of sensory signals and to detach them from the original cluster in order to set them up as reference-values of a new feedback loop that becomes embedded in an existing one. This detaching of recorded sensory coordinates constitutes the formation of a *representation*."[26]

Such representations would have to be cross-classified and made into components of hierarchically ordered systems serving in various ways as referential formations. A similar way of expressing this would be, as Davis has recently observed,[27] that the emergence of the man-made visual world —and in particular that part of it represented by upper Paleolithic figural imagery—is the result of a long practice of seeing marks as things: The features of representational image making can be logically derived from simple identities and similarities between marks and things and the chance perceptions of marks as things.[28]

Davis distinguishes between marks with semantic value and marks without such value, a distinction that would seem to correspond in one sense to what are termed sense-determinative and sense-discriminative features in linguistic systems—those features underlying phonemic units out of which morphemes and other semantically referential entities (such as words) are composed.[29] As is now understood, meaningful entities in speech are made up of bundles of relationally defined units serving a variety of specific functions. On a phonemic level, for example, the English phoneme p is construed as indirectly referential or semantic; its primary meaning lies in its differential function, as marking a difference between itself and other phonemes in the same language system (for example, b in English). The phonemic system of a given language serves to signal the fact that in that system there is a meaningful distinction between p and b because they serve to differentiate the semantic entities *pad* and *bad*. In effect, in the semiotic system comprising the English language, acoustic variations in p are not semantically significant (the way they are, say, in modern Hindi, in which the single English phoneme p is distinguished into several phonemes). In other words, an English speaker learning Hindi must learn to distinguish and to hear meaningful variations that in her own language are not semantically significant. Conversely, an English speaker groups together the p sound in *pad*, *pin*, *couple*, or *top*, despite the acoustic variations among these sounds.

Broadly speaking, the component parts of a representational image may serve a variety of systemic functions in building those qualities of the image we recognize as representational.[30] Consider that in the construction of an animal image—say, a Lascaux bison—the figure would be built up out of curved (out)lines (engraved or painted), fields of colored pigments, hatched lines suggestive of modeling and or shadow, and so on. In some cases, materially identical markings may serve quite distinct functions: Line X serves as the sign of an edge between the animal and the surround, while line Y serves as part of a series of diagonal lines marking the shadow on the underside of the torso. Both X and Y may be materially indistinct; yet each means something different, and the differences are defined by other qualities

of the imagistic system—say, relative position, orientation, or alignment. In short, the significance of an individual mark is a property of the entire system of marks in relationship [positionally] to one another. The representational image, then, is a system in the proper sense of the term—a network of relationships. It is the nature of that relational network that invests significance in what are discernible as component parts. Because line X is situated in a particular relationship to other lines (as well as to certain colors or modelings), it is immediately invested with referential value: It *is* (that is, it is the sign of) an edge.

Continually marking the world, notes Davis (following Wobst), increases the probability that marks will be seen as things: "If we abandon the idealist hypothesis that Mind just 'has' the ability to see things, potentially, as marks, as two-dimensional line-drawing 'abstractions' from the full-color experience of the three-dimensional object-world, then we can see clearly, I think, that adding perceptual ambiguity to the full-color experience of the three-dimensional object world will, predictably and eventually . . . result in the remarkable calibration of marks with things we call representational image-making."[31]

We may imagine that the florescence of parietal and other representational image making in the upper Paleolithic is grounded, logically, in similar calibrations of marks with things. But historically we have a long way to go in finding archaeological confirmation of this logically plausible scenario. Yet if we look back at Terra Amata, fully a quarter of a million years before Lascaux, it would seem that the systemic qualities of that artifact, made by our ancestral *Homo erectus* with approximately half our *sapiens sapiens* cranial capacity, are in no way fundamentally different from those we might see in the Lascaux bison. Indeed, as suggested above, we are dealing at Terra Amata with an artifact of equivalent cognitive complexity: similar systemic properties, similar degree of care in organization and articulation, similar complexity or functional diversity of component entities, and so forth. Both are made of marks that, in context, acquire significance as things. Both, it could be argued, are fully representational. Moreover, as noted above, the Terra Amata building is structurally identical to many in our contemporary world: As Leakey observed in a recent discussion, many peoples (such as the G/wi in Africa) build exactly the same way and for apparently similar functional reasons.[32]

It would seem, then, that the evolutionary scenario resulting in things we call representational image making was very long indeed and that such practices or habitual behaviors do not in themselves comprise a hallmark of *Homo sapiens sapiens*: If *Homo erectus* was doing what he did 300,000 years ago, he was articulating a visual environment according to principles grounded in

perceptual self-awareness (the ability to construe marks as things) of a sort equivalent if not identical to that evidently required to paint figural images of bisons and horses. What could this mean?

For one thing, the situation necessitates a change in perspective on the representational artwork of the upper Paleolithic and its position in our scenarios of the origins and evolution of art. The appearance of iconic imagery in the human line may not be a concomitant of the increased cranial (and presumably cognitive) capacities of *Homo sapiens sapiens.* Indeed, one might reasonably suppose that the appearance of representational art after 30,000 B.C. was brought about primarily by sociocultural changes in human communities in which such visual articulations acquired an additional significance and importance.

Of course, in one sense this supposition would be hard to demonstrate, for it rests upon the assumption that the reason we do not have such imagery much before 30,000 B.C. is because it did not exist. That circumstance may be purely an artifact of the archaeological record — the imagery having been destroyed, perhaps by being confined to perishable materials (rather than to cave walls sealed from the atmosphere for millenia) — or the artwork has simply not been found yet.

I think it unlikely that the lack of representational imagery before 30,000 B.C. is solely a function of the archaeological record. Yet, there are other imponderables and other problems, among them our assumptions regarding the artwork of the upper Paleolithic itself.

3. The Paleolithic Image: Narrativity and Textuality

The test of an image is not in its lifelikeness but in its efficacy within a context of action.
—*E. Gombrich*

During the same period in which Leroi-Gourhan and Laming-Emperaire were developing their structuralist analyses of parietal imagery (and in which de Lumley began his work at Terra Amata), Alexander Marshack began a study of the enigmatic markings found on many Paleolithic portable artifacts. His research over the past two decades has led to several important insights into the cognitive and functional aspects both of *l'art mobilier* and of *l'art pariétal*, which relate directly to the issues being discussed here.

As a result of exhaustive microscopic analyses of markings on portable objects in museums and private collections in several countries, Marshack

was able to demonstrate that, in many cases, series of markings on the same object—say, a piece of ivory or bone—had been made by several different flint points using different styles.[33] Moreover, there seemed to be multiple images of animals—suggesting that the portable objects had been engraved over and over again at different times.

Marshack was concerned with developing techniques and theoretical bases for an intensive internal analysis of imagery that would transcend interpretations based only on what the modern eye sees or on what more recent artwork might offer for analogic comparison.[34] He assumed that the means of production might yield more information about the purposes of the image than would a strictly formal or iconographic analysis or an analysis of apparent referential content. It seemed reasonable that a study of sequential steps in the making of an image or composition might yield clues to the cognitive and perceptual processes involved as well: "At a distance of 20,000 or more years simple visual examinations or 'recognitions' might be used in the construction of typologies of style, but for an understanding of semantics, one must try to determine the cognitive, conceptual *system within which an image functions* and those personal and cultural strategies and models that are involved in the making and use of images."[35]

Some of Marshack's work may seem rather familiar to the professional art historian concerned with distinguishing "hands" in the production of an image. Indeed, many of the techniques he employed—microscopy and a complex of photographic techniques involving infrared and ultraviolet light and spectroscopy—are shared by other art historians. But by and large, the context and purposes of these analyses are distinct: Marshack's concern was not with establishing individual stylistic provenance or with classifying ateliers according to formal criteria. Instead, he sought to reconstruct what might be termed the syntax or cognitive strategies involved in the making of images.

His research focused upon an aspect of Paleolithic imagery normally overlooked—namely that many images had been palimpsested over time, overlain with modifications and elaborations both figural and nonfigural, and, in short, reused in a variety of ways. Indeed, the images of much representational artwork are frequently not singular but multiple. Although this has long been recognized, the analysis of imagery has for the most part tended to ignore such complexities. Indeed, reproductions of many images often omit their overworkings.[36] To a certain extent, this tendency has reflected a modern bias toward the formal compositional coherence or integrity of the image: Within such a framework, the complications have seemed intrusive or extraneous.

Of course, not all Paleolithic imagery is so complicated; but enough of it is, in Marshack's perspective, to warrant treating figural complexities as more

than graffiti, doodling, or mere distractions to the analyst concerned with getting down to the true or original image. In 1971, Marshack extended his study of portable objects to parietal art, beginning with the important cave site of Pech Merle. Using ultraviolet and infrared photography on a complicated panel of horses with multiple superimpositions, he found that the images had been added to and renewed in a variety of ways over time. Often, these reworkings consisted of adding a new detail to an animal, for example another set of horns, or a new line or series of lines to parts of a torso.

In addition, he found that figures at Pech Merle were often painted with different colors, or different hues of the same color, at different times. Moreover, the same animal on a wall might have been successively repainted or reengraved, so that what appeared to be a single composition was in fact a highly complex assemblage of articulations—an evolving and dynamic system of interventions.

In a sense, then, many of these parietal figures were as much images of a process as they were of a particular animal. The perspective on Paleolithic imagery elaborated by Marshack in effect challenged one of the basic assumptions of Leroi-Gourhan regarding the coherence of the tableaux he had analyzed—namely, that these compositions were conceived and executed at one time. Marshack demonstrated that matters were not quite so clear and neat and that the actual complexities of the imagery had to be examined if the task of interpretation was to yield substantive answers to some basic questions.

Thus, by studying the detailed history of images and compositions, one might get a clearer idea of their meanings, functions, and roles in individual and collective life. Marshack accomplished an important change in analytic perspective wherein the act of marking surfaces became the primary focus. This displaced the question of signification from the individual boundaries of particular images to the performative or orchestrative context in which artworks are invested with meaning. In other words, individual images or image groups are seen as components in an ongoing, dynamic, multimodal performance or cultural activity. He explicitly suggested that

> it may not be the product (statement, gesture, or image) that "carries" the meaning, but the participatory act itself. No matter what the mode of production . . . they have no meaning outside of such contexts. Archaeologically, therefore, we are faced with a special problem. All we have for study are the products of cultural behavior that happen to have been made of imperishable materials and that have been accidentally retained in the soil or on a protected wall. Yet human symbolic activity occurs equally in all modes.[37]

Marshack's analyses permitted a way out of the ahistoricality of Leroi-Gourhan's paradigm on the one hand and allowed us to get beyond the art historicism and ethnocentrism of Breuil's generation on the other. During the first half of this century, the good Abbé Breuil had little choice but to approach Paleolithic imagery with traditional (at that time contemporary) analytic tools of connoisseurship and iconography and to view the parietal parade of animals as works of art.

In a way, Marshack's research opened up the synchronically biased structuralism of Leroi-Gourhan to a diachrony that went beyond the formalistic or stylistic typographies of Breuil. And he accomplished this by problematizing the notion of the autonomy of the image—a notion projected backward from our own modern history of Western painting. He expanded the structuralist concept of systematicity or structure to the temporal dimension, providing us with a more sensitive and supple discursive framework within which to address the problems of artistic evolution.

In effect, Marshack changed the nature of the question asked of the material,[38] deflecting attention away from the referential significance of images and compositions to the dynamic complexities of image construction and image construal. In other words, his findings foregrounded the situational context of usage and function and focused attention on the nature of the subject-object relationship. In short, this relationship became the object of study. To a certain extent, this new object of attention was an artifact of the kinds of materials he began working with—portable artifacts, such as pieces of bone, ivory, or stone, engraved with various markings, some of which suggested the existence of a kind of notational system or a system for reckoning or recording. At least initial examinations suggested this explanation because of a generic resemblance to more familiar systems of tallying and recording at many other places and times. In order to test out these assumptions, he developed a variety of microscopic analyses so as to distinguish between markings with recurrent patternings that might be largely decorative and those that might have been the long-term result of different tools or different hands but that conformed to a notational system with common morphological properties. By 1972, he had studied in detail more than one thousand objects.[39]

What he found was evidence to suggest that many patternings traditionally construed as decorative were more plausibly explained as cumulative tallies of some sort.[40] But unlike simple accumulations of identical markings, such as might be expected in tallies of a hunt, a number of the objects displayed marks arranged in patterned groupings, in which each mark—an incised groove, dot, or small curve—was evidently made by a different point, and, presumably, at a different time.

To Marshack, these phenomena, taken together, implied the presence of a notational system—an accounting of some sort. But what these incisions were an accounting of was unclear. Earlier scholars had suggested that some of the marked objects manifested an awareness of arithmetic; and some scholars (including Leroi-Gourhan) saw the evolutionary beginnings of the ruler, the musical staff, the calendar, or the peristyle of later temples.[41] Seeing these objects as possible evidence of what he termed "time-factored" thinking, Marshack examined them with the assumption that they might be calendrical in some way, for similar phenomena could be found in the ethnographic record or in the "calendar sticks" of various peoples.[42]

Although there are problems with some of the interpretations, Marshack made an impressive case for a number of the objects as indeed calendrical in function. (This theory appeared in many of his articles during the 1970s as well as in his *Roots of Civilization*, published in 1972.)[43] According to his analyses, some objects appear to have been lunar-month tallies in which the groupings and variations in marks index phases of the moon. His detailed arguments will not be followed here; for our purposes, Marshack's conclusions and some of their implications will suffice.[44]

It would appear that calendrical markings begin to occur early in the upper Paleolithic in the Franco-Cantabrian region, during the Aurignacian period, circa 30,000 B.C.[45] Moreover, the tradition appeared to have continued in various parts of the world throughout the upper Paleolithic into its latest phases (the Magdalenian) and into the Mesolithic period after circa 10,000 B.C.[46] Of interest here is the apparent fact that two classes of markings coexist—which I shall refer to as the iconic and indexical systems.

An example of the former is a small, ovoid-shaped plaque of bone, about five inches long, found in Aurignacian layers of the Abri Blanchard in the Dordogne region of France. The same layers of soil in which the plaque was found also held stone blocks with painted images of oxlike creatures, as well as engravings on other stones representing schematic vulvae.[47] The pattern on the plaque consisted of pocked markings arranged in a flattened spiral, each of which was made in a slightly different way. Of the sixty-nine marks, some resembled rounded circles, while others were variations on a C shape. Some twenty-four different points had been used in making the marks, and various changes of stroke were distinguishable (fig. 2).

Marshack's analysis of the markings indicated that the Abri Blanchard bone was a tally of phases of the moon over a series of months, for when the serpentine line of marks is followed from beginning (at the center) to end (at the outer edge), one can read successive images of the moon as it goes through full, half, and quarter phases in a rhythmic pattern of larger-to-

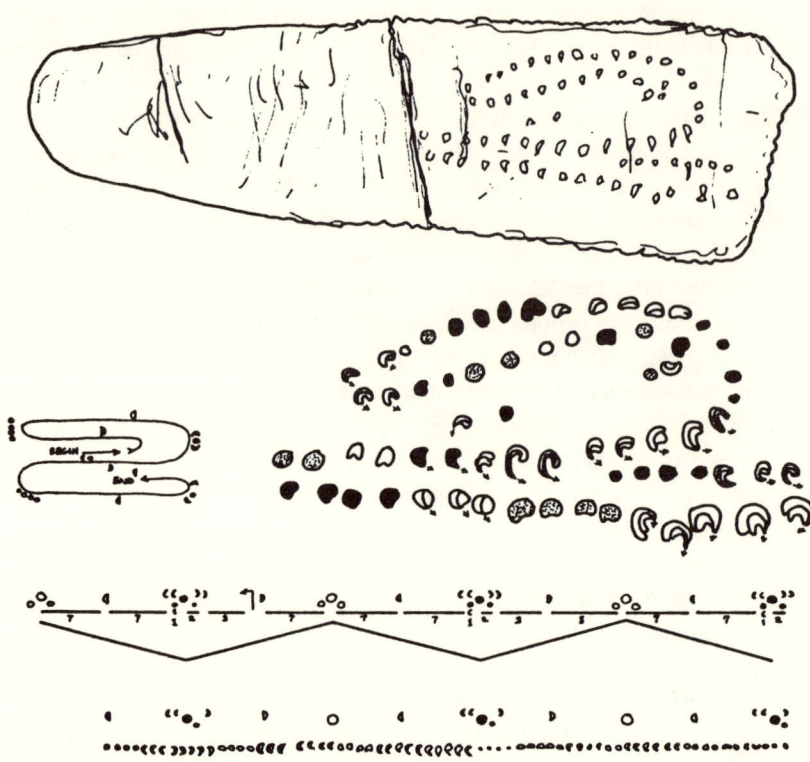

FIGURE 2. *Abri Blanchard Calendar Bone. Length of bone: 11 cm.*
(Adapted from Marshack, *The Roots of Civilization*, figs. 7, 9, and 10a.)

smaller-to-larger sizes. In short, the Abri Blanchard bone was a representational or iconic picture of the phases of the moon. Its marks bore a relationship of resemblance to their referents.

Marshack found and analyzed other calendrical objects of a noniconic type. One of the most spectacular was an engraved mammoth tusk found at the late upper Paleolithic hunting site of Gontzi in the Ukraine, the date of which corresponds to the Magdalenian of western Europe. A line running along the outer edge of the shaped tusk is bisected by small perpendicular incisions at regular intervals. Resembling a modern ruler at first glance, the sequence of marking variations corresponded, according to Marshack, to lunar phases: Each short perpendicular incision marked a day, with longer incisions marking what appeared to be occurrences of full or half moons. It appeared also that four lunar months were tallied, with slight differences in details among them (fig. 3).[48]

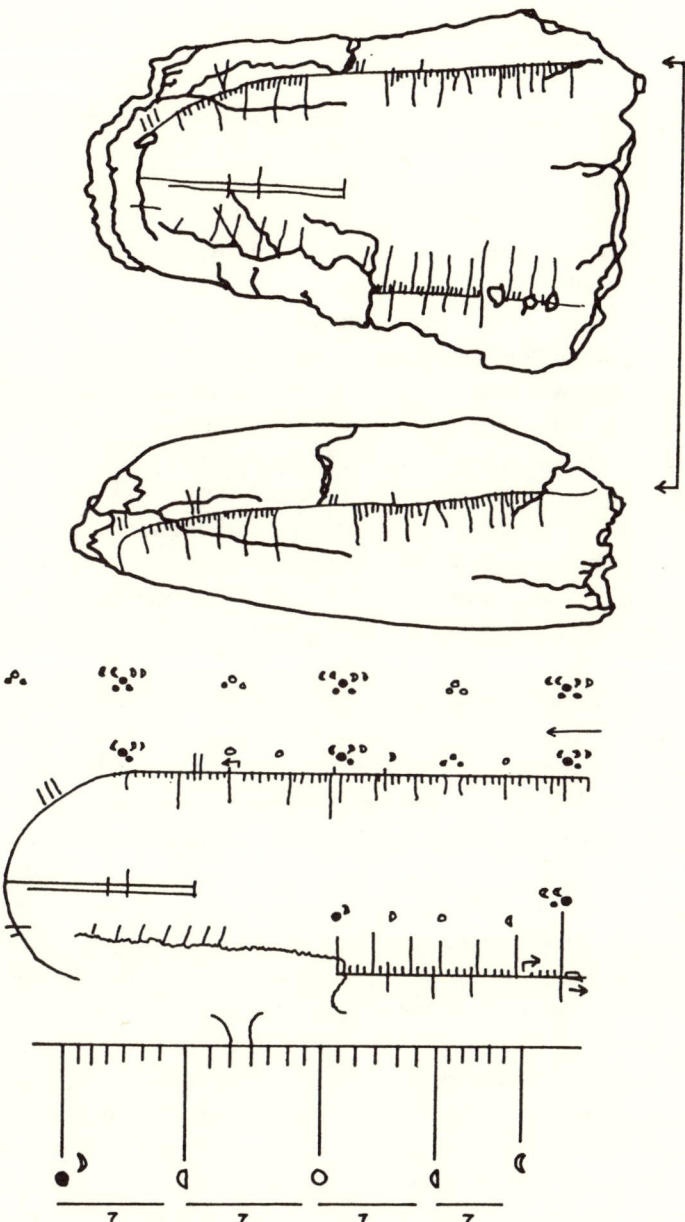

FIGURE 3. *Gontzi Tusk Calendar. Length of tusk: 15 cm.*
(Adapted from Marshack, *The Roots of Civilization*, figs. 5 and 6.)

The marking units on the Gontzi tusk are not images of the moon at different phases (as with the Abri Blanchard bone). Rather, this was apparently a system of indication in which differences among phases were marked by differences in line length. In other words, a set of equivalences is set up such that what must have been construed as significant phases of the moon during its waxing and waning is correlated with significant differences in marks. Some incisions ride above the common line, while others extend on both sides of that baseline.

In a sense, the Gontzi marking system is a somewhat more indirect image of seasonal variation. Each mark is an index of a significant change in another phenomenal system, just as the calibrations on a thermometer or barometer register differences in the quantity of heat or pressure. The latter, however, are somewhat more iconic than the Gontzi tusk, for in both the amount of heat or atmospheric pressure is related to the size of the registering medium—say, a column of mercury in a glass tube.

Although the Blanchard bone and the Gontzi tusk appear at the earlier and later limits of the upper Paleolithic, indexical calendrical systems also are found contemporaneously with the Blanchard bone (at La Ferrassie and Lartet) within the same cultural area.[49] So the differences between the two may not correspond to historical or evolutionary factors in a generic sense.

The two different systems recall a discussion in the previous section about distinctions between sense-determinative and sense-discriminative components of semiotic systems such as verbal language. In one sense, the Gontzi system seems like the phonemic system of language, marking difference pure and simple, in which the component elements are, so to speak, indirectly meaningful. And it might also seem that the Blanchard system is more sense-determinative or more directly meaningful, like the morphemic system of a language. There are similarities, but overall the systems are not identical.

If we consider the two objects on a scale of relative iconicity, the Blanchard bone might appear to be made up of more iconic marks (because they resemble their referents in appearance, however schematically) whereas the Gontzi tusk appears made up of more arbitrarily coded marks (because they do not resemble their referents in appearance). Yet in a sense, both objects are mixed, from this perspective: The serpentine trace of pictographs on the Blanchard bone is divided into a series of "turnings" that appear to correspond to turnings of the moon (as we might term them in English) in which the full moon begins to wane or vice versa. Such conventional patterning on the Blanchard bone is only minimally iconic, marking divisions that may be culturally symbolic. The waxing or waning of the moon, or the divisions among full, half, or quarter moons, are arbitrary phrasings, so to speak, within a continuum of change.

Conversely, on the Gontzi tusk, the overall time line rises in an arc on one edge of the tusk and descends down the other side. There are any number of ways in which the four-month (= single season?) tally could be splayed along the surface of the tusk, including, of course, a serpentine fashion as on the Blanchard bone. But the users might have construed this arc as iconic; in short, the tusk might be more directly significant within a sociocultural context.

It seems reasonable to assume that the concept of sequential, periodic time during the upper Paleolithic, as apparently represented in these and like objects, would be part and parcel of a whole series of cultural behaviors factored to seasonal variation—preparation and storage of food, the accumulation of resources for the future, calibrations of the appearance of different food sources in various parts of the inhabited landscape, as well as a wide variety of social and biological cycles in individual and communal life. If the assumption that these objects were calendrical is generically correct, then it is likely that the particular functions they may have served were multiple. Although we can imagine many scenarios for their use, the objects themselves do not signify specific functions.

If that is so, then we are dealing with artifacts of a highly complex symbolic nature, and the relationships between these objects and their sociocultural contexts will have been more than simply iconic or indexical. That is to say, their meanings will have gone beyond any simple relationships of resemblance or indexicality that we might devise abstractly or logically. In short, the meaning of the Gontzi tusk or the Blanchard bone is not simply lunar. The object, necessarily, is polysemous or multiply meaningful.[50]

And like the Terra Amata hut or the Lascaux bison, these "calendar bones" would have been more than mere objects of contemplation for those who could use them fully. As part of the tool kit of upper Paleolithic life (for some, and at some times, and in some places), they would have been instruments in the orchestration of cultural life and were objects of some art in their own right.

Both calendar bones are fully representational, employing variant means to figure fractions of a year. In both cases, marks are intended to be understood as signs (iconic or indexical) of things. Both objects function according to a similar underlying logic or syntax: In each, overlain upon a base diurnal rhythm, is an oscillating sequence of variations of a second rhythm. At Blanchard, each day is signaled by a slightly different lunar configuration; at Gontzi, by a uniform upright mark. And a rhythm of turnings of the moon is assimilated to the same marking system as variations upon the same mark (by length and by position relative to the basic horizontal line). Yet this referential function would have been but one function orchestrated by these instruments.

Marshack's research has significantly reoriented our ideas about the nature

of representation in the cognitive world of upper Paleolithic populations as well as about the nature of cognition itself among early humans. At the very least, a close reading of his work will sensitize us to the nature of the questions we ask about the period. At the same time, it can alert us to questions about art and representation in general and to the unexamined assumptions we bring to those questions.

We may not be able to reconstitute the full "context of action," to use Gombrich's phrase, that defines the "efficacy" of images; but if we attend to the marks and traces of that context in images themselves, we may be able to put aside much of the ideological baggage of essentialism and idealism so necessary on previous journeys toward the origins of artistic practice.[51]

Both Leroi-Gourhan and Marshack have taught us to attend closely to the nature of our analytic strategies and to the questions asked of our material. Leroi-Gourhan problematized previous assumptions concerning the autonomy of individual images by demonstrating a certain systematicity in the organization of thematic material in many Paleolithic cave paintings, ushering in an era of structuralist, synchronically oriented prehistoric archaeology. Marshack's research has not only problematized that autonomy further but has also disputed the synchronic frameworks of Leroi-Gourhan, alerting us to the dynamic complexities of subject-object relations. By demonstrating empirically that Paleolithic representations may not have been as fixed and stable as our own modern eyes might have led us to believe, he has alerted us to the spatiotemporal facets of aesthetic signification: Image construction and image construal overlap, interpenetrate, and afford opportunities for orchestrating meaning through use. Reading Leroi-Gourhan through Marshack makes it very clear that, for all the former's advance beyond traditional connoisseurship and iconography, he was still looking at Paleolithic imagery as a variant of modern Western painting: as if Lascaux or Altamira were the same kind of object as Giotto's Arena Chapel.[52]

The implications of Marshack's work went far beyond being another plea to consider the contexts of images and artifacts. Indeed, it was precisely the notion of context that was at stake: Once the semiotic autonomy of the image (or tableaux) is problematized, our notion of context itself changes. With that change comes a reorientation of our instrumentalist notions of the autonomy of subject and object, analyst and analysand, perception and interpretation. In short, the status of the object of study necessarily shifts. Marshack's work provided us with a palpable demonstration of that shift in status.

Leroi-Gourhan's work could be seen as an emblem of semiotic research in its structuralist phase; Marshack's could well be construed as emblematic of the poststructuralist critique of verbocentrist structuralism.[53]

4. Reckoning With Origins

Beginnings, observed Edward Said, are always assumed to provide us with ways of grasping the whole of a project or a history.[54] They occupy points in time or space the conception of which is invariably underlain by an emotional or imaginative quest for unity. Yet the moment we begin to speak of "the" beginning, knowledge becomes theologized, fixed, and useless.

If there are no Archimedean Levers outside of ourselves enabling us to lift up the history of art so as to expose, on its undersides, its nascent roots, seeds, or origins, whatever origins or beginnings we might have localized before the present seem to be slipping further away from us. We do not know, however, if that slippage is an optical illusion induced by the discursive apparatus of our historical questioning. The archaeological record shows that over a period of perhaps three million years, hominid populations were developing toward what we term culture by means of refinements in adaptational technology.[55]

Yet it remains a major problem that conceptual, cognitive, and symbolic Rubicons cannot be easily or securely identified. To be sure, the notion of an all-or-nothing cerebral Rubicon seems to have been largely and successfully put aside—that is, the notion that having reached a certain critical mass of cerebral capacity, what we term culture resulted from that nexus of enhanced abilities. Yet, as Geertz observes,[56] the greater part of human cortical expansion has followed rather than preceded cultural advances.

Part of the problem in dealing with these questions is the power of our unquestioned assumptions and metaphors. In some way, our picture of earlier humans has always been conflated with our observations of our own children—the notion that human ontogeny, or infant development, recapitulates or repeats the stages of human phylogeny or evolution.

Moreover, one of the principal assumptions accompanying the search for the origins of art has been that technological complexity is to be construed as a measure—indeed as an iconic sign of some sort—of cognitive or even biological advancement. In general, this may be true. Yet it is an assumption that in the long history of discourse about human origins has played a heavy, and one might even say a heavy-handed, role. It is a blunt instrument too often ill-suited to reading the fine and fragile details of evidence we might have of cognitive or cultural evolution in the Paleolithic record.

In our own modernist times, the notion of technological evolution is characteristically fused with the idea of human progress. Indeed, we can hardly think the one without the other, for they are bound up with some of our deepest images of ourselves and our world. And to no small degree, these ideas are applied to oppositions between morphological simplicity and com-

plexity. The implicit equation runs something like this: "Simplicity in form is to simplicity in cognitive capacity as complexity in form is to cognitive sophistication." While this may be true in certain circumstances, it is never *necessarily* true, and the seeming naturalness of the equation may be largely an artifact of an analytic apparatus attuned to an impoverished idea of art history as either a *vie des formes* or a *Geistesgeschichte*.

Certainly for the Abbé Breuil and his generation, the equation was an implicit rule of thumb in the establishment of chronological typologies for Paleolithic painting and art. He distinguished two broad periods of artistic evolution during the upper Paleolithic: an earlier style, characterized mainly by outline drawing, painting, or engraving, and a later stylistic period, culminating eventually in the full and dazzling polychromy of the great beasts inhabiting the famous caves of Lascaux or Altamira. Leroi-Gourhan's chronological sequence was essentially a further refinement of Breuil's.[57]

On the face of it, the equation was simple, elegant, and (in the absence of evidence to the contrary) self-evident. The problem is, however, that the equation does not hold true; the situation is rather more complex. For instance, this chronology was grounded in other assumptions concerning a certain cultural homogeneity throughout the upper Paleolithic and across recognizably varied cultural regions.[58] Moreover, less attention was given then than today to variabilities across and within media. There were few models for understanding the relationships of art to its sociocultural contexts apart from an implicit reflectionism,[59] itself based, as we have seen in the previous chapter, in innatist and essentialist theories of meaning.

Yet to a certain extent, Breuil's chronology seemed intuitively right—art should progress from simpler to more complex states over time, and the archaeological record could be made to read in that way. Despite occasional external support for Breuil's scenario of artistic evolution, however, the picture of unilinear evolution was an artifact of a homogeneous or monolithic bias concerning the nature of the upper Paleolithic as such. In short, the scenario may have been a kind of historicist, optical illusion, of the same sort that one might produce by collecting a hundred blades of grass in a meadow and by then aligning them on a table in morphologically related sequences showing an evolution from the short and squat to the slender and elegant. It is an illusion fostered largely by the panopticist mentality built into many disciplines, as we have seen above.

Mapping sequences of items from the formally simple to the formally complex onto (pre)historic time clearly ignores the obvious fact that in any cultural assemblage at any time simpler and more complex formations invariably coexist and that such distinctions do not in themselves necessarily index relative ages or, for that matter, relative differences in cognitive complexity.

The simple reason for this is that in any cultural assemblage the components are always elements in a system and derive their pertinence, significance, and even complexity from their uses, functions, and positions therein. Moreover, since any cultural assemblage is a dynamically relational system, signification is rarely fixed or static, but is constantly evolving and changing.

Part of the bias toward a fixity of signification in the analysis of aesthetic artifacts stems from powerful metaphors regarding the integrity of the artwork itself (the issue dealt with above at some length in chapter 2) wherein the work of art is invariably assimilated to notions of the coherence, integrity, and self-identity of the individual. The idea of art is always a displacement of the idea of the ideal human being. In the modern history of the West, that idea(l) is grounded powerfully in specific theologic assumptions.

Breuil and his generation may have viewed the assumptions regarding the beginnings and early florescence of human art as inexorably linked to a nexus of metaphors derived from an art history steeped in formalist idealisms. Certainly, the language of early prehistory points in that direction. In addition, the monolithic master theories of upper Paleolithic life, dominant up through Leroi-Gourhan, were in part a reflection of the importance of what was ultimately at stake: the question of the distinctness, integrity, and specialness of *Homo sapiens sapiens* in contrast to other hominids. It seemed right that, despite the apparent evidence of evolutionary biology, some special Rubicon, some clear leap, must be reserved for us.

We need hardly be surprised that creationist vipers lie coiled not far beneath the mantle of some of our more secular evolutionisms. It becomes apparent that the impulse toward telling tales of origins is at one with an impulse toward the establishment of transcendental signifieds—irreducible cores of features that serve as a *clavis universalis* to align and to genealogize all the variant aspects of the diachronic totality of human artifacts.[60] Such impulses appear nearly inseparable from their functions as ideological instruments, justifying received theological notions of some universal human essence that transcends, and thus erases, history. Such impulses have invariably required a diachronic Rubicon before which we must speak of proto- or prehuman (and therefore natural or animal) artifactualizations and after which we can safely and univocally speak of human art.

Interwoven with this nexus of attitudes is a semiological impulse specifying that because we have the capacity to see marks as things, it must be the case that things—indeed the world itself, including ourselves—are themselves *marks*: marks, of course, of an Intentionality prior to ourselves and the world; the world (as we have seen above) as Artifact or Mark of an absent Artificer.

Deep problems have arisen whenever we have attempted to project backward in time and space our own recent notions of art or of aesthetic behavior.

The farther away from our own historical and social circumstances we travel, the more our own sense of art seems to dissolve. In one sense, however, this evanescence is all to the good, if it is understood as an opportunity rather than as a barrier to understanding, and if it sensitizes us to the parochialisms of some of our original assumptions and definitions. Yet to be thrown back on the ironies of our own definitions requires that we either substantially revise those definitions or abandon the question impelling the search in the first place—namely, how and why, in the course of human evolution, did practices that we might term aesthetic begin?

While there are other alternatives, on the whole the discipline of art history in this century has chosen the latter course by bracketing the question,[61] periodically making some interesting and astute, although safe, observations and then tossing the ball back to archaeology and anthropology so as to get on with business as usual. This is a strong impulse; there is surely enough to attend to without getting entangled with imponderables. The art historian, it might seem, is on surer footing in wrestling with *Las Meninas* or even in trying to define the postmodern than in bothering about microscopic lines on Russian mammoth tusks or scratches and squiggles in the Pyrenees. The disciplinary memory theater is already straining its quarters without having to come to terms with material much more problematic than nonwestern art. Besides, what is the art historian supposed to do with Paleolithic art?

We have tended to assume that art is an all-or-nothing phenomenon. However deeply attractive that proposition has been in the history of art history, it may very well imply the wrong question. The problem is with the nature of the question and the projected range of expected answers. The deeper problem, of course, is whether our own modernist conceptions of art make much sense beyond our own spatiotemporal or sociocultural horizons. And the problem buried beyond that is whether we can expect any useful answers that are not dependent upon specific historical conditions. I think the answer to that must be largely in the negative, with some of the following important provisos.

A perusal of the anthropological literature of the past decade or so—at least that portion of it concerned with Paleolithic horizons—will reveal a notable shift away from a monolithic approach to the question of Paleolithic art. Especially important is a growing interest in the concept of style in the evolution of human culture and cognition and a tendency to treat this concept outside of its conventional idealist frameworks.[62] The definition of style offered a decade ago by Wobst signals this change in perspective; style is "that part of the formal variability in material culture which can be related to the participation of artifacts in the processes of information exchange."[63]

The notion of style here is related to the encoding and decoding strategies

prevalent in a social group, as Conkey also notes;[64] moreover, participation in a style enhances the predictability of a message, facilitates cultural integration, and standardizes the informational content borne by artifactual culture. Shapes and forms, whether natural or artificial, serve in part to codify experience.

Codifying experiences artifactually necessitates the establishment and maintenance of various boundaries, especially social ones. In this regard, the stylistic features of an artifact assemblage accomplish tasks similar to those of natural features of the topography—say, a river, lake, mountain, or forest. Stylistic features (such as a certain constancy, consistency, and predictability in shaping or marking topographical objects or made artifacts) may be important to the establishment and maintenance of territory as well as to the stabilization of protocols for social interrelationships.

Many archaeologists and ethnologists have employed the notion of style as an index of social boundaries, both within and between groups. As Conkey notes, however, it is frequently the case that the notion of style is employed in a rather passive, static, or reflective fashion, rather than in a dynamic way.[65] A more dynamic approach would focus upon style as more than index or ostensification, as rather an active, ongoing, subtle, and variable component in the social processes of boundary definition and maintenance.

On the face of it, the idea is attractive as a way of coming to grips with the evolutionary record of more common marking practices applied to portable and parietal surfaces. It resonates with a good deal that is known in the ethnographic record.[66] The idea would be potentially productive if it were linked to a nexus of sociocultural behaviors all serving to mark territory and to maintain a certain coherent self-identity. Conkey noted that

> one way to view culture is as a mode of organizing diversity to restrain potential chaos. This organization must be implicitly known by the participants in the cultural system. It is argued that hominids have not always organized diversity into bounded sets, and not always recognized and mediated the boundaries among such sets by symbolic behaviors and the creation of material culture. The hypothesis that hominids have not always organized diversity in this manner is supported in part by the lack of systematic differentiation among artifact assemblages during the many early millenia of tool-use. . . . Social distinctions create systematic differentiation in behavioral products, and vice-versa. . . . Entities that might otherwise become confounded are made discrete.[67]

The question arises, however, as to what in hominid evolution could have generated the need for doing so? We might presume that stylistic marking was required by changing circumstances in the life of certain populations, wherein a need for distinction from other groups might be conflated with a

need for strengthened alliances among group members (for example, cooperative ventures in food procurement).[68] In short, stylistic marking should have some survival advantages. But the question is whether such a development was cumulative or sudden.

Conkey argues that style could not have evolved cumulatively and that the transition from nonstylistic messages to stylistic ones must have been abrupt —after which stylistic evolution and diversification followed. Style, thus, is an all-or-nothing phenomenon. And as Wobst notes, once a bone or antler is treated stylistically and becomes the bearer of a stylistic message, it has lost its signaling innocence or neutrality.[69] In short, the making of a mark normally has the effect of causing other things to be seen as marks.

One of the background assumptions in these perspectives on cultural evolution is that after circa 70,000 B.C., according to some,[70] human evolution was characterized less by species diversity and more by cultural differentiations. The analogy behind this view is biological; that is, replacing the kinds of biological adaptations resulting in genetically differentiated characteristics possessing social significance (for example, differences in horns among mountain sheep)[71] is, in the human line, a form of stylistic or cultural differentiation, with similar adaptive advantages. Such a development involves a shift in the organization of adaptive behavior toward behavior dependent upon symbolization, as Geertz suggests.[72] Paleolithic art is thus one manifestation of the diversification of symbolic behavior systems evolving at that time.

The notion of style as both a passive and active component in the social processes of boundary formation and group solidarity does not, of course, exhaust the other functions of stylistic marking or formal patterning in visual articulations. And although we lack extensive information about other sites for stylization (such as more perishable media, including clothing), patterned articulations must surely have involved media other than bone, antler, and stone. We simply are unable to construct the full range of sociocultural practices. Phatic marking on portable objects or in parietal contexts might indeed have been necessary for the active maintenance of group solidarities and distinctions, but it surely would not have been sufficient on its own. For its requirements to be effectively met, phatic communication must have been multimodal, recurrent, and redundant across media as well as across sensory channels.

One could reasonably assume that this scenario for the evolution of stylistic practices is part of the picture. But it is by no means the whole story, as will become clear when we consider the broader contexts and functions of social communication.

If meaning can be said to inhere in anything, it resides in the total activity of communication and is a function of contextual circumstances. Style—in

Wobst's sense or more generally—is but a facet of a communicative act, and its usage in phaticism or territoriality is but one of its functions. Unless we envision Paleolithic individuals waving engraved antlers at each other in order to convey a message (recall *Gulliver's Travels*), we must assume that (a) stylized markings comprised one facet of communicational activity available to individuals, and (b) the same markings served a variety of communicational functions.

Any communicational system is intangible and never appears in its entirety but only in the incomplete individual performances that compose an available repertoire, indicating that any reasonable account of Paleolithic marking must be more holistic and context-sensitive. What makes any mark meaningful is not its individual qualities per se but the system of relationships activating that mark in the first place. In other words, the meaningfulness of any given mark is a function of a system of differences that define its relationships with other marks. In addition, marks may serve a variety of systemic functions—from the purely systemic to the fully semantic or referential. But what makes possible both of these functions is the place or situation of a mark relative to other marks. Some marks may work simply to build aggregates of articulations, and others, to signal referents more directly. A mark always marks difference.

If we attend to the semiological situation in its totalities, it may become evident that a variety of factors are copresent or coimplicative. Minimally, these would include a maker, a user (who may also be the maker), a message, a context or situation, a code within which marks operate according to some set of rules, as well as a certain mode of contact among maker and user.

Such a set of circumstances for any mark recalls Jakobson's diagrammatic paradigm of the speech event:[73]

$$\begin{array}{c} \text{context} \\ \text{message} \\ \text{addresser} \longrightarrow \text{addressee} \\ \text{contact} \\ \text{code} \end{array}$$

Within that perspective, the message does not and cannot supply all of the meaning of the interaction; a significant portion of what is communicated derives from the specific contextual situation, the code itself within which the individual articulation arises, and the means and circumstances of contact between maker and user or beholder.

Jakobson did not regard meaning as a stable, predetermined entity that is simply conveyed, like the contents of a delivery van, to a customer. Moreover, the six elements of the communication act are not necessarily in any perfect

balance: Any one (or several) may be dominant over any others. The nature of the resultant articulation is in a sense a function of degrees of dominance and subordination given any of these elements. For Jakobson, these elements were seen as specifying the following functional perspectives:[74]

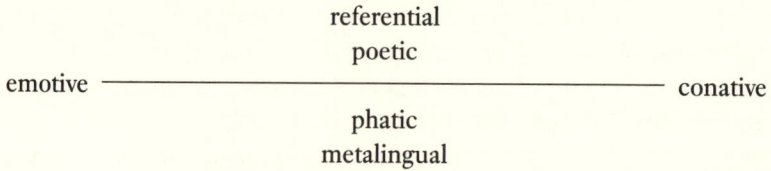

All of these are necessarily copresent as varying functions of a given articulation. Thus, in Jakobson's view, if the communication is oriented toward the context, then a referential function is dominant; if the communication is oriented toward the maker or speaker, then the emotive function of the message is foregrounded, and the speaker's perspective on, say, the referential content of the message becomes as prominent as the referential content itself. If I say, "Los Angeles is three thousand miles southwest of New York," the referential context would appear to be dominant; if I say, "Los Angeles is not all that far from New York," the presumption is that I am signaling not only some contextual circumstance but also my emotional perspective on the distance referred to.

In a similar fashion, if a supermarket checkout person says to me, "Thank you; have a good day," the message tends to be largely phatic in orientation, working to maintain contact (or to smoothly break contact), and to signal a certain solidarity in the harrowing circumstances of modern food foraging. The other functions are reasonably clear: Uttering "Did you say Newark or New York?" orients the message toward the code itself and serves a metalinguistic function, while saying "Why don't you . . . " focuses attention on the addressee, presumably for the conative or directive purpose of eliciting a direct response. In addition, according to Jakobson, an orientation upon the constitution of the utterance itself—wherein a foregrounding of the form of the message is as important as its content or reference—signals the poetic or aesthetic function. An extremely complex message such as "Good night; sleep tight; don't let the bed bugs bite" foregrounds both the poetic and the conative function within a framework of phaticism or boundary maintenance. (Consider, however, the unfortunate child who, hearing the phrase for the first time from her parent, may well construe the message as primarily referential—thereby experiencing even greater anxieties as to what might be lurking in the dark once the parent has departed.)

Although this astute paradigm may reasonably characterize semiotic activ-

ity in a general sense (or art or poetry in potentially any articulation, which was Jakobson's primary interest),[75] its pertinence must be a function of the sensitivity of the analyst to the myriad ways in which communication works. There are, however, several problems that should be noted.

First, the paradigm cannot be construed as fixed or stable. What constitutes phaticism or referentiality is necessarily always a function of highly complex cues that may or may not be inframodal (say, solely verbal) but may also (more likely) be multimodal: One might pronounce the sentence "Los Angeles is three thousand miles from New York" so as to highlight any of the other five functions in the paradigm. Moreover, with a wave of a hand or a flick of an eyebrow, one may signal one's emotional orientation upon the information just as effectively (or even more effectively) as inserting the lexical items "not all that far" into the sentence. In addition, the circumstances of utterance, the nature of the audience, or the intonation figuring the sentence may signal attitude, orientation on content, or work to prefabricate potential response. If the paradigm is to be productive, all such complications must be attended to—but not necessarily as complications, for it is precisely that richness and complexity that characterizes whatever we might consider normal or commonplace communication of all sorts.

Second, the question must be asked: For whom? Addresser or addressee? Necessarily, the perspectives on which function of a message is foregrounded will vary across individuals—as was the situation in the scenario of the child about to be traumatized at bedtime by the macabre humor of her caregiver. This situation is at the core of issues discussed above concerning the relationship of marks to things. It also alerts us to the fact that any signaling comprises, simultaneously, construction and construal for both maker and user of articulations. As Goethe once observed, even simple looking constitutes a theory.[76]

Third, the six functions in the Jakobsonian paradigm of communication must be thought of as relational in themselves. Phaticism should be understood as both maintaining and precluding contact. Conation may be simultaneously directive and nondirective. Emotion may be feigned, or emotive foregrounding may be a way of precluding insight into the speaker's emotional state. In short, in the actual complexities of any communicative situation, speakers commonly employ foregrounding ironically, using whatever means might be at hand, including the medium itself.

As for the poetic function, the implication is, of course, that poetry and prose (to employ a familiar opposition within our own cultural and historical horizons) do not exist per se; their nature is a function of the conventional roles given to particular patternings of language at given times and places as well as in varying circumstances within those contexts. Under different cir-

cumstances, those roles necessarily change: What is sauce for the goose may be mush to the gander, although things may differ on every second Tuesday. The aesthetic marking on upper Paleolithic antlers or cave walls may very well serve dominantly referential or phatic functions for their makers and their users.

Jakobson's paradigm may sensitize us to the potential complexities that must be taken into account in dealing with patterned markings employed by early hominids. At the very least, it might alert us to the reductionist character of monolithic or master theories of the use, function, or meanings of parietal and portable imagery in the upper Paleolithic period. Moreover, beyond attending to the fully relational character of communicative or signifying situations, we need to be sensitive to the fact that all semiotic activity is invariably multimodal and multifunctional.

Artistic activity may, at certain times and places, constitute an institution. But to consider art as a kind of thing distinct from other things in the sociocultural world may constitute an unwarranted reification and an impoverishment of our understanding of the roles played by visual practices in individual and collective life, both at present and in the past. To speak, then, of the origins or beginnings of art may be to mystify the problem of human evolution and sociocultural development. Such an origin cannot be found historically because, essentially, the "it" being sought does not exist as a thing: "It" constitutes one of the ways in which the resources of the material environment are employed in social life.

To integrate the study of Paleolithic material culture into the discourse of the discipline of art history would be to alter, in a number of fundamental ways, the shape and orientation of that discourse. It may not be far off the mark to suggest that, historically, the disciplinary resistance to substantive engagement with questions of origins (signaled by relegating accounts of origins to discursive marginality) has frequently been a measure of resistance to a deeper questioning of disciplinary investments.

If we look at the situation in this way, we have both changed our questions and redefined our tasks. At the same time, different problems arise in attempting to understand the altered relationships between subject and object, artist and beholder, analyst and analysand.

In addition, attention to the complexities potentially involved in any semiotic act may alert us to the ironic nature of codes themselves as well as to the shifting valences of what might appear iconic, indexical, or symbolic in one set of circumstances. In all of these cases, it makes more sense to consider such facets of signing as dynamically relative. To refer to a given articulation as an icon or an index may ignore the complex circumstances that define

iconic or indexical relationships between marks and things or among marks. The Blanchard and Gontzi calendars might have functioned iconically or indexically in terms of their referents, and yet it is more likely that iconism, indexicality, and symbolism are rarely pure and simple. There are, instead, differences in the perceived dominances of function for any given articulation or pattern of marks. Once again, it is necessary to be aware of the differential, systemic status of marking.

But any notion of system as applied to sociocultural practices must itself be simultaneously pertinent and ironic, for the notion of system is a logical (and often largely synchronic) abstraction and, as such, an artifact of a particular perspective on a slice through complexly evolving and dynamically interdependent practices. Artworks are not like broadcasting devices perpetually sending out the same signal or set of signals: The construal of meaning is dynamically constructive for both user and maker; it is a ceaseless production galvanized by objects in historically and socially specific circumstances.

To consider an object simply as a "text to be read" is as static and reductivist as a genealogy of markings or images (say, a history of art) can be fictive, and for complementary reasons. Both assume a fixity of signification somehow inhering in the object or text, and both require a certain hermeneutic or essentialist orientation on the part of the analyst or user, whose tasks become those of *e*vocation, *e*xplication, *inter*pretation, or *de*coding, as we have seen above.[77]

Rereading Leroi-Gourhan through Marshack may allow us to highlight some of these problems and to sensitize ourselves to some of the complexities of any communicative situation. This is not to say that Marshack's readings of upper Paleolithic markings or imagery are necessarily more correct. The point here has been that, whatever the actual referential associations of such artifacts, it is necessary to abandon the linguistic or logocentrist metaphors of reading objects as well as the entire chain of assumptions and orientations dependent upon that metaphor. The potential result may be a more productive attention to the actual complexities and complications of all forms of signifying practice, both past and present, including those dimensions characteristically understood as aesthetic. As we have seen throughout this study, the everyday language of disciplinary discourse has habitually reinforced specific notions of meaning and signification—as well as certain conceptions of the object of attention—and has worked thereby to naturalize various ideological constructs.

By implication, therefore, the artifactual environment cannot be a text in any ordinary sense of that term. For one thing, such a text would have to be understood as irreducibly plural, resisting characterization as a univocal sign or image. Moreover, reading a visual environment (or its components) more properly constitutes a writing: a performance or actualization on the part of

users. It is necessary to ironicize once and for all those theoretical orientations that have impoverished the study of visual signification by assimilating it to mechanistic and static models of speech as a stable and repeatable code, with its conjoined and fixed signifiers and signifieds and all that follows from that—presence, static identity, and the transcendental Subject.

In constru(ct)ing the visual environment, we work with a mass of elements that have been codified in the course of individual and collective history: But such codifications are invariably ironic and transitory, perpetually subject to transformation and deformation,[78] readable in terms of their materiality, by attention to relations, locations, processes, and differences. Moreover, such codifications are invariably contested grounds for the construction and construal of [social] sense: always oriented, never innocent; machineries for the social production of meaning in relation to other existing or potential productions; artifactual environments disciplining desire through the legitimation of socially specific realities. Within such an economy, our narrative capacities transform any given environment, any given present, into a fulfillment of a past from which we would wish to have descended.[79]

Any given visual environment, then, is less a *mise-en-scène* than a *mise-en-séquence*, an enabling device for the production, sustenance, replication, and setting into motion of multiple signifying practices in various media—the spatial, phonic, chromatic, and tactile. It is that device—which is to say that capacity for the orchestration of what in specific historical and social contexts become instruments—that has evolved, cross-modally, in the hominid line. Such an evolution has been extraordinarily long and complex, and, if Terra Amata is any indication, several versions of what we are now were working in those directions in various ways for a very long time indeed, with, undoubtedly, relative degrees of success.[80]

Thus, any visual environment has *topoi* so that thought may have *topics* with which to weave the tropisms of social life: We build in order to think and to act. The space and time of reading (that is, writing, scripting, using) a built environment involve an activity of repetition—remembering, repeating, and working through; of opening avenues through, and thereby inventing, the world as a text.

And as we have seen throughout this study, the individual subject is precisely that site where such textual activity is enacted and sustained:[81] In constituting objects, we enframe ourselves and others as subjects.

We have seen some of the ways in which the discipline of art history has simultaneously attended to and avoided the question of the origins of the analytic objects in its historical domain. Our discussion has highlighted a number of issues that also relate to the origins of language, and

we have noted certain similarities in the history of the two discourses.[82] In both areas, one of the central issues has been the question of human identity. And we have suggested that in the case of art history, the history projected backward has worked to legitimize basic assumptions regarding evolution and progress as well as contrasts between the primitive and the sophisticated, the simple and the complex.

The artwork of the upper Paleolithic has, since the discoveries of the nineteenth century, projected an image of a "time out of mind"—a time out of evolutionary synch according to the standards of the historicist canon of forms. Indeed, that artwork, in some of its extraordinary naturalism, posed a distinct and striking challenge to accepted scenarios of aesthetic evolution: How, indeed, could societies so technologically and materially impoverished or simple produce imagery so visually sophisticated by modern Western standards?

But in addition to ironicizing commonly accepted notions of aesthetic evolution, much about upper Paleolithic imagery and marking further ironicized modernist notions of the object itself. Recent studies of palimpsesting, multiple imagery, and the technologies of image construction have suggested that such artwork probably did not function in familiar ways, either in its construction or its construal.

Surely every period sees what it is prepared to see, and every historical narrative is a theory of the history we might wish to see fulfilled in our own contexts. Art history can claim no final knowledge of its object, no last word that is not subject to erasure or palimpsest, despite its operation in a discursive space carpented, historically, out of a lumberyard of last words.

The End(s) of Art History

*We have heard before of the end of the history of art: the end both of
art itself and of the scholarly study of art. Yet every time that
apparently inevitable end was lamented, things nevertheless carried
on, and usually in an entirely new direction. Art is produced today in
undiminished volume; the academic discipline, too, survives, although
with less vitality and more self-doubt than ever.*
 —H. Belting

*The problem here is essentially this: to which zone do we ascribe the
sign? to which side does painting belong—to the base? to the
superstructure? I do not believe an answer to the question of the
relation of art to power can be answered in this chicken-or-egg way.
. . . What we have to understand is that the act of recognition that
painting galvanizes is a production, rather than a perception, of
meaning. Viewing is an activity of transforming the material of the
painting into meanings, and that transformation is perpetual: nothing
can arrest it. . . . The viewer is an interpreter, and the point is that
since interpretation changes as the world changes, art history cannot
lay claim to final or absolute knowledge of its object.*
 —N. Bryson

1. Seeing through Art History

In this study, we have made provisional soundings in the archae-
ology of art history: test trenches through the tangled roots
below the surface of the modern discipline. A full excavation
must perforce be a collective and concerted enterprise, mounted dialectically
over time and through the many spaces of that history that are still invisible:
stories only hinted at by what has been exposed here.[1]

We have followed some of the lines of fracture visible on the surface, and
our soundings have made it plain that a history of art history along already
familiar lines—as a genealogical account of theoretical or methodological
schools or as a biographical account of the practices of prominent practi-

tioners—inadequately lays bare (indeed, often significantly masks) more fundamental issues, problems, and critical debates.[2]

The preceding chapters have served as probes into particular lines of fracture: the question of artistic signification or meaning; the integrity of the Subject and Object; the confabulation of proper distances between analyst and analysand; and the problem of origins. The probes have often intersected below the surface, giving hints as to the structural connections among guiding metaphors in art historical practice. We have seen how certain dominant metaphors in the discourse have determined attitudes toward issues: the problem of the limits and boundaries of the discipline; ideas concerning the roles and directions of disciplinary practice (who is served? toward what ends?); and assumptions regarding the roles and relationships among artist, critic, and historian (who speaks? to whom? under what conditions?). In addition, we have considered certain aspects of the nature of historical causality—an issue to which we will return shortly. These issues have been extensively and variously examined as they emerged and reemerged throughout the text.

An attempt to articulate a kind of stereoscopic attention to these issues has resulted in an oscillation between portrayals of the discipline as a singular body of knowledge and practice and as a heterotopic space of contradictory practices and theoretical positions. As we have tried to demonstrate, this oscillation is grounded in the ironic status of the discipline of art history as a form of institutionalized knowledge.

Indeed, modern art history could be said to have the status of an Ames Room or a Foucauldian heterotopia:[3] an illusory unity and coherence; an ideological matrix of projections from disparate sources onto a common screen. We have tried to read its history synchronically and its spaces diachronically. We have focused seriatim on the interior logic of the discipline constru(ct)ed as a body of knowledge and praxis and on a variety of guiding assumptions, tropes, and metaphors. And we have endeavored to articulate the simultaneous truth and falsity of the discipline's homogeneity and heterogeneity.

The place of art history was always multiple: The disciplinary practices lazily parceled out by the casual observer among various schools or methodologies turn out to be multiple and often contradictory. Each method is a spectrum of idealisms and materialisms. Prodded and questioned on certain key points—signification, the integrity of the Object and of the Subject —one can begin to discern deeper divisions and alignments. On balance, such divisions may be more important for our sense of the future prospects and possibilities of a history of art than the surface scenography on stage today.[4] The rhetorical battles between formalism and contextualism, between social history and connoisseurship, between modernist and poststructuralist

semiologies, owe their marching orders as much to the agonistic fragmentation naturalized by modern disciplinary knowledge as to substantive theoretical differences: As we have seen, the art historian is as much an artifact of the discipline as are its ostensible objects of study. Disciplines, as Foucault has poignantly reminded us, work above all to discipline desire. Our task here has been, in the final instance, to understand the history of the desires disciplined by art history. Clearly, we have only just begun.

It was noted in passing that the various schools of art historical practice could be seen as representing the staging of theoretical perspectives ranging from materialism to idealism. But this spectrum is not simple and straightforward in a historical sense. A case in point is the conflict between the secular semiology of Locke and the eucharistic semiologies of Port-Royal: The subsequent fate of the former is bound up with the latter, and both threads run through Taine, Saussure, and modern structuralism.[5] In seeing through the rhetorical and theoretical claims of particular art historical methodologies on stage today, and by attending more closely to the configurations of underlying complicity between apparently opposed modes of practice, we may be in a stronger position to articulate an archaeology of the discipline more useful to the current rethinking of art history than the Debrett's Peerages still dominating the market.

Such an archaeology would entail a close attention to the forms and protocols of practice and to the language and tropic scenography of art historians. This latter attention has guided the fabrication of the present study and explains why we have devoted space to seemingly minor or marginal questions: the topographical configuration of historical and critical study of artworks; the spaces of practice; and the manner whereby the historian-critic and archive are characteristically formatted together. There is still work to be done on many subjects—the history of lantern-slide projection, for example, or the history of the organization, housing, and protocols of access to documents, libraries, and visual or verbal archives. In this regard, the Fogg institution at Harvard is seen as prototypical of the question of formatting the discipline in a singular, designed space (at least for North America).[6] But other tasks remain, such as uncovering many of the arguments and justifications for the academic creation of art history as a university or institutionalized discipline; as a profession or science outside of the museum.[7]

Let us now take an oblique look back at our several probes into the corpus of the discipline: an anamorphic reading of our own arguments; a holding-up of our text to a raking light.

The following sections will serve as two such glances that may fulfill the rhetorically expected function of concluding our remarks. We shall first

consider the fact—implicit all along—that if the disciplinary panopticon is not singular or homogeneous, neither is it innocent or neutral. Beyond the palpable legitimization of certain idealist and even theologistic perspectives on artistic production and construal fabricated by the formatting of art historical knowledge, who benefits from the discipline of art history?

The third and final section will provide a glance at a historical example of (much of) what we have "meant" in this text. In so doing, we shall return to the rhetorical roots of the discipline itself: an emblem of the possibility of art history in the broadest sense.

2. Seeing through the Social History of Art

> *Everything, for Darwin no less than for Nietzsche, is just what it appears to be—but what things appear to be are data inscribed under the aspect of* mere contiguity in space *(all the facts gathered by naturalists all over the world)* and time *(the records of domestic breeders and the geological record). As the elements of a problem (or rather, of a puzzle . . .), the facts of natural history are conceived to exist in that mode of relationship which is presupposed in the operation of the linguistic trope of metonymy, which is the favored trope of all* modern *scientific discourse. . . . This metonymizing of the world, this preliminary encoding of the facts in terms of merely contiguous relationships, is necessary to the removal of metaphor and teleology from phenomena which every* modern *science seeks to effect.*
> —Hayden White

The disciplinary enterprise commonly appearing under the rubric of "the social history of art"[8] in the Anglo-American academic world has been one of the more ambitious of contemporary enterprises and, rather lamentably and ironically, among the most shortsighted and ahistorical. Compare the following observation:

> There is thus a general question which cannot be avoided, though the means of access to it must be particular: whether we can discover in the complex and specific material of a single artist's historical situation and experience the foundation of his unique subject matter and "style"[9];

with this remark:

> For the Marxist art historian this is the crucial point: the original meaning of a work of art is inseparable from the conditions under which it

was produced and first used. This original social context determines almost everything: the work's form, its subject matter, its first but not necessarily its only set of meanings[10];

or with this claim:

If we can qualify our techniques of investigation and pursue them with consistency, we won't need the abstraction of current "theories" in order to write a straightforward social and political history of art[11];

and with this lament:

For the most part, Marxist art historians have not had too much to say about the fundamental premises underlying their work.[12]

It might be proposed that the most fundamental concern of the discipline of art history, as well as the most common object of art historical study, is *the social production of meaning*, which may be saying both too little and too much. It constitutes too little in that this generic concern is common to a wide spectrum of humanistic and social-science study in the modern world: What, then, would comprise a specifically art historical inflection of this concern?

In another sense, the claim may be too strong, for such an object may merely constitute the distant horizon rather than the most immediate problematic of disciplinary practice: Indeed, there are those who might claim that such a concern is not the business of art historians at all and that it is better left to historians, sociologists, or anthropologists. For some, as we have seen, such issues are pragmatically external to the history of art.[13]

Social historians of art have taken pains to deconstruct the internal-external hierarchy of disciplinary concerns, with both stronger and weaker claims as to the role "social context" might play in conditioning the "subject matter and 'style'" or forms of an artist's work. Reviewing the first three statements, we might discern a certain difference in attitude toward the strength of the claim. The first, staged as a question of "whether we can discover" the traces of historical specificity and moment in artwork, would appear to contrast significantly with a Marxist perspective, which purports that "the original social context determines almost everything." Are we discerning here a contrast between a social-historical project of subtlety and historical sensitivity and another social history that, beneath the outward trappings of radical agendas, is simply an inflection of the idealisms of some bourgeois art history the latter seeks to oppose? Is this yet another lugubrious "dream of scientificity"?[14]

Over the past decade and a half, the self-proclaimed Marxist social history of art has had its waking hours haunted with these dreams: to wit, the third

quotation above.[15] In rhetorical opposition to a bourgeois art history—an art history of formalist sensibility, wherein the history of art seemed to have a life of its own, apart from some external social and historical conditions[16]— Marxist art history countered with designs for a science whose primary tenets seemed quite direct and coherent: If the historical facts were to be fully assembled in an orderly and lucid manner, then the transparency of social determinations would be established. By expanding the lenses of our historical eyes, the visible would become legible; what seems to have melted into air would once again become solid, condensed, and palpable.

Articulating such issues at this late date may seem strange but, indeed, appears to confirm the observation made by Hubert Damisch some time ago: namely, that Marxist theory had entered into art history only in its most reductivist and caricatured forms.[17] The project for a "Marxist art history" was mounted in response to the social movements and upheavals of the late 1960s and early 1970s and reflected a passionate desire by many academic art historians for a socially responsible form of disciplinary practice. It was also a reaction to a rediscovery of Marxist perspectives on art from the 1930s, forgotten or marginalized by the intellectual repressions accompanying the Cold War and McCarthyism.[18] The early writings of art historians working to elaborate a Marxist social history of art reveal a palpable nostalgia for the 1930s and for work begun but put aside with the onslaught of World War II.[19]

The projection of social-historical programs of work in the early 1970s was not, however, made in a disciplinary vacuum, and the discipline itself at that time, particularly in the United States, was in no way theoretically or methodologically monolithic. Apart from the partly conflicting enterprises of iconography and connoisseurship, that period also saw the emergence of feminist and structuralist perspectives on artwork[20] and the beginnings of postmodernism in the arts. From the beginning, social-historical perspectives on the discipline exhibited an ambition shared by these two other fields—that of realigning art historical scholarship to a superordinate set of protocols and to a set of practices that sought, in various ways, to revolutionize the discipline. Like nascent structuralism, the perspective of social history was generic and encyclopedic; it represented a diachronic science to counter ahistorical formalism or synchronic structuralism.[21]

The bourgeois art history set up in opposition to an emerging Marxist art history was mostly an ill-defined and simplistic bogeyman. But if its straw men were nebulous, its oppositional programmatics were similarly sketchy and hasty. The lament in the fourth quotation reflects a sad state of affairs: Marxist writing in art history did not match its rich tradition in other fields; there was no art historical Lefebvre or Macherey, no Eagleton or Williams.[22]

This state of affairs could be seen largely as a function of the nature of art historical education itself and of the constraints of specialist training and practice that all but precluded even the most basic literacy in history, philosophy, or critical thought in the other arts, notably literature.[23]

A case in point is a text considered by some Marxist art historians as a watershed in contemporary social-historical perspectives: Nicos Hadjinicolaou's *Art History and Class Struggle*. Published in Paris in 1973, it could well have been written in a monastery: Its omission of contemporary critical debates centering around the work of Foucault, Derrida, Lacan, and others is nothing short of astounding.[24] In reaching for paradigms of a science of art history along materialist lines, early Marxist writings in the discipline seem to have become immediately mired in a nostalgic nineteenth-century positivism. Sadly, energies motivated by passionately felt projections for a socially responsible discipline were spent on hammering together a charette without wheels.

Concurrent with Hadjinicolaou's work, two books by Timothy J. Clark were to have a more lasting rhetorical impact on the projected social history of art in the discipline: *The Image of the People* and *The Absolute Bourgeois*. In the first work, Clark devoted the opening chapter to outlining a social-historical agenda. Entitled "On the Social History of Art,"[25] the chapter became for many professionals and students (Marxists and others) a rallying point for the articulation of questions regarding the relationships between art and politics in specific historical contexts. In uncovering an "unimaginable time"—Paris of the mid-nineteenth century—when the connections between art and political life were open and on the surface of social consciousness, Clark delineated some of the specificities of history and moment that would provide a fuller understanding of the corpus of an artist:

> The encounter with history and its specific determinations is made by the artist himself. The social history of art sets out to discover the general nature of structures that he encounters willy-nilly; but it also wants to locate the specific conditions of one such meeting. How, in a particular case, a content of experience becomes a form, an event becomes an image, boredom becomes its representation, despair becomes spleen: these are the problems. . . . The making of a work of art is one historical process among other acts, events, and structures—it is a series of actions in but also on history. It may become intelligible only within the context of given and imposed structures of meaning; but in its turn it can alter and at times disrupt these structures.[26]

Clark's overriding contention in his two books was that the grand master narratives of the history of art, the great traditions, were not false in any simple sense; rather, they were but fragments of the story:

What we need, and what a study of any one period or problem in detail suggests, is a multiplicity of perspectives.

Just because [the social history of art] invites us to more contexts than usual—to a material denser than the great tradition—it may lead us far from the "work" itself. But the work itself may appear in curious, unexpected places; and . . . may never look the same again.[27]

The latter remarks can be seen as one founding motivation and intention of the work—to make it impossible to ever again see the work in the same way. And just as Courbet's *Burial at Ornans* could be thus transformed, so, too, would the discipline itself never be the same again, becoming forever inseparable from *history*. Social-historical research would accomplish, in effect, a dissolution of the internal-external hierarchy of art historical attention.[28]

Within the frameworks and protocols of the traditional discipline, this was taken by some as a provocative agenda and was quickly appreciated as such in the Anglo-American art historical world.[29] "If the social history of art has a specific field of study," he writes, "it is exactly this—the process of conversion and relation, which so much art history takes for granted. I want to discover what concrete transactions are hidden behind the mechanical image of 'reflection,' to know *how* 'background' becomes 'foreground;' *instead of analogy between form and content, to discover the network of real, complex relations between the two*" (italics mine).[30]

On the face of it, this was a laudable and apparently self-evident proposition: What could be more worthwhile than discovering "the network of real, complex relations" between form and content, between "foreground" and "background"? Yet Clark's vision of a social history of art was frequently met with a hostility of almost hysterical proportions, engendering attacks that continued for a long time.[31] But beneath the rhetorical landscape of the controversies surrounding Clark's work, there are important issues to be addressed if we are to understand the place of social history of art within or in opposition to the contemporary discipline. Here, as we shall see, there are problems that have not yet been effectively dealt with in the critical debates regarding "social" art history.

The most important of these issues relates to the sentence italicized in the preceding quotation. Here, it may be possible to read the central problematic pertaining to the potential of a social history of art as a factual history. The problem is succinctly characterized in an essay by historian Hayden White entitled "Fictions of Factual Representation."[32] White's essay, which appeared three years after Clark's works, addressed the possibilities of a discipline of history and the relationship of the modern discipline to critical debates in

the nineteenth century that gave rise to the methodologies and protocols of history writing as a systematic and scientific endeavor.

His quotation at the head of this section highlights the issues at stake and the problems faced by historical discourse. White calls attention to one of the principal characteristics of modern disciplinary discourse: It metonymizes the world and encodes facts in terms of contiguous relationships in space and time. "Considerations of *semblance* are tacitly retired in the employment of this trope, and so are considerations of *difference* and *contrast*," he writes. He shows how Darwin in his work justified the metonymic encodation of reality in order to "discharge the errors and confusion which a *merely* metaphorical profile of it has produced."[33] A palpable complementarity exists between the model of causality elaborated, in White's analysis, by Darwin, and that proposed, in quite another context, by Clark: "Instead of analogy between form and content," a network of relations of spatiotemporal contiguities must be substituted, the "specificities" of history and moment. These constitute the causal "background" within which the artwork, as historical act and event, emerges.

In this regard, Clark's project was thoroughly modernist, resonating with the paradigmatic assumptions of modern scientific discourse, over and against the premodernist theories of causality in the traditional discipline of art history: analogies between form and content; metaphorical relationships; webs of conversazioni among forms, themes, and techniques. Compared to the bricolage of the latter, a social history of art would be practiced by engineers or, in a Marxist view, scientists of the history of art.

We have seen enough of the "dreams of scientificity" in our probes into the modern discipline to recognize the stated underpinnings of this new social history of art: its complete compatibility with a wide variety of practices in art history.[34] Rather than being revolutionary, the program for the social history of art, as articulated by Clark in the early 1970s, enlarged traditional disciplinary programs rather than substantively altering them. The grand tradition is seen, in the final analysis, as incomplete and fragmented—not the full picture.

To extend or enlarge the analytic frame is not necessarily to alter perspective, even though the artwork might seem "forever changed" to our understanding. The problem, of course, as Derrida reminded us, was precisely the frame.[35] Was the social history of art really different from those practices it had sought to replace? Was its dream of objectivity substantially different from the questionable program of "putting oneself in the place of past agents, seeing things from their point of view," in Hayden White's words?[36]

The Marxist program for the social history of art can be seen as part of the

modernist project to distinguish history from fiction, and as a reaffirmation of the Aristotelian distinction between history and poetry, leading to an affirmation of the ironic fiction that the stories historians tell are simply found in the evidence. It constituted, in the words of Valesio, a "rhetoric of anti-rhetoric."[37] And the social history of art called for, in effect, a disciplining of the historical imagination, a setting of limits on what could be seen as constituting a historical event.[38]

In this regard, Clark's remarks might be seen as a counterclaim to statements that art history constitutes a special kind of discipline: Art history is always, everywhere, a subset of history, not a privileged domain in which the rules and determinations of the latter do not apply. The problem, however, is with the kind of history envisioned. As White observes:

> Since the constitution of historical studies as a discipline was carried out in the modern period in the service of political values and regimes that were in general antirevolutionary and conservative, the burden for establishing the feasibility and desirability of treating history as the object of a possible science falls upon those who would so treat it. This means that the politics of interpretation in modern historical studies turns upon the question of the political uses to which a knowledge thought to be specifically "historical" can or ought conceivably to be put.[39]

In proposing a fuller or more realistic reconstitution of the specificities of history and moment, the project for a social history of art came to involve a dilemma: a recommendation that history be viewed objectively and realistically by using the tools of a discourse fabricated out of a matrix of ideologies that a socially responsible art history must perforce oppose. And underlying this is a further problem: the fact that its picture of historical causality (Clark's relationship between background and foreground) is a discursive trope among others, the metonymization of the world as constituting a modern science.

This is hardly to deny the existence of factual specificities of history and moment; it points up, however, the problems to be faced when such data are spun into a causal, historical narrative, along with the irony that any such data are invariably in some sense *capta* of an already fabricated web of hypotheses as to their interrelationships. In short, the problem encountered by the social-historical program in art history was its unfailing literalism in reading the historical record. It is precisely the question of signification, and of assumptions regarding the conditions of artistic production and construal, that any adequate social history of art must address. Without a theory of meaning beyond a simplistic reflectionism inherited from the bourgeois

practices it would oppose, the program for a social history of art could remain, on balance, yet another perspective within the discipline rather than a blueprint of a discipline, or a reorientation on all facets of "the social production of meaning."[40]

Ironically, as our understandings of artworks have become denser, more complex, and more problematical because of disciplinary efforts to uncover the complexities of artistic creation, the discipline itself has remained framed in the same old ways. Has the social history of art, then, become yet another framed *veduta* in the art historical panopticon, yet another indifference to the complexities and contradictions of history?[41]

The question cannot be answered simply, for the social history of art was not merely a school among others, existing in some happy (or lamentable) pluralism of disciplinary methodology. It was, in all its multiplicity and plurality, not a school but a watershed: an interface between modernism and postmodernism composed of diverse tendencies, uneven growths, and conflicting agendas and analyses. Such diversity can be seen both between and within particular practitioners. Furthermore, the situation of the 1970s is very different from that of the late 1980s. More accurately, the current programs and problematics of the social history of art projected by writers in the mid-1970s have been subsumed under the rubric of contemporary critical theory, understanding the latter term to refer to the rich confluence of debates emerging within feminism, deconstruction, poststructuralist semiology, and psychoanalytic theory.[42]

There was, of course, a sensitivity by writers such as Clark to the inevitability of disciplinary co-option. The *Times Literary Supplement* of May 24, 1974, published an essay by Clark entitled "The Conditions of Artistic Creation."[43] The article included the following observations, which have been quoted verbatim in a number of other writings since that time:

> It ought to be clear by now that I'm not interested in the social history of art as part of a cheerful diversification of the subject, taking its place alongside of the other varieties—formalist, modernist, sub-Freudian, filmic, feminist, radical. For diversification read disintegration. And what we need is the opposite: concentration, the possibility of argument instead of this deadly co-existence, a means of access to the old debates. This is what the social history of art has to offer: *it is the place where the questions have to be asked*, but where they cannot be asked in the old way (italics mine).[44]

Yet thirteen years later, in a 1987 lecture at UCLA, Clark took the social history of art to task in its current state of disarray, asserting that it had in fact ceased to be "the place" where questions are being asked, having yielded

that place in the contemporary world to feminist theory.[45] Castigating what he termed "Neanderthal" Marxist art history for its deterministic, mechanistic, and theoretically naive analyses of complex historical events, he called for an engagement by social historians with contemporary critical and theoretical debates: "It's the feminists," he said, who are now asking "the *real* questions."[46]

In the quotation above, I have highlighted the last sentence, with its focus upon the term *place*, to bring up a telling parallel with Clark's comments of 1987. Spanning a decade and a half, the remarks could be seen as emblematic of a peculiarly panopticist mentality carpented into the discipline in its modernist origins: the desire to establish a privileged vantage point the positionality of which would render relationships transparent—in other words, to render the visible legible. As a poignant reminder of what is at stake in envisioning a discipline of art history, let us consider the following observations made in 1986 by John Tagg. In answering his own rhetorical question, "Should art historians know their place?" Tagg responds:

> NO: if it means declaring a position and raising a flag—to The New Art History or The Social History of Art, for example, as *the* privileged critique which will give rise to a coherent practice; if it means staking out a theoretical site, a place for miracles and healing, a place for pilgrimage, which will also be a place in the sun, a piece of the territory of the discipline for defense and possession. . . . [And again] NO: if it means repeating the claims of an Anglo-American social history of art which, almost 15 years ago, drawing strength from renewed theoretical debate on the left and in the women's movement, sought to rally the discipline around new unifying ambitions, rejecting diversifying debate as diversionary and claiming, in T. J. Clark's words, to be "the place where the questions have to be asked."[47]

It is necessary to recognize, as Tagg goes on to say in the following passage, that "this 'place where the questions have to be asked' was always inscribed within the institutional limits and power relations which cannot be reduced to methodological positions." Or, as we have seen elsewhere in this study, it was inscribed within the privileged positions of (instrumentalist) observation and mastery of the panoptic gaze and the anamorphic archive fabricated by art history as a modernist discipline: where, as Locke put it, things can "lie so orderly as to be found,"[48] with their meanings (trans)fixed and held in place.

We need not, however, construe Clark's substitution of social history in 1974 with feminist theory in 1987 as a simple perpetuation of the logocentrist fantasy that there is one place where the only significant questions can be asked. Such an *Ansatzpunkt*, as we have seen, would be coincident with

that of the patriarchal gaze that feminist research has sought to deconstruct. Feminist art history needs panopticons the way fish need bicycles (to paraphrase a saying current not long ago). One could hear Clark's words as primarily a lament for the current disarray of certain facets of social history, in particular the reductivist forms of Marxist art history in which issues of gender construction and gender relations had been marginalized.[49]

We can discern with increasing clarity (that of hindsight, of course) that the social history of art was a highly diverse and internally conflicted enterprise, ranging from critical-historical studies fully engaged with contemporary critical issues to designs for a Marxisant art history deeply complicit with the idealisms of bourgeois practice. What emerged, sadly, was often like that cramped and ultimately reactionary version of Marxism of the 1930s whose practitioners were sorely taxed by artwork that swerved too much from the norms of social realism:[50] a form of *feng-shui* geomancy, itself a product of disciplinary historicism.

In the final analysis (one says that with some irony), any useful forms of opposition to the excesses of late capitalism are not compatible with historicism. As we have sought to demonstrate throughout this volume, if it is patent that any form of intellection or artistic activity is a mode of political activity, then the pertinent problem might be this: Could a socially responsible art history demonstrate and articulate, in its finest details, what cultural domination is about (a) without relegitimizing historicist narrative knowledge and (b) without merely erecting alternate schemes of transcendence?[51]

Surely the fate of such a discipline rests upon facing such questions directly and upon rereading its history not simply oppositionally, as an armchair straw man, but rather anamorphically, ironically, and nonreductively, as, of course, even Marx himself well understood.

3. Seeing beyond the Panopticon

Metaphor circulates in the city; it conveys us like its inhabitants, along all sorts of passages, with intersections, red lights, one-way streets, crossroads or crossings, patrolled zones and speed limits. We are in a certain way — metaphorically of course, and as concerns the mode of habitation — the content and tenor of the vehicle: passengers, comprehended and displaced by metaphor.
—*J. Derrida*

Let us end, then, not by tying together the loose threads of the two previous sections but by superimposing them. Let us call that montage

an emblem of where we have been in this text. And let us site that emblem of the possibility and impossibility of art history where it belongs historically: on the Athenian akropolis. We end with a story winding us back full circle.

Looking back in our text, we recall the following. Visual environments orchestrate signification, deploy and stage relations of power, and construct and embody ideologies through the establishment of frameworks of legibility.[52] Such frameworks incorporate and fabricate cues as to how they are to be reckoned with by individual subjects and groups.

In all its marks, traces, and images, we do not, however, simply read that world. Rather, we *reckon* with it. This term may be more apt because of its double meaning: to think with and to cope with. Two of the most characteristic modes of reckoning with the visual environment are the anaphoric and the anamorphic.[53] By the anaphoric, a given portion of a built environment (a mark, form, image, or object) is apprehended as significant by its connectivity to or contrasts with other portions of that environment. Such relationships may involve contiguity (metonymy), similarity (metaphor), or some combination of the two. A given formation may thus be said to index adjacent or absent others by contiguity or semblance. What constitutes semblance is necessarily a function of given historical, social, or cultural conditions.[54]

The second and complementary device, anamorphism, involves the establishment of legibilities from particular and often surprisingly oblique perspectives.[55] As with anaphora, it operates within specific existing codes of formation. Any articulated intervention into a given visual environment induces altered relationships among such elements, causing them to be re-narrativized or reread: to be seen differently. What results is a picture of a visual environment as a dynamically unfolding, fluid, rhetorical stage, filled with revelations and occlusions, lucidities and undecidabilities. All tableaux are momentary and transitory; any genius loci is migratory, always subject to critique. Meaning is continually subject to displacement and deferral, and subjects are always subject to such displacements and migratory fixities: subjectivity, like objecthood, is a fictitious fact; a dialectical and ideological negotiation, a provisional homestead. And every city is thereby a hall of mirrors, an envelope of theses for a Subject.

The Periclean building program for the Athenian akropolis, begun in the middle of the fifth century B.C.,[56] engendered and worked to sustain a matrix of complementary and interrelated narratives: an ideology of the polis and its relationships to the individual. It operated as a prism through which the contradictions of Athenian social and political life might be resolved into an imaginary[57] homogeneity. As we shall see, it was a theory of the city, a *theatron* for seeing the city and its history, a machine for the manufacture of a history (fig. 4).

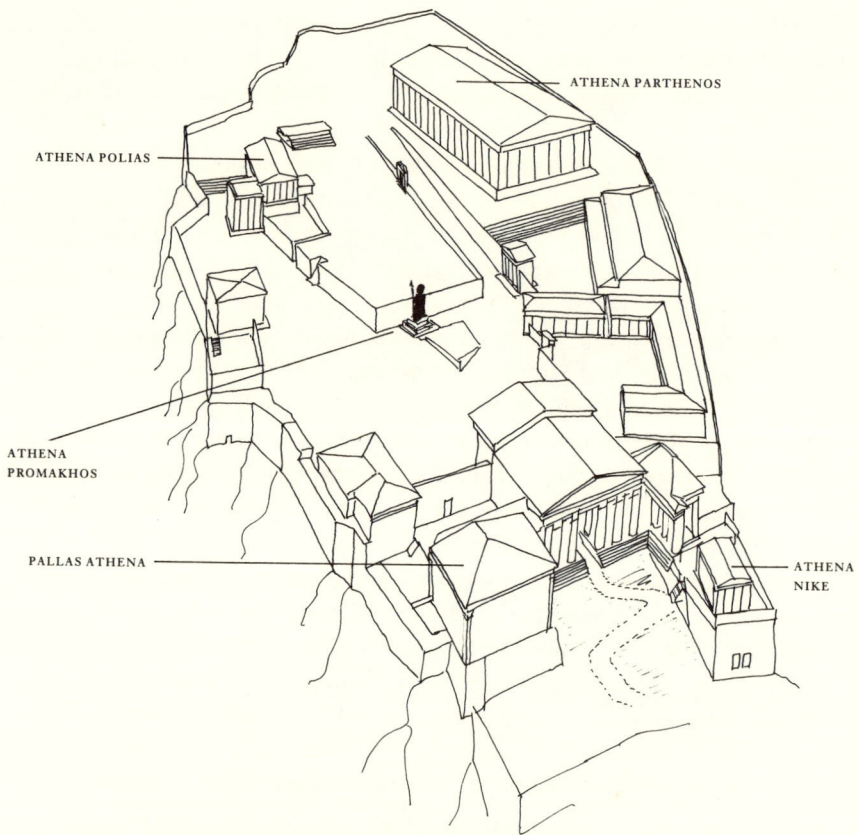

ATHENA PARTHENOS

ATHENA POLIAS

ATHENA
PROMAKHOS

PALLAS ATHENA

ATHENA
NIKE

FIGURE 4. *Athens: Akropolis Reconstruction.*
(Adapted from G. P. Stevens, *Hesperia* 15 [1946], fig. 1.)

One of the principal functions of cities has been the staging of relations of power through the orchestration and manipulation of desire. In this sense, every city is a utopic fiction (or a conglomerate of fictions), working simultaneously to reveal and to mask social contradictions and individual differences. In my intended use of the term here, power operates through everyone in pervasive, though discontinuous, gridworks, out of which knowledge and desire are manufactured. Accordingly, visual environments establish concerted distributions of bodies, boundaries, surfaces, visibilities and occlusions, both over space and time and in arrangements whose internal mechanisms produce and sustain the relationships in which individuals are caught up.

A city's geometric, topological, and temporal economies purport to operate as grids of certainties within historically specific codes of visibility or legibility. This order is spatiotemporal: Cities act as devices to track, stabilize, control, and predict behavior over space and time, thereby marking, demar-

cating, and defining what shall constitute appropriate behavior. Such an order is composed of webs of anaphoric relationships, both metonymically and metaphorically. And this wickerwork order weaves together larger shaped unities: One of the principal strategies of the city as an apparatus for generating and sustaining power relations is that when viewed from the right distance and proper perspective (that is, anamorphically), a profound visibility—a *legibility*—emerges. Indeed, it might be suggested that the visual environment is for the fabrication of the world as legible; it is a set of templates for constru(ct)ing the social self.

As we understand more fully the nature of the images of cities that subjects come to form,[58] we see that one of the primary functions of cities is precisely to engender and replicate images of themselves, thereby providing the means whereby life worlds and their perspectival imagery—which is perforce to say their ideologies—must be reckoned with. In this regard, the history of the visual environment can be understood as the ongoing, dynamic, and frequently contradictory generation of imaginary textual systems—of ideologies. And the individual Subject is precisely the *site* where ideology is actively enacted and maintained (or critiqued).

It is thus misleadingly simplistic to speak of visual environments and their components as literally representing some absent, ineffable, or immaterial content, and equally inappropriate to speak of reading that environment or its elements (even when they purport to be static tableaux to be scanned). What is galvanized is a production: a reckoning-with.[59]

Anaphora and anamorphism are social technologies, achieving their power and poignancy through the orchestration of tensions between ambiguity or disorder and clarity or canonically construable order. There is no legibility outside of historically specific codes of formations, and all such codes are carpented out of ideologically prefabricated materials. It is necessary to stress here that such prefabrication involves the replication of metaphors whose metaphoricity has been forgotten: In that *aporia* lies the possibility of re-reading and thereby the potential for change and critique; this is always a rhetorical economy.[60]

Both anaphora and anamorphism refer to relationships established and postulated among objects and images. They are dependent upon understanding perceptual or cognitive systems as working actively to resolve ambiguity and to order apparent disorder. Without rehearsing a very large and complex subject here,[61] such an observation can be taken as reasonably pertinent, with two important provisos. First, whatever might constitute perceptual disambiguity or order in an artifactual environment is always dependent upon social, cultural, and historical conditions. Second, balanced with this is (again, a historically conditioned and specific) need for stimulation (or

non-fatigue), which can be accomplished through the construction or construal of contrasts between order and ambiguity.

All this is by way of saying that no perception is innocent or neutral but is always invested in the [re]cognition of a "real" that individuals might be socially prepared to accept as such. This means, of course, that the perceptual facet of intellection is necessarily politically invested.[62] We do not perceive objects; instead we see meaningful or meaningless objects, what objects afford or preclude.

The Periclean akropolis was designed to function as a perfectly canonical religious sanctuary, despite some of its architectonic oddities. These include the unusual size and proportions of the temple dedicated to the *parthenos* aspect of Athena,[63] the bizarre shape and internal organization of that temple of arcana known as the Erechtheion, which also included space for commemoration of the *polias* aspect of Athena,[64] and the large, grandly built, and oddly shaped gatehouse on the western end, the Propylaia.[65]

Athena was deployed on the akropolis in several interrelated transmutations—as *parthenos* (virgin), *polias* (city emblem-protectress), *promakhos* (warrior), and *nikē* (victory).[66] We are presented, then, with various manifestations of a goddess whose name echoes that of the city itself: emblems of various [re]presentations which the *polis* purports to make of itself. In this regard, Athena is multiply present: in a sculptured image in the Parthenon, at an altar in the Erechtheion, in the guise of a colossal statue in the forecourt of the akropolis to the east of the Propylaia, and in an image[67] in the Nike temple. In addition, she appears as a victory figure[68] on the frieze and balustrade of the latter and on the pedimental and frieze sculpture of the Parthenon.[69] She is thus omnipresent in a variety of perspectives: as anamorphic images of the polis itself. Yet no one image stages the totality of her identity and powers, and we see her refracted through the prism of the akropolis.[70]

Within this prism that disperses the aspects of Athena throughout the sanctuary, individuals (re)cognize her as facets of their own civic roles. Rather than synthesizing all these roles and visions in a single sumptuary image, like some Ephesian Artemis, the akropolis *refracts* Athena (and Athens) into her socially and culturally meaningful personae. She becomes a pantheon in her own right, a metaphor of the city, and the akropolis multiplies Athena across a web of synecdoches.

This is an extremely clever and subtle fiction. And yet it is at odds with our usual understanding of classicism in art and architecture.[71] This may be apprehended precisely at the point of transition from outside to inside: at the Propylaia. In order to understand this contradiction, we need to look more closely at the building as it reflects the codes of artistic practice begun

during the fifth century. Half a millennium later, following the rhetoric of Roman art criticism, we have come to refer to this code as the classical style in art and architecture.[72]

Classicism is a large and complex subject, and we shall use the term specifically in connection with one of the essential principles of Greek and Roman criticism. This is the notion of *summētria*, from which our term *symmetry* derives. The modern term refers primarily to a geometric order or formal balance among component parts in any visual object or composition. In antiquity, however, *summētria* meant a commensurability among parts of some whole—a relational property among elements of a figural or architectonic composition, articulated, commonly, by means of a set of integrated ratios or proportions.

And yet the term appears to have had wider connotations, beyond that of an abstract correlation of measures or modules. Its referential field is metaphoric, evoking the perception of relationships among elements in a composition that could be construed as complementary to or equivalent to the relationships among parts of organic bodies—in particular, the human body. In other words, artifacts that we might term classical, and that a fifth-century Greek might have seen as embodying *summētria*, would be those composed and articulated within an organic metaphor—an organicism in which natural objects or the human body provided, by analogy, the principles of composition and construction. "Man is the measure" of all things, and conversely all well-made objects should embody the proportions, harmonies, and symmetries to be found (read) in organic bodies and forms.

In that sense, the temple dedicated to Athena *parthenos* could be seen as composed within a grammar of *summētria* not only with respect to its internal proportional details,[73] but also because its overall three-dimensional mass has approximately the same palpable proportions as the akropolis rock on whose highest point it stands. *Summētria* thus provided a series of protocols for the legibility of the artifactual environment: a certain coherent visual or architectonic logic whereby made forms could be read and understood. One might call this a grammar of sense.[74]

Let us look at the Propylaia in this context. Taken as a whole, the structure is not bilaterally symmetrical, particularly on its western front. The southern wing, in plan, is somewhat truncated (fig. 5): There is no southern chamber to echo that known in antiquity as the *pinakotheka*, or picture gallery. The commonly accepted explanation for this truncation is the existence of a piece of the old Mycenaean fortification wall on the south that, for reasons not fully understood, could not be taken down to make way for Mnesikles's supposedly full plan.[75] The southeastern angle of the southern portico is built directly against that old enceinte.

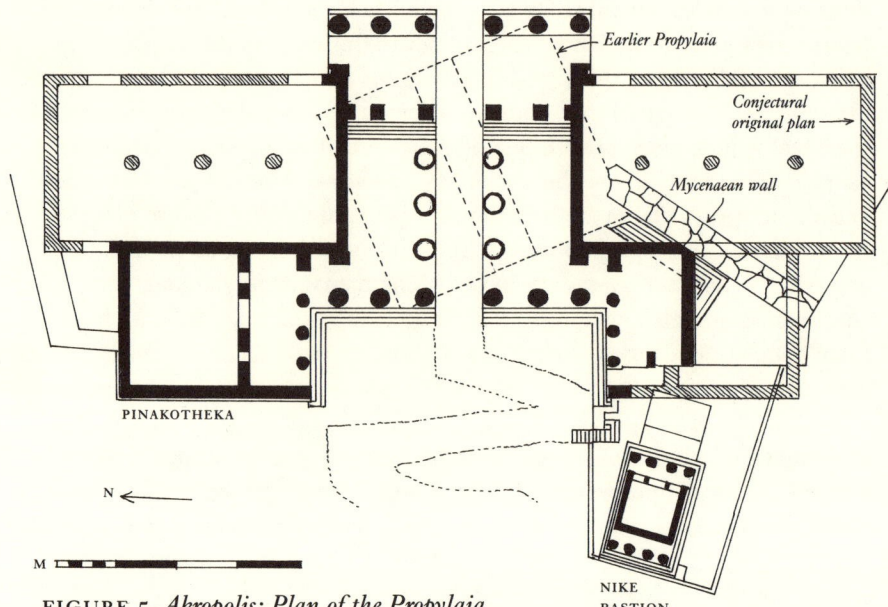

FIGURE 5. *Akropolis: Plan of the Propylaia.*
(Adapted from Travlos, *Pictorial Dictionary of Ancient Athens*, fig. 614.)

A good deal of controversy remains as to the original intentions of the builders, and various reconstructions of possible objectives have been mounted over the years.[76] We will not be concerned with these here. Suffice it to note that whatever distortion in plans might have occurred (if any at all), the west front of the Propylaia appears palpably balanced and symmetrical in its frontal elevation along the U-shaped arms of the outer colonnade. As actually constructed, the components project an impression of mirror-image symmetry to one ascending toward the central east-west passageway onto the akropolis platform.

All of this is preparatory and, to some extent, secondary to the following problem. One feature of the building abruptly and radically departs from the expected canons of classicism: the oddly skewed placement of the door and flanking windows of the northern chamber, or the *pinakotheka*.[77] The door is not centered on its wall, and the two flanking windows are not evenly apportioned within the space. Moreover, these openings are not centered on the intercolumniar spaces of the fronting portico when viewed head-on.[78] This situation contrasts with that of the east frontage of the temple known as the Erechtheion when viewed from an equivalent position, outside its prostyle portico;[79] and it contrasts with similar practice throughout the history of Greek building. There is no such bilateral symmetry here with respect to the

principles of *summētria*, nor do there appear to be any structural or material reasons why these elements are placed in this skewed position.[80]

But if one examines the plan carefully, there is indeed a point—and only one point—from which the door and flanking windows appear in their expected or canonical positions. This is precisely at the point where the arrowed lines converge in figure 6: that is, on the ascent to the western front of the Propylaia. Only at this point are the three elements fully and precisely framed by the columns of the portico in front of the *pinakotheka*.[81] And this point of resolution is coterminous with a position exactly on axis with the central passageway beginning on the western side of the main body of the Propylaia. In this regard, the south wall of the *pinakotheka* is in an anamorphic relationship to its viewers: Its components lock into a classically canonical position only when viewed from this skewed or oblique perspective—the perspective of one entering at the center of the embracing arms of the Propylaia's portico, on axis with the building's central and widest intercolumniation on the west.

But what is to be seen at this point, aside from a locking into place of an expected facade? Is this anything more than a visual pun—like so many "Aha!" points in recent postmodernist architecture? Is this building, at the supreme moment of classicism, yet another instance of postmodernist play *avant la lettre?*

If we consider this anamorphic perspective more carefully, however, we see that two additional visual phenomena occur at precisely this point. It is here that the entrant, ascending the steep slope toward the Propylaia, would evidently first see the head of the colossal statue of the *promakhos* Athena, standing to the east of that building.[82] She would be seen framed by the central passageway of the Propylaia, rendering that intercolumnial space a tableau or picture. In antiquity, the visibility of the *promakhos* statue had great significance. Its colossal size and brilliant material served as a landmark to sailors far out on the Saronic Gulf: Athena, with the sunlight flashing off her upright spear and shield, was the first glimpse of home.[83] To one entering the akropolis, this emblem of civic vigilance and military power first appears as a framed picture in an otherwise unfigured facade.

Thus, at this anamorphic point two striking things happen: The asymmetries of the picture gallery are resolved into a canonical symmetry, and Athena appears as the central framed picture of the facade of the Propylaia. At the same time, a third image is revealed, this time directly to the west, behind the entrant: the first clear view of the island of Salamis over the low hills to the west of the akropolis rock. This island was the site of the naval victory by the Greeks over the Persians in 480 B.C.—a battle that marked a decisive turning

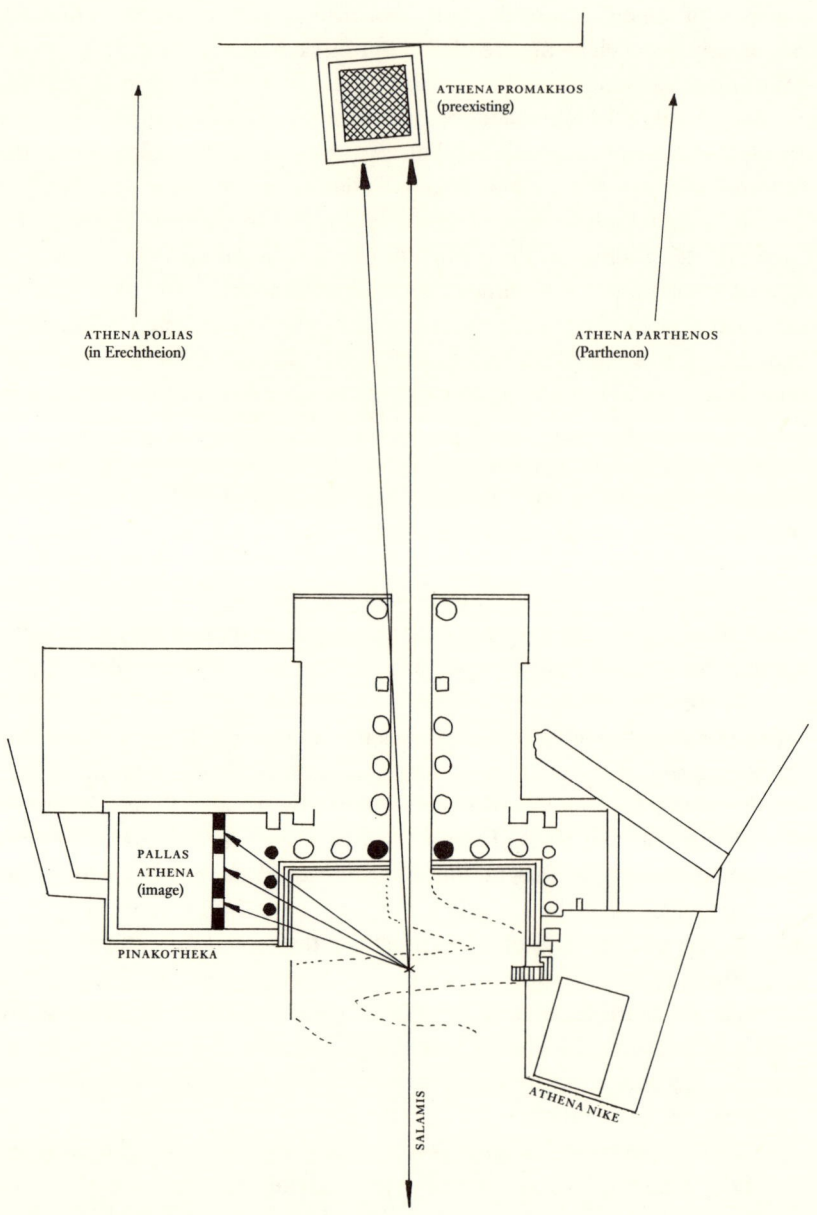

FIGURE 6. *Propylaia: Anamorphic Resolutions.*
Drawing by author.

point in the defense of the mainland, precipitating the withdrawal of the Persian imperial forces. A strong link has been created between the roles of Athena and Athens in that victory.

This connection is more than a one-dimensional statement by a city pointing with civic pride to its role in turning back the tides of Persian imperialism on behalf of Greece. It is legible as a political statement regarding the relative roles of Athens and of Sparta in that war as well as an emblem of contemporary Athenian hegemony amongst its allies and client city-states.[84] In short, it was a carefully orchestrated ambiguous tableau with variant political, historical, and ideological connotations. Is it Athens or Athena making the historical claim as to the cause of the victory? Does one pay tribute to Athenian cleverness or that of Athena? To have said Athens would, it seems safe to assume, have been politically provocative in the deteriorating climate of the time. The Peloponnesian Wars, that great struggle between Athens and Sparta for political and territorial hegemony over Greece, began the year after the completion of the Propylaia. We do not know the extent to which the tableau fabricated here should be factored into our understanding of the immediate causes of that war; most likely, for anyone (or any Spartan) attentive to this fabrication, reading Athens rather than Athena here would be just one more manifestation of Athenian hubris, one more demonstration that the Athenian *dēmokratia* was, in fact, an imperium.[85] And the Propylaia would have been one more reminder of the ways in which the Athenian state had reappropriated the taxes on its client-states for self-embellishment, rather than spending the money on a common defensive shield for the allies against possible later Persian intervention.[86]

What does all this have to do with classicism or with the principles of *summētria* with which we began? Apart from the referential aspects of the tableau constructed here, there are other contradictions that go to the heart of the practices under discussion. The most important of these is the fact that for this tableau to be legible at all, the organic wholeness of the object under discussion was deconstructed. In other words, the object orchestrated a kind of fictive classicism: Instead of being a complete, harmonious, and self-identical entity, a metaphor of organic wholeness, the Propylaia must depend upon an extrinsic, anaphoric reference to articulate any such canonical wholeness. By literally playing upon the perceptual expectancies of the beholder, it cues that subject into the only place from which the composition would grammatically read within the codes of classicism. The *pinakotheka* facade thereby fixes the subject at a singular site that is coincident with the viewing of a political-ideological tableau.

This reveals the Propylaia as more than a grand gate-house with a picture gallery wing; it is disclosed, in fact, as a kind of *theatron*, a place for seeing, a

place for constru(ct)ing meaning. It is the central point in a panoptic machinery from which, and only from which, the world is put into a telling and narrative order. This *theatron* does not simply render the subject a passive spectator on a tier of seats. Indeed, it is the obverse of the Greek theater, articulating the visual environment in such a way as to make of the Subject the site where meaning is produced and ideology enacted. The gaze and perspective of the subject here "measure" all things.

The Propylaia is thus a place of reckoning, in the double sense of the term. For meaning to be made legible, the subject must be sub-jected to a specific economy of constraints.[87] Upon entering into the sacral and religious core of the polis, the participant becomes a fixed and situated fiction, a democratic myth, a supporting player in a political and ideological drama scripted by a polis projecting itself as a democracy. The akropolis, then, in its prismatic economy, enframes the subject by articulating objects for its subjects.

The classical period, astutely termed by Pollitt a "moment,"[88] was, in fact, an instant of precarious balance. Even as its founding metaphors were being articulated, they were being unraveled. In their finest details, the marks of the chisel were never fully erased.

Which calls to mind the following from Calvino:

> "I have neither desires nor fears," the [Kublai] Khan declared, "and my dreams are composed either by my mind or by chance."

> "Cities also believe they are the work of the mind or of chance [Marco Polo replied], but neither the one nor the other suffices to hold up their walls. You take delight not in a city's seven or seventy wonders, but in the answer it gives to a question of yours."

> "Or the question it asks you, forcing you to answer, like Thebes through the mouth of the Sphinx."[89]

Or, as I have tried to articulate here, like Athens through the frame of the Propylaia: the very archetype of the theater of memory.[90]

Or, like art history through the frames of its history. We are today in a position to see beyond theory or history in their modernist, panopticist forms. And in this study we have begun to see something of the design and construction of art history's "history" as itself a *theory of* history with very particular ideological and metaphysical investments and naturalizations—an address to the present, transforming it into the fulfillment of a past we would wish to have descended from. And we have also seen just how precarious and solid that *theatron*, that discursive space, has been: metony-

mies perpetually working to fabricate the same metaphor, the same geomantic scenography.

Beyond the prefabricated places where questions have had to be asked, there are no metalanguages, only infralanguages that, like waves on an ocean, are vantage points, which are always part and parcel of what they arise to stand for or against. On that horizon, "art history" might be the history, theory, and criticism of the multiplicity of cultural processes that can be constru(ct)ed as enframing: an accounting for objects and their subjects, with all that that might entail.

A disciplinary practice that attends to all this—whether we name that art history or not—would itself be worth attending to.

Notes

Epigraphs on p. v: F. Nietzsche, *The Gay Science*, trans. W. Kaufmann (New York: Random House, 1974), 374; J.-F. Lyotard, "Philosophy and Painting in the Age of Their Experimentation," *Camera Obscura* 12 (1984): 111.

PREFACE

1. P. Bourdieu, *Outline of a Theory of Practice* (Cambridge: Cambridge Univ. Press, 1977), 197.
2. M. Foucault, "Of Other Spaces," *Diacritics* 16:1 (Spring 1986): 26. The essay originally appeared in the journal *Architecture-Mouvement-Continuité* 73 (October 1984): 6–9, under the title "Des Espaces Autres"; it was a transcription of a lecture given in Paris in March 1967.

CHAPTER ONE: *A Crisis in, or of, Art History?*

Epigraphs: J. Lardner, "War of the Words," *Washington Post* (Mar. 6, 1983), G1; J. Derrida, *De la grammatologie* (Paris: Minuit, 1967), 227; A. Parker, "Futures for Marxism," *Diacritics* 15:4 (Winter 1985): 62; H. Zerner, "The Crisis in the Discipline," *Art Journal* 42:4 (Winter 1982): 279.

1. *Art Journal* 42:4 (Winter 1982): 279–325. In addition to the statement by the guest editor, H. Zerner ("The Crisis in the Discipline"), the special issue contained articles by O. Grabar ("On the Universality of the History of Art"), O. K. Werckmeister ("Radical Art History"), J. Hart ("Reinterpreting Wölfflin"), D. Summers ("The 'Visual Arts' and the Problem of Art Historical Description"), R. Krauss ("Photography's Discursive Spaces"), and D. Preziosi ("Constru[ct]ing the Origins of Art").
2. The question as to whether the academic discipline has "reduced" the thought of its founders is an important one, which we shall consider in various ways throughout this book. The choice of the term *reduce* is an interesting one, for it might equally be claimed that the opposite is the case. One might also argue that the "thought of [art history's] founders" was in large part responsible for the more recent "uninspired professional routine" within the discipline.
3. This view is recognized most notably, though hardly exclusively, in the field of literary theory. For a succinct and penetrating discussion of the current situation there, see J. Tompkins "The Reader in History," in Tompkins, ed., *Reader-Response*

Criticism (Baltimore: Johns Hopkins Univ. Press, 1980), 201–32. See also P. de Man, "The Resistance to Theory," *Yale French Studies* 63 (1982): 3–20.

4. A useful discussion dealing with these issues, albeit somewhat obliquely, is C. Owens, "Representation, Appropriation and Power," *Art in America* (May 1982): 9–21. See also S. Alpers, "Is Art History?" *Daedalus* (1977): 1–13.

5. R. Barthes, *Mythologies* (Paris: Seuil, 1957).

6. The *Washington Post* article of March 1983 was written in the wake of a furor created by two articles: one in *Harvard Magazine* (Sept./Oct. 1982) by Bate entitled "The Crisis in English Studies"; and the other in the *Wall Street Journal* (Dec. 31, 1982) by W. Bennett, then chairperson of the National Endowment for the Humanities, entitled "The Shattered Humanities." As Derrida himself observed, "The latter . . . carries ignorance and irrationality so far as to write the following: 'A popular movement in literary criticism called "Deconstruction" denies that there are any texts at all. If there are no texts, there are no great texts, and no argument for reading.' " (Derrida, "The Principle of Reason," *Diacritics* 13:3 [Fall 1983]: 15 n. 8).

7. Quoted in E. Holt, *A Documentary History of Art*, vol. 2, (New York: Doubleday, 1958), 47. Discussed at length by L. Marin in *Détruire la peinture* (Paris: Galilee, 1977), a partial translation of which can be found in *Enclitic* (1980): 3–38.

8. The quotes from Bate and Johnson appear in Lardner, op. cit., G10.

9. C. Campbell, "The Tyranny of the Yale Critics," *New York Times Magazine* (Feb. 9, 1986): 20–48.

10. Perusal of this curious magazine, edited by a retired *New York Times* art critic and funded by a conservative political foundation, could lead to the impression that any form of historical or critical practice coming to prominence over the past quarter century was part of a vast conspiracy aimed at the suppression of humane arts and letters and that this practice was supported by pinko dupes and fellow travellers. If it weren't for the frequently vicious *ad hominems* of its writing (to wit, its recent vilification of Marxist art historians at Harvard), the whole situation would be patently ludicrous: a kind of Disneyland version of the Stalinism of the 1930s. For parallel developments in England, see the polemics of R. Scruton, in particular, *The Aesthetics of Architecture* (Princeton: Princeton Univ. Press, 1979), esp. pt. 2, 137–256.

11. In *Vision in Painting* (New Haven: Yale Univ. Press, 1983), N. Bryson raises the issue in his introductory remarks and in chap. 3, 37ff. Bryson's perspectives reflect the situation in England, on which see also A. L. Rees and F. Borzello, eds., *The New Art History* (Atlantic Highlands, N.J.: Humanities Press International, 1988).

12. M. Holly, *Panofsky and the Foundations of Art History* (Ithaca: Cornell Univ. Press, 1984), 10.

13. Over the past decade the following journals have devoted significant amounts of space to discussions of art historical and critical studies or have included critical and historical essays exemplifying or critiquing various new disciplinary directions: *October, The Art Journal, Art Criticism, Journal of Aesthetics and Art Criticism, Glyph,*

Diacritics, Semiotica, Parachute, American Journal of Semiotics, New Literary History, Modern Language Notes, Screen, Oppositions, Enclitic, Sub-Stance, Art Forum, Jump-Cut, Boundary 2, Yale French Studies, Camera Obscura, Critical Inquiry, Representations, L'Esprit Createur, Social Text, Art in America, Art News, and *The Art Bulletin,* among North American publications. To this list may be added two from England, *Art History* and *Block,* as well as a new English journal devoted to aspects of cultural history, *Theory, Culture and Society.* The American *Semiotext(e)* has published articles dealing with theoretical issues affecting the arts, while a number of journals published by art history and other graduate students periodically address questions on art historical and disciplinary knowledge and practice generally: *The Rutgers Art Review* (Rutgers Univ.), *Apocrypha* (SUNY-Binghamton), and *Strategies* (UCLA). It is of no small interest that a number of journals listed above have been primarily literary or cinematic in focus, an indication of the fact that an increasing number of professionals in various fields have become actively engaged in addressing theoretical and critical issues with interdisciplinary pertinence. A parallel phenomenon can be observed in disciplinary congresses and colloquia, with an increasing number of art historians participating or organizing symposia and panels at, for example, the Modern Language Association (MLA). Moreover, recent meetings of the College Art Association of America (CAA), beginning notably with the Los Angeles meetings of 1985, have begun to alter their formats to accommodate broader discussion of fundamental issues affecting the discipline at large. The 1987 meetings, for example, included two special major symposia: on deconstruction and art history; and a postmortem on *Marxisant* art history in the United States in the 1970s.

14. On Panofsky and semiology, see H. Damisch, "Semiotics and Iconography," in T. A. Sebeok, ed., *The Tell-Tale Sign* (Lisse, The Netherlands: Peter de Ridder Press, 1975), 27–36; and Holly, op. cit. See also W. J. T. Mitchell, *Iconology* (Chicago: Univ. of Chicago Press, 1986). On Riegel and structuralism, see S. Nodelman, "Structural Analysis in Art and Anthropology," *Yale French Studies* 36–37 (1966): 89–102; also of relevance is A. Michelson, "Art and the Structuralist Perspective," in *On the Future of Art* (New York: Viking, 1970): 37–60. On the relationships between Panofsky and Saussure, see P. Bourdieu, *Outline of a Theory of Practice* (Cambridge: Cambridge Univ. Press, 1977), 23f.; see also chap. 4, this vol., for a detailed discussion.

15. See the interesting article by Owens, op. cit., on the seeming incompatibility of traditional art historical practice and the postmodern critique of representation.

16. We will discuss this issue in chap. 3 in connection with a consideration of the disciplinary artifact of the art historian.

17. The exceptions are still few indeed. Although some undergraduate departments in the United States incorporate a theory and methodology seminar or proseminar in their curricula, this normally remains a requirement only for art history majors. Some departments have established traditions of what are currently termed social-historical perspectives in the organization of curricula—notably UCLA (which pioneered this approach in the 1970s, before its more recent post-Marxian period),

SUNY-Binghamton, and the University of British Columbia. For the most part, however, undergraduate curricula retain the traditional survey format as a primary structure. On the graduate level, the picture in the United States is more varied, and in the 1980s two universities—UCLA and Binghamton—developed critical theory concentrations on the M.A. and Ph.D. levels.

18. See G. Chase, "The Fine Arts 1874–1929," in S. E. Morison, ed., *The Development of Harvard University* (Cambridge: Harvard Univ. Press, 1930), 130–45. The background to the establishment of the Norton lectures included an exchange of letters between Henry James and President Eliot on the subject of the place of the fine arts in the scheme of the university, in which Eliot responded to a series of "informal propositions" made to the latter by James.

19. A useful introduction to the subject can be found in T. Reiss, *The Discourse of Modernism* (Ithaca: Cornell Univ. Press, 1982), which connects what the writer terms "analytico-referential discourse" and modern disciplinary knowledge. See also, in regard to art history and the techniques of connoisseurship, C. Ginzburg, "Morelli, Freud and Sherlock Holmes," *History Workshop* 9 (1980): 5–36. Another version of the latter appeared as "Clues: Morelli, Freud and Sherlock Holmes," in U. Eco and T. Sebeok, eds., *The Sign of Three* (Bloomington: Indiana Univ. Press, 1983), 81–118. On the situation in Germany, see L. Dittman, *Stil/ Symbol/ Struktur* (München: Fink Verlag, 1967); and H. Dilly, *Kunstgeschichte als Institution* (Frankfurt am Main: Suhrkamp, 1979), esp. 13–79.

20. See M. Roskill, *What is Art History?* (New York: Harper & Row, 1976), for a traditional essay on art history as a disciplinary science; and W. E. Kleinbauer, *Modern Perspectives in Western Art History* (New York: Holt, Rinehart & Winston, 1971), esp. 1–105. The latter is examined in some detail in chap. 2, this vol.; see also chap. 6, sec. 2.

21. Sec. 43 of *The Critique of Judgment*, trans. J. H. Bernard (New York: Hafner Press, 1972). For a commentary on the latter, see Derrida, "Economimesis," *Diacritics* 11:2 (Summer 1981): 3–25 (written 1975), as well as *La Vérité en peinture* (Paris: Flammarion, 1978), esp. "Parergon," 21–168.

22. H. Kramer, "Does Gerome Belong with Goya and Monet?" *New York Times* (April 13, 1980), sec. 2, 35. For a commentary and discussion on the latter, see D. Crimp, "On the Museum's Ruins," *October* 13 (1980): 41–57, esp. 41–43.

23. This theme is taken up in chap. 2.

24. This question is discussed in chap. 4. See C. Hasenmueller, "Panofsky, Iconography, and Semiotics," *Journal of Aesthetics and Art Criticism* 36 (Spring 1978): 289–301; M. Schapiro, "On Some Problems in the Semiotics of Visual Art," *Semiotica* 1 (1969): 223–42; and Bryson, op. cit., 67–86.

25. The discipline is inward-looking in terms of its devotion to what Zerner (op. cit., 279) calls "an uninspired professional routine feeding a busy academic machine." See also Holly, op. cit., 158–93, and Y.-A. Bois, "Panofsky Early and Late" (review of Holly), *Art in America* (July 1985): 9–15.

26. Both Holly and Bryson deal indirectly with this question, although, curiously, neither mentions the work of Jan Mukařovský in the 1930s on the semiotics of

art, which, evidently, Panofsky was not familiar with. See chap. 4, sec. 7.

27. See the discussion of crisis by A. Megill in *Prophets of Extremity* (Berkeley: Univ. of California Press, 1985), 259–98.

28. Ibid., 299–337.

29. M. Mandelbaum, *History, Man and Reason* (Baltimore: Johns Hopkins Univ. Press, 1971), 42.

30. Kleinbauer, op. cit., 2.

31. C. Lévi-Strauss, *The Savage Mind* (New York: Harper & Row, 1966), 258.

32. Derrida, *Of Grammatology*, trans. G. Spivak (Baltimore: Johns Hopkins Univ. Press, 1976), 86. Derrida refers to this linearity as the repression of pluridimensional symbolic thought.

33. Ibid. Derrida's critique of Saussurean and structuralist semiology centers in part on the latter's linearist model of language. The issue will be taken up in chap. 5 in connection with the vexed problem of origins.

34. F. Jameson, *The Political Unconscious* (Ithaca: Cornell Univ. Press, 1981), 27.

35. Kleinbauer, op. cit., esp. 67ff.: intrinsic genres of scholarship include materials and technique, connoisseurship, formal analysis, iconography, and function; extrinsic genres deal with artistic biography, the psychology of personality, social forces, cultural history, and the history of ideas.

36. Derrida, "Economimesis," 5ff.; see also chap. 5, sec. 3, this vol.

37. Cf. Reiss, op. cit., 328ff. He observes (331) that "like the parallels of Euclid, these various types of discourse never meet (though one may bisect them with the line of a 'cross-section'). They are separated into [what were to become] quite rigidly compartmentalized 'disciplines'." Chap. 2 will discuss this issue further in connection with a consideration of M. Foucault's *The Order of Things* (New York: Pantheon, 1970).

38. See Derrida's *The Truth in Painting* and *Of Grammatology*. His writings contain what is surely the most important and incisive critique in modern times of the metaphysical, ontotheological, and logocentrist programs of Western philosophy and art.

39. A perusal of Kleinbauer (op. cit., 1–105) will readily demonstrate this. See also S. Weber, "Ambivalence, the Humanities, and the Study of Literature," *Diacritics* 15:2 (Summer 1985): 11–25. On the connections between academic professionalism and theocentrism, see Weber's "The Faulty Eye" (forthcoming), which expands on the former essay. (I am grateful to Sam Weber for allowing me to read this essay in typescript prior to its publication.)

40. See n. 33, this chap., and R. Terdiman, "Deconstructing Memory," *Diacritics* 15:4 (Winter 1985): 13–36.

41. Owens, op. cit., 9.

42. The phrase is taken from a discussion by Foucault in *Archaeology of Knowledge* (New York: Harper & Row, 1972), 224 in connection with the truth of Gregor Mendel's statements about botanical inheritance, which during their time would have been impossible objects for the orthodox disciplinary discourse.

43. See esp. the recent volume by H. Belting, *The End of Art History?* (Chicago: Univ.

of Chicago Press, 1987), which attests to contradictory attitudes in the same essays.

44. See Foucault's *Discipline and Punish*, trans. A. Sheridan (New York: Pantheon, 1977), 195–228. Introductions to Foucault's work abound; the most useful are A. Sheridan, *Michel Foucault: The Will to Truth* (London: Tavistock, 1980), esp. pt. 2, 135–67; H. Dreyfus and P. Rabinow, *Michel Foucault: Beyond Structuralism and Hermeneutics*, 2d ed. (Chicago: Univ. of Chicago Press, 1983), esp. 132 and 189–98; J. Merquior, *Foucault* (London: Fontana, 1985). The latter study also discusses relationships between the work of Foucault and that of Panofsky (78ff.). Perhaps the best introduction to date is G. Deleuze, *Foucault* (Paris: Minuit, 1986 [English translation forthcoming]). One of the most perceptive discussions is J. Rajchman, "Foucault's Art of Seeing," *October* 44 (Spring 1988): 89–119.

45. On new art history, see Rees and Borzello, op. cit., which contains sixteen brief essays by English art historians on the impact of recent critical thinking under feminist, structuralist, Marxian, poststructuralist, and psychoanalytic rubrics on art historical practice in Great Britain. A perusal of those essays will make clear the extent to which recent art history in England came to define itself in opposition to the work of Gombrich and the work of Clark in the early 1970s. The essays are nonetheless too sketchy to allow any full assessment of what is "new" therein.

46. De Man, op. cit., 12.

47. Ibid.; see also n. 3, this chap.

48. See, for example, J. Elkins, "Art History without Theory," *Critical Inquiry* 14 (Winter 1988): 354–78, which rehearses (yet again) the theory versus practice double bind in the discipline. The claim therein (377 n. 53) that "in art history, practice does not exist to support theory" is symptomatic of the problems addressed in the present volume.

CHAPTER TWO: *That Obscure Object of Desire*

Epigraphs: W. E. Kleinbauer, *Modern Perspectives in Western Art History* (New York: Holt, Rinehart & Winston, 1971), 1; C. Lévi-Strauss, *The Savage Mind* (New York: Harper & Row, 1966), 258; Kleinbauer, 34; W. Stevens, "The Palm at the End of the Mind," in H. Stevens, ed., *The Palm at the End of the Mind* (New York: Random House, 1972), 398; F. Jameson, *The Political Unconscious* (Ithaca: Cornell Univ. Press, 1981), 127; this remark is attributed to Stanford White.

1. Vasari's *Lives of the Most Eminent Painters, Sculptors and Architects* was first published in Florence in 1550 and then in 1568 as an enlarged edition. In the introduction to his biographies of individual artists, Vasari includes a tripartite schema for historical development (infancy, adolescence, maturity) that is cyclical. On the latter, see the critical appraisal by S. Alpers, "Ekphrasis and Aesthetic Attitudes in Vasari's *Lives*," *Journal of the Warburg and Courtauld Institutes* 23 (1960): 190–215.

2. J. Derrida's now classic critique of Lévi-Straussian structuralism ("Structure, Sign and Play in the Discourse of the Human Sciences," a lecture delivered in 1966 at the International Colloquium on Critical Languages and the Sciences of Man at Johns Hopkins University and published in A. Bass, ed. and trans., *Writing and Difference* [Chicago: Univ. of Chicago Press, 1978], 278–93) opposes mythomorphic discourse to epistemic discourse, which is founded on the principle of return to origins (286–87 and n. 8). As will become apparent, art historical discourse partakes of both and, indeed, works to frame the former by the latter.

3. On this distance, see the important article by J. Snyder, "Picturing Vision," in W. J. T. Mitchell, ed., *The Language of Images* (Chicago: Univ. of Chicago Press, 1980), 219–46, esp. 219 and nn. 1 and 2 in reference to Descartes's *Dioptrics*. See also n. 6, this chap.

4. These terms will be used more or less interchangeably in this and subsequent chapters in reference to the disciplinary practice of interpretation of artwork; for our purposes, both critic and historian will be seen as occupying equivalent discursive positions within the disciplinary apparatus. In contrast, see the curious *Artwriting* by D. Carrier (Amherst: Univ. of Massachusetts Press, 1987).

5. The most important modern critique of the metaphysical, ontotheological programs of Western philosophy and art is that of J. Derrida (understood as a reaction to and in part an extension of the work of Heidegger). See especially *De la Grammatologie* (Paris: Editions du Seuil, 1967). See also *La Vérité en peinture* (Paris: Flammarion, 1978); the latter includes an important critique of interpretations of Van Gogh's *Trois paires de souliers* (Fogg Museum) by M. Schapiro and M. Heidegger in the chap. entitled "Parergon," 21–168. As we shall see in this chap., the metaphysical dimension in art historical writing remains deeply entrenched: See the remarkable statement that art must "return to its sacramental roots and forge a mythical language of transcendence" in S. Gablik, *Has Modernism Failed?* (New York: Thames & Hudson, 1984). Related issues are discussed in O. K. Werckmeister, "Kunstgeschichte als Divination," in Werckmeister, ed., *Ideologie und Kunst bei Marx und andere Essays* (Frankfurt am Main: S. Fischer, 1974), 64–78.

6. See N. Bryson's fine but incomplete critique of perceptualism in *Vision and Painting* (New Haven: Yale Univ. Press, 1983), esp. chaps. 2 and 3, 13–66. Bryson's discussion of Gombrich and his theses is focused particularly on the latter's *Art and Illusion* (Princeton: Princeton Univ. Press, 1960). Bryson omits mention of a publication that arose out of a series of three lectures addressing problems in Gombrich's theses and conclusions (E. H. Gombrich, J. Hochberg, and M. Black, *Art, Perception and Reality* (Baltimore: Johns Hopkins Univ. Press, 1972). In the latter, a noted perceptual psychologist and a philosopher give critiques of what Bryson refers to as Gombrich's "perceptualism"; in addition, Gombrich re-presents his positions from *Art and Illusion*. Gombrich's 1972 essay, "The Mask and the Face" in *Art, Perception and Reality*, contains a more explicit statement of the historical connection between perceptualism and Cartesian mechanical philosophies, as first set out systematically by Charles le Brun (3–5

and n. 9). On the Albertian Window, see M. A. Hagen, ed., *The Perception of Pictures*, vol. 1, *Alberti's Window* (New York: Academic Press, 1980), for a useful collection of essays by psychologists and historians of art on the subject of the projective model of pictorial information. The work by Alberti is *On Painting*, trans. J. R. Spencer (New Haven: Yale Univ. Press, 1966). Perhaps the most important recent discussion of these questions is C. Hasenmueller, "Images and Codes," *Semiotica*, in press 1984, which reviews W. Steiner, ed., *Image and Code* (Ann Arbor: Univ. of Michigan Press, 1981), and also considers Gombrich's revisions to *Art and Illusion* in his title essay in the Steiner volume. Of particular pertinence to the present discussion is the essay by J. Lyotard in the latter, in which he notes that "criticism, like the exegetical stories we have been examining, makes its point not by direct argument, but by putting the reader in a position to accept its assumptions" (76). This putting in position is, as we shall see, precisely the art historical and critical strategem and connects with the panopticism of disciplinary knowledge: See secs. 2 and 3, this chap. and the more extended and focused discussion of chap. 3.

7. The phrase refers to a discussion by M. Foucault in *Archaeology of Knowledge* (New York: Harper & Row, 1972), 224 in connection with the truth of Gregor Mendel's statements about botanical inheritance, which during their time would have been impossible objects for the orthodox discipline.

8. See Derrida, *Dissemination*, trans. B. Johnson (Chicago: Univ. of Chicago Press, 1981), in particular "Plato's Pharmacy," 61–172 (esp. subsec. 1.4, "The Pharmakon," 95–117). The Platonic *pharmakon* plays a role analogous to that of *supplément* in Derrida's reading of Rousseau and connects with the notion of writing as both an aid to memory and that which destroys memory in the Platonic myth (96 and n. 43). As we shall see, Derrida's text is central to any serious consideration of the object of art history as a domain of disciplinary knowledge, as well as to the problematic of intentionality in artistic and critical praxis.

9. *Lust for Life* presents itself as intelligible only because it implies a total historical archive of which it purports to form an episode. The movement is implicit in Vasari's project from the beginning (see n. 1). See Kleinbauer, op. cit., 13–36, for a historical overview of "history writing" in the discipline. While Kleinbauer rightly notes the opposition in aesthetic theory between history and antihistory (the belief, suggested by Croce and others, that "there is no history of art, only artists creating"[13]), he fails to understand that the two poles of this opposition are, in fact, mutually defining positions within a disciplinary apparatus; see secs. 2 and 3, this chap. As will be suggested, the two extremes are held in suspension by mainframe art history as a rhetorical double bind.

10. The term *funicity*, referring to traces of historical or ontogenetic sedimentation, is employed by the science historian and metallurgist C. S. Smith of MIT; see esp. *A Search for Structure* (Cambridge: MIT Press, 1981), 327ff., in which he connects the notion of funicity with the unfortunate character in Borges's story "Funes the Memorious," who remembered everything he had ever experienced. Everything complex, Smith notes, must have a history, and its internal structure

might thereby be termed *funeous*.

11. This much discussed subject has recently been revived in S. Guilbaud, *How New York Stole the Idea of Modern Art* (Chicago: Univ. of Chicago Press, 1983).

12. Kleinbauer, op. cit., 1; see also n. 9, this chap.

13. See Derrida, *Writing and Difference*, 280, on the centrality of Being and Subjecthood, which is "decentered" by Freud, Nietzsche, and Heiddeger. The purpose of "continuous history," is, in the words of Foucault (op. cit., 12), "to preserve, against all decenterings, the *sovereignty* of the subject." These "decenterings," as we are reminded by F. Lentricchia in *After the New Criticism* ([Chicago: Univ. of Chicago Press, 1980], 192), refer to the work of Marx, Nietzsche, and Freud in fundamentally problematizing the notion of sovereignty of the Subject as precisely an ideological fiction. On the mechanisms of ideological fabrication and construction of a centered Subjecthood, see D. Carroll, *The Subject in Question* (Chicago: Univ. of Chicago Press, 1982), esp. 9–26 and 51–87; see also C. Belsey, *Critical Practice* (London: Methuen, 1980), esp. chap. 3, "Addressing the Subject," 56–84. The latter discusses the perspective of L. Althusser (related to the works of Freud and Lacan) of the purpose of ideology as such to precisely construct and to constitute individuals as Subjects (60f.).

14. Kleinbauer, op. cit., 34. Kleinbauer's introductory essay clearly performs the art versus science dichotomy at the level of the uniqueness-replicability trope and thereby retains in suspension, within his version of the discipline, the spurious opposition (see n. 9, this chap.). It is argued here that the very power of art historical disciplinary knowledge is maintained by this rhetorical ploy: Under the guise of an oppositional contradiction, the discipline in effect legitimizes both perspectives on artwork (and on the ideal art historian's purported task). But the opposition is in fact asymmetrical: The uniqueness pole is the unmarked or base state, occluded as such by disciplinary attention to "historicity" and its implication of the existence of a class of like objects over time and place. By designation of the discipline as art history, critical practice masks the fact of its essential and fundamental ahistoricity. Indeed, art history is at base an ahistorical discipline with (as we are seeing) an ahistorical, metaphysical technical language, able to survey and to order history precisely because it is not in history. See the excellent and penetrating essay by D. Crimp, "On the Museum's Ruins," *October* 13 (Summer 1980): 41–58, and the anthology *The Anti-Aesthetic*, ed. H. Foster (Port Townsend, Wash.: Bay Press, 1983). In no small measure, the conundrum here arises out of the problematics of the traditional notion of the sign in Western philosophy and art as evidenced in Port-Royal grammar and theology. As M. Doueihi observes in his excellent review of L. Marin's *Le Portrait du Roi* (Paris: Editions de Minuit, 1981) in the journal *Diacritics* 14:1 (Spring 1984): 67, what was required (by the seventeenth-century authors of the Port-Royal grammar, Arnauld and Nicole) was a formula making possible the support of a "perfect signifier" that "would have to be simultaneously (a) visible and material in order to articulate the signified, and (b) invisible and immaterial in order not to obstruct the presence of the signified itself." It will be obvious that Kleinbauer's rhetorical

imagery here ("draining away . . . aesthetic integrity") is struck, however unwittingly, from the same ontotheologic mold. Doueihi's article makes it clear, following Marin's study, that the lynchpin of Port-Royal grammar was the problematic of the Eucharist and its enunciation (*hoc est corpus meum*); we may say by extension that this is the central problematic of the semiology of the visual arts—as we shall see in the course of the present book, particularly in chap. 4.

15. The classic statement of the problem of the opposition between the two voices in grammar is in E. Benveniste, *Problems in General Linguistics*, vol. 1, trans. M. E. Meek (Coral Gables, Fla.: Univ. of Miami Press, 1971), in particular "The Correlations of Tense in the French Verb": "Two different levels of utterance, which we shall distinguish between that of *histoire* and that of *discourse*" (206); "the historian never says *je* or *tu* or *maintenant* [now]" (206). The subject of the utterance (*énoncé*) is not the same as the subject who performs the linguistic act of utterance (*énonciation*). "Person" here is, in fact, a linguistic entity: See the exemplary discussion of the implications of Benveniste's work by Carroll, op. cit., 20–26, and his observation that "the 'error' of phenomenology and other theories of the subject according to Benveniste was to neglect, even obscure, the true ground of Being: language" (25), an observation consonant with the perspective being developed in the present chap. (see n. 14). See also n. 82, this chap., and chap. 6, sec. 2.

16. See W. J. T. Mitchell's important discussion of Lessing's criteria for distinguishing painting and poetry and of their ultimate grounding in concepts of social decorum, related to the idea of proper sex roles: "The Politics of Genre," *Representations* 6 (Spring 1984), 98–115. The latter should alert us to the ideological investments underlying disciplinary distinctions even among something as seemingly neutral and self-evident as medium or materials.

17. We might, for example, view the object domain as in fact a matter of functional dominance on the part of any kind of artifact, in a manner recalling R. Jakobson's "poetic function" in language ("Language and Poetics," in T. A. Sebeok, ed., *Style in Language* [Cambridge: MIT Press, 1960], 350–77). Within such a framework, the aesthetic facet of an(y potential) object is in dominance when the object is principally self-referential or autotelic with respect to its own morphology. Jakobson's schema, which has been extremely influential in modern literary (poetic) theories, would appear reasonably applicable to the visual realm (as we will discuss in chaps. 4 and 5). But it is not without interest that Jakobson's schema is arguably derived from an originally visual formulation on the part of his art historical colleague in the Prague Linguistic Circle in the 1930s, Jan Mukařovský. The subject is discussed in detail in two recent volumes by D. Preziosi: *Architecture, Language, and Meaning* (The Hague: Mouton, 1979), 47–57; *The Semiotics of the Built Environment* (Bloomington: Indiana Univ. Press, 1979), 61–73 and 92–95.

18. Nelson Goodman, *Ways of Worldmaking* (Indianapolis: Hackett, 1978), 57–70, and esp. 66: "Part of the trouble lies in asking the wrong question—in failing to recognize that a thing may function as a work of art at some times and not at others. In crucial cases, the real question is not 'What objects are (permanently)

works of art?' but 'When is an object a work of art'—or more briefly, as in my title, 'When is art?'" Related issues are taken up by A. Danto in *The Transfiguration of the Commonplace* (Cambridge: Harvard Univ. Press, 1981), which in a curious way returns to a problematic raised seventy years ago by the Russian Formalist movement in its notion of *ostranenie* or defamiliarization (of the commonplace). On Russian Formalism, see V. Ehrlich, *Russian Formalism* (The Hague: Mouton, 1955); K. Pomorska, *Russian Formalist Theory and its Poetic Ambiance* (The Hague: Mouton, 1968); a useful general introduction to the subject is T. Bennett, *Formalism and Marxism* (London: Methuen, 1979). Jakobson's ideas were central to the formation of the movement in the late 1910s.

19. Discussed by Lentricchia, op. cit., 178, in connection with M. H. Abrams's article "The Deconstructive Angel," *Critical Inquiry* 3 (Spring 1977): 426, as a Romanticist phenomenology of determinacy. That the discipline frequently does not function in this manner will be patent by contrasting the rhetoric of mainframe disciplinary journals such as *The Art Bulletin* to that of comparably authoritative journals in cognate disciplines—for example, *Current Anthropology*, which prints articles along with several discussant essays, followed by a reply from the original author. By contrast, many art journals (of which *The Art Bulletin* is an exemplar) work to occupy an authoritative center, marginalizing alternate perspectives or interpretations. Until the last decade, to publish in *The Art Bulletin* was perforce to speak *dans le vrai*. Recently, attempts have been made to incorporate overviews of various methodological perspectives.

20. The discussion of the concept of style by Schapiro ("Style," in A. L. Kroeber, ed., *Anthropology Today* [Chicago: Univ. of Chicago Press, 1953]) remains the classic examination of the variations in definition of the term. See also chap. 5, sec. 4.

21. Kleinbauer (op. cit., 38–51) provides a useful compendium of basic writings in the area of connoisseurship while justifying this branch of art study as properly a part of art history, in contrast to the point of view of Wittkower (43 and n. 83); Kleinbauer notes that the aim of connoisseurship is "to restore works of art to their original positions—of time and place—in the stream of creative production" (43). As a method of establishing authenticity and authorship, connoisseurship achieved a certain systematicity in the hands of G. Morelli (1816–91), a physician and comparative anatomist, whose critical study of Italian painters was published in Leipzig in 1890–93. It is not without interest that Kleinbauer connects his discussion of Morelli's methods of discerning artistic personality through a close examination of apparently least significant details in a work (fingernails, nostrils, earlobes)—because these are assumed to be almost automatic in execution—with the work of Freud (45, 71) in reading telltale signs of personality, although he notes that Freud's "psycho-analytic method cannot explain the nature of the creative process" (71).

22. B. Berenson's *Three Essays in Method* (Oxford: Oxford Univ. Press, 1927) is cited by Kleinbauer (op. cit., 45) as an example of "taking content into consideration."

23. The product of connoisseurist analysis is a rectified corpus (catalogue raisonné) charting the entire body of known work of an artist during the course of his life,

which consequently serves as a major data base for interpretative study by the compiler and others. The system of a catalogue raisonné is one of mutual definition and coimplication wherein each object resonates with all others both morphologically and, to some extent, thematically. The project is clearly an extension of the Vasarian program and of the exegetical program of St. Jerome. See Foucault's classic "What is An Author?" originally delivered as a lecture at the Collège de France in 1969, appearing in *Language, Counter-Memory, Practice*, ed. D. F. Bouchard (Ithaca: Cornell Univ. Press, 1977), 113–38.

24. See Doueihi, op. cit., 66–75. As discussed in chap. 4, the work of Saussure (*Cours de linguistique générale*, 2d ed. [Paris: Payot, 1922]) may be viewed as an interface between traditional semiotic theories of the sign and more modern and contemporary versions; that is, the former connect more directly with structuralist programs of research, the latter with more recent poststructuralist work. The best discussion of this issue is Derrida's *Grammatology*, op. cit., 27–73; see also "Semiology and Grammatology" (interview with J. Kristeva) in *Positions*, ed. A. Bass (Chicago: Univ. of Chicago Press, 1981), 17–36.

25. On the question of periodicization, see the remarks of F. Jameson (p. 40 and n. 58, this chap.); see also J. Rajchman, "Foucault, or the Ends of Modernism," *October* 24 (Spring 1983): 37–62, esp. 56. See also chap. 1, n. 33.

26. On the project of Vasari, see n. 1, this chap; see also M. Roskill, *What is Art History?* (New York: Harper & Row, 1976), 74ff. An important discussion of Vasari's project can be found in M. Foucault's "'The Father's 'No,' '" in Bouchard, op. cit., 68–86, esp. 72, 80, 115. This essay (originally published in 1962 in *Critique* 178 [1962]: 195–209) observes that the Vasarian project proceeds according to an ordained and ritual order, in contrast to the "pathological project" of Hölderin: "Any discourse which seeks to attain the fundamental dimensions of a work must, at least implicitly, examine its relationship to madness" (80). As we have seen in connection with *Lust for Life*, this coincides with the latter's agenda. The film ostensifies a metrology that is a *pharmakon* (see n. 8)—constitutive of order and destructive of that order by the revelation of a deep disorder. In terms of the present discussion, a well-formed system is an ordered system.

27. Foucault, "What is an Author?" 127.

28. Discussed by Foucault in the aforementioned essay; see also E. Arns, *La Technique du livre d'après Saint Jérôme* (Paris: Editions de Minuit, 1953).

29. Foucault, "What is an Author?" 129.

30. As discussed in chap. 3, the development of art history as a modern discipline was made possible in no small measure by a crossing of a technological threshold engendered by the nineteenth-century development of photography. Indeed, art history could not have arisen in its twentieth-century form apart from its groundings in filmic technology. At the same time, it is the development of cinema specifically that works both to recuperate the Western Realist tradition in art and to establish the foundations for the discursive framework of art history. *Lust for Life* can be seen in this regard not simply as a moving-picture illustration of a Vasarian program but, in fact, as part of the disciplinary apparatus of the network

of strategies considered here under the disciplinary rubric of art history. For a consideration of the ideological issues of filmic narrative, see chaps. 1 and 2 of S. Heath's *Questions of Cinema* (Bloomington: Indiana Univ. Press, 1981), 1–75. On the subject of technological breakthrough or threshold as constitutive of disciplinary status see Foucault, *Archaeology of Knowledge*, esp. pt. 2, 21–78.

31. Foucault, "What is an Author?" 128.

32. This is, in fact, the guiding metaphor underlying the connoisseurist program; see n. 21, this chap.

33. Foucault, "What is an Author?" 128.

34. See Kleinbauer (op. cit., 48) on the implication that the need for connoisseurist practice has lessened in modern times since "problems of attribution to major masters and groups or schools [are] no longer critical," indicative in part of a belief that the archival canon is approaching a certain completion (apart, of course, from modern and contemporary artwork). The assumption is that the way is now open for the integration of the results of connoisseurship "with those of other techniques, such as iconography, psychology and psychoanalysis, and social and cultural history." On the Archive as such, see Foucault, *Archaeology of Knowledge*, pt. 3, 79–134, and A. Sheridan, *Michel Foucault* (London: Tavistock, 1980), 89–110, esp. 102ff. Foucault sees the Archive as being not an inert depository of past statements preserved for future use but rather the very system that makes the emergence of statements possible.

35. One thinks of the work of Picasso in the popular imagination as having been devoted to forging original Picassos. On connoisseurship apotheosized as psychoanalytic analysis of artworks, see the work of E. Kris, in particular, *Psychoanalytic Explorations in Art* (New York: International Universities Press, 1952).

36. See Doueihi, op. cit., 76–77; T. Eagleton, *Criticism and Ideology* (London: Verso, 1978), 134ff.; E. W. Said, "Opponents, Audiences, Constituencies, and Community," in W. J. T. Mitchell, ed., *The Politics of Interpretation* (Chicago: Univ. of Chicago Press, 1983), 7–32; and T. J. Clark, "Arguments About Modernism," in Mitchell, 239–48, and 240, n. 1, with respect to the nineteenth-century enterprise of literature; Clark here quotes Foucault, *The Order of Things* (New York: Random House, 1973), 300.

37. Kleinbauer, op. cit., 1–105, gives a perfectly typical and detailed account of the various genres of art historical scholarship within mainframe art history prior to the contemporary period (pre-1970). Particularly instructive is his distinction between intrinsic and extrinsic approaches to art, which nicely sets out the major configurations of the discipline's orthodox ideological program: the former refer to artistic morphology (art as such, so to speak), the latter to the content side of things. Within the latter, the author distinguishes among three categories: psychology, society/culture, and ideas.

38. It can be argued that the divisions in the discipline among various theoretical or methodological positions have less to do with their ostensible aims and more with a contradiction between materialist and metaphysical agendas in every form of art historical practice, from iconography to stylistic analysis to biographical study to

semiology to psychoanalytic theory to Marxian social history. It is questionable, for example, whether Marxist art history could properly be considered a single approach to artwork given the fact that work in this area spans an enormous spectrum from metaphysicist determinism (by no means confined to the generation of Lukacs) to materialist social history actively engaged in a more contemporary dialogue with semiology or poststructuralism. Curiously, Kleinbauer (op. cit., 80) asserts that "the Marxist interlude in American scholarship of the visual arts was both short-lived and confined to the New York area." Presumably a further implication is that this interlude was also confined to certain ethnic groups. Admittedly, Kleinbauer was writing in 1971, before the florescence of neo-Marxian art history in the United States, and at a time when a statement to the effect that Sidney Hook was "America's leading scholar and theoretician of the varieties of Marxism" might go unremarked by an art historical readership. See now A. Wallach, "Marxism and Art History," in *The Left Academy*, ed. B. Ollman and E. Vernoff (New York: Praeger, 1984), 25–53, with extensive bibliography.

39. H. Brown, *Perception, Theory and Commitment* (Chicago: Univ. of Chicago Press, 1979), 155.

40. On artwork as consisting of the aesthetic function of any facet of the made environment, see n. 17, this chap., and references cited; see also chap. 5, sec. 4.

41. See Foucault, *Archaeology of Knowledge*, 32f.: "The problem arises of knowing whether the unity of a discourse is based not so much on the permanence or uniqueness of an object as on the space in which various objects emerge and are continuously transformed." He notes further that "the unity of the discourses . . . would be the interplay of the rules that define the transformations of these different objects, their non-identity through time" (33). In speaking of medical science in the nineteenth century, Foucault observes that "medical science was characterized not so much by its objects or concepts as by a certain *style*, a certain constant manner of statement . . . the same way of looking at things . . . the same system of transcribing what one perceived in what one said (same vocabulary, same play of metaphor)." Such a perspective resonates with the arguments developed in this chap. On problems with Foucault's archaeology project, see the important volume by H. L. Dreyfus and P. Rabinow, *Michel Foucault*, 2d ed., with an afterword and an interview with Foucault (Chicago: Univ. of Chicago Press, 1983), 16–43 and 61ff. Dreyfus and Rabinow take issue with what they see as Foucault's stronger claim that the rules of discursive practice have autonomous intelligibility, a view later modified in the more recent interpretative analytics phase of Foucault's projects.

42. See chap. 3; Foucault's study of the Panopticon will be found in *Discipline and Punish*, trans. A. Sheridan (New York: Random House, 1979), 195–230; and in "The Eye of Power," in C. Gordon, ed., *Power/Knowledge* (New York: Pantheon, 1980), 146–65. The latter was originally published as a preface to J. Bentham, *Le Panoptique* (Paris: Belfond, 1977). The subject of Bentham's Panopticon has been treated in many writings over the past decade and extensively in Foucault's *Discipline and Punish*. As Foucault astutely demonstrates, the panoptic model served as

one of the important bases for the conceptualization of the new disciplines of knowledge arising during and after the Enlightenment. An interesting recent study on the Harvard College Core Curriculum and its panopticist underpinnings is W. V. Spanos, *The End of Education* (in press as of this writing).

43. It is clear that the disciplinary archive itself is a spatial transform of the Panopticon in that its objects are arranged in systematic and discrete order so as to be visible or accessible by any users; see n. 6, this chap.

44. See again n. 6, and chap. 3. It is not without interest that the center of the Penitentiary Panopticon is occupied by a circular Chapel over the Inspector's Lodge and lit by a skylight above; thus (as Foucault does not discuss) the architectonic center of this Eye of Power is divinity Itself—a regime resonating with Derrida's observations concerning the ontotheologic centrality of Western discourse; see n. 5, this chap.

45. See Derrida's *Dissemination*, 63ff., and his observation that "a text is not a text unless it hides from the first comer, from the first glance, the law of its composition and the rules of its game" (63). The opposition object-context is of the same status as the form-content dyad discussed above. Instrumentalism, in fact, recontextualizes objects within a new system, a new context, one susceptible to panoptic visibility and legibility.

46. This is well illustrated in Kleinbauer's (op. cit., 1–103) strategies of disciplinary centrality and marginalities with regard to approaches to art.

47. See the excellent essay by H. Damisch, "Semiotics and Iconography," in T. A. Sebeok, ed., *The Tell-Tale Sign* (Lisse: Peter de Ridder Press, 1975), 27–36, in which Damisch observes that "iconography as a method is founded on the postulate that the artistic image (and indeed any relevant image) achieves a signifying articulation only within and because of the textual reference which passes through and eventually imprints itself in it" (31). In concerning itself primarily with the signified in images, iconography reduces the plastic signifier to a question of treatment, a connotation of style and thereby necessarily is led to confuse meaning and verbal denotation. Iconography, as Damisch notes, is deeply entrenched in the Platonic metaphysics of the sign and represents an early modern resuscitation of the logocentrism infusing Panofsky's paradigmatic model, the iconologia of Cesare Ripa of 1593.

48. The phrase "shape grammars" refers to recent computer-generated transformations of abstracted spatial syntaxes of architectonic objects, wherein an imaginary complete corpus of all of the buildings a Renaissance architect could have designed can be modeled. The technology, an outgrowth of architectural computer graphics, enjoys a vogue among architectural practitioners of a markedly formalist inclination, substituting for historical research.

49. For example, artwork is tacitly understood as a diagram of economic determinations or as superstructure to an economic base; see n. 41, this chap., and F. Antal, *Classicism and Romanticism* (New York: Basic Books, 1966 [written 1935–41]).

50. The work of E. Kris is notable in this regard; see "A Psychotic Artist of the Middle Ages," in Kris, op. cit., 118–27.

51. Derrida, *Writing and Difference*, 17: "This geometry is only metaphorical, it will be said. Certainly. But metaphor is never innocent. It orients research and fixes results. When the spatial model is hit upon, when it functions, critical reflection rests within it. In fact, even if criticism does not admit this to be so."

52. See the important article by R. Krauss, "Sculpture in the Expanded Field," *October* 8 (Spring 1979): 31–44.

53. Jameson's *The Prison House of Language* (Princeton: Princeton Univ. Press, 1972), 101–217, presents a strong case for this. See also Dreyfus and Rabinow, op. cit., and T. Reiss, *The Discourse of Modernism* (Ithaca: Cornell Univ. Press, 1982).

54. See Doueihi, op. cit.; and Reiss, op. cit., 36ff.

55. In Bentham's Penitentiary Panopticon, anyone may perform the role of the observer, and the site of observation is carefully hidden (even to the extent that no shadows or extraneous light is allowed to be seen by inmates in the observation area).

56. See n. 15, this chap.

57. The Panopticon itself may be said to be anamorphic in an architectonic sense, permitting the program of the structure to become apparent only at carefully situated viewpoints. In this regard, Bentham's model can be seen as part of a common historical matrix of architectonic and urban thinking in Europe after the Renaissance. Complementary notions are discussed in F. Yates, *Theatre of the World* (Chicago: Univ. of Chicago Press, 1969), in Elizabethan and Jacobean contexts; see also Belsey, op. cit., 97f., and D. Preziosi, "Structure as Power" (forthcoming in a volume on the ideological organization and articulation of Ottoman Islamic cities). The subject is expanded upon in chap. 3 and chap. 6, sec. 3, this vol.

58. Jameson, *The Political Unconscious*, 127. Note also the remarks of Rajchman, op. cit.: "The problem with taking art as allegorical of an age, as Foucault did in *The Order of Things*, is that it entails that there is a reality (or 'spirit') of an age as a whole which *precedes* our specific problems, and which we as 'universal' intellectuals have the special office of articulating or representing." Rajchman's essay, an otherwise exemplary discussion of modernism in art, is uncharacteristically off the mark in its consideration of the intent of Foucault's notion of the *episteme*; cf. Dreyfus and Rabinow, op. cit., 18ff. and esp. 129. See also chap. 1, n. 33.

59. See n. 36, this chap.; in addition, this program necessarily involves the ideological construction of the Subject as a subject for and subject to disciplinary discourse. See Dreyfus and Rabinow, op. cit., 143–83, and R. Coward and J. Ellis, *Language and Materialism* (London: Routledge & Kegan Paul, 1977), in particular 93–121 on the subject of Lacan; they note: "Signifying practice . . . shows the constitution of a necessary *positionality*, which is the language-using subject (Lacan calls this the Symbolic). But it also shows how that positionality only appears in an ideological formation" (80).

60. A recent discussion of the modern museum as ideological iconographic program is C. Duncan and A. Wallach, "The Museum of Modern Art as Late Capitalist Ritual," *Marxist Perspectives* (Winter 1978): 28–51. The article should now be updated to accommodate the major architectonic and programmatic changes to MOMA completed in 1984, although the essential thrust of the authors' remarks

still hold. This work is part of a larger study of museological ideology currently in preparation. The work of D. Crimp has more recently extended this discussion in important ways.

61. Such a movement, of course, is embodied in that peculiar institution, the art history survey textbook, nearly all examples of which have seemed to fall into the gap of compromise between pedagogical packaging and historical seriousness, and the most prominent of which have been little more than instructor's guides for assembling slide stories for undergraduates. Alternative introductory texts to the history of art have been little better; the time for a fundamental rethinking of the entire system is long overdue. Such a rethinking should begin with a study of the ideological investments projected by the genre. A useful discussion can be found in P. Hills, "Art History Textbooks," *Artforum* 14:10 (Spring 1976): 33–42.

62. Kubler's *The Shape of Time* (New Haven: Yale Univ. Press, 1962) has been the most astute example of this interest, and the author's exhortation to open up the field of art history has influenced a whole generation of younger scholars. With regard to the latter, Kubler's text has also elicited predictable resistance on the part of practitioners bent upon preserving the *hortus inclusus* of traditional art history and flatly contradicts the disciplinary program outlined most notably by Kleinbauer (see his revealing remarks in Kleinbauer, op. cit., 32). It is perhaps ironic that the glottochronological paradigm could provide an important cognate justification for certain mainframe art historical formalisms. See Kubler's important recent article, "*The Shape of Time* Reconsidered," *Perspecta* 19 (1982): 112–21.

63. See W. D. Whitney, *Sanskrit Grammar*, 2d ed. (Cambridge: Harvard Univ. Press, 1964); Bloch, *Indo-Aryan, From the Vedas to Modern Times*, trans. A. Master (Paris: Adrien-Maissonneuve, 1965).

64. Stafford, *Voyage into Substance* (Cambridge: MIT Press, 1983). See also her "Beauty of the Invisible," *Zeitschrift für Kunstgeschichte* 43 (1980): 65–78. We shall discuss the latter in chap. 3.

65. See Kleinbauer, op. cit., 32–36. On Wölfflin and philology, see J. Hart, "Reinterpreting Wölfflin," *Art Journal* 42:4 (Winter 1982): 292–300.

66. A point made in complementary ways by Foucault, *Archaeology of Knowledge*; Reiss, op. cit., 55–107 and 351–86; Jameson, *Political Unconscious*; Coward and Ellis, op. cit., esp. 61–152; Belsey, op. cit., 56–84; Derrida, in *Grammatology*, *Writing and Difference*, *La Carte postale de Socrate à Freud et au-delà* (Paris: Aubier-Flammarion, 1980), and *La Vérité en peinture*.

67. With regard to the cinematic aspect of this, see S. Heath, *Questions of Cinema*, op. cit.; C. Metz, *The Imaginary Signifier*, trans. C. Britton, A. Williams, B. Brewster, and A. Guzzetti (Bloomington: Indiana Univ. Press, 1982); J. Ellis, *Visible Fictions* (London: Routledge & Kegan Paul, 1982); B. Nichols, *Ideology and the Image* (Bloomington: Indiana Univ. Press, 1981).

68. A good introductory survey of various aspects of this question can be found in W. J. T. Mitchell, ed., *The Language of Images* (Chicago: Univ. of Chicago Press), with articles by Argan, Taylor, Abel, Steinberg, Mast, Metz, Arnheim, Gombrich, Snyder, Searle, and others; see also W. J. T. Mitchell, "The Politics of Genre";

Stafford, "Beauty of the Invisible"; and W. Steiner, ed., *Image and Code* (Ann Arbor: Univ. of Michigan Press), with articles by Gombrich, Sebeok, Lyotard, Culler, Veltruský, Mayenova, Vallier, Frascari, Conley, and Preziosi; and see D. Preziosi, *The Semiotics of the Built Environment*.

69. The problem of defining minimal significative unities—that is, forms—remains one of the most intractable in the discipline, as we shall see in chap. 5. A good example of this is the question of Paleolithic art and its contexts, as a quick survey of literature on the subject may indicate. See Preziosi, "Constru(ct)ing the Origins of Art," *Art Journal* 42:4 (Winter 1982): 320–25, and W. Davis, "Representation and Knowledge in the Prehistoric Rock Art of Africa," *African Archaeological Review* 2 (1984): 7–35. We will examine the problem of aesthetic or artistic origins below. It will be apparent that the entire art historical issue of uniqueness versus replication is a reflection of the problematic of significative unity in a semiotic sense. Perhaps the closest to a consideration of the significative dimensions of artworks, or at least as regards painting, was the iconographic project in the early modern period of the discipline (see the following note). It is not without interest that one of Kleinbauer's objections to Kubler's project was that "Kubler's thesis asks us to focus on individual characteristics or aggregates [of artworks], rather than on the whole work of art" (op. cit., 32). In other words, it is made apparent that a consideration of the constituent elements or components in artworks is antithetical to the art historical program as Kleinbauer construes it—which means, in short, a serious consideration of the systemic or codelike aspects of visual artwork. A good introduction to this issue will be found in G. Shapiro, "Intention and Interpretation in Art," *Journal of Aesthetics and Art Criticism*, 1978. See also M. Pleynet, *Système de la peinture* (Paris: Seuil, 1977).

70. See Preziosi, "Subjects + Objects," in J. E. Copeland, ed., *New Directions in Linguistics and Semiotics* (Houston: Rice Univ., 1984), 179–205, for a general introduction and bibliography on the history of visual semiology in this century. On the relationship of the latter to iconography and to the Panofskian version of iconography in particular, see H. Damisch, op. cit.; G. C. Argan, "Ideology and Iconology," in W. J. T. Mitchell, ed., *The Language of Images* (Chicago: Univ. of Chicago Press, 1980), 15–24; G. Shapiro, op. cit.; M. Wallis, *Arts and Signs* (Bloomington: Indiana Univ. Press, 1975). The early work of Mukařovský in the 1930s on visual semiology was known in German translation at the time but evidently unknown to Panofsky; had it been, I suspect that Panofsky's version of iconography might have developed along more conceptually sophisticated lines. Panofsky also appears to have been unaware of the growing body of semiotic research on cinema. Mukařovský's body of writings on diverse aspects of art and architecture is now available in English; see J. Burbank and P. Steiner, eds. and trans., *Structure, Sign and Function* (New Haven: Yale Univ. Press, 1978). The general subject of the relationships between traditional iconographic methodologies, including Panofsky's, and modern visual semiology is discussed at length in chap. 4, this vol. For an important critique of Panofsky's relationship (or nonrelationship) to the work of Saussure, see P. Bourdieu, *Outline of a Theory of*

Practice (Cambridge: Cambridge Univ. Press, 1977), 23f.

71. A glance at Eagleton's work, op. cit., 44–101, will reveal a similar perspective for literature; along with the earlier work of P. Macherey (*A Theory of Literary Production*, trans. G. Wall [London: Routledge & Kegan Paul, 1978]), Eagleton's work is a good introduction to the question of the productive processes in the literary arts and their relation to ideology.

72. The term is Derrida's and refers to the bias toward the Voice in Western philosophy and art, on which his *Grammatology* and *Writing and Difference* are the most useful introductions. See especially G. Spivak's introductory essay to the former, as well as Derrida's *Positions*, esp. 15–36. Cf. Bryson's *Vision and Painting*, 133–62. On the general problem of the coordination of Vision and Voice, see Derrida's *La Vérité en peinture*, esp. 12ff.

73. On the traditional role of the critic in literature, see Eagleton, op. cit., 11–43.

74. Eagleton's *Literary Theory* (Minneapolis: Univ. of Minnesota Press, 1983) considers the problem of the "openness of the literary text" and the various ways in which the question has been dealt with by recent work on reader-response theory; see esp. 81f. An excellent introduction to the latter is J. P. Tompkins, "The Reader in History," in *Reader-Response Criticism*, ed. Tompkins (Baltimore: Johns Hopkins Univ. Press, 1980), 201–32.

75. See J. Baudrillard, *For a Critique of the Political Economy of the Sign*, trans. C. Levin (St. Louis: Telos Press, 1981), esp. 102–22. In various works, Baudrillard argues that consumption has today become a kind of labor, an active manipulation of signs in which the individual desparately attempts to organize his privatized existence and invest it with meaning: One consumes not objects as such but systems of objects. It is this very condition of semiosis, engendered by the universalization of commodity relations, that privatizes experience in the first place in the contemporary world. As we consume the code, in effect, we reproduce the system (see the translator's introduction, 5ff.). In the pages referenced above, Baudrillard discusses contemporary art and the format of the modern art auction. On Baudrillard's critique of Marxism, see 5–28.

76. We will have occasion to consider the object domain of linguistics in chap. 4.

77. For Derrida, there can only be traces, the originary Voice being a projection. See "Freud and the Scene of Writing," in *Writing and Difference*, 196–231.

78. R. Arnheim, "Gestalt and Art," *Journal of Aesthetics and Art Criticism* 2 (1943): 71–75; Arnheim, "The Gestalt Theory of Expression," *Psychological Review* 56 (1949): 156–71; E. Gombrich, "The Use of Art for the Study of Symbols," *American Psychologist* 20 (1965): 34–50; Gombrich, "The Mask and the Face," in E. Gombrich, J. Hochberg, and M. Black, eds., *Art, Perception and Reality* (Baltimore: Johns Hopkins Univ. Press, 1972); 1–46.

79. M. Baxandall, *Painting and Experience in Fifteenth Century Italy*, (Oxford: Oxford Univ. Press, 1972); Bryson, op. cit.; T. J. Clark, *Images of the People*, 2d ed. (Princeton: Princeton Univ. Press, 1982); M. Fried, *Absorption and Theatricality* (Berkeley: Univ. of California Press, 1980); Krauss, op. cit. See also n. 6, this chap.

80. See, as exceptions, the body of writing of Arnheim, grounded in Gestaltist theory

(for example, "A Plea for Visual Thinking," *Critical Inquiry* 6 [Spring 1980]: 489–97); or the works of H. Gardner (*Artful Scribbles* [New York: Basic Books, 1980]), J. Goodnow (*Children Drawing* [Cambridge: Harvard Univ. Press, 1977] — the best introduction), or M. Krampen (*Wie Kinder Zeichnen?* [Stuttgart: Design Center, 1980]), which relates research on children's art to contemporary psychological and semiotic work.

81. See the recent volume by S. Alpers, *The Art of Describing* (Chicago: Univ. of Chicago Press, 1983), for an illuminating discussion of this problem.

82. See Coward and Ellis, op. cit., esp. 108f., on the Lacanian concept of the Other, the positionality that characterizes language — in which meanings exist for a subject who functions as the place of intention of those meanings, commencing with the separation of subject and object; these specular images are seen as making up the prototype of the world of objects. The best recent introduction to the work of Lacan is J. F. MacCannell, *Figuring Lacan* (Lincoln: Univ. of Nebraska Press, 1986); see also A. Lemaire, *Jacques Lacan*, trans. D. Macey (London: Routledge & Kegan Paul, 1977), with an extensive, though somewhat dated, bibliography. As Coward and Ellis observe (op. cit., 76), "the function of ideology is to fix the individual in place as subject for a certain meaning. This is simultaneously to provide individuals with a subject-ivity, and to sub-ject them to the social structure with its existing contradictory relations and powers." Cf. Foucault's discussion of the panoptic paradigm (discussed in chap. 3), and see also Preziosi, "Reckoning with the World," *American Journal of Semiotics* 4:1–2 (1986): 1–15. The subject is taken up in a particular art historical setting in chap. 6, sec. 3.

83. See n. 17, this chap.; and chap. 5, sec. 3.

84. Preziosi, "Subjects + Objects," 179–205.

85. Heath, op. cit., 8.

86. This is poignantly illustrated in the recent article by J. Elkins, "Art History without Theory," *Critical Inquiry* 14 (Winter 1988): 354–78: "Art history is in an amazing position: it is made possible by unstated notions and beliefs which cannot be brought to light. If they were, they would be contradicted by what practice is actually doing, or else they would collapse under the weight of their own inconsistency. At the same time art history depends on the repression of such ideas and cannot accommodate their discussion" (377).

CHAPTER THREE: *The Panoptic Gaze and the Anamorphic Archive*

Epigraphs: P. Francastel, *Etudes de sociologie de l'art* (Paris: Denoël, 1970), 136–37; M. Foucault, "The Eye of Power," in C. Gordon, ed., *Power/Knowledge: Selected Interviews and Other Writings by Michel Foucault 1972–1977* (New York: Pantheon, 1980), 152; D. Carroll, *The Subject in Question* (Chicago: Univ. of Chicago Press, 1982), 157; R. Coward and J. Ellis, *Language and Materialism* (London: Routledge & Kegan Paul, 1977), 42.

1. See T. Reiss, *The Discourse of Modernism* (Ithaca: Cornell Univ. Press, 1982), 41–42.

2. Ibid., 31–54. Analytico-referential discourse, according to Reiss, assumes that the world represents a fixed object of analysis quite separate from the forms of discourse by which individuals speak of it and by which they represent their thoughts.

3. Ibid., 33. See also B. Stafford, *Voyage into Substance* (Cambridge: MIT Press), 1984.

4. See sec. 2, this chap.

5. Reiss, op. cit., 33, and his chap. on Bacon and Descartes (198–225). See also F. Yates, *The Art of Memory* (Chicago: Univ. of Chicago Press, 1966), esp. chap. 17, "The Art of Memory and the Growth of Scientific Method," 368–89.

6. Reiss, op. cit., 31, 33f.; discussed in Galileo's *Discourse on Comets* (1619) in *The Controversy of the Comets of 1618*, trans. S. Drake and C. D. O'Malley (Philadelphia: Univ. of Pennsylvania Press, 1960), 44, 223.

7. Reiss, op. cit., 54. He discusses what he terms "the discourse of patterning" in chap. 2, 55–105.

8. See sec. 4 and nn. 98–102, this chap.

9. Reiss, op. cit., 56, 79. Reiss is arguing that the Renaissance marks a significant break with antiquity with regard to its discursive practices (in contrast to views put forth by Husserl and Derrida) and enlists Panofsky's perspective in *Renaissance and Renascences in Western Art* (New York: Harper & Row, 1969), esp. 4, 37.

10. This point was made in a similar fashion by S. Alpers in *The Art of Describing* (Chicago: Univ. of Chicago Press, 1983), xix: "To a remarkable extent the study of art and its history has been determined by the art of Italy and its study. This is a truth that art historians are in danger of ignoring in the present rush to diversify the objects and the nature of their studies. Italian art and the rhetorical evocation of it has not only defined the practice of the central tradition of Western artists, it has also determined the study of their works. . . . I have in mind the Albertian definition of a picture." See also nn. 8 and 11 in the same introduction. As will be evident in this chapter and the following one, the perspectives elaborated here suggest the modern discipline of art history conflates systems of value in which meaning is both read (Alpers's Italian perspective) and seen (Alpers's Dutch perspective). Alpers's distinctions between the two visual traditions may indeed be historically pertinent; it cannot be maintained, however, that the modern discipline is wholly dependent upon the rhetorical system of the former tradition.

11. L. Alberti, *On Painting* [ca. 1435] (New Haven: Yale Univ. Press, 1966), 51. An excellent introduction to this subject, and a good discussion of the general question of perspectival realism, is J. Snyder, "Picturing Vision," *Critical Inquiry* 6 (Spring 1980): 499–526. See also S. Heath, "Narrative Space," *Screen* 17:3 (Fall 1976): 68–112 and nn. 12 and 20.

12. See B. Nichols, *Ideology and the Image* (Bloomington: Indiana Univ. Press, 1981), 52–57.

13. Ibid., 53.

14. Heath, op. cit., 29 and n. 12. Galileo referred to this as "una confusa e inordinata mescolanza di linee e di colori" (Galileo Galilei, *Opere*, ed. A. Favaro, vol. 9, [Florence: Edizione nazionale: 1929]).

15. Heath, loc. cit.; see also E. Gilman, *The Curious Perspective* (New Haven: Yale Univ. Press, 1978) on the subject of anamorphism more broadly.
16. Alberti, quoted and discussed in N. Bryson, *Vision and Painting* (New Haven: Yale Univ. Press, 1983), 102. We will discuss Bryson's book in the following chap.
17. M. Baxandall, *Giotto and the Orators* (Oxford: Clarendon Press, 1971), 121–39; Bryson, op. cit., 99; and see Yates, op. cit., 92–94, on Giotto's Capella Arena at Padua and its *imagines agentes*.
18. These observations were presented in a lecture at the Center for Advanced Study in the Visual Arts, National Gallery of Art, Washington, D.C., November 1982, on the connections between the new perspectivalism and the discursive space of chess. Damisch's views on the positionalities induced by perspectivism can be found in "Six Notes in the Margin of Meyer Schapiro's 'Words and Pictures,'" *Social Research* 45:1 (Spring 1978): 15–35, in which he also connects the problem with Benveniste's work on linguistic positionality. See also Damisch, "La prise de langue et le faire signe," *Actes du Colloque Roland Barthes* (Cerisy-la-Salle: Seuil, 1977); and Damisch, *L'Origine de la perspective* (Paris: Flammarion, 1987), esp. pt. 1, 19–64.
19. Bryson, op. cit., 121.
20. Ibid. Bryson contrasts this *durée* with "the instantaneous, duration-free time of the compositional structure (which is also, given the assiduous efforts of the 'shifters', the alleged instant of the founding perception)." The term *shifters*, taken from linguistics, refers to linguistic elements whose meaning shifts to one or another concrete referent. See R. Jakobson, "Two Aspects of Language and Two Types of Aphasic Disturbances," in S. J. Rudy, ed., *Selected Writings of Roman Jakobson* (The Hague: Mouton, 1971), 2: 239–59. We will take up the issue in chap. 4 in connection with our discussion of signification.
21. Foucault, remarkably, does not connect panopticism with its Albertian background, despite his attention to the cognitive and perceptual issues raised by *Las Meninas*. See *"Las Meninas"* in *The Order of Things* (New York: Random House, 1970), 3–16. Foucault's essay has engendered discussions of the problems of representation addressed by Velasquez's painting of 1656. See J. Searle, *"Las Meninas* and Representation," *Critical Inquiry* 6 (1980): 477–88; J. Snyder and T. Cohen, "Reflections on *Las Meninas,"* *Critical Inquiry* 7 (1980): 429–47; L. Steinberg, "Velazquez' *Las Meninas,"* *October* 15 (1981): 45–54; J. Brown, "The Meaning of *Las Meninas,"* in his *Images and Ideas in Seventeenth Century Spanish Painting* (Princeton: Princeton Univ. Press, 1978), 91; S. Alpers, "Interpretation without Representation, or, The Viewing of *Las Meninas,"* *Representations* 1:1 (1983): 31–42.
22. J. Locke, *An Essay Concerning Human Understanding*, ed. A. C. Fraser (1894; rpt., New York: Pantheon, 1959), 1:121–22, 211–12. Locke, as Reiss notes (op. cit., 376), rejected outright the possibility of unconscious elements in the mind.
23. See chap. 2, sec. 1 and n. 1.
24. Yates, op. cit., chap. 6, 129–59, remains the most important discussion. A diagram of Camillo's Memory Theater is given between 144–45.
25. Viglius Zuichemus's remarks are recorded in his letters to Erasmus (Erasmus, *Epistolae*, P. S. Allen, ed. [Oxford: Clarendon Press, 1906–58], 10: 29–30). Eras-

mus's attitudes toward Camillo's theater are discussed by Yates, op. cit., 129–34, 157, 242. Yates discusses the Hermetic-Cabalist traditions during the Renaissance in *Giordano Bruno and the Hermetic Tradition* (Chicago: Univ. of Chicago Press, 1964), chaps. 1–10. Camillo (Giulio Camillo Delminio), born ca. 1480, was for a time a professor at Bologna. His chief patron was to become the king of France, François Ier. In 1558, fourteen years after Camillo's death, a wooden replica of the theater was built in the French court.

26. Yates, *Art of Memory*, 145.

27. The Memory Theater in effect reversed the normal function of the theater: The solitary spectator stands where the stage would be and looks toward the auditorium, reviewing images on the seven rising tiers. The theater represented the universe expanding from first causes through the stages of creation. See Yates, *Art of Memory*, 137ff., for a detailed description.

28. On Giotto, see especially Yates's discussion in *Art of Memory*, 92–94 and 97, pls. 3a and 3b. Yates connects these practices of painting *imagines agentes* with the medieval rhetorical tradition centered around the Ciceronian *Ad Herennium* and the Petrarchian *Rerum memorandarum libri* of 1343–45, which was based upon Cicero's *De inventione*. On the part played by Dante in this tradition, and in particular the mnemonic architectonics of the Inferno, Purgatorio, and Paradiso, see *Art of Memory*, 95. See also n. 86, this chap.

29. See sec. 4, this chap.

30. On the Albertian Window, see M. Hagen, ed., *Alberti's Window*, vol. 1 of *The Perception of Pictures* (New York: Academic Press, 1980), esp. the foreword by J. Gibson, and chap. 5, "The Renaissance Artist as Quantifier," by S. Edgerton, Jr., 179–212. Note his interesting discussion of fifteenth-century scientific illustrations and the invention of "exploded" and "transparent" views of machinery (200–12).

31. See E. Benveniste, "The Correlations of Tense in the French Verb," in *Problems in General Linguistics*, trans. M. Meek (Coral Gables, Fla.: Univ. of Miami Press, 1971), for the distinction between *histoire* and *discours*. The *récit historique* characteristically "excludes every 'autobiographical' linguistic form" (206). "No one speaks here; the events seem to narrate themselves" (208). The subject is taken up by Carroll, op. cit., 20ff.

32. The imaginary world of the museum is not, strictly speaking, a utopia but rather a heterotopia (in the sense used in the preface)—that is, not a transitive or direct impression of actual conditions but rather an orchestration of disparate elements to create an alternate order within society, offering the compensations of lucidity against the chaos of ordinary life. In that sense, all of the "invisible cities" of I. Calvino's *Invisible Cities* (New York: Harcourt Brace Jovanovich, 1974) are heterotopias rather than utopias.

33. See chap. 2, n. 42, for sources. *Le Panoptique*, a facsimile of the 1791 English edition of Bentham's *Panopticon*, was published in Paris by Belfond in 1977, with a preface by Foucault. That preface is reprinted as "The Eye of Power" in C. Gordon, ed., *Power/Knowledge* (New York: Pantheon, 1980), 146–65. The Belfond edition contains an excellent bibliography on Bentham and his project.

34. Fo .cault's extensive discussion on the Panopticon can be found in *Discipline and*

Punish (New York: Pantheon, 1980), 195–228.

35. On logocentrism, see chap. 2, n. 72.

36. Foucault, *Discipline and Punish*, 200.

37. Ibid., 201–02.

38. Ibid., 203 with references.

39. The literature on the subject is extensive. A good introduction to some basic issues can be found in A. Vidler, "The Idea of Type," *Oppositions* 8 (1977): 95–115 with references; see esp. his discussions of Ledoux and Quatremère de Quincey.

40. Foucault, *Discipline and Punish*, 205–06.

41. Foucault, "Eye of Power," 152.

42. Foucault, *Discipline and Punish*, 215.

43. Foucault, "Eye of Power," 155.

44. Ibid., 147.

45. On Ledoux, see n. 39, this chap.

46. Foucault, *Discipline and Punish*, 201. On subjects as bearers or enacters of power relations (and ideology) see D. Preziosi, "Reckoning with the World," *American Journal of Semiotics* 4:1 (1986): 1–15, on the orchestration of the Propylaia of the Athenian Akropolis as a site for fixing the subject in place for the construal of certain meanings. We will expand on that subject in chap. 6.

47. That behavior can be accounted for not only visually. In Bentham's Panopticon, the chief inspector was connected with each cell by means of tin tubes that allowed him to hear inmates speaking and also, apparently, to communicate with inmates; this was an ingenious yet simple intercom system. See Foucault, "Eye of Power," 154.

48. On instrumentalism, see the discussions in chap. 2, esp. secs. 1 and 2, passim.

49. Lacan's imaginary order is a concept not to be contrasted to the concept of real; rather, it refers to imagery—the imagistic identification of self as a unified whole in the "mirror" stage of development. A good introduction to Lacan's work can be found in R. Coward and J. Ellis, *Language and Materialism* (London: Routledge & Kegan Paul, 1977), 61–121, esp. 75ff. and 93ff.; a useful recent introduction is J. MacCannell, *Figuring Lacan* (Lincoln: Univ. of Nebraska Press, 1986); see also J. Gallop, *Reading Lacan* (Ithaca: Cornell Univ. Press, 1985).

50. On Lacan's symbolic order, see Coward and Ellis, 80–81, 112–17, 134–45. This order is preestablished, that within which the individual subject, in order to become a signifying subject, has to find itself. Signification only becomes possible with the construction of an Other as a place of the signifier—that is, the construction of an outside referent by which the individual's voice is verified. We will discuss the Lacanian paradigms in chap. 4 in connection with the concept of meaning in the discipline.

51. See Coward and Ellis, op. cit., 76ff., for a good introduction to this issue, with connections to Althusser; see Althusser, *Eléments d'autocritique* (Paris: Hachette, 1974), esp. 37.

52. J. Kristeva, *La Révolution du langage poétique* (Paris: Editions du Seuil, 1974), 44.

53. J. Lacan, *Les Quatre Concepts fondamentaux de la psychanalyse*, vol. 11 of *Le Séminaire*

(Paris: Editions du Seuil, 1973), 185.

54. From Simon's novel *Histoire*, 67; quoted in Carroll, op. cit., 153.

55. To capture this essence of the individual in a portrait is thus to immobilize him by spatializing diachrony and giving an illusion of presence. This corresponds to the fixing in place of the Lacanian Subject: Both are imaginary artifacts.

56. A useful introduction to the history of museums and collecting can be found in J. Alsop, *The Rare Art Traditions* (New York: Harper & Row, 1982), 615–65, with extensive bibliography. Our concern here is with the modern art museum as an apparatus for situating viewer with respect to viewed object, more *galleria* than *museo* in A. Danto's terms (see "Dürer and the Art of Nuremburg," *The Nation* [June 21, 1986]: 865–68). Two recent articles are essential here: D. Crimp, "On the Museum's Ruins," *October* 13 (Summer 1980): 41–58; and C. Duncan and A. Wallach, "The Museum of Modern Art as Late Capitalist Ritual," *Marxist Perspectives* 1:4 (Winter, 1978): 28–51. A critical study of the museum public can be found in P. Bourdieu and A. Darbel, *L'Amour de l'art* (Paris: Editions du Seuil, 1969). See also O. Impey and A. MacGregor, *The Origins of Museums* (Oxford: Oxford Univ. Press, 1985).

57. Discussed in D. Preziosi, "*On signe ici*," a paper presented at the Symposium *L'Amour Fou: Photography and Surrealism*, Corcoran Gallery of Art, Washington, D.C., September 1985; also discussed in chap. 4.

58. Duncan and Wallach, op. cit., consider the ways in which the Museum of Modern Art in New York operates as a ritual labyrinth glamorizing competitive individualism and naturalizing the history of modern art as a progressive evolution. Discussions of MOMA's biases can be found in *Artforum* (Oct. 1974): 51–57, and (Nov. 1974): 46–53, in connection with observations of the art historical bind wherein abstract expressionism completed the inner logic of the discursive space of the museum. Art of the 1960s and 1970s, collected by MOMA, appeared principally in rotating, temporary installations. Since the time of Duncan and Wallach's essay, there have been additions and expansions to the structure; nonetheless, the same discursive logic can be found to apply.

59. S. Lotringer, "Cryptique," in *Claude Simon* (Paris: *1018*, 1975), 316–17. The orientation described here recalls that of traditional literary critical interpretation, posited as describing the central or dominant point of view in a novel: summarizing novels such that their unity is made visible in the name of an ideal of form imposed on them (making the legible visible, as it were, the equivalent of the art historical task of making the visible legible). See Carroll, op. cit., chap. 3, 51ff., in connection with the Subject for Henry James as one posited in a classically philosophical manner as presence (H. James, "The Art of Fiction," in L. Edel, ed., *The House of Fiction* [London: Mercury, 1962]); see also chap. 2, n. 3, for references to Derrida's deconstruction of presence, and n. 89, this chap.

60. Derrida's *La Vérité en peinture* (Paris: Flammarion, 1975) is essential on the problem of enframing; see also C. Owens, "Detachment from the *parergon*," *October* 9 (1979): 12–49.

61. The art object, in this apparatus, is always, ultimately, a metaphor of the Self. For

a parallel instance in realist cinema, see J.-L. Baudry, "Effets idéologiques de l'appareil cinématographique de base," *Cinéthique* 7–8 (1970): 1–8, in which he considers the relationship of the cinematic apparatus to *camera obscura*. The ideological effects of different lenses (for example, wide-angle or telephoto lenses) are still defined in relation to the ideology inherent in perspective. As a metaphor of the Self, the art object is thus a medium, a conveyance of meaning, of the meaning of the Self, a Self composed as finished, homogeneous, the mirror image of the realist perspectival object. As Derrida noted, "Every time philosophy defines art, masters it, and encloses it within the history of meaning or the ontological encyclopedia, it is assigned the function of a *medium*" (Derrida, op. cit., 41).

62. In its circular arrangement of continuous tiers around a central open atrium and the disposition of artworks along a continuous peripheral path, Frank Lloyd Wright's museum repeats the discursive space of Bentham's Panopticon; the viewer is set in motion, much like a prison guard making the rounds, instead of occupying a central fixed position. There is such a central position in the Guggenheim, corresponding to the observation room of the Panopticon, but it is a virtual position—in midair at the center of the atrium, a position no one without a ladder could physically occupy. In that sense, the ideal position of visual central- ity in the Guggenheim always *beckons*, is always made approximate from the views across the atrium: it is the ghost in the machine.

63. See Duncan and Wallach, op. cit., on the fixity of itinerary. One way in which the modern art museum works to establish itineraries is by alluding to past or present moments on the passage through. In the Indiana University Art Museum, designed by I. M. Pei, there is an art history itinerary mapped out on the ground floor, consisting of a unicursal maze starting with ancient art and proceeding up to contemporary art. Some of the walls of this maze have large cutouts, enabling the visitor to see vignettes of later or earlier artworks: The visitor is constantly situated relative to present and past. See M. Wallace, "Visiting the Past," in S. Benson, S. Brier, and R. Rosenzweig, eds., *Presenting the Past* (Philadelphia: Temple Univ. Press, 1986), 137–61.

64. On geomancy, see Yates, *Art of Memory*, 336; Robert Fludd's memory arts and memory theaters in the early seventeenth century are described in C. H. Josten, "Robert Fludd's Theory of Geomancy," *Journal of the Warburg and Courtauld Institutes* 27 (1964): 327–35. Ancient Chinese geomantic practices are discussed in J. Needham, *Science and Civilisation in China* (Cambridge: Cambridge Univ. Press, 1960), vol. 3, *Mathematics and the Science of the Heavens and the Earth*. Yates (342ff.) discusses the relationships between Fludd's Memory Theater and the original Globe Theatre erected in London in 1559.

65. See Benson, Brier, and Rosenzweig, op. cit., 151ff.

66. See chap. 2, secs. 1 and 5.

67. See chap. 2, sec. 1, with n. 36.

68. M. Innes, *A Private View* (London: Gollancz, 1952), 12; Michael Innes is the pen name of J. I. M. Stewart, formerly Reader in English in Oxford University. Any

semiotics of taste would surely begin with an analysis of its nonverbal signaling codes, which might also constitute *eremai* in spatiokinetic display (see chap. 6, n. 75).

69. This could hardly be otherwise in an age when the cinema is the ubiquitous primary instance of the popular art form; it could be argued that in the twentieth century all of the traditional pictorial arts have been subsumed into the discursive frame of the cinematic apparatus. The academic discipline of art history has never, or only rarely, dealt with the cinema; and the history, theory, and criticism of film has emerged as a distinct discipline in the American university system, with its own intensely rich theoretical and critical tradition.

70. The Fogg was modern, that is, in the senses elaborated upon below. A useful introductory account of this development is given in G. Chase, "The Fine Arts 1874–1929," in S. E. Morison, ed., *The Development of Harvard University* (*Since the Inauguration of President Eliot*) *1869–1929* (Cambridge: Harvard Univ. Press, 1930), 13–145.

71. The Fogg Art Museum, erected in 1894–95, was founded in memory of William Hayes Fogg of New York by his wife. It remained the home of the discipline for thirty-two years, although there were continual complaints from staff and students about inadequate space and technical facilities. Chase records that the architect, Richard Hunt, drew up plans without consulting the teaching staff. The first curator was Charles Henry Moore, who had been an instructor in free-hand drawing and water color in the university since 1871 (although his teaching was physically carried out in the Lawrence Scientific School, and Harvard College undergraduates were not able to take his classes until 1874, the year that Charles Eliot Norton was appointed as the first instructor in art history in the university). Moore's title was changed to director in 1896.

72. Pressure to change the Fogg Art Museum into a more complete gallery of original works (apart from the Fogg Collection bequest already installed) was strong from the outset: In its first year of existence, sixteen Greek vases were loaned by a recent alumnus; and in 1895–96 two collections of engravings, already bequeathed to the university by Francis Calley Gray and John Randall were transferred to Cambridge. The Gray and Randall Funds provided a modest sum for increasing these collections (which already numbered over thirty thousand). Extensive alterations and rearrangements were made to the building in 1912–13 to accommodate more original artworks and to improve existing teaching facilities.

73. The new building was designed by Charles Coolidge with the assistance of Meyrick Rogers; Rogers, a former staff member of the Metropolitan Museum in New York, had architectural expertise in the areas of museum planning, circulation, and lighting. See also C. Jones, *Modern Art at Harvard* (New York: Abbeville Press, 1985), esp. 15–30.

74. An adequate history of the evolution of academic architecture in the United States is yet to be written. To be sure, several studies of American campus planning exist, but very little attention is characteristically payed to the problem of siting disciplines in architectonic space with respect to the actual organization of

internal dispositions of disciplinary tasks. A highly suggestive beginning can be found in Derrida's "The Principle of Reason," *Diacritics* 13:3 (Fall 1983): 3–20, a response to J. Siegel's "Academic Work," *Diacritics* 11:1 (Spring 1981): 68–83, which comments on K. Parsons, *The Cornell Campus* (Ithaca: Cornell Univ. Press), 1968. See also S. Weber, "The Limits of Professionalism," *The Oxford Literary Review* 5:1–2 (1982): 59–72. See also chap. 1, sec. 2.

75. It was not a panopticon in a literal sense of a common framework installing a single encompassing visibility.

76. Chase, op. cit., 133. The stances can be considered as determining with respect to (1) the organization of the archive and (2) the organization of courses of study, both formatted so as to reveal the essential genius of a people. The task is discussed in some depth by Derrida (see n. 74, this chap.). In that sense, research carried out in the archive and the classroom is necessarily already oriented as to results.

77. The operators of the apparatus—teaching staff, students, visiting researchers, and so on—perform an operation not unlike that of the scientific draughtsman in creating transparent or exploded views on the data mass. Indeed, the primary task of research might be seen as analogous to this latter activity in its very pragmatics: establishing a stance from which the data mass is rendered transparent, its component parts displayed, and the logical connections between components described. See Edgerton, op. cit. (n. 30, this chap.).

78. Fine Arts 2 and 3 were regularly taught by Norton. As of this writing, I have been unable to ascertain the subjects of Norton's advanced courses.

79. Chase, op. cit., 137. This new modern course dealt largely with French Impressionism and Postimpressionism, and their relationships to the earlier realist tradition.

80. It is important to stress Norton's orientation toward literary history and criticism. In no small measure, early art history in the United States was legitimized by its association with a discipline already assimilated into the university system. For an illuminating discussion of the growth of "English studies" (principally in England), see T. Eagleton, *Literary Theory* (Minneapolis: Univ. of Minnesota Press, 1983), esp. chap. 1, 17–53. The key figure in this rise was Matthew Arnold. By linking the newly dominant middle classes to "the best culture of their nation," the schools would confer on them "a greatness and a noble spirit, which the tone of these classes is not itself at present adequate to impart." English studies were designed to become the equivalent of the classics for the rising bourgeoisie (who had no Latin or Greek). There is a rich literature on this subject; a good introduction can be found in W. Spanos, "The Uses and Abuses of Certainty," *Boundary 2* 12:3 and 13:1 (a special double issue entitled *On Humanism and the University*). Spanos's remarks on the new Harvard core curriculum and on the recent report on the state of the humanities in the United States authored for the recent Reagan administration by William Bennett are especially incisive. In contrast to the latter, Matthew Arnold's remarks are refreshingly unhypocritical, as are many early writings on the social importance of English studies: "Deny to

working-class children any common share in the immaterial, and presently they will grow into the men who demand with menaces a communism of the material" (G. Samson, *English for the English* [1921], quoted by C. Baldick, *The Social Mission of English Criticism* [Oxford: Oxford Univ. Press, 1983], 153).

81. The Vasarian framework is examined in chap. 2, sec. 1.

82. See G. Richter, *Sculpture and Sculptors of the Greeks*, 4th ed. (New Haven: Yale Univ. Press, 1970).

83. For an excellent introduction to Wölfflin's intellectual and methodological development, see J. Hart, "Reinterpreting Wölfflin," *Art Journal* 42:4 (Winter 1982): 292–300. The son of a noted classical philologist with an abiding interest in methodological exactitude based on the comparative method, he was grounded, even in his earliest major works of the late 1880s, in the affordances of filmic technology, notably in what today is referred to as lantern-slide comparison. On the relation of art history to philology, see chap. 2, sec. 4 and n. 62. In the case of new institutions like the Fogg Art Museum, photography and its slide technology clearly served to make up for a lack of original artworks in the collection. And yet there is another important reason for its assimilation into the new discipline: It permitted the possibility of a more "scientific" approach to the study of the history of art by reducing all analysands to a common scale and frame for comparison and contrast. Variations within the frame (like those observable in the lens of a telescope or a microscope) could be immediately and readily linked to other characteristics of the object of study, enabling generalizations and broad principles to be derived.

84. In other words, it is less like Borges's "Fantasia of the Library" and more like the library in Umberto Eco's *The Name of the Rose*.

85. See the discussion in sec. 3, this chap.

86. See M. Baxandall on this: *Painting and Experience in Fifteenth Century Italy* (Oxford: Oxford Univ. Press, 1972), esp. his discussion of *imagines agentes*, 40–46.

87. I am not suggesting that this is a neutral data mass waiting to be unlocked by the desires and intentions of an independent Subject: The point here is that these desires and active intentions are themselves prefabricated within the entire scopic apparatus of the discipline. This is not to suggest that they are totally predetermined; rather, that what may be intended is always articulatable within the framework of patterns of expectancies cued by the archive itself.

88. A good introduction to this subject can be found in Coward and Ellis, op. cit., 97ff. But see chap. 2, n. 36, this vol.

89. On the question of fixing in place, see D. Polan, "Above All Else to Make you See," *Boundary* 2 11:1–2 (Fall/Winter 1982–83): 129–44. Although dealing specifically with what he terms a "cinema of the spectacle," Polan's remarks have a broader pertinence. He notes that entertainment should be understood more closely with respect to its etymological sense as related to containment, a holding in place, in which awareness of any realities other than the aesthetic object at hand gives way to a pervading image of sense as something that "simply happens." This sense of the aestheticization of reality resonates with the observations of W.

Benjamin in "The Work of Art in the Age of Mechanical Reproduction," in *Illuminations*, ed. H. Arendt (New York: Schocken, 1969), and the fabrication of presence in such an order is the subject of Derrida's "Structure, Sign and Play in the Discourse of the Human Sciences," in *Writing and Difference* (Chicago: Univ. of Chicago Press, 1978), 278–93.

90. See Coward and Ellis, op. cit., 98–99.

91. Ibid., 111. The self-presence of the subject, according to Lacan, arises from a primary alterity: The subject represents itself by a stand-in. Discussed in Lacan, op. cit., vol. 11, passim, esp. 185f.

92. Every house of the discipline aspires to the condition of encyclopedic fullness, transcending the traditional selectivity of the museum of originals, as André Malraux astutely observed a generation ago.

93. Carroll, op. cit., 192.

94. Derrida notes in *Truth in Painting* (63): "Every analytic of aesthetic judgment supposes up to the end that it is rigorously possible to distinguish between the intrinsic and the extrinsic. Aesthetic judgment *must* concern itself rightly with intrinsic beauty, not with ornaments and surroundings. It is necessary therefore to know . . . what is being excluded as frame *and* as outside-the-frame."

95. Carroll, op. cit., 193. See also Owens, op. cit., 44. The *parergon* (a term resuscitated from ancient Greek by Kant in speaking of the frames of painting) follows exactly the same logic as the supplement in Rousseau, discussed by Derrida in *Of Grammatology*, trans. G. Spivak (Baltimore: Johns Hopkins Univ. Press, 1976). As the latter demonstrates, what is normally construed as an extrinsic adjunct is in fact that by which the intrinsic can only be defined. In that sense, the discipline of art history might rightly be described as the history and theory of the phenomenon of enframing as such. See the discussions in chap. 6, sec. 3.

96. S. Heath, *Questions of Cinema* (Bloomington: Indiana Univ. Press, 1981), 8.

97. On the history of scenography as such, see D. Graham, "Theatre, Cinema, Power," *Parachute* (Summer 1983): 11–19; K. Forster, "Stagecraft and Statecraft," *Oppositions* (Summer 1979): 63–87; R. Klein, "Vitruve et le théâtre de la Renaissance italienne," in Klein, ed., *La Forme et l'intelligible* (Paris: Gallimard, 1970), esp. 297ff.; and J. Clair, "Seven Prolegomenae to a Brief Treatise on Magrittian Topics," *October* 8 (Spring 1979): 89–110, esp. 94ff.

98. On August 13, 1883, Kaiser Wilhelm, emperor of Germany, stepped out onto a Berlin stage. Before him was a vast battlefield representing the battle with the French at Sedan. Very slowly, the stage began to revolve, giving the emperor a panoramic view across the battlefield. The Kaiser was in fact standing in a circular theater several stories high, viewing a painted panorama of such perspectival fidelity that all visitors reported that they had been transported back in time and awestruck by the naturalness of the scene. A dozen years later, the Lumiere brothers held the first cinema performance in a Paris cafe (in which the image moved rather than the stage). The Berlin panorama was one of the last great successful examples of a medium that enjoyed extraordinary popularity throughout the nineteenth century. See E. Breitbart, "The Painted Mirror," in Benson,

Brier, and Rosenzweig, op. cit., 105ff. The Forest Lawn auditorium clearly combines elements of the cinema, the panorama or diorama, and the art history lecture hall.

99. Yates, *Art of Memory*, chap. 17, 368ff.

100. Ibid., 369. In 1632, five years before the publication of Descartes's *Discourse on Method*, the subject of method was addressed at a conference in Paris, which included discussions of the relative merits of Cabalistic methodologies, the methodologies of the *ars memorativa*, and "the method of ordinary philosophy." See N. Gilbert, *Renaissance Concepts of Method* (New York: Columbia Univ. Press, 1960), and W. Ong, *Ramus, Method, and the Decay of Dialogue* (Cambridge: Harvard Univ. Press, 1958), 231–39.

101. Yates, *Art of Memory*, 372. Francis Bacon was one of the few who actually had a "memory house" constructed, as recorded in J. Aubrey's *Brief Lives* (Ann Arbor: Univ. of Michigan, 1962), 14. On causing phenomena to "lie orderly" (Locke), see n. 22, this chap.

102. As described by Yates (*Art of Memory*, 374f.), Descartes's suggested reform of memory is closer than Bacon's to the older tradition of occult memory, which was in fact organized around networks of causal relationships.

103. Ibid., 376.

CHAPTER FOUR: *The Coy Science*

Epigraphs: I. Calvino, *Invisible Cities*, trans. W. Weaver (New York: Harcourt Brace Jovanovich, 1974), 96–97; J. Derrida, "Semiology and Grammatology," in *Positions*, ed. A. Bass (Chicago: Univ. of Chicago Press, 1981), 19–20; S. Freud, "The Moses of Michelangelo," *Imago* 3 (1914): 222; H. Balzac, *Livre mystique* (Paris: Werdet, 1835), 26; E. Panofsky, *Studies in Iconology* (1939; rpt. New York: Harper & Row, 1962), 5; A. C. Argan, "Ideology and Iconology," *Critical Inquiry* 2 (Winter 1975): 299.

1. R. Williams, *Marxism and Literature* (Oxford: Oxford Univ. Press, 1977), 149–50.

2. On reader-response theory, see J. Tompkins, ed., *Reader-Response Criticism* (Baltimore: Johns Hopkins Univ. Press, 1980), for a basic introduction to issues and debates, and esp. her essay, "The Reader in History," 201–32, as well as the extensive and up-to-date bibliography, 233–72. See also M. L. Pratt, "Interpretative Strategies/Strategic Interpretations," *Boundary* 2 11:1–2 (Fall/Winter 1982–83): 201–31, for a perspective slightly different from that of Tompkins.

3. Pratt, op. cit., 205, observes that the difficulty reader-response criticism has in breaking out of its "formalist mold" is attributable less to institutional inertia than to a set of ideological commitments that both formalism and reader-response criticism share. Nevertheless, of course, both factors pertain.

4. Ibid., 205ff.

5. Ibid., 205–06; Pratt goes on to observe that "despite all the cries that readers make meaning, it is still easy to lose sight of the fact that reception of art is

production—the production of meaning according to socially constitutive signi-fying practices, which is what, in a different mode, artistic production is as well." She examines Eagleton's notion of the literary text as producing ideology, as opposed to reflecting, reproducing, or representing it (see T. Eagleton, *Criticism and Ideology* [London: Verso, 1978], esp. 64ff.), and goes on to examine the ways in which Eagleton's perspective transforms that touchstone of modern criticism, Roman Jakobson's six-point model of communication, with its addresser, addressee, message, code, channel, and context existing at more or less a single theoretical level (see chap. 2, sec. 5; and sec. 7, this chap.).

6. See chap. 2, sec. 2, and this chap., passim.

7. H. White, "The Politics of Historical Interpretation," in W. J. T. Mitchell, ed., *The Politics of Interpretation* (Chicago: Univ. of Chicago Press, 1983), 119–43, and esp. 123. The same volume contains a debate between M. Fried and T. J. Clark on the politics of modernism in the arts.

8. See n. 5, this chap.; and chap. 2, sec. 5.

9. On panopticism, see chap. 3, secs. 1 and 2.

10. See chap. 3, sec. 4.

11. See chap. 3, sec. 4, for Chase's comments on the function of art historical instruction; see also secs. 4–7, this chap.

12. Kleinbauer's *Modern Perspectives*, as we have seen in chap. 2, plots the various scenarios of this practice.

13. As will have been clear from our discussions in the two previous chaps., disciplinary technologies comprise a wide range of rhetorical protocols and analytic strategies working in tandem with technologies of analysis in the strict sense of the term.

14. See sec. 7, this chap., for a discussion on this modality in Panofsky's writings. Secs. 4–6 discuss the historical and theological origins of this metaphor.

15. See chap. 2, sec. 2, for references to Foucault's use of this phrase.

16. On the institutionalization of "English studies," see Eagleton's *Literary Theory* (Minneapolis: Univ. of Minnesota Press), 17–90. See also the discussion in chap. 3, sec. 4, this vol.

17. See Tompkins, op. cit., 224, for discussion of the complementary situation faced by formalist literary study and of the efforts of New Criticism to address similar critiques from the sciences. In transferring the philological formalisms of his age to art history, Wölfflin's strategies and motivations can be seen as identical. See J. Hart, "Reinterpreting Wölfflin," *Art Journal* 42:4 (Winter 1982): 292–300.

18. The strategy (see M. Abrams, "The Deconstructive Angel," *Critical Inquiry* 3 [Spring 1977]: 426) is clearly to contain an indeterminacy or ineffability within the bounds of determinacy: To assert the ineffability of a work is, in the disciplinary panoptic frame, to fix it as a species of the determinate. See chap. 3, sec. 4.

19. According to the fundamental paradigm of modernism in the human sciences, elemental entities are not static components with an ultimately fixed identity but rather are defined by the web of interactions constituting some whole from a particular standpoint or perspective taken up by an analyst-observer (who is himself, of course, always a locus relative to a system of loci). In short, units of any

kind are dependent for their value on a system of differences. A principal illustration of this perspective is Saussure's concept of the sign, which contrasts with the classical notion of the sign as a representation of an object endowed with intrinsic (and fixed) meaning. Representation, in this modernist semiology (stemming in no small measure from the work of John Locke) is a secondary activity quite different from perception, and from what I will characterize as a classical or eucharistic semiology later in this chap. By far the most lucid account of these issues is that of P. Lewis in "The Post-structuralist Condition," *Diacritics* 12:1 (Spring 1982): 2–24, which characterizes the principal differences between classical and structuralist perspectives on meaning and between structuralist and poststructuralist perspectives. For Lewis (whose argument I follow), the latter constitutes a self-critical activity within the former: structuralist semiology's deconstructive dialogue with itself. If modernist semiology is already an instrument enabling the deconstruction of representation, poststructuralist practice could be seen as a further elaboration of that enterprise and a deeper critique of idealist philosophies, including elements of the latter retained within the structuralist enterprise set in motion by Saussure. Although poststructuralist writings can be cited as beginning in the late 1960s, "post" is an unfortunate and misleading prefix, implying that the contemporary critical and theoretical discourse within the humanities is somehow after structuralism, when, in fact, it continues its problematic. As we shall see below, the discipline of art history (always and everywhere a semiological enterprise since its academic institutionalization) incorporates elements of both a classical (or eucharistic) and a structuralist (or modernist) perspective on the visual sign. See also S. Hall, "On Postmodernism and Articulation," *Journal of Communication Inquiry* 10:2 (Summer 1986): 45–61, on the "post" question.

20. See Pratt, op. cit., 228.
21. See J. Derrida, "Economimesis," *Diacritics* 11:2 (Summer 1981): 3–25; and R. Klein's commentary on the latter, "Kant's Sunshine," *Diacritics* 2:2 (Summer 1981): 26–41.
22. See N. Goodman, *Ways of Worldmaking* (Indianapolis: Hackett, 1978) for an incisive summation of such perspectives.
23. See sec. 5 and n. 126, this chap.
24. See W. J. T. Mitchell's discussion of Lessing, "The Politics of Genre," *Representations* 6 (Spring 1984): 98–116.
25. W. E. Kleinbauer, *Modern Perspectives in Western Art History* (New York: Holt Rinehart & Winston, 1971), 1.
26. C. Brooks and R. P. Warren, *Understanding Poetry* (New York: Holt & Co., 1938); see esp. xxxvii.
27. Chap. 2, sec. 5.
28. The discussion by Derrida in *Margins of Philosophy* (Chicago: Univ. of Chicago Press, 1982), esp. 329, outlines the various forms such a metaphor has taken.
29. This is not to imply that the discipline simply stumbled into some prefabricated trap but rather that its work as an academic discipline was destined to circulate

within this paradigm of communication—a paradigm that the study of art since the Renaissance helped produce, as we have suggested in various ways in the preceding chap. and in chap. 2. See also sec. 3, this chap.

30. See the discussion of Saussure in secs. 6 and 7, this chap.

31. The history of this reinstallation is the subject of sec. 3, this chap.

32. See Gombrich's articulation of this assumption in sec. 7, and n. 169, this chap.

33. See our discussion of Reiss's analytico-referentiality in chap. 3, sec. 1, and nn. 1–9.

34. See also the interesting essay by S. Toulmin, "The Construal of Reality," in W. J. T. Mitchell, op. cit., 99–117, esp. his observation (108) that "the Newtonian choice for passive over active matter seems . . . to have turned as much on issues of social imagery—God being seen to 'inspire' matter and confer motion on it, just as the king was seen to be the final source of political agency—as it did on genuine matters of scientific interpretation and explanation." As we shall see below, "the Newtonian choice" resonates with comparable views on the nature of language and signification during the eighteenth century—views that Locke's philosophy of *semeiotike* was designed to combat in very explicit terms: Locke viewed any notions of innatism or essentialism as ultimately complicit with a politics of monarchical absolutism.

35. See chap. 2, sec. 5.

36. The term *abcedarium culturae* is taken from E. Said's remarkable study *Beginnings* (Baltimore: Johns Hopkins Univ. Press, 1975); the phrase "metaphysics of quiddity" is a reference to innatist theories of signification, wherein the "thingness" of the artwork is construed as permeated with or revealing innate and ineffable meaning or value.

37. Discussed by F. Yates in *Art of Memory* (Chicago: Univ. of Chicago Press, 1966), 370f.

38. Saussure's *Cours de linguistique générale* (*Course in General Linguistics*, ed. C. Bally and A. Sechehaye, trans. Wade Baskin [New York: Philosophical Society, 1959]) was first published in 1916 from university lecture notes compiled by his students. The Baskin translation has been superseded by more recent editions, which have resulted from contemporary studies of the materials that Bally and Sechehaye originally worked with. The edition of *Cours de linguistique générale* edited by T. de Mauro (Paris: Payot, 1973) contains an extensive discussion of Saussure's intellectual background. There is also an *édition critique* of the *Cours* by R. Engler in two immense volumes (Wiesbaden: Harrassowitz, 1967–74). The best up-to-date discussion of Saussure and his intellectual background is the recent volume by H. Aarsleff, *From Locke to Saussure* (Minneapolis: Univ. of Minnesota Press, 1982).

39. The use of Saussure among contemporary humanists frequently carries with it an implication that Saussure was a founder of a science with few antecedents, which is not only untrue but specifically misleading, as we shall see. The issues of signification raised in the *Cours* were part of a long tradition of speculation that included writings within the framework of art history and criticism, particularly in

France. What Saussure termed *sémiologie* (reviving a very ancient word) was part of a discourse on meaning and form current through the last quarter of the nineteenth century in various fields of study.

40. See Aarsleff, op. cit., 356–71.

41. On the correspondence between Taine and Nietzsche, see Aarsleff, op. cit., n. 18 (the original correspondence was published in the *Gesammelte Briefe* in 1905).

42. Cousin's *Cours de l'histoire de la philosophie* was first published in 1829; see Aarsleff, op. cit., 120–45, for an extensive and detailed account of Locke's reputation in nineteenth-century England.

43. Discussed by Aarsleff, op. cit., 360ff.

44. H. Taine, *Essais de critique et d'histoire*, 12th ed. (Paris: Hachette, 1911), xviii; F. Saussure, op. cit., 115–17; compare the latter with Engler's *Cours*, 177, for variations in terminology in the notes on which the Saussure text was based.

45. Discussed in detail by Aarsleff, op. cit., 32–37 and 360ff. In the 1850s, Taine prepared a dissertation on Condillac at the *Ecole normale*, but his *agrégation* was denied by a conservative examination committee (despite the fact that he was considered the most brilliant student of the time). His interests in the eighteenth century were taken by some of his professors to be academically heterodox, but the specific reasons for the denial of the *agrégation* were, contrary to the school's regulations, never filed and remain unknown.

46. Ibid., 358ff. In addition to the notion of the arbitrariness of the sign, Saussure's distinction between *langue* and *parole* parallels methodological distinctions made by Taine (*Essais*, xxii). For both Taine and Saussure, changes in *langue* are necessarily initiated in the *parole* and can be distinguished in what Taine refers to as *les petits faits*.

47. By 1909, *Philosophie de l'art* (Paris: Hachette) had gone into its 13th ed. *De l'idéal dans l'art* is part of vol. 2 (221–346) of *Philosophie*. Saussure's concept of *la valeur linguistique* (op. cit., 154–69) echoes that of Taine's notion of artistic *valeur* (*Philosophie*, vol. 2, 234, 268). For both, it is the place in the system of cultural significations that determines value.

48. Taine, *Histoire de la littérature anglaise*, 12th ed. (Paris: Hachette, 1911), xxix, xxxvi.

49. Pasteur expressed these views in his 1882 *Discourse de réception à l'Académie française*; see Aarsleff, op. cit., n. 22.

50. E. Durkheim, *Revue Blanche* 13 (1897): 287–91.

51. Like many of Taine's writings, *De l'Intelligence* (Paris: Hachette, 1870) had been reprinted over a dozen times by the first decade of the twentieth century (the 13th ed., in 2 vols., appeared in 1909). See esp. vol. 2, 259, on *les signes*. Taine's perspective is echoed in Saussure's phrase "every material thing is already a sign for us" (op. cit., 157).

52. Taine, *De l'Intelligence*, vol. 1, 329. The passage was first published in 1877 in *Revue philosophique* 3 (January 1877): 7, and then included in the 3d (1878) and all subsequent editions of *De l'Intelligence*.

53. Saussure, op. cit., 157. He states that "the linguistic sign is a psychic entity with two sides" (99).

54. See Tompkins, op. cit., 224, and the references to Lacan in chap. 3.

55. See Aarsleff, op. cit., 362f.

56. Taine, *Histoire*, xxvii.

57. T. Huxley, "On the Method of Zadig," in *Science and Culture* (London: Macmillan, 1881), 128–48.

58. See D. Mahon, *Studies in Seicento Art and Theory* (London: London University-Warburg Institute, 1947), for discussions of the importance of Mancini as a connoisseur.

59. C. Ginzburg, "Clues," in *The Sign of the Three* (Bloomington: Indiana Univ. Press, 1983), 94f.

60. A critical edition of Mancini's text first appeared in 1956–57 under the title *Considerazioni sulla pittura*, ed. A. Marucchi, 2 vols. (Rome: Accademia Nazionale dei Lincei).

61. Ibid., vol. 1, 134.

62. Ibid.

63. See Ginzburg's discussion of this, op. cit., 95f. and his n. 38.

64. Ibid., n. 39. Ginzburg discusses the question of the circulation of Baldi's and other treatises of the time on this topic as well as the problem of who read them and when.

65. Quoted and discussed in E. Raimondi, *Il romanzo senza idillio* (Turin: Einaudi, 1974), 23–24; also discussed in Ginzburg, op. cit., 97.

66. Ginzburg, op. cit., 97–99, discusses Mancini's position as a "point of contact" between a divinatory perspective (in his activities as a physician and connoisseur) and a generalizing model (as anatomist and naturalist) in his role in the debates surrounding the discovery of a two-headed calf born near Rome in 1625. The calf was dissected in order to establish not the singular character of that particular animal but the common character of an entire species.

67. J. J. Winckelmann, *Briefe*, ed. H. Diepolder and W. Rehm, 2 vols. (Berlin: Walter de Gruyter, 1952–54), 1:341, 2:316.

68. See Ginzburg's discussion, op. cit., 101–02 and his nn. 53 and 54. W. Heckscher, in "Petites Perceptions," *The Journal of Mediaeval and Renaissance Studies* 4 (1974): 130–31, examines the development of Warburg's methodology within the framework of the same tradition discussed by Ginzburg.

69. Ginzburg, op. cit., 102.

70. Quoted by R. Messac, *La "Detective Novel" et l'influence de pensée scientifique* (Paris: Librairie Ancienne Honore Champion, 1929), 34–35.

71. E. Gaboriau, *L'Enquête*, vol. 1 of *Monsieur Lecoq* (Paris: Fayard, 1869), 44.

72. The first English translation of Morelli appeared in 1883. Henry Doyle met Morelli in 1887, the same year in which the first Sherlock Holmes story was published. See Ginzburg, op. cit., n. 9.

73. The story first appeared in *The Strand Magazine* 5 (Jan.–June 1893).

74. See Ginzburg, op. cit., 83–84 and his n. 8.

75. R. Longhi, *Saggi e ricerche: 1925–1928* (Florence: Sansoni, 1967), 234, 321.

76. B. Croce, *La critica e la storica delle arti figurative* (Bari: Laterza, 1946), 15.

77. See E. Wind, *Art and Anarchy* (New York: Knopf, 1964), 40–41.
78. See H. Zerner, "Giovanni Morelli et la science de l'art," *Revue de l'Art* (1978), 40–41. Ginzburg, "Spie. Radici di un paradigma indiziario," in A. Gargani, ed., *Crisi della ragione* (Turin: Einaudi, 1979), 57–106, discusses related questions. The Ginzburg essay on Freud, Morelli, and Holmes includes a note (n. 1) referring to the author's hopes to publish an expanded and revised version of the study in the near future.
79. G. Morelli, *Della pittura italiana* (Milan: Treves, 1897), 4.
80. See secs. 2, 4, and 5, this chap.
81. Discussed by Ginzburg, op. cit., 84–88. Any account of such resonances should be read in the light of the discussion by T. Reiss in *Discourse of Modernism* (Ithaca: Cornell Univ. Press, 1982), 363ff., of Freud's telescope metaphor for the mental apparatus. See also the discussion of panopticism in chap. 3.
82. Ginzburg, op. cit., 87.
83. This tradition also dates back to Galen. For an extensive discussion of the history of the term *semiotics*, see T. A. Sebeok, " 'Semiotics' and Its Congeners," originally written in 1971 and published most recently in the important volume *Frontiers in Semiotics*, ed. J. Deely, B. Williams, and F. Kruse (Bloomington: Indiana Univ. Press, 1986), 255–63. The essay traces the appearances of semiotic(s) from ancient Greek times through Locke (a physician by profession) to the present in a wide variety of disciplines and languages. See also R. Jakobson, *Coup d'oeil sur le développement de la sémiotique* (Bloomington: Indiana Univ. Publications/Studies in Semiotics, vol. 3, 1975).
84. See n. 57, this chap.
85. See the discussion of Galileo's telescope in chap. 3.
86. The basic text is *The Collected Papers of Charles Sanders Peirce*, vols. 1–6, ed. C. Hartshore and P. Weiss (Cambridge: Harvard Univ. Press, 1931–35); vols. 7–8, ed. A. A. Burks (1958). Jakobson (op. cit., 2–3) regards J. H. Lambert (1728–77) as an important ancestor to Peirce; his *Neues Organon* (1764) contains ten chaps. on "Semiotik oder Lehre von der Bezeichnung der Gedanken und Dinge." See also Sebeok, op. cit., 256.
87. In 1890, Peirce reviewed an article on Locke (commemorating the bicentennial of his *Essay*) in *The Nation* 51 (September 25, 1890), 254–55. Peirce commented on the sophistry of recent anti-Lockean work.
88. Reuben Lucius Goldberg (1883–1970); see P. Garner, *Rube Goldberg: A Retrospective* (New York: Delilah Books/Putnam Group, 1983).
89. On the Necker Cube Illusion, see R. L. Gregory, *Concepts and Mechanisms of Perception* (London: Duckworth, 1974), 54–58. A photograph of the Ames Room appears on p. 58; a Necker Cube is shown on p. 56.
90. Discussed by Tompkins, op. cit., 202–14. The text as object of study or contemplation had little importance during the Greek period, for example, and was seen, according to Tompkins, as a unit of force whose power is exerted on the world. In a similar fashion, she argues, a Renaissance work of art was valued for what it could do, especially for the aristocracy it served. The place of the artwork within

the socio-political system, she writes, kept literature in the Renaissance from being regarded either as a free-standing activity whose products had autonomous value (the modernist view) or as a craft whose products, whether moral or recreational, must contribute to the common good (the classical view). By contrast, the first requirement of a work of art in the twentieth century is that it should *do* nothing. In part, she argues, these changes are determined by the nature of the audience or constituency. Nevertheless, it must be said that "doing nothing" (in Tompkin's terms, in reference to formalist New Criticism) is a supremely socio-political function: See J. Baudrillard, *For a Critique of the Political Economy of the Sign*, trans. C. Levin (St. Louis: Telos Press, 1981), esp. 102–11 and 112–22. See also his *L'effet baubourg* (Paris: Galilée, 1977).

91. Aarsleff, op. cit., 32.

92. During the seventeenth century it was assumed that an etymological distillation of all existing languages could result in recapturing the essentials of the Adamic language that would contain a nomenclature referring directly to what knowledge and thought are about. These hopes were conflated with contemporary philosophical speculation regarding the imperfect state of common languages (with respect to their being sources of epistemological error). Typical of this perspective was the *Essay Towards a Real Character and a Philosophical Language* by J. Wilkins, presented to the Royal Society in 1668 with its official imprimatur: See Aarsleff, op. cit., 260.

93. Locke's *Essay*, almost twenty years in the making, was published in 1690. The last edition to receive Locke's own revisions was the fifth, which appeared in 1706. A good recent edition is that prepared by P. Nidditch (Oxford: Oxford Univ. Press, 1979).

94. In Locke's view, languages were created by men, by "ignorant and illiterate people" for ease of communication. They are subject to change and flux over time for many reasons, with no necessary directionality to such change. Hence, the current state of languages is not necessarily a guide to some past "perfect" state.

95. See J. Deely, "The Coalescence of Semiotic Consciousness," in Deely, Williams, and Kruse, op. cit., 5–34, on the relationship between Locke's project and those of Aristotle and John Poinsot (whose *Tractatus de Signis* appeared in 1632, the year of Locke's birth); see esp. 22–23. The quotation from Locke is discussed by Aarsleff, op. cit., 27ff.

96. A useful compilation of readings on the notion of the sign and of semiotic theory can be found in A. Rey, *Théories du signe et du sens* (Paris: Editions Klincksieck, 1973). See also, as a general introduction to structuralist semiotics, T. Hawkes, *Structuralism and Semiotics* (Berkeley: Univ. of California Press, 1977), esp. chap. 4, 123–50.

97. Quoted and discussed in Aarsleff, op. cit., 25f.

98. Ibid., 117, 55, 239–77.

99. Locke, op. cit., 1.4.25.

100. Ibid., 3.2.1.

101. T. Carlyle, *Critical and Miscellaneous Essays*, 5 vols. (New York: P. F. Collier, 1899),

1:215.

102. See Aarsleff's essay "Locke's Reputation in Nineteenth Century England" (op. cit., 120–45) for an account of the debates during that century. Locke was not a neutral subject.

103. See sec. 2, this chap. On Taine's relationships with Saussure, see Aarsleff, op. cit., 356ff.

104. Aarsleff, op. cit., 31, 32ff. There were also claims of disengagement from ideology—a term referring specifically to the *idéologues* of the Revolutionary period, the target of much contempt on the part of Napoleon.

105. Aarsleff, op. cit., 125–27.

106. One of the criticisms of Locke during the nineteenth century was the inferiority of his philosophy of rational empiricism to that of the critical school of Kant and of German transcendentalism in general.

107. Cousin's *Cours de l'histoire de la philosophie* (Paris: Pichon et Didier, 1829), incorporated the lectures on Locke. The attitudes of Cousin are reflected in Carlyle's writings during the late 1820s: Locke had caused philosophy "to treat itself popularly," whereas in Germany it "dwells aloft in the Temple of Science, the divinity of its inmost shrine; her dictates descend among men, but she herself descends not"; and the disastrous course of philosophies holding that "as the stomach secretes Chyle, so does the brain secrete Thought" led to Carlyle's question, "And what then was Religion, what was Poetry, what was all high and heroic feeling? Chiefly a delusion" (Carlyle, op. cit., vol. 1, 76, 215, and vol. 2, 64; and "Signs of the Times," *Edinburgh Review* 49 [June 1829]: 439–59).

108. See Aarsleff, op. cit., 125. Coleridge went to extraordinary lengths to deny any originality in Locke's works, claiming that if he set before him volumes by Gassendi, Hobbes, Descartes, and Spinoza, he could construct all of Locke's principles out of citations from these writers. Needless to say, Coleridge never undertook such a project.

109. Ibid., 130 and n. 38. Cousin's *Cours* was required reading (along with Locke's *Essay*) for the "moral science tripos" under the heading "Mental Philosophy" at Cambridge University as late as 1868 (as reported in the university calendar for that year).

110. Cousin, *Course of the History of Modern Philosophy*, 2 vols., trans. O. W. Wright (New York: D. Appleton, 1852), 2:429.

111. Ibid., 392–93. An anonymous reviewer in the *Edinburgh Review* (59 [July 1834]: 359–73) demolished Cousin's attacks on Locke.

112. G. H. Lewes in *A Biographical History of Philosophy* (London: C. Knight, 1845) took Cousin and other critics of Locke (notably Whewell) to task for their misunderstandings of Locke's philosophical system, suggesting that they could barely have read the *Essay*, given the outlandish notions attributed to Locke. As Aarsleff notes (op. cit., 31), Heine, in his writings on the Romantic school in Germany, pointed out that Cousin knew little German.

113. Aarsleff, op. cit., 33ff.

114. See sec. 3, this chap.

production—the production of meaning according to socially constitutive signi-

115. On Whewell's writings, see Aarsleff, op. cit., 35, 133–35.

116. Ibid., 144, n. 38.

117. See the discussion of glottochronology in chap. 2. On Müller, see Aarsleff, op. cit., 36, 303, 385.

118. A. Arnauld and C. Lancelot, *Grammaire générale et raisonée de Port-Royal* (Paris: Bossange et Masson, 1809); A. Arnauld and P. Nicole, *La Logique ou l'art de penser*, 6th ed. (Paris: G. Desprez, 1724).

119. See J. Lough, "Locke's Reading during his Stay in France (1675–79)," *The Library*, 5th ser., 8:4 (Dec. 1953): 229–58. Aarsleff comments on Locke's knowledge and appreciation of the Port-Royal Grammar (op. cit., 4, 11, 45, 104).

120. L. Marin, *Le portrait du Roi* (Paris: Minuit, 1981); M. Doueihi, "Traps of Representation" (review of Marin), *Diacritics* 14:1 (Spring 1984): 66–77.

121. See Doueihi, op. cit., 68, for an elaboration of the arguments.

122. Ibid., 72–74.

123. See n. 99, this chap.

124. Locke, op. cit., 3.2, 5.

125. Discussed by Aarsleff, op. cit., 37–38.

126. Ibid., 37.

127. See n. 19, this chap.

128. See n. 115, this chap., and refs.

129. On Peirce, see n. 86, this chap. See also U. Eco, "On Symbols," in Deely, Williams, and Kruse, op. cit., 153–80, on the relationships between Peirce's symbol, icon, and index.

130. See sec. 5, this chap.

131. See Aarsleff, op. cit., 356–71, for his discussion of Taine.

132. See the discussions in chap. 3 of this vol. on Reiss, op. cit., esp. 21–54. Reiss uses the term *discourse* to refer to the ways in which the material embodying sign processes is organized—the visible and describable praxis of what is called thinking, which is understood as nothing but the organization of signs as an ongoing process.

133. Discussed in sec. 5 of this chapter; see also Aarsleff, op. cit., 33–37.

134. This has been the view of several poststructuralist writers; see n. 19, this chap.

135. J. Donzelot, *The Policing of Families*, trans. R. Hurley (New York: Pantheon, 1979), esp. 217–33. The term is also used by M. Seltzer in "Reading Foucault," *Diacritics* 14:1 (Spring 1984): 78–89.

136. Chap. 2, passim.

137. Saussure, op. cit., 164. See also Derrida, op. cit., 18f.

138. As indicated by the following remarks of Jakobson, this difference between the sensible and the intelligible in regard to the Saussurian concept of the sign remains an important one: "Modern structuralist thought has clearly established this: language is a system of signs, and linguistics is an integral part of the science of signs, *semiotics* (or to use Saussure's terms, *semiology*). The medieval definition —*aliquid stat pro aliquo*—resuscitated by our epoch has shown itself to be still valid and fruitful. Thereby, the constitutive mark of every sign in general, of the

linguistic sign in particular, resides in its double character: every linguistic unity is bipartite, and comports two aspects: one sensible and the other intelligible — on the one hand, the *signans* (Saussure's *signifier*), and on the other, *the signatum* (the signified)" (Jakobson, *Essais de linguistique générale* [Paris: Minuit, 1963], 162).

139. Derrida, op. cit., 19.

140. See chap. 2, sec. 5.

141. This reaction in the United States dates from the late 1960s. For some early perspectives on the issues, see A. Michelson, "Art and the Structuralist Perspective," in *On The Future of Art*, introd. E. F. Fry (New York: Viking Press, 1970), 37–60; and S. Nodelman, "Structural Analysis in Art and Anthropology," *Yale French Studies* 36–37 (October 1966): 89–103. Nodelman compares the basic concerns of Lévi-Straussian structuralism and those of the *Strukturforschung* school of German art history of the 1920s (esp. Guido von Kaschnitz-Weinberg); Michelson focuses on Lévi-Strauss, Jakobson, and Barthes and the application of some of their analytic principles to painting in the 1960s. See also B. Harlow, "Realignment," *Glyph* 3 (1978), 118–36.

142. This phrase is still commonly construed as being opposed to or complementary to "practice." For many, this phrase has been replaced by the umbrella term *theory* to denote contemporary practice informed by the discourse of semiotics.

143. The most notable of Panofsky's works are: *Studies in Iconology*, op. cit.; *Meaning in the Visual Arts* (Garden City, N.Y.: Doubleday, 1955); and "The History of Art as a Humanistic Discipline," in T. M. Greene, ed., *The Meaning of the Humanities* (Princeton: Princeton Univ. Press, 1940).

144. M. Holly, *Panofsky and the Foundations of Art History* (Ithaca: Cornell Univ. Press, 1984), 184; Holly is suggesting that Panofsky never viewed iconology as this sort of technique.

145. H. Zerner, "L'art," in *Faire de l'histoire*, vol. 2, ed. J. LeGoff and P. Nora (Paris: Gallimard, 1974), 188.

146. The proceedings of the colloquium have been published in J. Bonnet, ed., *Erwin Panofsky* (Paris: Pandora, 1983), including notable pieces by A. Chastel, H. Damisch, M. Holly, M. Podro, and A. Roger (Centre Georges Pompidou).

147. W. J. T. Mitchell, *Iconology* (Chicago: Univ. of Chicago Press, 1986), 12; the reference is to a remark made by Panofsky in *Meaning in the Visual Arts*, 32. See also P. Bourdieu's observations about Panofsky's project in *Outline of A Theory of Practice* (Cambridge: Cambridge Univ. Press, 1977), 1–2, 23.

148. The phrase is used by Panofsky in a review written in A. Riegl's writings in "Der Begriff des Kunstwollens," *Zeitschrift für Ästhetik und allgemeine Kunstwissenschaft* 14 (1920): 321–39. The relevant passage is given in the original in Holly, op. cit., 210–11 (n. 36). Note Holly's words: "He has suggested that we need to discover a single permanent Archimedean viewpoint from which to interpret various cultural artifacts, for the artifacts and the cultural complexes they embody offer only intrinsic principles of interpretation" (95). Panofsky took Riegl to task for offering purely historical interpretations (!) and sought to remove artworks from their places as links in a historical chain into the realm of a reality they had apart from

that chain. Panofsky's criticism of Riegl employs a strategy opposite to that which he employed in earlier critiques of Wölfflin's enterprise. This is before Panofsky's encounters with Ernst Cassirer. On German art history in general, see n. 187, this chap.

149. Holly comments on some of Panofsky's early writings (brought together in this book), although in a rather obfuscatory manner. See by contrast the following works by M. Podro: *The Critical Historians of Art* (New Haven: Yale Univ. Press, 1982); and *The Manifold in Perception* (Oxford: Oxford Univ. Press, 1972).

150. See esp. Holly, op. cit., 43–44, 181–84. The best discussions of the relationships between Panofskian iconology and semiological research are in C. Hasenmueller, "Panofsky, Iconology, and Semiotics," *Journal of Aesthetics and Art Criticism* 36 (Spring 1978): 289–301; and H. Damisch, "Semiotics and Iconology," in T. A. Sebeok, ed., *The Tell-Tale Sign* (Lisse: Peter de Ridder Press, 1975), 27–36.

151. Holly, op. cit., 185–86, writes that Panofsky's "repeated emphasis in 1939 (*i.e.*, in *Studies in Iconology*) on 'those basic principles which *underlie* the choice and presentation of *motifs*, as well as the production and interpretation of *images*, *stories* and *allegories*, and which give meaning even to the formal arrangements and technical procedures employed,' (p. 14) anticipates the work of the French philosopher of history Michel Foucault. In *The Order of Things* (1966, *Les mots et les choses*), Foucault describes what can aptly be termed as his iconological task (although he calls it 'archaeological'). . . . Like Panofsky, Foucault is interested in the 'essential tendencies of the human mind' but believes that the mind can be known only as it manifests itself in the surfaces of things it produces." This misconstrues Foucault's project profoundly. Cf. H. White, "Michel Foucault," in J. Sturrock, ed., *Structuralism and Since* (Oxford: Oxford Univ. Press, 1979), 81–115; J. Rajchman, "Foucault, or the Ends of Modernism," *October* 24 (Spring 1983): 37–62, esp. 49ff.

152. See esp. H. Dreyfus and P. Rabinow, eds., *Michel Foucault*, 2d ed. (Chicago: Univ. of Chicago Press, 1983), for a comprehensive account of Foucault's intellectual development, and, in particular, of the changes in his thinking from the time of *Les mots et les choses* in 1966 to the time of his death. A critical assessment of Foucault's work can be found in J. G. Merquior, *Foucault* (London: Fontana, 1985); see Merquior's discussion of Panofsky's awareness of the work of Charles Sanders Peirce (78–79, 166–67).

153. K. Forster, "Critical History of Art, or Transfiguration of Values?" *New Literary History* 3 (Spring 1972): 465. See also S. Alpers and P. Alpers, "Ut Pictura Noesis?" *New Literary History* 3 (Spring 1972): 437–58.

154. Holly, op. cit., 44.

155. Locke is discussed in sec. 4, this chap.

156. Holly, op. cit., 43 and n. 55.

157. Ibid., 44. Panofsky made a single reference to Peirce on p. 14 of his "History of Art as a Humanistic Discipline" in connection with the conventionality of hat tipping.

158. Ibid., 45. On contemplation, see sec. 1, this chap.

159. Recall Kleinbauer's distinction in *Modern Perspectives* between intrinsic and extrinsic methods in the discipline, discussed in chap. 2.

160. This remains unclear from Holly's account (op. cit., 114–57). Panofsky's work, of course, never had the theoretical and speculative scope of Cassirer's, and his use of the term *symbolic* (in the one piece that might most closely reflect Cassirer's project, his "Perspective as Symbolic Form," published first in the 1924–25 Vorträge der Bibliothek Warburg and later in 1929) is, as Snyder astutely points out, curiously ambiguous (Snyder, "Picturing Vision," *Critical Inquiry* 6 [Spring 1980]: 499–526). Holly's account of Panofsky's "Perspective" essay (op. cit., 131ff.; see also her "Panofsky et la perspective comme forme symbolique," in Bonnet, op. cit., 85–99) omits any reference to the Snyder essay, which indicates the ways in which Panofsky misunderstood Alberti's text.

161. Only within the last twenty years has the work of the Prague School become more widely known in the Anglophone world. Originally established in 1926 as the Prague Linguistic Circle, the group by 1929 had begun to publish a series of volumes on linguistic, literary, and aesthetic issues under the title of *Travaux du Cercle Linguistique de Prague*. On the linguistic facets of their research, see J. Vachek, *A Prague School Reader in Linguistics* (Bloomington: Indiana Univ. Press, 1964). The Circle was founded by Vilem Mathesius, a professor of English in the University of Prague, with an initial stimulus from Roman Jakobson, who had migrated from Moscow in 1920, bringing the teachings of the Russian Formalists in language, literature, and aesthetics. As R. Wellek writes in *The Literary Theory and Aesthetics of the Prague School* (Ann Arbor: Univ. of Michigan/Slavic Languages, 1969), the decisive departures made by the Prague Circle from neo-Kantian philosophy (as represented by Cassirer's 1923–29 *Philosophie der symbolischen Formen*) and Russian Formalism led to the establishment of structuralism and a notion of structure distinct from contemporary notions of Gestalt or Ganzheit on the one hand, and formalism on the other. As Mukařovský (see n. 162) wrote in 1934, "The concept of structure is based on an inner unification of the whole by the mutual relations of its parts: and that not only by positive relations, agreements, and harmonies—but also by contradictions and conflicts" (quoted in Wellek, op. cit., 5). Structure was a dialectical concept, and one in line with the *sémiologie* of Saussure.

162. The text of Mukařovský's "L'art comme fait sémiologique" can be found in *The Semiotics of Art*, ed. L. Matejka and I. R. Titunik, trans. I. R. Titunik (Cambridge: MIT Press, 1976), 8ff. He increasingly expanded the notion of structuralism to encompass a general theory of signs within which aesthetic objects are seen as systems of signs serving particular social functions. His 1936 monograph *Aesthetic Function, Norm and Value as Social Facts*, trans. M. Suino (Ann Arbor: Univ. of Michigan/Slavic Contributions, 1979) outlines a theory of aesthetic signification envisaged as the basis of an enterprise similar to Cassirer's symbolic project (as noted by Wellek, op. cit., 19). Mukařovský was one of the dominant figures in the Prague Circle, and Wellek's account of the history of the Circle focuses principally on Mukařovský's literary endeavors. In all of his writings,

Mukařovský opposed the idealism and essentialism represented by Cassirer's neo-Kantian perspectives. For a recent anthology of Mukařovský's writings, see J. Burbank and P. Steiner, eds., *Structure, Sign, and Function* (New Haven: Yale Univ. Press, 1978), which also includes Mukařovský's important writings on semiotic functions in architecture.

163. As Wellek observes (op. cit., 25–26), Mukařovský emphasized that the work of art was a totality conceived as a dynamic dialectical process rather than as an organic body and saw art as part of a general theory of signs.

164. Panofsky believed that the tri-level iconographic diagrammatics of meaning comprised a circular series of foci beginning with a preiconographic level and returning to it. See Holly's comment on this, op. cit., 182.

165. See the discussion of Taine in sec. 2, this chap.

166. Compare Holly's assertion (op. cit., 181): "Contemporary semiotics presumes not to be accountable to anything outside of itself. Iconology, as a mode of interpretation, is more temperate, more conservative." This is nonsense; if anything, as we have seen, the reverse is true.

167. Mukařovský, op. cit., 9.

168. See the account of the Prague Circle scholars given in Burbank and Steiner, op. cit., introd.

169. E. Gombrich, *Art and Illusion*, 2d ed., rev. (Princeton: Princeton Univ. Press, 1961), 9.

170. Mukařovský, "On the Problem of Functions in Architecture," in Burbank and Steiner, op. cit., 236ff.; R. Jakobson, "Language and Poetics," in T. A. Sebeok, ed., *Style in Language* (Cambridge: MIT Press, 1960), 350–77; and see D. Preziosi, *The Semiotics of the Built Environment* (Bloomington: Indiana Univ. Press, 1979), 65–72; 92–95; id., *Architecture, Language and Meaning* (The Hague: Mouton, 1979), 47–57, for a discussion of similarities between Mukařovský's multifunctional paradigm for architecture and Jakobson's multifunctional paradigm for communication (one of whose functional foci is the poetic or aesthetic functional dominance). It is frankly unclear as to which direction the influences went, since the two were colleagues within the Prague Circle during the 1930s. In conversations during the winter of 1980–81, Jakobson suggested to the present writer that Mukařovský's schemata derived from suggestions made by Jakobson before World War II. At any rate, Jakobson's own writings do not, before the 1960 essay, include any such perspectives, although notions of communication, whereby meaning resides in the total interactive context, permeate his writings at all periods. See also T. Hawkes, op. cit., 82–87, on the importance of the Jakobsonian six-part paradigm in modern literary theory. We will have occasion to discuss the paradigm in chap. 5.

171. Damisch, op. cit., 9. Ripa's *Iconologia* was published in Rome in 1593; the Italian text and a French translation of the *proemio* appear in *Critique* 315–16 (Aug.–Sept. 1973).

172. Peirce (op. cit., 5.283) writes that "a sign has, as such, three references; first, it is a sign *to* some thought that interprets it; second, it is a sign *for* some object to

which in that thought it is equivalent; third, it is a sign *in* some respect or quality, which brings it into connection with its object." The first reference is what Peirce will later refer to as the "interpretant." The interpretant interprets by bringing the sign into a relation of equivalence with an object, but such equivalence derives not from the object as such (cf. the problem of double conformity addressed by Locke) and is therefore not absolute or exhaustive, but relative ("in some respect or quality"). As S. Weber notes ("Closure and Exclusion," *Diacritics* 10:2 [Summer 1980]: 42), "By thus construing *signification and interpretation as inseparable*, Peirce situates 'diachrony' at the heart of the semiotic process. The latter is both temporal and historical. The process is not, however, diachronic in the sense of simple linearity. It is both pro- and retro-spective." Weber's essay is an excellent introduction to similarities and differences between Peirce and Saussure, from a contemporary perspective sensitive to issues raised by Derrida.

173. Mukařovský, "Art as Semiotic Fact," 4–5.

174. See chap. 2, sec. 5.

175. See the discussion in sec. 1, this chap.

176. See Holly, op. cit., 92–93. In Panofsky's perspective, only after a work's immanent sense in made manifest can it be related to larger comparative notions and descriptive terms. This contrasts sharply with the relational perspective of Mukařovský and the entire structuralist semiotic tradition. For a critique of Panofsky's iconology from a Praguean perspective, see J. Veltrusky, "Some Aspects of the Pictorial Sign," in Matejka and Titunik, op. cit., 245–64, esp. 252. Veltrusky also criticizes the view that a "semiotics of painting" should be founded on an imitation of a linguistic model (248).

177. Damisch, op. cit., passim, criticizes the textual reductionism of Panofskian iconology, which conflates meaning with textually based subject matter.

178. See Damisch, op. cit., 9, and his remarks that Ripa's text, in fact, went beyond various subsequent iconographies (including Panofsky's) in suggesting a science of sign-analysis.

179. A good introduction to this concept is Gombrich's essay "Image and Code," in W. Steiner, ed., *Image and Code* (Ann Arbor: Michigan Studies in the Humanities, 1981), 11–42. The volume is a useful introduction to the wide variety of perspectives on the semiotics of the visual current during the late 1970s.

180. N. Bryson, *Vision in Painting* (New Haven: Yale Univ. Press, 1983), esp. chaps. 1–4.

181. Holly, op. cit., 181.

182. The most comprehensive introduction to the thirty-year-old history of architectural semiotics is found in M. Krampen, *Meaning in the Urban Environment* (London: Pion, 1979), 6–50. As Krampen notes (36), the bulk of writing in that tradition has been from within a generically Saussurian framework. Krampen goes on to indicate some of the implications of a Peircean perspective on the problem of architectonic signification (37–50). See his discussion of Mukařovský (35).

183. This distinction is largely institutionalized in the American academy; although some art history departments offer specialized courses in architectural history

and criticism, most architectural history, as a disciplinary focus, is divided between schools or departments of architecture and design. And courses are often duplicated. The College Art Association of America and the Society of Architectural Historians met annually at the same time and place until 1977; since then, they have gone separate ways.

184. See chap. 1, n. 12.

185. See the remarks of W. J. T. Mitchell in *Iconology*, 62–63; and compare Deely's "Semiotic as Framework and Direction," in Deely, Williams, and Kruse, op. cit., 264–71. In 1984 a major conference entitled "Semiotics: Field or Discipline? State of the Art," was held at Indiana University in Bloomington. Deely's essay comments on Edmund Leach's address to that conference and places it in a broad historical context of the evolution of metalanguages developed in response to revolutionary changes in science and philosophy from the seventeenth century to the present. Today, the status of metalanguages as such has been under question —one of the distinguishing traits of the poststructuralist dialogue within semiotics, yet one that has firm roots in the writings a century ago of Charles Sanders Peirce, for whom (see n. 172) signification and interpretation are always interlinked and inseparable.

186. These remarks are paraphrased from J. Kavanagh, *Diacritics* 12:1 (Spring 1982): 42. Surely a measure of art history's maturity as a discipline must be its capacity to resist, deconstruct, and ironicize that "vast and convoluted labor."

187. Useful discussions of the German art historical traditions can be found in L. Dittman, *Stil/Symbol/Struktur* (Munich: Wilhelm Fink, 1967), esp. 84–139 (on Panofsky); O. Bätschmann, "Logos in der Geschichte," in L. Dittman, ed., *Kategorien und Methoden der Deutschen Kunstgeschichte 1900–1930* (Stuttgart: Franz Steiner, 1985), 89–112; see also, in the same vol., M. Podro, "Art History and the Concept of Art," 209–18. *Kunstgeschichte als Institution: Studien zur Geschichte einer Disziplin* by Heinrich Dilly (Frankfurt am Main: Suhrkamp, 1979) discusses Panofsky's impact on American academic practice (13ff.) within the wider context of the academicization of art history. The volume is especially useful for understanding the development of art history in Germany during the nineteenth century and its relationships with the emerging profession of science in Europe.

188. K. Jaspers, *Nietzsche* (Chicago: Henry Regnery, 1969), 290. A useful beginning might be J. Garnier, *Le Problème de la vérité dans la philosophie de Nietzsche*, (Paris: Seuil, 1966); see also *The New Nietzsche*, ed. and introd. D. Allison (New York: Delta, 1979), with essays by Heidegger, Deleuze, Klossowski, Blanchot, Derrida, Kofman, and others. The latter collection is an excellent introduction to the range of influences Nietzsche's works have had upon contemporary critical theory.

CHAPTER FIVE: *Reckoning with the World*

Epigraphs: Shakespeare, *The Rape of Lucrece*, in *The Complete Works of William Shakespeare*, edited by W. A. Wright (New York: Garden City, 1936), ll. 1422–29;

E. Gombrich, *Art and Illusion* (Princeton: Princeton Univ. Press, 1961), 110.

1. This issue of *October* (37 [Summer 1986]) contained the following articles: A. Michelson, "In Praise of Horizontality," 3–5; Leroi-Gourhan, "The Religion of the Caves," 6–17; and Leroi-Gourhan, "The Hands of Gargas," 18–40.

2. Michelson, op. cit., 3.

3. Ibid., 4.

4. See chap. 4, sec. 7, with regard to the relationships between iconology and structuralist semiology.

5. A. Leroi-Gourhan, "Répartition et groupement des animaux dans l'art pariétal paléolithique," *Bulletin de la Société Préhistorique Français* 55 (1958): 515–27.

6. H. Breuil, *Four Hundred Centuries of Cave Art* (Montignac: Centre des études et de documentation préhistorique, 1952).

7. For an assessment of such theories, see A. Laming, *Lascaux*, trans. E. Armstrong (Harmondsworth: Penguin Books, 1959); S. Giedion, *The Eternal Present* (New York: Pantheon, 1962); P. Graziosi, *Palaeolithic Art* (New York: McGraw-Hill, 1960); P. Ucko and A. Rosenfeld, *Palaeolithic Cave Art* (London: World Univ. Library, 1967); Leroi-Gourhan, *Treasures of Prehistoric Art*, trans. N. Guterman (New York: Abrams, 1967); M. W. Conkey, "To Find Ourselves," in C. Schire, ed., *Past and Present in Hunter-Gatherer Studies* (New York: Academic Press, 1984), 253–76. Other citations will be found below.

8. Conkey, "Ritual Communication, Social Elaboration, and the Variable Trajectories of Palaeolithic Material Culture," in T. D. Price and J. A. Brown, eds., *Prehistoric Hunter-Gatherers* (New York: Academic Press, 1985), 299–323; quotation from p. 308.

9. See nn. 5 and 7, this chap.; see also the following works by Leroi-Gourhan: "The Evolution of Paleolithic Art," *Scientific American* (February 1968): 58–74; "La fonction des signes dans les sanctuaires paléolithiques," *Bull. Soc. Préh. Fran.* 55 (1958): 307–21; "Le symbolisme des grands signes dans l'art pariétal paléolithique," *Bull. Soc. Préh. Fran.* 55 (1958): 384–98; "Considérations sur l'organisation spatiale des figures animales dans l'art pariétal paléolithique," in M. A. Basch and M. A. Garcia Guinea, eds., *Santander Symposium* (1972), 281–308; *The Dawn of European Art* (Cambridge: Cambridge Univ. Press, 1982).

10. Concise discussions of these questions can be found in Leroi-Gourhan, "Evolution of Paleolithic Art"; see also A. Sieveking, *The Cave Artists* (London: Thames & Hudson, 1979), 55–71.

11. Leroi-Gourhan, "Evolution of Paleolithic Art," 59. Laming-Emperaire was a former student of Leroi-Gourhan. See also C. Tomkins, "Thinking in Time," *New Yorker Magazine* (April 22, 1974): 109–17; the article, which discusses the research of Marshack, provides a useful background. Laming-Emperaire's interpretations were similar to Leroi-Gourhan's, although she later revised some of her views on the details of identification of particular animals and their gender. Her *Origines de l'archéologie préhistorique en France* (Paris: Picard, 1964) is an excellent history of interpretations of prehistoric art "des superstitions médiévales à la découverte de l'homme fossile"; the text was written as a dissertation at the

Sorbonne in 1957.

12. See also the following works by Laming-Emperaire: "Pour une nouvelle approche des sociétés préhistoriques," *Annales Économies, Sociétés, Civilisations* 5 (Sept.–Oct. 1969): 1261–70; and "Système de pensée et organisation sociale dans l'art rupestre paléolithique," in *L'Homme de Cro-Magnon, Anthropologie et Archéologie 1868–1968* (Paris: Arts et Metiers Graphiques, 1968), 197–212.

13. Works by Leroi-Gourhan are cited in n. 9. See also H. G. Bandi, "Quelques réflexions sur la nouvelle hypothèse de A. Leroi-Gourhan concernant la signification de l'art quartenaire," *Santander Symposium*, 309–19.

14. See also G. Sauvet and A. Wlodarczyk, "Essai de Sémiologie préhistorique," *Bull. Soc. Préh. Fran.* 74 (Etudes et Travaux): 545–48.

15. Discussions can be found in the following: Leroi-Gourhan, "Evolution of Paleolithic Art"; H. Delporte, *L'Image de la femme dans l'art préhistorique* (Paris: Picard, 1979); P. Rice, "Prehistoric Venuses," *Journal of Anthropological Research* 37 (1981): 402–19; C. Gamble, "Interaction and Alliance in Palaeolithic Society," *Man*, n.s., 17 (1982): 92–107, esp. 92–98. See also Conkey, "Style and Information in Cultural Evolution," in C. Redman et al., eds., *Social Archaeology* (New York: Academic Press, 1978), 61–85. Leroi-Gourhan analyzed female figurines from the point of view of isometric congruences in design in Leroi-Gourhan, *Treasures*; see esp. 92, fig. 52a.

16. For a typical vitalist popular account of Paleolithic art, see A. Mosby, "Prehistory's Underground Museums," *New York Times* (January 19, 1986), Travel Section, 15. On p. 14 is a visitor's guide to sites in the Dordogne region in France. An idea of what to expect in the way of interpretation by site guides is given on p. 15.

17. A summary of such findings can be found in Conkey, "On the Origins of Palaeolithic Art," in E. Trinkhaus, *The Mousterian Legacy* (Oxford: BAR International Series 164, 1983), 201ff.

18. An excellent discussion of the problems can be found in Conkey, "Ritual Communication," 312–16. It should be noted that some of the objections to Leroi-Gourhan's theses regarding the textuality of parietal art stem from a monolithic attitude (fostered also by Leroi-Gourhan) of an all-or-nothing approach: If not all cave art reveals the same properties, then the overall thesis would be at fault. It is surely possible that Leroi-Gourhan might have been right about some art some of the time, in this twenty-thousand-year time span.

19. Leroi-Gourhan, in "Evolution of Paleolithic Art," gives a concise outline of his chronological schemata; see also Sieveking, op. cit., 18–53. Leroi-Gourhan's *Le Geste et la parole*, vol. 1, and *Technique et langage*, vol. 2, of *La Mémoire et les rythmes* (Paris: Editions Albin Michel, 1964–65), flesh out his chronological and evolutionary scenarios at a time when he was first elaborating his structuralist methodologies.

20. Conkey, in "Origins of Palaeolithic Art," 223, notes that views of art as initiation ceremony, promotion of social solidarity, manifestation of cosmological structure, or sympathetic hunting magic are commonly elaborated within such an assumption of social equilibrium. As she observes, the archaeological record of the upper

Paleolithic does not easily conform to what is known from contemporary ethnographic data from less technologically advanced societies (what Lévi-Strauss once referred to as "cold" [versus our "hot"] societies).

21. See Sieveking, op. cit., esp. chap. 1, 7–26. Note also the following (26): "They established a tradition that lasted for about twenty thousand years; in the ten thousand or so years between its disappearance and the present day a great many other such traditions have grown up and declined but artistic comprehension and sensibility seem not to have changed, for to a twentieth-century visitor one of the horses in Niaux, for example, is instantly comprehensible and wholly appreciable." This is surely a classic example of a projection of modern sensibilities onto ancient materials and a confusion of a remarkable, but still not uncommon, order.

22. See chap. 2, sec. 4.

23. Conkey's critique of this perspective is among the most lucid; see Conkey, "Origins of Palaeolithic Art," 220–23, and references.

24. See H. de Lumley, "Les fouilles de Terra Amata à Nice," *Bulletin du Musée d'Anthropologie préhistorique de Monaco* 13 (1966): 29–51; id., "A Palaeolithic Camp at Nice," *Scientific American* (May 1969): 42ff.; D. Preziosi, *Architecture, Language and Meaning* (The Hague: Mouton, 1979), esp. 83–88. Engraved portable objects from the same period are discussed in F. Bordes, "Os percé moustérien et os gravé acheuléen du Pech de l'Azé II," *Quarternaria* 11 (1960): 1–6.

25. See Preziosi, op. cit., 83; a drawing of de Lumley's reconstruction is given on p. 84. Another discussion of the significance of the Terra Amata site can be found in W. Fairservis, *The Threshold of Civilization* (New York: Charles Scribner's Sons, 1975), 55–73. For a critique of the latter, see Preziosi, "Constru(ct)ing the Origins of Art," *Art Journal* 42 (Winter 1982): 320–25. Fairservis attempted to apply J. S. Bruner's three stages in the development of the child's worldview to the archaeological record (Bruner, *Studies in Cognitive Growth* [New York: Wiley, 1966]). Preziosi, *Architecture, Language and Meaning*, discusses problems with Fairservis's scenarios (77–80). See also the sensible perspectives elaborated by J. Yellen in *Archaeological Approaches to the Present* (New York: Academic Press, 1977), esp. 36–51 and 132–36.

26. E. von Glasersfeld, "The Development of Language as Purposive Behavior," in *Origins and Evolution of Language and Speech* (New York: New York Academy of Sciences, 1976), 21–226; citation from 223. The volume (OELAS) contains the proceedings of a major conference on origins held in 1975 that brought together anthropologists, archaeologists, biologists, linguists, semioticians, specialists in primate behavior, and cognitive psychologists. It had been over two hundred years since an important scientific academy had sponsored an exchange of ideas on the subject by scholars of different backgrounds. The 1975 OELAS conference reopened the question and in doing so once again recognized this area of research and writing. See G. Isaac, "Stages of Cultural Elaboration in the Pleistocene," OELAS, 275–88; and A. Marshack, "Some Implications of the Symbolic Evidence for the Origin of Language," 289–311. See also C. D. Laughlin and E. G. d'Aquili,

Biogenetic Structuralism (New York: Columbia Univ. Press, 1974). The first session on the subject of Paleolithic art ever held at the annual meetings of the College Art Association of America took place in Los Angeles in 1985, with presentations by Conkey, Davis, Nodelman, and the present writer.

27. W. Davis, unpublished paper presented at the 1985 College Art Association of America meeting. Davis also discusses the issue at length in "The Origins of Image Making," *Current Anthropology* 27 (1986): 193–215.

28. The reference text is E. Gombrich, *Art and Illusion* (Princeton: Princeton Univ. Press, 1961), critiqued by Davis. Davis's concern, in part, is in demonstrating the fallacies of an "idealist history" approach to the question of the origins of representation in the upper Paleolithic. Some of his perspectives are elaborated in "Canonical Representation in Egyptian Art," *RES* 4 (1982): 21–46; and "Representation and Knowledge in the Prehistoric Rock Art of Africa," *African Archaeological Review* 2 (1984): 7–35.

29. Of many introductions to this subject, one of the most lucid is R. Jakobson and L. Waugh, *The Sound Shape of Language* (Bloomington: Indiana Univ. Press, 1979). A quick introduction to the subject can be found in T. Hawkes, *Structuralism and Semiotics* (Berkeley: Univ. of California Press, 1977), esp. 21–25.

30. Discussed in Preziosi: "Architectonic and Linguistic Signs," in W. Steiner, ed., *Image and Code* (Ann Arbor: Univ. of Michigan Studies in the Humanities, 1981), 167–75; and "Subjects + Objects," in J. E. Copeland, ed., *New Directions in Linguistics and Semiotics* (Houston: Rice Univ. Studies, 1984), 179–205. See also M. Schapiro, "On Some Problems in the Semiotics of Visual Art," *Semiotica* 1:3 (1969): 222–42. See also the discussions in chap. 4, passim.

31. Davis, *Seeing Through Culture* (forthcoming); cf. M. Wobst, "Stylistic Behavior and Information Exchange," in *Papers for the Director*, C. E. Cleland, ed. (Ann Arbor: Univ. of Michigan Museum of Anthropology Anthro-Papers, No. 61, 1977), 317–42. See also Wobst, "Boundary Conditions for Palaeolithic Social Systems," in *American Antiquity* 39 (1974): 147–78. On the relationships between perception and representation, see J. Hochberg, E. Gombrich, and M. Black, *Art, Perception and Reality* (Ithaca: Cornell Univ. Press, 1972); U. Neisser, *Cognition and Reality* (San Francisco: W. H. Freeman, 1976); K. Pribram, *Languages of the Brain* (Englewood Cliffs, N.J.: Prentice-Hall, 1971).

32. R. E. Leakey and R. Lewin, *Origins* (New York: Dutton, 1977), 129ff., 109–12, 167.

33. See the following works by Marshack: "The Baton of Montgaudier," *Natural History* 79:3 (March 1970): 56–63; 79:4 (April 1970): 78; "New Techniques in the Analysis and Interpretation of Mesolithic Notation and Symbolic Art," *Valcamonica Symposium* (Capo di Ponte: Centro Camuno di Studi Preistorici, 1970), 479–94; *Notation dans les gravures du Paléolithique supérieur*. Pub. de l'Institut de Préhistoire de l'Université de Bordeaux, mémoire no. 8 (Bordeaux: Delmas, 1970); *The Roots of Civilization* (New York: McGraw-Hill, 1972). The latter is a good summary of the techniques developed by Marshack and of the history of his involvement with these problems beginning in the early 1960s.

34. See Marshack, "Upper Paleolithic Symbol Systems of the Russian Plain," *Current Anthropology* 20:2 (June 1979): 271–95, with comments by various scholars, 295–303. Marshack's reply appears on 303–09, followed by an extensive bibliography. See also id., "Upper Paleolithique Notation and Symbol," *Science* 178 (1972): 817–28; id., "Cognitive Aspects of Upper Paleolithic Engraving," *Current Anthropology* 13 (1972): 445–77.

35. Marshack, "The Meander as System," in P. Ucko, ed., *Form in Indigenous Art* (Canberra: Australian Institute of Aboriginal Studies, 1978), 286–317.

36. In particular, see Breuil, op. cit. Cf. Marshack's observations, reported in Tomkins, op. cit., 115, on his findings at Pech Merle; and see *La préhistoire, problèmes et tendances* (Paris: Editions du CNRS, 1968), esp. L. Pales and M. Tassin de Saint-Péreuse, "Humains superposés de la Marche," 327–36. Superimpositions are discussed passim in Marshack's *Roots* (see esp. his discussion of the cave at Les Trois Frères, 236–41), by Breuil, 167ff., and by Ucko and Rosenfeld, op. cit., 181.

37. Marshack, "Symbol Systems of the Russian Plain," 304.

38. Leroi-Gourhan did so as well, relative to the tradition of interpretation he inherited. In 1962, he wrote to Marshack (noted in *Roots*, 15) that "it is now clear that the painted or engraved works were created as a single more or less monumental ensemble just as any sanctuary of classical times."

39. Marshack, *Science* 178 (November 24, 1972): 827, n. 1. By that time he had examined artifacts in some eighty private and public collections in nine European countries.

40. See Marshack, *Roots*, 35.

41. See Leroi-Gourhan, *Treasures*, 40; Marshack, *Roots*, 36; B. A. Frolov, "Numbers in Paleolithic Graphics" (Novosibirsk: Institute of History, Philology, and Philosophy, 1977); J. Christensen, "Comments," in Marshack, "Symbol Systems of the Russian Plain," 295–98, gives a good summary of arithmetic solutions to some cave markings.

42. See Marshack, *Roots*, 140; R. H. Merrill, "The Calendar Stick of Tshi-zun-hau-kau," *The Cranbrook Institute of Science Bulletin* 24 (October 1945).

43. In addition to references cited above, see also Marshack, "The Ecology and Brain of Two-Handed Bipedalism" (paper delivered at the Harry Frank Guggenheim Conference on Animal Cognition, Columbia University, June 2–4, 1982), which discusses the subject of human handedness as related to cognitive evolution and to the evolution of various kinds of semiotic practices. The paper also gives a good and concise account of the decipherment of the Abri Blanchard plaque discussed below.

44. The interchange in *Current Anthropology* cited in n. 34, this chap., gives a good overview of the issues involved and arguments for and against Marshack's interpretations.

45. Marshack, *Roots*, 43–108; a relative chronology is given on 96–97.

46. Mesolithic and Neolithic examples are examined in Marshack, *Roots*, 341–66.

47. Ibid., 43–50. The term *abri* refers to a rock shelter formed by a large outcropping

of rock overhead. On gender signs, see also Leroi-Gourhan, "Evolution of Paleolithic Art"; and Sieveking, op. cit., 76, on Abri Blanchard site finds.

48. Marshack, *Roots*, 38–41; on possible interpretations of markings, see p. 40. The Gontzi tusk was analyzed by Marshack in "Lunar Notations on Upper Paleolithic Remains," *Science* 146 (Nov. 6, 1964): 743–45.

49. Analyses of the La Ferrassie and Lartet pieces are given in Marshack, *Roots*, 349 and 50–55. The latter were found in 1865; Marshack quotes at length the original excavators' attempts to understand the markings on the bone.

50. On meaning ranges, see Conkey, "Context, Structure, and Efficacy in Paleolithic Art and Design," in M. L. Foster and S. Brandes, eds., *Symbol as Sense* (New York: Academic Press, 1980), 225–48, esp. 243–44. See also N. Munn, "Visual Categories," *American Anthropologist* 68:4 (1966): 939–50; and id., *Walbiri Iconography* (Ithaca: Cornell Univ. Press, 1973). The latter is a classic structuralist semiotic study of the active use of graphic symbolism, notation, and narrative line in a contemporary society which, in part because of the paucity of its material culture, is often compared to the upper Paleolithic societies known in the archaeological record. As Conkey notes, differentiation of meanings into more specific ranges would be dictated by context: See sec. 4, this chap.

51. See chap. 4, on innatist theories of signification.

52. See F. Yates, *Art of Memory* (Chicago: Univ. of Chicago Press, 1966), 92–94.

53. On the relationship of Marshack's findings and proposals to semiotics and sign theory, see Z. Kobyliński and U. Kobylińska, "Comments," in Marshack, "Symbol Systems of the Russian Plain," 300–301. Marshack's response to those comments (303ff.) delineates precisely the problems faced in interpreting marks as symbol, icon, or sign, alluding to the problem of whether or not a superimposed mark (sign) should be read iconically or symbolically in relation to what might be construed as iconic or symbolic in an earlier mark. As he rightly observes, only the broader cultural context, once known, could provide answers to such questions. A 1981 research paper that I received in translation from the University of Tartu in the Soviet Union addresses these problems from the point of view of ranges of iconicity in marks (J. Valsiner and J. Allik, "General Semiotic Capabilities of the Higher Primates," Tartu: n.d.); the authors also discuss the multiply overlapped systems of marks in gestural languages, which they see as providing a clue to ways of dealing with the apparent redundancy in Paleolithic marking practices.

54. E. Said, *Beginnings* (Baltimore: Johns Hopkins Univ. Press, 1975).

55. A good review of the problems will be found in Conkey, "Context, Structure, and Efficacy," 230–32.

56. C. Geertz, "The Growth of Culture and the Evolution of Mind," in J. Sher, ed., *Theories of the Mind* (New York: Free Press of Glencoe, 1962), 713–40, esp. 721f. Another facet of this question is addressed in a recent volume (unpublished as of this writing) by Davis entitled *Seeing Through Culture*; I am grateful to the author for allowing me to read that manuscript prior to its publication.

57. See n. 19, this chap.

58. On regionalism and differential trajectories in upper Paleolithic society and culture, see Conkey, "Ritual Communication," 312–16. On the relative ages of various kinds of practices, see id., "On the Origins of Paleolithic Art," 210–20.

59. See chap. 4, esp. secs. 5 and 6.

60. See also chaps. 3 and 4, passim, on various searches for a universal key to unlock the history of art, and esp. chap. 4, sec. 7, on Panofsky.

61. The discipline has evaded the question almost as if there had been a proscription like that laid down in 1868 by the Société de Linguistique de Paris banning papers on the origin(s) of language. The usual introductory sections of standard art history textbook surveys essentially repeat current wisdoms, with little awareness of the range and depth of research and speculation on the questions of origins. Perhaps significantly, the first issue of the English journal *Art History* opened with an article by D. Collins and J. Onians entitled "The Origins of Art" (*Art History* 1:1 [1978]: 1–25; see discussion of the latter in Conkey, "Origins of Palaeolithic Art," 206–07). S. Giedion's *The Eternal Present* (New York: Pantheon, 1962), has little to say of value, apart from the drama of speculation. On signs that the situation has recently begun to change, see n. 26, this chap.

62. See Conkey, "Context, Structure, and Efficacy," for a review of recent developments, with useful bibliography.

63. Wobst, "Stylistic Behavior," 321.

64. Conkey, "Context, Structure, and Efficacy," 229ff.

65. Ibid., 229.

66. See especially Munn, *Visual Categories*.

67. Conkey, "Context, Structure, and Efficacy," 232.

68. See Gamble, op. cit., 92–107, and esp. 101f.

69. Wobst, "Stylistic Behavior," 317–42; also cited by Davis, "Origins of Image Making," in his discussion of the "all-or-nothing" of marking. On the logic of the mark and its transformations, see G. S. Brown, *Laws of Form* (London: Allen & Unwin, 1969).

70. See Isaac, "Chronology and the Tempo of Cultural Change during the Pleistocene," in W. W. Bishop and J. A. Miller, eds., *Calibration of Hominoid Evolution* (Edinburgh: Scottish Academic Press, 1972), 381–430, esp. 382.

71. See V. Geist, *Mountain Sheep* (Chicago: Univ. of Chicago Press, 1971); J. Kitahara-Frisch, "Symbolizing Technology as a Key to Human Evolution," in M. Foster and S. Brandes, eds., *Symbol as Sense* (New York: Academic Press, 1980), 211–23; R. L. Holloway, "Culture," *Current Anthropology* 10 (1969): 395–407.

72. Geertz, "The Transition to Humanity," in S. Tax, ed., *Horizons of Anthropology* (Chicago: Univ. of Chicago Press, 1964), 37–48; id., "Art as a Cultural System," *Modern Language Notes* 91:6 (Dec. 1976): 1473–99.

73. See Jakobson, "Closing Statement," in T. A. Sebeok, ed., *Style in Language* (Cambridge: MIT Press, 1960), 350–77, esp. 353. See also chap. 2, sec. 2.

74. Ibid., 357.

75. Ibid., 356. Jakobson's paradigm has generated much response and commentary over the past two decades. A useful discussion can be found in C. MacCabe,

Tracking the Signifier (Minneapolis: Univ. of Minnesota Press, 1985), 126–29; see also Preziosi, *The Semiotics of the Built Environment* (Bloomington: Indiana Univ. Press, 1979), 65–72, on the possible relationships with multifunctionalities in visual (architectonic) systems and on the relationships of Jakobson's scheme to Mukařovský's work on architecture in the 1930s (on which see also chap. 4, sec. 7). On multifunctionality in language as conceived by K. Bühler, see T. A. Sebeok, "Animal Communication," *Science* 147:3661 (Feb. 26, 1965): 1006–14; and Bühler, *Sprachtheorie* (Jena: Fischer, 1934).

76. This issue will be taken up in chap. 6, sec. 3; see also chap. 4, n. 172.

77. See the discussion in chap. 4, sec. 1. See also A. Argyros, "The Warp of the World," *Diacritics* 16:3 (Fall 1987): 47–55, on the relationship between the hermeneutic project of Heidegger and Derridean deconstruction.

78. On codification, see U. Eco, *A Theory of Semiotics* (Bloomington: Indiana Univ. Press, 1976), esp. 48–139.

79. This issue is taken up at length in H. White, *The Content of the Form* (Baltimore: Johns Hopkins Univ. Press, 1987).

80. Fairservis saw Terra Amata as indicative of an enactive stage of cognitive growth, akin to similar stages of ontogenetic development; see n. 25, this chap. What has evolved in the human line, surely, is a cross-modal capacity for making sense and, within that capacity, abilities to construe and to construct particular instrumentalities. It might be said that our ancestors designed us with a predisposition toward the mixing of metaphors, knowing full well in their emergent wisdom that if the only tool we had were a hammer, we would tend to treat everything as if it were a nail. See Preziosi, "Architectonic and Linguistic Signs," 167–75.

81. See Preziosi, "Reckoning with the World," *American Journal of Semiotics* 4:1–2 (1986): 1–15; and chap. 6, sec. 3, this vol. See also the remarks of Davis in "Representation and Knowledge," 28–29, esp. the following: "The work or operation of art is not just the illustration or reflection or expression of social themes or strategies of social life, but in a strong sense is also one medium of thought, at least, in which social life and strategy is actual constructed, for purposes which might be quite specific, ideological or rhetorical, or even private. Representation, in other words, is the material site of one's thought about one's knowledge of the world."

82. See esp. the discussion of the issue of Adamic language in chap. 4, sec. 4, and references (n. 92ff.).

CHAPTER SIX: *The End(s) of Art History*

Epigraphs: H. Belting, *The End of the History of Art?* (Chicago: Univ. of Chicago Press, 1987), ix; N. Bryson, *Vision and Painting* (New Haven: Yale Univ. Press, 1983), xiii–xiv; H. White, *Tropics of Discourse* (Baltimore: Johns Hopkins Univ. Press, 1978), 131; J. Derrida, "The *retrait* of metaphor," *Enclitic* 2 (1978): 28.

1. In a sense, such a collective endeavor has been going on for some time, as the discussions in chap. 1 have made clear; see esp. nn. 1, 4, 11, 13, 14, 15, and 20

for references to this literature.

2. See esp. the recent volume by M. Holly, *Panofsky and the Foundations of Art History* (Ithaca: Cornell Univ. Press, 1984), discussed in chap. 4. As an example, the recent book by H. Belting, *The End of Art History?* (Chicago: Univ. of Chicago Press, 1987), situates the problems facing the discipline today as stemming from the loss of a "coherent 'history of art' . . . as by the loss of the eternal 'work of art,' which demands an order and universally valid act of interpretation, or representation" (63). Yet, as we have tried to make clear, nostalgia is not enough: The problem is locating the sources and motivations for such nostalgia. How and why does the discipline stage its nostalgia?

3. See preface, with references.

4. A program of the College Art Association of America meetings would provide a case in point, as would the programs of any similar disciplinary organization (such as those of the Association of Art Historians [AAH] in England). The history of such stagings has not been examined critically. What constitutes topicality in any year, and to whom are entrusted the definitions of pertinent subjects for sessions, workshops, and seminars? Related issues are discussed in C. R. Sherman, ed., *Women as Interpreters of the Visual Arts, 1820–1979* (Westport, Conn.: Greenwood Press, 1981), esp. pt. 3 by Sherman.

5. A detailed discussion of these issues will be found above in chap. 4, secs. 1–4.

6. We have taken the Fogg institution as paradigmatic of the modernist discipline in the United States (see chap. 3). Complementary instances can be cited, such as that of Princeton University where the influence of Charles Rufus Morey was dominant. See E. Panofsky, "Charles Rufus Morey (1877–1955)," *American Philosophical Society Year Book* (1955), 482–91. Morey founded the *Art Bulletin* in 1913 and The Index of Christian Art in 1918, copies of which are located at New York, Princeton, UCLA, Utrecht, the Vatican, and Washington, D.C. There was nothing in the United States to echo the institutionalized differences in practice housed by the Warburg and Courtauld institutions in England. See Rees and Borzello, op. cit., for essays on art history in England; and Dilly, op. cit., for Germany.

7. Our knowledge here is anecdotal and scanty; see E. Panofsky, "Three Decades of Art History in the United States," in his *Meaning in the Visual Arts* (Garden City, N.Y.: Doubleday, 1955), and W. E. Kleinbauer's *Modern Perspectives in Western Art History* (New York: Holt, Rinehart and Winston, 1971) as examples of accounts that have dominated the study of disciplinary history to date. Two recent essays deal with the formatting of visual information through the use of photography: A. Sekula, "The Body and the Archive," *October* 39 (Winter 1986): 3–64; and F. Biocca, "Sampling from the Museum of Forms," *Communication Yearbook* 10 (1987): 684–708, with an extensive bibliography. To these may be added J.-A. Miller, "Jeremy Bentham's Panoptic Device," *October* 41 (Summer 1987): 3–30. For German perspectives, see chap. 4, n. 187, this vol.

8. There is by now a large literature on the subject of a social history of art. Two useful recent assessments can be found in A. Wallach, "Marxism and Art History," in B. Ollman and E. Vernoff, eds., *The Left Academy* (New York: Praeger,

1984), 25–53; and in *Radical History Review* 38 (April 1987), esp. J. Hutton, "Left of Center, Against the Grain," 59–71.

9. T. J. Clark, *Image of the People* (Princeton, N.J.: Princeton Univ. Press, 1973), 17.

10. Wallach, op. cit., 30–31.

11. Quote attributed to O. Werckmeister in the College Art Association of America "Announcement and Call for Participation; 1988 Annual Meeting" (Winter 1986–87), 3.

12. Wallach, op. cit., 32

13. See esp. Kleinbauer's account of the history of art history, as discussed in chap. 2, this vol.

14. The phrase is Roland Barthes's; see chap. 2, sec. 2, of this vol. for a detailed discussion.

15. See also N. Hadjinicolaou, *Histoire de l'art et lutte des classes* (Paris: Maspero, 1973), based on a rather reductivist reading of writings of Poulantzas and Althusser.

16. "In practice, bourgeois art history is not usually an historical discipline. Instead . . . it tends to separate art from history, thus making works of art susceptible to various types of ahistorical interpretation: Art as a testimonial to individual male genius, to national character, and so forth. A great deal is invested in this separation" (A. Wallach, op. cit., 31).

17. H. Damisch, "Semiotics and Iconography," in T. A. Sebeok, ed., *The Tell-Tale Sign* (Lisse: Peter de Ridder Press, 1975), 29. It seems clear that Damisch's comments were in reference to the Hadjinicolaou volume that had appeared in Paris earlier that year.

18. See the account of J. Hutton, op. cit., 59–61, and the observations of Wallach in "Marxism and Art History," passim. Also of use here are the two analyses by S. Guilbaud: *How New York Stole the Idea of Modern Art* (Chicago: Univ. of Chicago Press, 1984); and "The New Adventures of the Avant-Garde in America," *October* 15 (Winter 1980): 61–78. On the subject of Greenbergian formalism, see *The Politics of Interpretation*, ed. W. J. T. Mitchell (Chicago: Univ. of Chicago Press, 1983), which included a noteworthy interchange between M. Fried and T. J. Clark: T. J. Clark, "Clement Greenberg's Theory of Art," 203–20; M. Fried, "How Modernism Works: A Response to T. J. Clark," 221–38; and T. J. Clark, "Arguments about Modernism: A Reply to Michael Fried," 239–48.

19. The nostalgia has continued. At a 1981 conference at Binghamton on recent developments in the social history of art (organized by Eunice Lipton), one workshop was devoted to "Whatever happened to Meyer Schapiro's Marxism?" with remarks by T. J. Clark, A. Wallach, C. Duncan, J. Gear, L. Nochlin, M. Turim, and the present writer.

20. See writings by A. Michelson and S. Nodelman in the late 1960s (discussed in chap. 4, this vol.) and by Damisch, op. cit., 27–36. See also these works by M. Schapiro: "On Some Problems in the Semiotics of Visual Art," *Semiotica* 1:3 (1969); and *Words and Pictures* (The Hague: Mouton, 1973). The Feminist Caucus at the College Art Association of America began in 1973, several years before a Marxist Caucus (currently defunct) began. Literature on feminist issues relat-

ing to art and art history is enormous; a useful introduction to some basic issues can be found in G. Pollock, "Vision, Voice and Power," *Block* 6 (1982): 2–20. See the important essay by L. Nochlin, "Why Have There Been No Great Women Artists?" conveniently found in E. Baker and T. Hess, eds., *Art and Sexual Politics* (New York: Macmillan, 1973), 1–43. See also two recent volumes edited by R. Parker and G. Pollock: *Old Mistresses* (New York: Pantheon, 1982); and *Framing Feminism* (London: Pandora, 1987). A good summary of developments is T. Gouma-Peterson and P. Mathews, "The Feminist Critique of Art History," *Art Bulletin* 69:3 (Sept. 1987): 326–57.

21. This diachronic perspective had little impact on the discipline in the Anglo-American world; as we noted in chap. 4, its impact was largely in the area of architectural history and criticism. Indeed, structuralist semiology was addressed only with the advent of various poststructuralist perspectives within the discipline. The first CAA session devoted to semiotics took place in 1981, a quarter of a century after architectural historians had begun to deal with such issues. See the odd remarks of Hadjinicolaou (op. cit., 144 n. 10) on the "approach to the history of the production of pictures with the aid of linguistics" [*sic*], in reference to the current works of Damisch (*Théorie du nuage* [Paris: Seuil, 1972]) and of J. Kristeva ("L'Espace Giotto," *Peinture* 2:3 [1972]), which (in Hadjinicolaou's words) "claim to have found an 'Open Sesame' which is the key to everything and renders historical research unnecessary." The most salient critique of Lévi-Straussian structuralism was that by Derrida, written seven years earlier: "Structure, Sign and Play in the Discourse of the Human Sciences," in A. Bass, ed., *Writing and Difference* (Chicago: Univ. of Chicago Press, 1978), 278–94. On the ahistoricality of certain facets of structuralist semiotics, see chap. 4, n. 172, this vol., with the observations of Weber on Charles Sanders Peirce's perspective on signification and interpretation as necessarily inseparable.

22. See Wallach, op. cit., for a discussion of the progenitors of Marxist art history during the 1970s; cf. Hadjinicolaou's volume (op. cit.) with those of P. Macherey (*Pour une théorie de la production littéraire* [Paris: Maspero, 1974]), T. Eagleton (*Criticism and Ideology* [London: Verso, 1978], esp. chap. 3, "Towards a Science of the Text"), or R. Williams (esp. "Base and Superstructure in Marxist Cultural Theory," *New Left Review* 82 [Nov./Dec. 1973]: 1–19). A useful introduction to these questions can be found in Eagleton, 11–63, along with an assessment of the *Scrutiny* movement in England, the development of Williams's work, and the problem of the possibilities for materialist criticism and Marxist aesthetic theory. The Williams essay noted above was first delivered as a lecture in Montreal in April 1973. See also O. Werckmeister, "Marx on Ideology and Art," *New Literary History* 4 (1973); K. Forster, "Critical History of Art, or Transfiguration of Values," *New Literary History* 3 (1972); Forster, "Aby Warburg's History of Art," *Daedalus* 105 (1976). A postmortem on Marxist art history was held as a special symposium at the 1988 CAA meetings in Houston, chaired by Werckmeister.

23. A study of institutional curricula on art history is sorely needed; see the discussions in chap. 3, passim, and references, nn. 70 and 80.

24. The English translation was published in 1978 (five years after the original French edition), the same year that Derrida's *La Vérité en peinture* appeared. See also n. 17, this chap. As an example of Hadjinicolaou's avoidance of current debates in the volume, see his section on structuralist approaches to the study of art (op. cit., 64–68), which centers on work of half a century earlier.

25. Clark, *The Image of the People*, 2d ed. (1982), and *The Absolute Bourgeois*, 2d ed. (Princeton: Princeton Univ. Press, 1982). Identical prefaces to the second editions, written in 1981, comment on the reactions to the first editions over the previous eight years and note that most of the original texts were written during 1969–70. In the new prefaces, Clark remarks that "Left and Right were, and remain, ill-equipped to recognize the books' main line of inquiry: the Right because it wished to have them be a 'contribution' to some dismal methodological change of gear . . . ; the Left because it went on pining either for the simplicities of socialist realism or the happy life on the avant-garde reservation" (6, both volumes). In *Image of the People*, the title of chap. 1 was, in Clark's words of 1981, an "ironic courtesy to Arnold Hauser," which he later regretted.

26. See also his "Preliminaries to a Possible Treatment of Manet's *Olympia* in 1865," *Screen* 21 (1980): 18–41, devoted to an understanding of salon criticism at the time; see also Clark, *Image of the People*, 130–54, and T. Crow, "The Oath of the Horatii in 1785," *Art History* 1:4 (Dec. 1978): 424–71.

27. Clark, *Image of the People*, 13, 19, 18.

28. We have commented on this dichotomy at length in chap. 2 in connection with a critique of Kleinbauer's *Perspectives*.

29. See n. 25, this chap., and the campaigns of critic H. Kramer in the political journal *The New Criterion*, referred to in chap. 1.

30. Clark, *Image of the People*, 12.

31. See esp. Kramer, "T. J. Clark and the Marxist Critique of Modern Painting," *The New Criterion* (March 1985): 1–8; F. Cachin, "The Impressionists on Trial," *The New York Review of Books* (May 30, 1985): 30. For criticism from the Left, see A. Rifkin, "Marx's Clarkism," *Art History* (Dec. 1985), and Rifkin, "No Particular Thing to Mean," *Block* 8 (1983). See the discussion by Hutton, op. cit., esp. 63–70, in connection with the 1985 book by Clark, *The Painting of Modern Life* (New York: Knopf), the more recent target of Kramer and Rifkin. Rees and Borzello, op. cit., include critiques of Clark by several writers.

32. White, op. cit.

33. Ibid., 131, 132.

34. See the discussions in chap 2, sec. 2; see also J. Derrida, "Structure, Sign and Play," 288–94; and the *parergon* section of chap. 1 in his *La Vérité en peinture* (Paris: Flammarion, 1978), 44–94 (on which also see C. Owens, "Detachment from the *parergon*," *October* 9 [Summer 1979]: 42–50). On the strong feminist reactions to the Marxist art history of the early 1970s (and in particular to one characteristic of Clark's 1973 books), see Pollock, op. cit., 2–20; see also n. 20, this chap. Derrida's earlier critique of the scientism of Lévi-Straussian structuralism, its oppositions between science and bricolage, remains poignant in review-

ing many of the claims of Marxist social history in art history since the early 1970s.

35. See Owens, op. cit., and the tenor of our arguments in chap. 3.

36. White, "The Politics of Historical Interpretation," in W. J. T. Mitchell, ed., *The Politics of Interpretation* (Chicago: Univ. of Chicago Press, 1983), 129.

37. Ibid., 128, in reference to P. Valesio, *Novantiqua* (Bloomington: Univ. of Indiana Press, 1980), 41–60.

38. White, *Politics of Historical Interpretation*, 128–29.

39. Ibid., 122–23.

40. Some glimpses of this can be read in the recent book by H. Foster, *Recodings* (Port Townsend, Wash.: Bay Press, 1985), esp. pt. 2, 121–80. See also the Fall 1985 issue of *New German Critique* (no. 33) for a mapping of such issues along the modernism-postmodernism debate, esp. F. Jameson, "The Politics of Theory," 53ff. (see also Jameson, "Postmodernism, or the Cultural Logic of Late Capitalism," *New Left Review* 146 [1985]: 53–92); and the special issue on the fate of modernity of *Theory, Culture and Society* 2:3 (1985). On problems facing a Marxist aesthetic today, see Jameson, *The Political Unconscious* (Ithaca: Cornell Univ. Press, 1981), esp. chaps. 1 and 6. Further references in n. 42, this chap.

41. See Derrida, "Structure, Sign and Play," esp. 292–93; compare this 1966 perspective with the 1985 essay by A. Callinicos, "Postmodernism, Post-Structuralism and Post-Marxism?" *Theory, Culture and Society* 2:3 (1985): 85–102.

42. An important collection of discussions, entitled "Marx after Derrida," appeared in *Diacritics* 15:4 (Winter 1985), ed. S. P. Mohanty. In this issue, Eagleton provides a sensible and intelligent appraisal of the relationships between Marxism and contemporary critical theory (especially deconstruction). His article, entitled "Marxism, Structuralism, and Post-Structuralism" (2–12), highlights Derrida's political agenda regarding deconstructive practice (in contrast to the American appropriation of his work as confirming dominant political and economic interests), spelled out quite unambiguously in Derrida's *La Vérité en peinture* (23–24). Eagleton sees P. Anderson's recent volume *In the Tracks of Historical Materialism* (Chicago: Univ. of Chicago Press, 1984) as emblematic of the inability of certain dominant trends in late Western Marxism to deal with the complexities of the contemporary critical-theoretical scene, and particularly with structuralism and its aftermaths. Eagleton's thrust is one that resonates with our own remarks above: namely, that the mounting of a Marxist art history in the early 1970s on scientistic and nostalgic lines resulted in no small measure from a misreading of the radical political implications in the work of Foucault, Derrida, and Lacan. An intelligent study of Lacan and his importance to critical studies is the book by J. F. MacCannell, *Figuring Lacan* (Lincoln: Univ. of Nebraska Press, 1986), a work that clearly foregrounds the ways in which Lacan has historicized the universalist and mythicist perceptions of Freud and problematized the latter's masculist subject. The newly published *Marxism and the Interpretation of Culture*, ed. C. Nelson and L. Grossberg (Urbana: Univ. of Illinois Press, 1988), is the best introduction to Marxist and post-Marxist interpretation to date, although not a single one of

the thirty-seven essays deals with art history as such.

43. In no small measure, that essay can be seen as a response to some of the critical controversy arising out of the two important books published the previous year by Clark.

44. Quoted in Pollock, op. cit., 2; and Hutton, op. cit., 63. Note Pollock's unease at projections for a Marxist art history focused simply on class relations and disinterested in or unaware of the social history of sexuality, kinship, the family, and the acquisition of gender identity.

45. The 1982 article by Pollock cited above remains an exemplary discussion of the issues. Clark's lecture at UCLA on April 3, 1987, was given as an informal seminar on the current state of social-historical study within the discipline.

46. Clark's reference to a "Neanderthal" Marxist art history resonates with a continuing controversy in one corner of Marxist art history regarding the relevance of contemporary critical theory to the self-styled political agendas of the former; see nn. 40 and 42, this chap. The third quotation at the beginning of this section can be read as emblematic of one pole of the controversy.

47. These remarks were originally part of a lecture delivered in 1986 at a conference entitled "Arts and Histories Reconsidered" at UCLA and later published in *Journal: A Contemporary Art Magazine* 46:6 (Winter 1987): 32 by LAICA (Los Angeles Institute of Contemporary Art).

48. See chap. 3, sec. 2, and chap. 4, secs. 2 and 3.

49. See H. Hartman, "The Unhappy Marriage of Marxism and Feminism," *Capital and Class* 8 (Summer 1979), 11ff.

50. See F. Lentricchia, *Criticism and Social Change* (Chicago: Univ. of Chicago Press, 1983), esp. 34 and 110ff., for a discussion of this problem.

51. This question is succinctly put by S. Cohen in *Historical Culture* (Berkeley and Los Angeles: Univ. of California Press, 1986), 10.

52. The following remarks resonate with our observations in chap. 3; see also the discussion at the end of chap. 5.

53. On anamorphism, see chap. 3. In an unpublished essay ("Anamorphism: Jasper Johns"), R. Shiff makes similar observations with respect to painting.

54. On metaphoric relations and iconism in their relationships to metonymy, see T. E. Lewis, "Reference and Dissemination," *Diacritics* 15:4 (Winter 1985): 37–56, esp. 41–49.

55. As we have proposed in chap. 3, one-point perspective can be construed as a mode of anamorphism itself.

56. The literature pertaining to the classical monuments of the Athenian akropolis is immense; reliable recent introductions include the following: R. E. Wycherley, *The Stones of Athens* (Princeton: Princeton Univ. Press, 1978), esp. 105–54; V. J. Bruno, ed., *The Parthenon* (New York: W. W. Norton, 1974); *Parthenos and Parthenon*, suppl. no. 10 to *Greece and Rome* 1963; C. J. Herington, *Athena Parthenos and Athena Polias* (Manchester: Manchester Univ. Press, 1955); G. P. Stevens, "The Periclean Entrance Court of the Acropolis of Athens," *Hesperia* 5 (1936): 443–520; B. Ashmole, *Architect and Sculptor in Classical Greece* (London: Phaidon, 1972),

esp. chaps. 4 and 5; R. J. Hopper, *The Acropolis* (London: Weidenfeld and Nicholson, 1971); J. A. Bundgaard, *Mnesikles, A Greek Architect at Work* (Copenhagen: Gyldendal, 1957); J. D. Travlos, *Pictorial Dictionary of Ancient Athens* (New York: Praeger, 1971); Travlos, *Poleodomike Exelixis tōn Athenōn* (Athens: Athens Archaeological Society, 1960); G. P. Stevens and J. M. Paton, *The Erechtheum* (Cambridge: Harvard Univ. Press, 1927); N. Kontoleon, *The Erechtheion as a Building of Chthonic Cult* (Athens: Athens Archaeological Society, 1949); Pausanias, *Guide to Greece* (written ca. late 150s to late 170s A.D.), vol. 1, Central Greece, trans. P. Levi (Harmondsworth: Penguin Books, 1971), esp. 61ff. See also J. J. Pollitt, *Art and Experience in Classical Greece* (Cambridge: Cambridge Univ. Press, 1972), esp. 64–110.

57. I use the term with its Lacanian connotations of imagery (see MacCannell, op. cit., 61, 124, 134).

58. The literature on this is now very large, starting with the classic text of K. Lynch, *The Image of the City* (Cambridge: MIT Press, 1960); a recent important study is M. Krampen, *Meaning in the Urban Environment* (London: Pion Ltd., 1979); see also D. Preziosi, *The Semiotics of the Built Environment* (Bloomington: Indiana Univ. Press, 1979), for bibliography. For a Marxian perspective on the subject, see Jameson, "Cognitive Mapping," in Nelson and Grossberg, op. cit., 347–60; the important recent study of architecture and ideology by M. Tafuri, *The Sphere and the Labyrinth* (Cambridge: MIT Press, 1987) may provide a historically more sophisticated picture than the former.

59. See Preziosi, "Reckoning with the World," *American Journal of Semiotics* 4:1–2 (1986): 1–15; see also chap. 2, passim; and Bryson, op. cit., esp. chaps. 4 and 5.

60. In that sense, any reading is in a way a misreading.

61. A useful beginning would be U. Neisser, *Cognition and Reality* (San Francisco: Freeman, 1976); J. Hochberg, *Perception*, 2d ed. (Englewood Cliffs, N.J.: Prentice-Hall, 1978). An extensive bibliography pertinent to visual environment issues can be found in Preziosi, *Architecture, Language and Meaning* (The Hague: Mouton, 1979), 115–22.

62. This, of course, has been the tenor of our observations in chap. 3; see also Bryson, op. cit., 133–62.

63. See the important study by C. J. Herington cited in n. 56, this chap.

64. See the recent discussion by Wycherley, op. cit., 143–54, with bibliography, and the useful plan on p. 218 (fig. 218) of Travlos's *Pictorial Dictionary* (reproduced by Wycherley on p. 151 of his work). Travlos restores a shrine to Athena *polias* on the east wall of the west room of the building, in a small *adyton*; see the Levi edition of Pausanias, op. cit., 74ff.

65. See references for the Propylaia in n. 56, this chap.; and the useful summary by Wycherley, op. cit., 132–36.

66. On the Athena *nikē* temple, see Wycherley, op. cit., 128–32.

67. The statue itself has not survived, although we have a record of its dedication in 425–24 B.C.; see Wycherley, loc. cit., with references.

68. See the excellent discusson of the *nikē* frieze and balustrade by Pollitt, op. cit.,

111–25.

69. See Bruno, op. cit., 225–322, for two important essays by E. Harrison and P. Fehl on the pediment and frieze.

70. Bruno, op. cit., 55ff., gives a good summary account of the place of the akropolis monuments in the religious and ceremonial life of the city, and in particular with regard to the Parthenon; Herington, op. cit., presents an intriguing study of the relationships between the *parthenos* and *polias* personae of Athena, which he sees as deriving from two distinct ancient female divinities whose characteristics later became fused in the Athena of the classical period.

71. A separate volume would be required simply to list the writings on the subject of classicism. Pollitt's study (op. cit., 1–14) remains the best recent introduction to the question; see also G. Gruben, *Die Tempel der Griechen* (Munich: Hirmer, 1966), on proportionality in classical temple design; on sculpture, see B. Ashmole, *The Classical Ideal in Greek Sculpture* (Cincinnati: Univ. of Cincinnati Press, 1964).

72. A useful compendium of ancient sources, with commentaries, can be found in Pollitt, *The Art of Greece* (Englewood Cliffs, N. J.: Prentice-Hall, 1965), esp. 55–126; on the Periclean building program, see 114–21.

73. See W. B. Dinsmoor, "The Design and Building Techniques of the Parthenon," in Bruno, op. cit., 171–98; A. Mavrikios, "Aesthetic Analysis Concerning the Curvature of the Parthenon," in Bruno, 199–224; and Pollitt, *Art and Experience*, 75–78.

74. On *summētria*, see Pollitt, *Art and Experience*, 72 and 106–07 for an introduction, and 54ff. for a correlative principle (*rhythmos*) in sculpture, whereby a particular pose-pattern could, when poignantly chosen, convey the entire nature of a continuing movement. The basic meaning of the term *rhythmos* was shape or pattern, and it was associated with music, as is its modern variant. Could we not also consider, in a generic way, that the variant images of Athena on the akropolis were akin to the *eremai* or "stops" in her fluid and multiple persona, part of a rhythmic economy?

75. See Bundgaard, op. cit., and G. P. Stevens, "The Periclean Entrance Court," cited n. 56, this chap. On the *pinakotheka*, see the description by Pausanias, 1.22.6; 62ff. in the Levi translation.

76. As of this writing, Avghi Tzakou of the Greek Ministry of Culture is in the process of making a complete reevaluation of the reconstructions of the Propylaia in connection with a doctoral dissertation; I am grateful for her advice on the subject in this discussion. See her *Propylaia* (Athens: Ministry of Culture, 1981), with bibliography.

77. See n. 75, this chap. Pausanias describes paintings of Odysseus and Diomedes (stealing the image of Athena from Troy), along with other Homeric subjects. In contrast to the essentially private clubhouse (*leschē*) gallery of the Knidians at Delphi, the *pinakotheka* was what might be recognized as the first public art gallery. The depiction of Diomedes stealing the Trojan Athena image could be said to set the historical stage for the manifestations of Athena within the akropolis beyond the gateway. These paintings have not survived, and Pausanias's descrip-

tion is too brief to allow even the most sketchy reconstruction.

78. This is clearly visible in fig. 63 of H. Berve, G. Gruben, and M. Hirmer, *Greek Temples, Theatres and Shrines* (New York: Abrams, 1962), 381. In this plan, hatched areas indicate conjectural walls possibly left incomplete, according to some; dotted lines indicate the traces of the earlier gateway building beneath the central hall of the Mnesiklean building.

79. This is clearly indicated in fig. 66 of Berve et al., op. cit., 387.

80. There are traces of fittings for banquet couches within the *pinakotheka*, and it is reasonable to assume that the gallery may have functioned as a formal dining room as well. The room is restored in this way by Travlos, *Pictorial Dictionary*, 482; see also A. W. Lawrence, *Greek Architecture*, 4th ed., rev., with additions by R. A. Tomlinson (Harmondsworth: Penguin Books, 1983), 208–09 and fig. 179. The seventeen restored couches would, in Travlos's reconstruction, fit snugly around the walls of the room, with two couch lengths accounting for the length of the east (shorter) outer wall and two couch lengths plus the width of a perpendicular couch making up the length of the west outer wall. The couches (which would have been made of wood) have not, of course, survived, but from what remains of their supporting surfaces, Travlos sees enough to assay the reconstruction just given. I find it difficult to imagine, however, that the outer wall was skewed primarily for this reason: the couches were portable, and other arrangements are possible: There is no intrinsic reason why we must suppose that all the couches had to occupy the entire circumferential wall space. More palpable traces remain for the fittings of the wooden *pinakes* on which the pictures were painted.

81. Many visitors and tourists have noticed this phenomenon, as do Berve et al., op. cit., 383. It is important to add that this framing would not have been evident from the opposite (south) platform of the Nike bastion because of the foreshortening involved, but only at the point shown.

82. Also noted in Berve et al., loc. cit. The colossal statue of the *promakhos* originally stood against the west retaining wall beyond the empty forecourt to the east of the Propylaia. It has not survived, although there are extant descriptions of it; see G. P. Stevens, *Hesperia* 5 (1936): 491–99, for a discussion of its position; Stevens, *Hesperia* 15 (1946): 107–14; and Travlos, op. cit., 55. See also A. Raubitschek, *Dedications on the Athenian Acropolis* (Cambridge: Harvard Univ. Press, 1949), 191–205.

83. Pausanias (1.28.2) observes that "the point of the spear of this Athena and the crest of the helmet can be seen as you come in by sea from [Cape] Sounion." The *parthenos* Athena statue, also by Pheidias (Pausanias 1.24.5–7; Pliny, *Natural History* 36.18) was approximately 26 cubits high; we may imagine that the *promakhos* Athena was of similar height.

84. See M. I. Finley, *The Ancient Greeks* (Harmondsworth: Pelican Books, 1977), esp. 54–93, for historical background; a useful short introduction to relevant political and social events is P. Green, *Ancient Greece* (New York: Viking Press, 1974), 124–47.

85. See Finley, op. cit., 62ff., based largely on book 1 of Thucydides's History of the

Peloponnesian Wars.

86. Emblematic of the change was the removal to Athens in 454 B.C. of the common treasury of the Delian League from the island of Delos; the consequent "growth of the power of Athens, and the alarm which this inspired in Sparta, made war inevitable" (Thucydides, I.23.6).

87. See R. Coward and J. Ellis, *Language and Materialism* (London: Routledge & Kegan Paul, 1977), for a succinct articulation of this, esp. 61–75.

88. Pollitt, *Art and Experience*, 64–110.

89. I. Calvino, *Invisible Cities*, trans. W. Weaver (New York: Harcourt Brace Jovanovich, 1972), 44; see also the Calvino quotation at the beginning of chap. 4, this vol.

90. See our discussions at the end of chap. 3 and nn. 27 and 98 of that chap. on the *artes memorativae*.

Bibliography

Aarsleff, Hans. *From Locke to Saussure (Essay on the Study of Language and Intellectual History)*. Minneapolis: University of Minnesota Press, 1982.

Abrams, M. H. "The Deconstructive Angel." *Critical Inquiry* 3 (Spring 1977): 426.

Alberti, Leon Battista. *On Painting*. New Haven: Yale University Press, 1966.

Allison, David, ed. *The New Nietzsche: Contemporary Styles of Interpretation*. New York: Delta, 1979.

Alpers, Svetlana. *The Art of Describing*. Chicago: University of Chicago Press, 1983.

———. "Ekphrasis and Aesthetic Attitudes in Vasari's *Lives*." *Journal of the Warburg and Courtauld Institutes* 23 (1960): 190–215.

———. "Interpretation Without Representation, or the Viewing of Las Meninas." *Representations* 1, no. 1 (1983): 31–42.

———. "Is Art History?" *Daedalus* (1977): 1–13.

Alpers, S., and P. Alpers. "Ut Pictura Noesis?: Criticism in Literary Studies and Art History." *New Literary History* 3 (Spring 1972): 437–58.

Alsop, Joseph. *The Rare Art Traditions: The History of Art Collecting and Its Linked Phenomena*. New York: Harper and Row, 1982.

Althusser, Louis. *Eléments d'autocritique*. Paris: Hachette, 1974.

Anderson, Perry. *In the Tracks of Historical Materialism*. Chicago: University of Chicago Press, 1984.

Antal, Frederick. *Classicism and Romanticism, with Other Studies in Art History*. New York: Basic Books, 1966.

Argan, Giulio Carlo. "Ideology and Iconology." In *The Language of Images*, edited by W. J. T. Mitchell, 15–24. Chicago: University of Chicago Press, 1980.

Argyros, Alex. "The Warp of the World: Deconstruction and Hermeneutics." *Diacritics* 16, no. 3 (Fall 1987): 47–55.

Arnauld, A., and C. Lancelot. *Grammaire générale et raisonée de Port-Royal*. Paris: Bossange et Masson, 1809 (original edition 1660).

Arnauld, A., and P. Nicole. *La Logique ou l'art de penser*. 6th ed. Paris: G. Desprez, 1724.

Arnheim, Rudolf. "Gestalt and Art." *Journal of Aesthetics and Art Criticism* 2 (1943): 71–75.

———. "The Gestalt Theory of Expression." *Psychological Review* 56 (1949): 156–71.

———. "A Plea for Visual Thinking." *Critical Inquiry* 6 (Spring 1980): 489–97.

Arns, Evaristo. *La Technique du livre d'après Saint Jérôme*. Paris: Editions de Minuit, 1953.

Ashmole, B. *Architect and Sculptor in Classical Greece*. London: Phaidon, 1972.

———. *The Classical Ideal in Greek Sculpture*. Semple Memorial Lecture. Cincinnati: University of Cincinnati Press, 1964.

Aubrey, John. *Brief Lives*, edited by O. L. Dick. Ann Arbor: University of Michigan Press, 1962.

Baldick, Chris. *The Social Mission of English Criticism*. Oxford: Oxford University Press, 1983.

Bandi, H. G. "Quelques réflexions sur la nouvelle hypothèse de A. Leroi-Gourhan concernant la signification de l'art quarternaire." In *Actas del Symposium Internacional de Arte Prehistórico*, edited by M. A. Basch and M. A. Garcia Guinea, 309–19. Santander: Patronato de las Cuevas Prehistóricas, 1972.

Barthes, Roland. *Mythologies*. Paris: Seuil, 1957.

Bate, W. J. "The Crisis in English Studies." *Harvard Magazine* (Sept./Oct. 1982): 41–45.

Bätschmann, Oskar. "Logos in der Geschichte: Erwin Panofskys Ikonologie." In *Kategorien und Methoden der deutschen Kunstgeschichte 1900–1930*, edited by L. Dittman, 89–112. Stuttgart: Franz Steiner, 1985.

Baudrillard, Jean. *L'Effet Baubourg*. Paris: Galilée, 1977.

———. *For a Critique of the Political Economy of the Sign*. Translated by C. Levin. St. Louis: Telos Press, 1981. Originally published as *Pour une critique de l'économie politique du signe* (Paris: Gallimard, 1972).

Baxandall, M. *Giotto and the Orators*. Oxford: Claredon Press, 1971.

———. *Painting and Experience in Fifteenth Century Italy*. Oxford: Oxford University Press, 1972.

Belsey, Catherine. *Critical Practice*. London and New York: Methuen, 1980.

Belting, Hans. *The End of Art History?* Chicago: University of Chicago Press, 1987.

Benjamin, Walter. "The Work of Art in the Age of Mechanical Reproduction." In *Illuminations*, edited by H. Arendt. New York: Schocken, 1969.

Bennett, Tony. *Formalism and Marxism*. London and New York: Methuen, 1979.

Bennett, William. "The Shattered Humanities." *The Wall Street Journal* (Dec. 31, 1982): 1.

———. "To Reclaim a Legacy: Report on Humanities in Education." *The Chronicle of Higher Education* (Nov. 28, 1984): A4–A8.

Bentham, Jeremy. *Le Panoptique*. Paris: Belfond, 1977. Originally published as *Panopticon* (London: T. Payne, 1791).

Benveniste, Emile. "The Correlations of Tense in the French Verb." In *Problems in General Linguistics*. Coral Gables, Fla.: University of Miami Press, 1971.

———. *Problems in General Linguistics*. Vol. 1. Coral Gables, Fla.: University of Miami Press, 1971.

Berenson, Bernard. *Three Essays in Method*. Oxford: Oxford University Press, 1972.

Berve, H., G. Gruben, and M. Hirmer. *Greek Temples, Theatres and Shrines*. New York: Abrams, 1962.

Biocca, Frank. "Sampling from the Museum of Forms: Photography and Visual Thinking in the Rise of Modern Statistics." *Communication Yearbook* 10 (1987):

684–708.

Bloch, Jules. *Indo-Aryan, From the Vedas to Modern Times*. Paris: Adrien-Maissonneuve, 1965.

Bois, Yve-Alain. "Panofsky Early and Late." *Art in America* (July 1985): 9–15.

Bonnet, J., ed. *Erwin Panofsky: Cahiers pour un temps*. Paris: Pandora, 1983.

Bordes, F. "Os percé moustérien et os gravé acheuléen du Pech de l'Azé 11." *Quarternaria* 2 (1960): 1–6.

Bourdieu, Pierre. *Outline of a Theory of Practice*. Cambridge: Cambridge University Press, 1977.

Bourdieu, Pierre, and Alain Darbel. *L'Amour de l'art: Les musées d'art européens et leur public*. Paris: Editions du Seuil, 1969.

Breitbart, Eric. "The Painted Mirror." In *Presenting the Past: History Museums in the United States*, edited by S. Benson, S. Brier, and R. Rosenzweig. Philadelphia: Temple University Press, 1986.

Breuil, Henri. *Four Hundred Centuries of Cave Art*. Montignac: Centre des études et de documentation préhistorique, 1952.

Brooks, Cleanth, and Robert Penn Warren. *Understanding Poetry*. New York: Holt and Co., 1938.

Brown, Harold I. *Perception, Theory and Commitment: The New Philosophy of Science*. Chicago: University of Chicago Press, 1979.

Brown, Jonathan. *Images and Ideas of Seventeenth Century Spanish Painting*. Princeton: Princeton University Press, 1978.

Brown, Spencer G. *Laws of Form*. London: Allen and Unwin, 1969.

Bruno, Vincent J., ed. *The Parthenon*. Norton Critical Studies in Art History. New York: W. W. Norton, 1974.

Bryson, Norman. *Vision in Painting: The Logic of the Gaze*. New Haven: Yale University Press, 1983.

Bühler, Karl. *Sprachtheorie*. Jena: Fischer, 1934.

Bundgaard, J. A. *Mnesikles, A Greek Architect at Work*. Copenhagen: Gyldendal, 1957.

Burbank, J., and Peter Steiner, eds. *Structure, Sign and Function: Selected Writings of Jan Mukařovský*. New Haven: Yale University Press, 1978.

Burks, A. A., ed. *The Collected Papers of Charles Sanders Peirce*. Vols. 7 and 8. Cambridge: Harvard University Press, 1958.

Cachin, F. "The Impressionists on Trial." *New York Review of Books* (May 30, 1985): 30.

Callinicos, Alex. "Postmodernism, Post-Structuralism and Post-Marxism." *Theory, Culture and Society* 2, no. 3 (1985): 85–102.

Calvino, Italo. *Invisible Cities*. Translated by William Weaver. New York: Harcourt Brace Jovanovich, 1974.

Campbell, Colin. "The Tyranny of the Yale Critics." *New York Times Magazine* (Feb. 9, 1986): 20–48.

Carlyle, Thomas. *Critical and Miscellaneous Essays*. Vols. 1–5. New York: P. F. Collier, 1899.

————. "Signs of the Times." *Edinburgh Review* 49 (June 1829): 439–59.

Carrier, D. *Artwriting*. Amherst: University of Massachusetts Press, 1987.

Carroll, David. *The Subject in Question: The Languages of Theory and the Strategies of Fiction*. Chicago and London: University of Chicago Press, 1982.

Cassirer, Ernst. *Philosophie der symbolischen Formen*. Berlin: B. Cassirer, 1923–29.

Chase, George H. "The Fine Arts 1874–1929." In *The Development of Harvard University (Since the Inauguration of President Eliot) 1869–1929*, edited by S. E. Morison, 130–45. Cambridge: Harvard University Press, 1930.

Claire, Jean. "Seven Prolegomenae to a Brief Treatise on Magrittian Topics." *October* 8 (Spring 1979): 89–110.

Clark, Timothy J. *The Absolute Bourgeois: Artists and Politics in France, 1848–1851*. Princeton: Princeton University Press, 1982.

————. "Arguments About Modernism: A Reply to Michael Fried." In *The Politics of Interpretation*, edited by W. J. T. Mitchell, 7–32. Chicago: University of Chicago Press, 1983.

————. "Clement Greenberg's Theory of Art." In *The Politics of Interpretation*, edited by W. J. T. Mitchell, 203–20. Chicago: University of Chicago Press, 1983.

————. *Image of the People: Gustave Courbet and the 1848 Revolution*. 2d ed. Princeton: Princeton University Press, 1982.

————. *The Painting of Modern Life*. New York: Knopf, 1985.

————. "Preliminaries to a Possible Treatment of Manet's *Olympia* in 1865." *Screen* 21 (1980): 18–41.

Cohen, Sande. *Historical Culture: On the Reading of an Academic Discipline*. Berkeley, Los Angeles, and London: University of California Press, 1986.

Collins, D., and J. Onians. "The Origins of Art." *Art History* 1, no. 1 (1978): 1–25.

Conkey, Margaret W. "Context, Structure and Efficacy in Paleolithic Art and Design." In *Symbol as Sense*, edited by M. L. Foster and S. Brandes, 225–48. New York: Academic Press, 1980.

————. "On the Origins of Palaeolithic Art: A Review and Some Critical Thoughts." In *The Mousterian Legacy*, edited by E. Trinkhaus. Oxford: BAR International Series 164, 1983.

————. "Ritual Communication, Social Elaboration, and the Variable Trajectories of Palaeolithic Material Culture." In *Prehistoric Hunter-Gatherers*, edited by T. D. Price and J. A. Brown, 299–323. New York: Academic Press, 1985.

————. "Style and Information in Cultural Evolution: Toward a Predictive Model for the Paleolithic." In *Social Anthropology*, edited by C. Redman et al., 61–85. New York: Academic Press, 1978.

————. "To Find Ourselves: Art and Social Geography of Prehistoric Hunter Gatherers." In *Past and Present in Hunter-Gatherer Studies*, edited by C. Shire, 253–76. New York: Academic Press, 1984.

Cousin, Victor. *Course of the History of Modern Philosophy*. 2 vols. Translated by O. W. Wright. New York: D. Appleton, 1852. Originally published as *Cours de l'histoire de la philosophie* (Paris: Pichon et Didier, 1829).

Coward, Rosalind, and John Ellis. *Language and Materialism: Developments in*

Semiology and the Theory of the Subject. London: Routledge and Kegan Paul, 1977.

Crimp, Douglas. "The End of Painting." *October* 16 (Spring 1981): 69–86.

———. "On the Museum's Ruins." *October* 13 (1980): 41–57.

Croce, Benedetto. *La critica e la storica delle arti figurative; questioni di metodo*. Bari: Laterza, 1946.

Crow, T. "The Oath of the Horatii in 1785." *Art History* 1, no. 4 (Dec. 1978): 424–71.

Damisch, Hubert. *Actes du colloque Roland Barthes*. Cerisy-la-Salle: Editions du Seuil, 1977.

———. *L'Origine de la perspective*. Paris: Flammarion, 1987.

———. "Semiotics and Iconology." In *The Tell-Tale Sign: A Survey of Semiotics*, edited by T. A. Sebeok, 27–36. Lisse, The Netherlands: Peter de Ridder Press, 1975.

———. *Théorie du nuage*. Paris: Seuil, 1972.

Danto, Arthur. "Dürer and the Art of Nuremburg." *The Nation* (June 21, 1986): 865–68.

———. *The Transfiguration of the Commonplace*. Cambridge: Harvard University Press, 1981.

Davis, Whitney. "Canonical Representation in Egyptian Art." RES 4 (1982): 21–46.

———. "Representation and Knowledge in the Prehistoric Rock Art of Africa." *African Archaeological Review* 2 (1984): 7–35.

Deely, John. "Semiotic as Framework and Direction." In *Frontiers in Semiotics*, edited by J. Deely, B. Williams, and F. Kruse, 264–71. Bloomington: Indiana University Press, 1986.

———. "The Coalescence of Semiotic Consciousness." In *Frontiers in Semiotics*, edited by J. Deely, B. Williams, and F. Kruse, 5–34. Bloomington: Indiana University Press, 1986.

Deleuze, Gilles. *Foucault*. Paris: Minuit, 1986. English translation forthcoming.

Delporte, Henri. *L'Image de la femme dans l'art préhistorique*. Paris: Picard, 1979.

de Lumley, Henri. "Les Fouilles de Terra Amata à Nice." *Bulletin du Musée d'Anthropologie préhistorique de Monaco* 13 (1966): 29–51.

———. "A Palaeolithic Camp at Nice." *Scientific American* (May 1969): 42.

de Man, Paul. "The Resistance to Theory." *Yale French Studies* 63 (1982): 3–20.

Derrida, Jacques. *Dissemination*. Translated by Barbara Johnson. Chicago and London: University of Chicago Press, 1981. Originally published as *La Dissemination* (Paris: Editions du Seuil, 1972).

———. "Economimesis." *Diacritics* 2, no. 2 (Summer 1981): 3–25.

———. *Margins of Philosophy*. Translated by Alan Bass. Chicago and London: University of Chicago Press, 1982. Originally published as *Marges de la philosophie* (Paris: Editions de Minuit, 1972).

———. *Of Grammatology*. Translated by G. C. Spivak. Baltimore and London: Johns Hopkins University Press, 1976. Originally published as *De la grammatologie* (Paris: Editions du Seuil, 1967).

———. "The Principles of Reason: The University in the Eyes of its Pupils." *Diacritics* 13, no. 3 (Fall 1983): 3–20.

———. "The *retrait* of metaphor." *Enclitic* 2 (1978): 5–34.

———. "Semiology and Grammatology." In *Positions*, translated by A. Bass, 17–36. Chicago: University of Chicago Press, 1981. Originally published in *Information sur les sciences sociales* 7 (June 3, 1968).

———. "Structure, Sign and Play in the Discourse of the Human Sciences." In *Writing and Difference*, translated by A. Bass, 278–93. Chicago: University of Chicago Press, 1978.

———. *The Truth in Painting*, translated by Geoff Bennington and Ian McLeod. Chicago: University of Chicago Press, 1987. Originally published as *La Vérité en peinture* (Paris: Flammarion, 1978).

———. *Writing and Difference*, translated by A. Bass. Chicago: University of Chicago Press, 1978. Originally published as *L'Écriture et la différence* (Paris: Seuil, 1967).

Dilly, Heinrich. *Kunstgeschichte als Institution: Studien zur Geschichte einer Disziplin.* Frankfurt am Main: Suhrkamp, 1979.

Dinsmoor, W. B. "The Design and Building Techniques of the Parthenon." In *The Parthenon*, edited by V. J. Bruno, 171–98. Norton Critical Studies in Art History. New York: W. W. Norton, 1974.

Dittman, L. *Stil/Symbol/Struktur: Studien zu Kategorien der Kunstgeschichte.* Munich: Wilhelm Frank, 1967.

Dreyfus, H., and P. Rabinow, eds. *Michel Foucault: Beyond Structuralism and Hermeneutics.* Chicago: University of Chicago Press, 1983.

Donzelot, Jacques. *The Policing of Families.* New York: Pantheon, 1979.

Doueihi, Milad. "Traps of Representation." *Diacritics* 14, no. 1 (Spring 1984): 66–77.

Duncan, Carol, and Alan Wallach. "The Museum of Modern Art as Late Capitalist Ritual: An Iconographic Analysis." *Marxist Perspectives* (Winter 1978): 28–51.

Durkheim, Emile. *Revue Blanche.* Vol. 13, 1897.

Eagleton, Terry. *Criticism and Ideology: A Study in Marxist Literary Theory.* London: Verso, 1978.

———. *Literary Theory: An Introduction.* Minneapolis: University of Minnesota Press, 1983.

Eco, Umberto. *A Theory of Semiotics.* Bloomington and London: Indiana University Press, 1976.

———. "On Symbols." In *Frontiers in Semiotics*, edited by J. Deely, B. Williams, and F. Kruse, 153–80. Bloomington: Indiana University Press, 1986.

Ehrlich, Victor. *Russian Formalism: History, Doctrine.* The Hague: Mouton, 1955.

Elkins, J. "Art History Without Theory." *Critical Inquiry* 14 (Winter 1988): 354–78.

Ellis, John. *Visible Fictions.* London and Boston: Routledge and Kegan Paul, 1982.

Fairservis, W. *The Threshold of Civilization: An Experiment in Prehistory.* New York: Scribner's, 1975.

Finley, M. I. *The Ancient Greeks.* Harmondsworth: Pelican Books, 1977.

Forster, Kurt. "Aby Warburg's History of Art: Collective Memory and the Social Mediation of Images." *Daedalus* 105 (1976): 169–76.

———. "Critical History of Art, or Transfiguration of Values?" *New Literary History* 3 (Spring 1972): 465.

———. "Stagecraft and Statecraft." *Oppositions* (Summer 1979): 63–87.

Foster, Hal. *Recodings: Art, Spectacle, Cultural Politics*. Port Townsend, Wash.: Bay Press, 1985.

Foster, Hal, ed. *The Anti-Aesthetic: Essays on Postmodern Culture*. Port Townsend, Wash.: Bay Press, 1983.

Foucault, Michel. *Archaeology of Knowledge*, translated by A. Smith. New York: Harper and Row, 1972. Originally published as *L'Archéologie du savoir* (Paris: Gallimard, 1969).

———. *Discipline and Punish*, translated by A. Smith. New York: Pantheon, 1977. Originally published as *Surveiller et punir* (Paris: Gallimard, 1975).

———. "The Eye of Power." In *Power/Knowledge: Selected Interviews and Other Writings 1972–1977*, edited by C. Gordon, 146–65. New York: Pantheon, 1980.

———. "The Father's 'No'." In *Language, Counter-Memory, Practice: Selected Essays and Interviews by Michel Foucault*, edited by D. F. Bouchard, 68–86. Ithaca: Cornell University Press, 1977. Originally published in *Critique* 178 (1962): 195–209.

———. "Of Other Spaces." *Diacritics* 16, no. 1 (Spring 1986): 22–28. Originally published as "Des Espaces Autres." *Architecture-Mouvement-Continuité* 73 (October 1984): 6–9.

———. *The Order of Things*, translated by A. Smith. New York: Random House, 1973. Originally published as *Les Mots et les choses* (Paris: Gallimard, 1966).

———. "What is an Author?" In *Language, Counter-Memory, Practice: Selected Essays and Interviews by Michel Foucault*, edited by D. F. Bouchard. Ithaca: Cornell University Press, 1977.

Fried, Michael. *Absorption and Theatricality: Painting and Beholder in the Age of Diderot*. Berkeley, Los Angeles, and London: University of California Press, 1980.

———. "How Modernism Works: A Response to T. J. Clark." In *The Politics of Interpretation*, edited by W. J. T. Mitchell, 221–38. Chicago: University of Chicago Press, 1983.

Frolov, B. A. "Numbers in Paleolithic Graphics." Institute of History, Philology and Philosophy. Novosibirsk: Nauka (Siberian Division), 1977.

Gablik, S. *Has Modernism Failed?* New York: Thames and Hudson, 1984.

Gaboriau, Émile. *Monsieur Lecoq*. Vol. 1, *L'Enquête*. Paris: Fayard, 1869.

Galileo, Galilei. "Discourse on the Comets [1619]". In *The Controversy of the Comets of 1618*. Philadelphia: University of Pennsylvania Press, 1960.

———. *Opere*. Vol. 9, edited by A. Favaro. Florence: Edizione Nazionale, 1929.

Gallop, Jane. *Reading Lacan*. Ithaca and London: Cornell University Press, 1985.

Gamble, Clive. "Interaction and Alliance in Palaeolithic Society." *Man* (n.s.) 17 (1982): 92–107.

Gardner, Howard. *Artful Scribbles; The Significance of Children's Drawing*. New York:

Basic Books, 1980.

Garner, Philip. *Rube Goldberg: A Retrospective*. New York: Delilah Books/Putnam Group, 1983.

Garnier, Jean. *Le Problème de la vérité dans la philosophie de Nietzsche*. Paris: Seuil, 1966.

Geertz, Clifford. "Art as a Cultural System." *Modern Language Notes* 91, no. 6 (Dec. 1976): 1473–99.

———. "The Growth of Culture and the Evolution of Mind." In *Theories of the Mind*, edited by J. Sher, 713–40. New York: Free Press of Glencoe, 1962.

———. "The Transition to Humanity." In *Horizons of Anthropology*, edited by S. Tax, 37–48. Chicago: University of Chicago Press, 1964.

Geist, V. *Mountain Sheep: A Study in Behavior and Evolution*. Chicago: University of Chicago Press, 1971.

Giedion, Siegfried. *The Eternal Present: The Beginnings of Art*. Bollingen Series 35. New York: Pantheon, 1962.

Gilbert, Neal. *Renaissance Concepts of Method*. New York: Columbia University Press, 1960.

Gilman, Ernest. *The Curious Perspective: Literary and Pictorial Wit in the Seventeenth Century*. New Haven: Yale University Press, 1978.

Ginzburg, Carlo. "Morelli, Freud and Sherlock Holmes: Clues and Scientific Method." *History Workshop* 9 (1980): 5–36. Second version, "Clues: Morelli, Freud and Sherlock Holmes." In *The Sign of Three*, edited by T. A. Sebeok and U. Eco, 81–118. Bloomington and London: Indiana University Press, 1983.

———. "Spie. Radici di un paradigm indiziario." In *Crisi della ragione*, edited by A. Gargani, 57–106. Turin: Einaudi, 1979.

Gombrich, E. H. *Art and Illusion: A Study in the Psychology of Pictorial Representation*. 2d ed., rev. Bollingen Series 35.5. Princeton: Princeton University Press, 1961.

———. "Image and Code: Scope and Limits of Conventionalism in Pictorial Representation." In *Image and Code*, edited by W. Steiner, 11–42. Studies in the Humanities. Ann Arbor: University of Michigan, 1981.

———. "The Mask and the Face: The Perception of Physiognomic Likeness in Life and Art." *Art, Perception and Reality*, edited by E. H. Gombrich, J. Hochberg, and M. Black, 1–46. Baltimore and London: Johns Hopkins University Press, 1972.

———. "The Use of Art for the Study of Symbols." *American Psychologist* 20 (1965): 34–50.

Goodman, Nelson. *Ways of Worldmaking*. Indianapolis and Cambridge: Hackett, 1978.

Goodnow, Jacqueline. *Children Drawing*. Cambridge: Harvard University Press, 1977.

Gouma-Peterson, T., and P. Mathews. "The Feminist Critique of Art History." *Art Bulletin* 39, no. 3 (Sept. 1987): 326–57.

Grabar, Oleg. "On the Universality of the History of Art." *Art Journal* 42, no. 4 (Winter 1982): 281–83.

Graham, D. "Theatre, Cinema, Power." *Parachute* (Summer 1983): 11–19.

Graziosi, Paolo. *Palaeolithic Art*. New York: McGraw-Hill, 1960.

Green, Peter. *Ancient Greece*. New York: Viking Press, 1974.

Gregory, R. L. *Concepts and Mechanisms of Perception*. London: Duckworth, 1974.

Gruben, Gottfried. *Die Tempel der Griechen*. Munich: Hirmer, 1966.

Guilbaud, Serge. *How New York Stole the Idea of Modern Art: Abstract Expressionism, Freedom and the Cold War*. Chicago and London: University of Chicago Press, 1984.

———. "The New Adventures of the Avant-Garde in America." *October* 15 (Winter 1980): 61–78.

Hadjinicolaou, Nicos. *Art History and Class Struggle*. Translated by Louise Asmal. London: Pluto Press, 1978. Originally published as *Histoire de l'art et la lutte des classes* (Paris: Maspero, 1973).

Hagen, M. A., ed. *The Perception of Pictures*. Vol. 1, *Alberti's Window*. New York: Academic Press, 1980.

Hall, Stuart. "On Postmodernism and Articulation." *Journal of Communication Inquiry* 10, no. 2 (Summer 1986): 45–61.

Harlow, Barbara. "Realignment: Alois Riegl's Image of Late Roman Art Industry." *Glyph* 3 (1978): 118–36.

Hart, Joan. "Reinterpreting Wölfflin: Neo-Kantianism and Hermeneutics." *Art Journal* 42, no. 4 (Winter 1982): 292–300.

Hartman, Heidi. "The Unhappy Marriage of Marxism and Feminism." *Capital and Class* 8 (Summer 1979): 19–26.

Hartshore, Charles, and Paul Weiss, eds. *The Collected Papers of Charles Sanders Peirce*. Vols. 1–6. Cambridge: Harvard University Press, 1931–35.

Hasenmueller, Christine. "Images and Codes: Implications of the Exegesis of Illusionism for Semiotics." *Semiotica* 50, nos. 3–4 (1984): 335–57.

———. "Panofsky, Iconography, and Semiotics." *Journal of Aesthetics and Art Criticism* 36 (Spring 1978): 289–301.

Hawkes, Terence. *Structuralism and Semiotics*. Berkeley: University of California Press, 1977.

Heath, Stephen. *Questions of Cinema*. Bloomington and London: Indiana University Press, 1981.

Heckscher, William. "Petites Perceptions: An Account of Sortes Warburgianae." *The Journal of Mediaeval and Renaissance Studies* 4 (1974): 130–31.

Herington, C. J. *Athena Parthenos and Athena Polias*. Manchester: Manchester University Press, 1955.

Hills, P. "Art History Textbooks: The Hidden Persuaders." *Artforum* 14, no. 10 (Summer 1976): 33–42.

Hochberg, Julian. *Perception*. Englewood Cliffs, N.J.: Prentice-Hall, 1978.

Holloway, R. "Culture: A Human Domain." *Current Anthropology* 10 (1969): 395–407.

Holly, M. *Panofsky and the Foundations of Art History*. Ithaca and London: Cornell University Press, 1984.

Holt, E. *A Documentary History of Art*. Vol. 2. New York: Doubleday, 1958.

Hopper, R. J. *The Acropolis*. London: Weidenfeld and Nicholson, 1971.

Hutton, John. "Left of Center, Against the Grain: T. J. Clark and the Social History of Art." *Radical History Review* 38 (Apr. 1987): 59–71.

Huxley, Thomas. "On the Method of Zadig: Retrospective Prophecy as a Function of Science." In *Science and Culture, and Other Essays*, edited by T. Huxley. London: Macmillan, 1881.

Innes, Michael. *A Private View*. London: Gollancz, 1952.

Isaac, Glynn. "Chronology and the Tempo of Cultural Change during the Pleistocene." In *Calibration of Hominid Evolution*, edited by W. W. Bishop and J. A. Miller, 381–430. Edinburgh: Scottish Academic Press, 1972.

———. "Stages of Cultural Elaboration in the Pleistocene: Possible Archaeological Indicators of the Development of Language Capabilities." In *Origins and Evolution of Language and Speech*, edited by Stevan Harnad, Horst Steklis, and Jane Lancaster, 275–88. Annals of the New York Academy of Sciences, vol. 280, 1976.

Jakobson, Roman. "Closing Statement: Linguistics and Poetics." In *Style in Language*, edited by T. A. Sebeok, 350–77. Cambridge: MIT Press, 1960.

———. *Coup d'oeil sur le développement de la sémiotique*. Studies in Semiotics, vol. 3. Bloomington: Indiana University Publications, 1975.

———. *Essais de linguistique générale*. Paris: Minuit, 1963.

———. "Language and Poetics." In *Style in Language*, edited by T. A. Sebeok, 350–77. Cambridge: MIT Press, 1960.

———. "Two Aspects of Language and Two Types of Aphasic Disturbances." In *Selected Writings of Roman Jakobson*, edited by Stephen J. Rudy. The Hague: Mouton, 1971.

Jakobson, Roman, and Linda Waugh. *The Sound Shape of Language*. Bloomington: Indiana University Press, 1979.

James, Henry. "The Art of Fiction." In *The House of Fiction*, edited by L. Edel. London: Mercury, 1962.

Jameson, Frederic. "Cognitive Mapping." In *Marxism and the Interpretation of Culture*, edited by C. Nelson and L. Grossberg, 347–60. Urbana: University of Illinois Press, 1988.

———. *The Political Unconscious: Narrative as a Socially Symbolic Act*. Ithaca: Cornell University Press, 1981.

———. "The Politics of Theory: Ideological Positions in the Postmodernism Debate." *New German Critique* 33 (Fall 1985): 53–60.

———. "Postmodernism, or the Cultural Logic of Late Capitalism." *New Left Review* 146 (1985): 53–92.

———. *The Prison House of Language: A Critical Account of Structuralism and Russian Formalism*. Princeton: Princeton University Press, 1972.

Jaspers, Karl. *Nietzsche*. Chicago: Henry Regnery Company, 1969.

Jones, Caroline. *Modern Art at Harvard*. New York: Abbeville Press, 1985.

Joston, C. H. "Robert Fludd's Theory of Geomancy (and His Experiences at

Avignon in the Winter of 1601 to 1602)." *Journal of the Warburg and Courtauld Institutes* 27 (1964): 327–35.

Kant, I. *The Critique of Judgment*. New York: Hafner Press, 1972.

Kavanagh, James. "Marxism's Althusser: Toward a Politics of Literary Theory." *Diacritics* 12, no. 1 (Spring 1982): 25–45.

Kitahara-Frisch, J. "Symbolizing Technology as Key to Human Evolution." In *Symbol as Sense*, edited by M. Foster and S. Brandes, 211–23. New York: Academic Press, 1980.

Klein, Richard. "Kant's Sunshine." *Diacritics* 2, no. 2 (Summer 1981): 26–41.

Klein, Robert. "Vitruve et le théâtre de la Renaissance italienne." In *La Forme et l'intelligible: Ecrits sur la Renaissance et l'art moderne*, edited by R. Klein. Paris: Gallimard, 1970.

Kleinbauer, W. E. *Modern Perspectives in Western Art History*. New York: Holt, Rinehart and Winston, 1971.

Kontoleon, N. *To Erechtheion hōs oikodomena chthonias latreis* (The Erechtheion as a Building of Chthonic Cult). Athens: Athens Archaeological Society, 1949.

Kramer, Hilton. "Does Gerôme Belong with Goya and Monet?" *New York Times* (Apr. 13, 1980): 35, sect. 2.

———. "T. J. Clark and the Marxist Critique of Modern Painting." *The New Criterion* (March 1985): 1–8.

Krampen, Martin. *Meaning in the Urban Environment*. London: Pion, 1979.

———. *Wie Kinder zeichnen*. Stuttgart: Design Center, 1980.

Krauss, Rosalind. "Photography's Discursive Spaces: Landscape/View." *Art Journal* 42, no. 4 (Winter 1982): 311–19.

———. "Sculpture in the Expanded Field." *October* 8 (Spring 1979): 31–44.

Kris, Ernst. *Psychoanalytic Explorations in Art*. New York: International Universities Press, 1952.

Kristeva, Julia. *La Révolution du langage poétique*. Paris: Editions du Seuil, 1974.

Kubler, George. *The Shape of Time: Remarks on the History of Things*. New Haven: Yale University Press, 1962.

———. *"The Shape of Time* Reconsidered." *Perspecta* 19 (1982): 112–21.

Lacan, Jacques. *Le Séminaire*. Paris: Editions de Seuil, 1973.

Laming, Annette. *Lascaux: Paintings and Engravings*. Harmondsworth and Baltimore: Penguin Books, 1959.

Laming-Emperaire, Annette. *Origines de l'archéologie préhistorique en France*. Paris: Picard, 1964.

———. "Pour une nouvelle approche des sociétés préhistoriques." *Annales Economies, Sociétés, Civilisations* 5 (Sept.–Oct. 1969): 1261–70.

———. "Système de pensée et organisation sociale dans l'art rupestre paléolithique." In *L'Homme de Cro-Magnon, anthropologie et archéologie 1868–1968*, 197–212. Paris: Arts et Metiers Graphiques, 1970.

Laughlin, C. D., and E. G. d'Aquili. *Biogenetic Structuralism*. New York: Columbia University Press, 1974.

Lawrence, A. W. *Greek Architecture*. 4th ed., rev., with additions by R. A. Tomlinson.

Harmondsworth: Penguin Books, 1983.

Leakey, R. E., and R. Lewis. *Origins*. New York: Dutton, 1977.

Lemaire, Anika. *Jacques Lacan*. London and Boston: Routledge and Kegan Paul, 1977.

Lentricchia, Frank. *After the New Criticism*. Chicago and London: University of Chicago Press, 1980.

———. *Criticism and Social Change*. Chicago: University of Chicago Press, 1983.

Leroi-Gourhan, André. "Considérations sur l'organisation spatiale des figures animales dans l'art pariétal paléolithique." In *Actas del Symposium Internacional de Arte Prehistórico*, edited by M. A. Basch and M. A. Garcia Guinea, 281–308. Santander: Patronato de las Cuevas Prehistóricas, 1972.

———. *The Dawn of European Art*. Cambridge: Cambridge University Press, 1982.

———. "The Evolution of Paleolithic Art." *Scientific American* (Feb. 1968): 58–74.

———. "La Fonction des signes dans les sanctuaires paléolithiques." *Bulletin de la Société Préhistorique Français* 55 (1958): 307–21.

———. *Le Geste et la parole*. Vol. 1, *Technique et langage*; vol. 2, *La Mémoire et les rythmes*. Paris: Editions Albin Michel, 1964–65.

———. "The Hands of Gargas." *October* 37 (Summer 1986): 18–40.

———. "The Religion of the Caves: Magic or Metaphysics?" *October* 37 (Summer 1986): 6–17.

———. "Répartition et groupement des animaux dans l'art pariétal paléolithique." *Bulletin de la Société Préhistorique Français* 55 (1958): 515–27.

———. "Le Symbolisme des grands signes dans l'art pariétal paléolithique." *Bulletin de la Société Préhistorique Français* 55 (1958): 384–98.

———. *Treasures of Prehistoric Art*. New York: Abrams, 1967.

Lévi-Strauss, Claude. *The Savage Mind*. New York: Harper and Row, 1966.

Lewes, George Henry. *A Biographical History of Philosophy*. London: C. Knight, 1845.

Lewis, Philip. "The Post-structuralist Condition." *Diacritics* 12, no. 1 (Spring 1982): 2–24.

Lewis, Thomas E. "Reference and Dissemination: Althusser after Derrida." *Diacritics* 15, no. 4 (Winter 1985): 37–56.

Locke, John. *An Essay Concerning Human Understanding*, edited by A. C. Fraser. New York: Pantheon, 1959.

Longhi, Roberto. *Saggi e ricerche: 1925–1928*. Florence: Sansoni, 1967.

Lotringer, Sylvère. "Cryptique." In *Claude Simon: Colloque de Cerisy*, 316–17. Paris: 1018, 1975.

Lough, John. "Locke's Reading during his Stay in France (1675–79)." *The Library* 8, no. 4, 5th ser. (Dec. 1953): 229–58.

Lynch, Kevin. *The Image of the City*. Cambridge: MIT Press, 1960.

MacCabe, Colin. *Tracking the Signifier*. Minneapolis: University of Minnesota Press, 1985.

MacCannell, Juliet Flower. *Figuring Lacan: Criticism and the Cultural Unconscious*. Lincoln: University of Nebraska Press, 1986.

Macherey, Pierre. *A Theory of Literary Production*. Translated by Geoffrey Wall. London and Boston: Routledge and Kegan Paul, 1978. Originally published as *Pour une théorie de la production littéraire* (Paris: Librairie François Maspero, 1974).

Mahon, Denis. *Studies in Seicento Art and Theory*. London: London University-Warburg Institute, 1947.

Mandelbaum, Maurice. *History, Man and Reason: A Study in Nineteenth Century Thought*. Baltimore: Johns Hopkins University Press, 1971.

Marin, Louis. *Détruire la peinture*. Paris: Galilée, 1977. Partial translation in *Enclitic* (1980): 3–38.

―――. *Portrait of the King*. Translated by Martha Houle. Minneapolis: University of Minnesota Press, 1988. Originally published as *Le Portrait du roi* (Paris: Editions de Minuit, 1981).

Marruchi, A., ed. *Considerazioni sulla pittura*. Vols. 1 and 2. Rome: Accademia Nazionale dei Lincei, 1956–57.

Marshack, Alexander. "The Baton of Mongaudier." *Natural History* 79, no. 3 (March 1970): 56–63.

―――. "Cognitive Aspects of Upper Paleolithic Engraving." *Current Anthropology* 13 (1972): 455–77.

―――. "The Ecology and Brain of Two-Handed Bipedalism: An Analytic, Cognitive and Evolutionary Assessment." Paper delivered at Harry Frank Guggenheim Conference on Animal Cognition, Columbia University, June 2–4, 1982.

―――. "Lunar Notations on Upper Paleolithic Remains." *Science* 146 (Nov. 1964): 743–45.

―――. "The Meander as System: The Analysis and Recognition of Iconographic Units in Upper Paleolithic Composition." In *Form in Indigenous Art*, edited by P. Ucko, 286–317. Canberra: Australian Institute of Aboriginal Studies, 1978.

―――. "New Techniques in the Analysis and Interpretation of Mesolithic Notation and Symbolic Art." *Valcamonica Symposium, Actes du symposium international d'art préhistorique*, 479–94. Capo di Ponte: Centro Camuno di Studi Preistorici, 1970.

―――. *Notation dans les gravures du Paléolithique supérieur*. Publications de l'Institut de Préhistoire de l'Université de Bordeaux, Mémoire no. 8. Bordeaux: Delmas, 1970.

―――. *The Roots of Civilization*. New York: McGraw-Hill, 1972.

―――. "Some Implications of the Symbolic Evidence for the Origin of Language." In *Origins and Evolution of Language and Speech*, edited by Steven Harnad, Horst Steklis, and Jane Lancaster, 289–311. Annals of the New York Academy of Sciences, vol. 280, 1976.

―――. "Upper Paleolithic Symbol Systems of the Russian Plain: Cognitive and Comparative Analysis." *Current Anthropology* 20, no. 2 (June 1979): 271–95.

―――. "Upper Paleolithique Notation and Symbol." *Science* 178 (1972): 817–28.

Mavrikios, A. "Aesthetic Analysis Concerning the Curvature of the Parthenon." In

The Parthenon, edited by V. J. Bruno, 171–98. Norton Critical Studies in Art History. New York: W. W. Norton, 1974.

Megill, Allan. *Prophets of Extremity*. Berkeley and Los Angeles: University of California Press, 1985.

Merquior, J. *Foucault*. London: Fontana, 1985.

Merrill, R. H. "The Calendar Stick of Tshi-zun-hau-kau." *The Cranbrook Institute of Science Bulletin* 24 (Oct. 1945).

Messac, Régis. *La "Detective Novel" et l'influence de pensée scientifique*. Paris: Libraire Ancienne Honore Champion, 1929.

Metz, Christian. *The Imaginary Signifier*. Bloomington and London: Indiana University Press, 1982.

Michelson, Annette. "Art and the Structuralist Perspective." In *On the Future of Art*, 36–60. New York: Viking, 1970.

———. "In Praise of Horizontality: André Leroi-Gourhan 1911–1986." *October* 37 (Summer 1986): 3–5.

Mitchell, W. J. T. *Iconology: Image, Text, Ideology*. Chicago and London: University of Chicago Press, 1986.

———. "The Politics of Genre: Space and Time in Lessing's Laocoon." *Representations* 6 (Spring 1984): 98–115.

———. *The Politics of Interpretation*. Chicago: University of Chicago Press, 1983.

Mohanty, S. P., ed. "Marx After Derrida." *Diacritics* 15, no. 4 (Winter 1985): 1–112.

Morelli, Giovanni. *Della pittura italiana: Studii storico critici—Le gallerie Borghese e Doria Pamphili in Roma*. Milan: Treves, 1897.

Mosby, Aline. "Prehistory's Underground Museums." *New York Times* Travel Section (Jan. 19, 1986): 15.

Mukařovský, Jan. *Aesthetic Function, Norm and Value as Social Facts*. 1936. Reprint. Ann Arbor: University of Michigan/Slavic Contributions, 1979.

———. "L'Art comme fait sémiologique." In *The Semiotics of Art*, edited by L. Matejka and I. R. Titunik. Cambridge: MIT Press, 1976. Originally published in *Actes du huitième Congrès international de philosophie à Prague 2–7 septembre 1934*, 1065–73 (Prague, 1936).

———. "On the Problem of Function in Architecture." In *Structure, Sign and Function: Selected Writings of Jan Mukařovský*, edited by J. Burbank and P. Steiner. New Haven: Yale University Press, 1978.

Munn, Nancy. "Visual Categories: An Approach to the Study of Representational Systems." *American Anthropologist* 68, no. 4 (1966): 939–50.

———. *Walbiri Iconography: Graphic Representation and Cultural Symbolism in a Central Australian Society*. Ithaca: Cornell University Press, 1973.

Needham, Joseph. *Mathematics and the Science of the Heavens and the Earth*. Vol. 3, *Science and Civilisation in China*. Cambridge: Cambridge University Press, 1960.

Neisser, Ulric. *Cognition and Reality*. San Francisco: W. H. Freeman, 1976.

Nelson, Cary, and Lawrence Grossberg, eds. *Marxism and the Interpretation of Culture*. Urbana: University of Illinois Press, 1988.

Nichols, Bill. *Ideology and the Image: Social Representation in the Cinema and Other Media*. Bloomington and London: Indiana University Press, 1981.

Nochlin, Linda. "Why Have There Been No Great Women Artists?" In *Art and Sexual Politics*, edited by E. Baker and T. Hess, 1–43. New York: Macmillan, 1973.

Nodelman, Sheldon. "Structural Analysis in Art and Anthropology." *Yale French Studies* 36–37 (Oct. 1966): 89–103.

Ong, Walter J. *Ramus, Method, and the Decay of Dialogue*. Cambridge: Harvard University Press, 1958.

Owens, Craig. "Representation, Appropriation and Power." *Art in America* (May 1982): 9–21.

Pales, L., and M. Tassin de Saint Péreuse. "Humains superposés de la Marche." In *La Préhistoire, problèmes et tendances*, 327–36. Paris: Editions du CNRS, 1968.

Panofsky, Erwin. "Charles Rufus Morey (1877–1955)." *American Philosophical Society Year Book*. Philadelphia: American Philosophical Society, 1955.

———. "The Concept of Artistic Volition." *Critical Inquiry* 8 (Fall 1981): 17–31. Originally published as "Der Begriff des Kunstwollens." In *Zeitschrift für Ästhetik und allgemeine Kunstwissenschaft* 14 (1920): 321–39.

———. "The History of Art as a Humanistic Discipline." In *The Meaning of the Humanities*, edited by T. M. Greene. Princeton: Princeton University Press, 1940.

———. *Meaning in the Visual Arts: Papers In and On Art History*. Garden City, N.Y.: Doubleday, 1955.

———. "Die Perspektive als 'symbolische Form'." *Vorträge der Bibliothek Warburg*, 1924–25, Leipzig/Berlin, 258–81.

———. *Renaissance and Renascances in Western Art*. New York: Harper and Row, 1969.

———. *Studies in Iconology: Humanistic Themes in the Art of the Renaissance*. 1939. Reprint. New York: Harper and Row, 1962.

Parker, Rozsika, and Griselda Pollock, eds. *Framing Feminism: Art and the Women's Movement 1970–1985*. London and New York: Pandora, 1987.

———, eds. *Old Mistresses: Women, Art and Ideology*. New York: Pantheon, 1982.

Parsons, Kermit. *The Cornell Campus: A History of Its Planning and Development*. Ithaca and London: Cornell University Press, 1968.

Pausanias. *Guide to Greece*. Vol. 1, *Central Greece*. Harmondsworth: Penguin Books, 1971.

Peirce, Charles Sanders. *Collected Papers*, edited by C. Hartshorne and P. Weiss, vol. 5. Cambridge: Harvard University Press, 1935.

———. "Commentary." *The Nation* 51 (Sept. 25, 1890): 254–55.

Pleynet, Marcelin. *Système de la peinture*. Paris: Seuil, 1977.

Podro, Michael. "Art History and the Concept of Art." In *Kategorien und Methoden der deutschen Kunstgeschichte 1900–1930*, edited by L. Dittman, 209–18. Stuttgart: Franz Steiner, 1985.

———. *The Critical Historians of Art*. New Haven: Yale University Press, 1982.

———. *The Manifold Perception: Theories of Art from Kant to Hildebrand*. Oxford: Oxford University Press, 1972.

Polan, Dana B. "*Above All Else to Make You See:* Cinema and the Ideology of the Spectacle." *Boundary 2* 11, nos. 1–2 (Fall/Winter 1982–83): 129–44.

Pollitt, J. J. *Art and Experience in Classical Greece*. Cambridge: Cambridge University Press, 1972.

———. *The Art of Greece: 1400–31 B.C.* Sources and Documents in the History of Art Series. Englewood Cliffs, N.J.: Prentice-Hall, 1965.

Pollock, Griselda. "Vision, Voice and Power: Feminist Art History and Marxism." *Block* 6 (1982): 2–20. Originally published in *Kvinnovetenskaplig Tdiskrift* 4 (Lund).

Pomorska, Krystina. *Russian Formalist Theory and its Poetic Ambiance*. The Hague: Mouton, 1968.

Pratt, Mary Louise. "Interpretative Strategies/Strategic Interpretations: On American Reader-Response Criticism." *Boundary 2* 11, nos. 1–2 (Fall/Winter 1982–83): 201–31.

Preziosi, Donald. "Architectonic and Linguistic Signs." In *Image and Code*, edited by W. Steiner, 167–75. Ann Arbor: University of Michigan Studies in the Humanities, 1981.

———. *Architecture, Language and Meaning: The Origins of the Built World and Its Semiotic Organization*. The Hague, Paris, and New York: Mouton Publishers, 1979.

———. "Constru(ct)ing the Origins of Art." *Art Journal* 42, no. 4 (Winter 1982): 320–25.

———. "On signe ici: Tracing with a Pencil the Shadow of the Tracing Pencil." Paper presented at conference, *L'Amour fou: Photography and Surrealism*. Washington, D.C.: Corcoran Gallery of Art, 1985.

———. "Reckoning with the World: Figure, Text and Trace in the Built Environment." *American Journal of Semiotics* 4, nos. 1–2 (1986): 1–15.

———. *The Semiotics of the Built Environment*. Bloomington and London: Indiana University Press, 1979.

———. "Subjects + Objects: The Current State of Visual Semiotics." In *New Directions in Linguistics and Semiotics*, edited by James E. Copeland, 179–205. Rice University Studies New Series, no. 2. Houston: Rice University, 1984.

Pribram, Karl. *Languages of the Brain*. Englewood Cliffs, N.J.: Prentice-Hall, 1971.

Raimondi, Ezio. *Il romanzo senza idillio*. Turin: Einaudi, 1974.

Rajchman, J. "Foucault, or the Ends of Modernism." *October* 24 (Spring 1983): 37–62.

———. "Foucault's Art of Seeing." *October* 44 (Spring 1988): 89–119.

Raubitschek, A. *Dedications on the Athenian Acropolis*. Cambridge: Harvard University Press, 1949.

Reiss, Timothy J. *The Discourse of Modernism*. Ithaca and London: Cornell University Press, 1982.

Rees, A. L., and F. Borzello, eds. *The New Art History*. Atlantic Highlands, N.J.:

Humanities Press International, 1988.

Rey, Alain. *Théories du signe et du sens*. Paris: Editions Klincksieck, 1973.

Rice, Prudence. "Prehistoric Venuses." *Journal of Anthropological Research* 37 (1981): 402–19.

Richards, I. A. *Speculative Instruments*. Chicago: University of Chicago Press, 1955.

Richter, Gisela. *Sculpture and Sculptors of the Greeks*. 4th ed. New Haven: Yale University Press, 1970.

Rifkin, A. "Marx's Clarkism." *Art History* (Dec. 1985): 488–95.

———. "No Particular Thing to Mean." *Block* 8 (1983): 33.

Roskill, M. *What is Art History?* New York and London: Harper and Row, 1976.

Said, Edward. *Beginnings*. Baltimore: Johns Hopkins University Press, 1975.

———. "Opponents, Audiences, Constituencies and Community." In *The Politics of Interpretation*, edited by W. J. T. Mitchell, 7–32. Chicago: University of Chicago Press, 1983.

Saussure, Ferdinand de. *Course in General Linguistics*, edited by Charles Bally and Albert Sechehaye with Albert Riedlinger and translated by Wade Baskin. New York: Philosophical Library, 1959. Originally published as *Cours de linguistique générale* (Paris: Payot, 1916). *Edition critique* by Rudolf Engler. Vol. 1, fascs. 1–3; vol. 2, fasc. 4 (Wiesbaden: Harrassowitz: 1967–74).

Sauvet, G., and A. Wlodarczyk. "Essai de sémiologie préhistorique." *Bulletin de la Société Préhistorique Français* 74 (Etudes et Travaux) (1974): 545–48.

Schapiro, Meyer. "On Some Problems in the Semiotics of Visual Art: Field and Vehicle in Image-Signs." *Semiotica* 1/3 (1969): 223–42.

———. "Style." In *Anthropology Today*, edited by A. L. Kroeber. Chicago: University of Chicago Press, 1953. Reprinted in *Aesthetics Today*, edited by M. Philipson and P. J. Gudel. New York: Meridian, 1980.

———. "Words and Pictures." *Social Research* 45, no. 1 (Spring 1978): 15–35.

Scruton, Roger. *The Aesthetics of Architecture*. Princeton: Princeton University Press, 1979.

Searle, John. "Las Meninas and Representation." *Critical Inquiry* 7 (1980): 477–88.

Sebeok, Thomas A. "Animal Communication." *Science* 147, no. 3661 (Feb. 1965): 1006–14.

———. "Semiotics and Its Congeners." In *Frontiers in Semiotics*, edited by J. Deely, B. Williams, and F. Kruse, 255–63. Bloomington: Indiana University Press, 1986.

Sekula, Allan. "The Body and the Archive." *October* 39 (Winter 1986): 3–64.

Seltzer, Mark. "Reading Foucault: Cells, Corridors, Novels." *Diacritics* 14, no. 1 (Spring 1984): 78–89.

Shapiro, Gary. "Intention and Interpretation in Art: A Semiotic Analysis." *Journal of Aesthetics and Art Criticism* 33, no. 1 (1978): 33–42.

Sheridan, Alan. *Michel Foucault: The Will to Truth*. London and New York: Tavistock, 1980.

Sherman, Claire R. *Women as Interpreters of the Visual Arts, 1820–1979*. Westport, Conn.: Greenwood Press, 1981.

Siegel, James. "Academic Work: The View from Cornell." *Diacritics* 11, no. 1 (Spring 1981): 68–83.

Sieveking, Ann. *The Cave Artists*. London: Thames and Hudson, 1979.

Smith, Cyril S. *A Search for Structure: Selected Essays on Science, Art and History*. Cambridge: MIT Press, 1981.

Snyder, Joel. "Picturing Vision." In *The Language of Images*, edited by W. J. T. Mitchell, 219–46. Chicago: University of Chicago Press, 1980. Originally published in *Critical Inquiry* 6 (Spring 1980): 499–526.

Snyder, Joel, and Ted Cohen. "Reflections on Las Meninas: Paradox Lost." *Critical Inquiry* 7 (1980): 429–47.

Spanos, William V. "The Uses and Abuses of Certainty." *Boundary 2* 12, no. 3; 13, no. 1 (Spring/Fall 1984): 1–17.

Stafford, Barbara Maria. "Beauty of the Invisible: Winckelmann and the Aesthetics of Imperceptibility." *Zeitschrift für Kunstgeschichte* 43 (1980): 65–78.

———. *Voyage Into Substance*. Cambridge: MIT Press, 1983.

Steinberg, Leo. "Velazquez' Las Meninas." *October* 15 (1981): 45–54.

Steiner, W., ed. *Image and Code*. Michigan Studies in the Humanities, no. 2. Ann Arbor: University of Michigan Press, 1981.

Stevens, G. P. "The Periclean Entrance Court of the Acropolis of Athens." *Hesperia* 5 (1936): 443–520.

Stevens, G. P., and J. M. Paton. *The Erechtheum*. Cambridge: Harvard University Press, 1927.

Stevens, Wallace. "The Palm at the End of the Mind." In *The Palm at the End of the Mind: Selected Poems*, edited by H. Stevens, 398. New York: Random House, 1972.

Summers, David. "The Visual Arts and the Problem of Art Historical Description." *Art Journal* 42, no. 4 (Winter 1982): 301–10.

Tafuri, Manfredo. *The Sphere and the Labyrinth*. Cambridge: MIT Press, 1987. Originally published as *La sfèra e il labirinto* (Turin: Einaudi, 1980).

Tagg, John. "Should Art Historians Know Their Place?" *Journal: A Contemporary Art Magazine* 46, no. 6 (Winter 1987): 30–33.

Taine, H. *De l'idéal dans l'art*. 13th ed. Paris: Hachette, 1909.

———. *De l'intelligence*. Vols. 1 and 2. 13th ed. Paris: Hachette, 1909.

———. *Essais de critique et d'histoire*. 12th ed. Paris: Hachette, 1911.

———. *Histoire de la littérature anglaise*. 12th ed. Paris: Hachette, 1911.

Terdiman, Richard. "Deconstructing Memory: On Representing the Past and Theorizing Culture in France since the Revolution." *Diacritics* 15, no. 4 (Winter 1985): 13–36.

Tomkins, Calvin. "Thinking in Time." *New Yorker Magazine* (April 22, 1974): 109–17.

Tompkins, Jane P. "The Reader in History: The Changing Shape of Literary Response." In *Reader-Response Criticism: From Formalism to Post-Structuralism*, edited by J. Tompkins, 201–32. Baltimore and London: Johns Hopkins University Press, 1980.

Toulmin, Stephen. "The Construal of Reality: Criticism in Modern and Postmodern Science." In *The Politics of Interpretation*, edited by W. J. T. Mitchell, 99–117. Chicago and London: University of Chicago Press, 1983.

Travlos, John D. *Pictorial Dictionary of Ancient Athens*. New York: Praeger, 1971.

———. *Poleodomike Exelixis tōn Athenōn*. Athens: Athens Archaeological Society, 1960.

Tzakou, Avghi. *Propylaia: A Study for the Reconstruction of the Entablature of the East Stoa*. Athens: Ministry of Culture, 1981.

Ucko, Peter, and Andrée Rosenfeld. *Palaeolithic Cave Art*. London: World University Library, 1967.

Vachek, Josef. *A Prague School Reader in Linguistics*. Bloomington and London: Indiana University Press, 1964.

Valesio, Paolo. *Novantiqua: Rhetorics as a Contemporary Theory*. Bloomington and London: University of Indiana Press, 1980.

Vasari, Giorgio. *Lives of the Most Eminent Painters, Sculptors and Architects*. 4 vols. Translated by A. B. Hinds and edited by William Gaunt. New York: Dutton, 1963 (original edition in 1550).

Veltruský, Jiri. "Some Aspects of the Pictorial Sign." In *The Semiotics of Art*, edited by L. Matejka and I. R. Titunik, 245–64. Cambridge: MIT Press, 1976.

Vidler, Anthony. "The Idea of Type: The Transformation of the Academic Ideal 1750–1830." *Oppositions* 8 (1977): 95–115.

Wallace, Michael. "Visiting the Past: History Museums in the United States." In *Presenting the Past: History Museums in the United States*, edited by S. Benson, S. Brier, and R. Rosenzweig. Philadelphia: Temple University Press, 1986.

Wallach, Alan. "Marxism and Art History." In *The Left Academy*, edited by B. Ollman and E. Vernoff, 25–53. Praeger Special Studies, vol. 2. New York: Praeger, 1984.

Wallis, Mieczyslaw. *Arts and Signs*. Bloomington: Indiana University Press, 1975.

Weber, Samuel. "Ambivalence, the Humanities, and the Study of Literature." *Diacritics* 15, no. 2 (Summer 1985): 11–25.

———. "Closure and Exclusion." *Diacritics* 10, no. 2 (Summer 1980): 35–46.

———. "The Faulty Eye: Remarks on Knowledge and Professionalism." Forthcoming.

———. "The Limits of Professionalism." *The Oxford Literary Review* 5, nos. 1–2 (1982): 59–72.

Wellek, Rene. *The Literary Theory and Aesthetics of the Prague School*. Ann Arbor: University of Michigan/Slavic Languages, 1969.

Werckmeister, O. K. *Ideologie und Kunst bei Marx und andere Essays*. Frankfurt am Main: S. Fischer, 1974.

———. "Marx on Ideology and Art." *New Literary History* 14 (1973): 500–519.

———. "Radical Art History." *Art Journal* 42, no. 4 (Winter 1982): 284–91.

White, Hayden. *The Content of the Form: Narrative Discourse and Historical Representation*. Baltimore: Johns Hopkins University Press, 1987.

———. "Michel Foucault." In *Structuralism and Since: From Lévi-Strauss to Derrida*,

edited by J. Sturrock, 81–115. Oxford: Oxford University Press, 1979.

———. "The Politics of Historical Interpretation: Discipline and De-Sublimation." In *The Politics of Interpretation*, edited by W. J. T. Mitchell, 119–43. Chicago and London: University of Chicago Press, 1983.

———. *Tropics of Discourse: Essays in Cultural Criticism*. Baltimore and London: Johns Hopkins University Press, 1978.

Whitney, W. D. *Sanskrit Grammar*. 1889. Reprint. Cambridge: Harvard University Press, 1964.

Williams, Raymond. "Base and Superstructure in Marxist Cultural Theory." *New Left Review* 82 (Nov./Dec. 1973): 1–19.

———. *Marxism and Literature*. Oxford: Oxford University Press, 1977.

Winckelmann, J. J. *Briefe*, edited by H. Diepolder and W. Rehm. 2 vols. Berlin: Walther de Gruyter, 1952–54.

Wind, Edgar. *Art and Anarchy*. New York: Knopf, 1964.

Wobst, Martin. "Boundary Conditions for Palaeolithic Social Systems: A Simulation Approach." *American Antiquity* 39 (1974): 147–78.

———. "Stylistic Behavior and Information Exchange." In *Papers for the Director: Research Essays in Honor of James B. Griffin*, edited by C. E. Cleland, 317–42. Ann Arbor: University of Michigan Museum of Anthropology Anthro-Papers, no. 61, 1977.

Wycherley, R. E. *The Stones of Athens*. Princeton: Princeton University Press, 1978.

Yates, Frances. *Art of Memory*. Chicago: University of Chicago Press, 1966.

———. *Giordano Bruno and the Hermetic Tradition*. Chicago: University of Chicago Press, 1964.

———. *Theatre of the World*. Chicago: University of Chicago Press, 1969.

Zerner, Henri. "L'Art." In *Faire de l'histoire: Nouveaux problèmes*. Vol. 2, edited by J. LeGoff and P. Nora, 186–96. Paris: Gallimard, 1974.

———. "The Crisis in the Discipline." *Art Journal* 42, no. 4 (Winter 1982): 279–325.

———. "Giovanni Morelli et la science de l'art." *Revue de l'Art* (1978): 40–41.

Index

Aarsleff, Hans, 88, 96, 98, 99, 105
Abcedarium culturae, 107
Abri Blanchard calendar bone, 137–38, 140–41
Academic research, end-oriented research and, 9–11
Aesthetic activity, as speech act, 44–49
Aesthetic production, 21–22
Aesthetic standards, 25–26
Akropolis, Athenian. *See* Athenian akropolis
Alberti, Leon Battista, 57, 58
Albertian ideal painting, 58, 60
Alberti's Window: art museum compared to, 69–79; discursive space of, 60–62; Subject in, 67–68, 69
Allaci, Leone, 92
Alpers, Svetlana, 201n10
Analytico-referential discourse, 55–56
Anamorphic art, 57–58
Anamorphism, 39–40, 76, 169, 171
Anaphora, 75, 169, 171
Anatomy, comparative, 101–02
Architecture, 224n170
Archival organization, 75–76
Argan, Giulio C., 112
Arnheim, Rudolf, 49
Art Bulletin, 191n19
Art Journal, 1–2
Art mobilier, 124, 125, 133–34
Art museum: Alberti's Window compared to, 69–79; Bentham's Panopticon compared to, 70; functions of, 68–69; imaginary world of, 203n32
Artes memorativae. *See* Memory arts
Artistic production, reader-response criticism and, 81–82
Artwork: as autonomous sign, 116–18; defined, 85
Athena, 172, 173, 175–77

Athenian akropolis, 169–70, 172–73; Propylaia in, 173–78
Attribution, problems of, 193n34
Authen-tication, 31–33
Authorial self-identity, 32–33
Authority, appeal to, 7

Bacon, Francis, 79, 87
Baldi, Camillo, 92
Balzac, Honoré de, 105, 106
Barthes, Roland, 4
Bate, Walter Jackson, 5
Bateson, Gregory, 49
Baudrillard, Jean, 199n75
Baxandall, Michael, 49, 58
Bentham, Jeremy, 36, 62–66
Bentham's Panopticon, 62–63; art museum compared to, 70; God in, 71; Memory Theater compared to, 66; power in, 64–65
Benveniste, Emile, 39, 190n15
Berlin panorama (*1883*), 210n98
Biblical exegesis, author in, 32
Bourgeois art history, 239n16
Breuil, Henri, 123, 124, 126–27, 136, 144, 145
Brooks, Cleanth, 85
Brown, Harold I., 35
Bryson, Norman, 58, 119
Bühler, Karl, 116

Calendrical objects, 137–41
Calvino, Italo, 81, 86, 178
Camillan theater. *See* Memory Theater
Camillo, Giulio, 59–62
Carlyle, Thomas, 99, 100, 105
Carroll, David, 77
Cassirer, Ernst, 114
Catalogue raisonné, 191n23
Cave art. *See* Paleolithic cave art
Chase, George H., 73

Cinema, 72–73, 192*n*30, 207*n*69
Clark, Timothy J., 49, 162–68
Classicism, 172–78
Codification of visual environment, 154
Coleridge, Samuel Taylor, 100
Commodity marketplace, 10
Communication: Jakobsonian paradigm of, 149–52; marking in Paleolithic art as, 149, 152–53; signification as, 110; *See also* Speech act
Comparative anatomy, 101–02
Composition, 58
Comte, August, 89
Conan Doyle, Arthur, 93, 94
Condillac, Etienne Bonnot de, 88, 96, 100
Conkey, Margaret, 123, 127–28, 147–48
Connoisseurship, 191*n*21
Consumption, 199*n*75
Contextual reintegration, 37
Cousin, Victor, 88, 89, 100–101, 106
Croce, Benedetto, 94, 106
Cultural sign, 90
Curriculum in art history, 74–75, 183*n*17
Cuvier, Georges, 88, 93, 101–02, 105

Damisch, Hubert, 58, 117, 161, 195*n*47
Darwin, Charles Robert, 102, 164
Davis, Whitney, 131, 132
de Lumley, Henri, 129
Deconstruction, 2–3
Derrida, Jacques, 4, 14, 77, 110, 164, 182*n*6
Descartes, René, 79
Discipline, art history as, 51–53, 83–86
Discourse, analytico-referential. *See* Analytico-referential discourse
Discursive space: of Alberti's Window, 60–62; of modern art history, 58
Doueihi, Milad, 103
Doyle, Henry, 93
Durkheim, Emile, 89

Edison, Thomas Alva, 24
End-oriented research, academic research and, 9–11

Essentialism, 96–97, 98, 101–02, 104–05
Eucharist, as perfect signifier, 103–04
Evolution, natural, 41–42

Fakes, 33
Feminist theory, 167–68
Fictionality of art history, 43–44
Film. *See* Cinema
Fogg Art Museum (Harvard University), 73–75, 77, 207*nn*71–73
Forgeries, 33
Formalism, reader-response criticism and, 81
Forster, Kurt, 113
Foucault, Michel, 32, 36, 62, 63–66, 105, 113, 158
French Revolution, 99–100
Freud, Sigmund, 56, 78, 94
Fried, Michael, 49
Fuller, Buckminster, 24
Funicity, 188*n*10

Gaboriau, Emile, 93
Galileo, Galilei, 56, 57, 92
Geertz, Clifford, 143, 148
Gestalt psychology, 47, 49
Ginzburg, Carlo, 92, 93, 94
Giotto, 60
Glottochronology, 41–42
God, in Bentham's Panopticon, 71
Goethe, Johann Wolfgang von, 151
Goldberg, Reuben Lucius, 96
Gombrich, Ernst, 49, 117, 119
Gontzi tusk calendar, 138–41
Goodman, Nelson, 29, 119
Grabar, Oleg, 1
Guggenheim Museum (New York), 70, 206*n*62

Hadjinicolaou, Nicos, 162
Hazlitt, William, 100
Heath, Stephen, 52–53
Hippocrates, 92, 94
Historicism, 14–15, 189*n*14
History, art history as subset of, 165–66
Holbein, Hans, 57
Holloway, John, 105

Holly, Michael Ann, 7, 112–14
Homo sapiens sapiens, 128, 132–33, 145
Hunt, Richard, 73
Huxley, Thomas, 91, 93, 94

Iconography, 111–21, 195*n*47
Ideological fiction, 43–44
Indexes, as signs, 95
Indiana University Art Museum, 206*n*63
Innateness doctrine, 98–99
Innes, Michael, 72
Instrumentalism, 35–39

Jakobson, Roman, 116, 117, 149–52, 220*n*138, 224*n*170
Jameson, Frederic, 14–15
Jaspers, Karl, 121
Johnson, Barbara, 5

Kant, Immanuel, 10, 15, 77, 84
Kleinbauer, W. E., 14, 26, 48, 85, 107, 118
Krauss, Rosalind, 49
Kristeva, Julia, 68
Kubler, George, 197*n*62

Lacan, Jacques, 68, 76
Laming-Emperaire, Annette, 125
Language: of art history, 35–39; origin of, 96–97; philosophy of, 97–101; *See also* Speech act
Lascaux bison, 131–32
Leaky, R. E., 132
Ledoux, Claude-Nicolas, 66
Leroi-Gourhan, André, 122–28, 135–36, 142, 144
Lévi-Strauss, Claude, 14, 105, 126
Lewis, Philip E., 212*n*19
Linguistic sign, 89–90, 108–09, 220*n*138
Locke, John, 59, 96, 97–101, 104–05, 106–07, 113
Logocentrist paradigm. *See* Speech act
Longhi, Roberto, 93
Lotringer, Sylvère, 69
Lust for Life, 21–26, 29–30

Madness, sanity and, 22–23
Mancini, Giulio, 91–92
Mandelbaum, Maurice, 14
Marin, Louis, 103
Marking in Paleolithic art: as communicational system, 149–53; marks as things, 131–33; stylistic marking, 146–48; systems of marking, 140–41
Marshack, Alexander, 133–42
Marxist art history, 160–68, 193*n*38, 239*n*42
Meanings, Subject and, 68
Memory arts, 79
Memory Theater, 59–62, 66, 203*n*27
Mendel, Gregor, 23
Metalanguages, 226*n*185
Metaphor: in art history, 108–09; instrumentalist, 35–39; telescope as, 55–56; voyage of discovery as, 55
Methodologies, pluralism of, 34–35
Michelson, Annette, 122–23
Mitchell, W. J. T., 112
Modernism, in human sciences, 212*n*19
Moore, Charles Henry, 207*n*71
Morelli, Giovanni, 7, 93–95, 191*n*23
Mukařovský, Jan, 115–19, 198*n*70, 223*n*162, 224*n*170
Müller, Max, 102
Museum. *See* Art museum
Museum of Modern Art (New York), 205*n*58

Napoleon Bonaparte, 99–100
National self-identity, 33
Natural evolution, 41–42
Necker Cube illusion, 86, 96, 107
New Criterion, 6
New York Times Magazine, 5
Nichols, Bill, 57
Nietzsche, Friedrich Wilhelm, 88, 121
Norton, Charles Eliot, 9, 73, 74

Object of study, 17–20
Organization of archives, 75–76
Oriented research. *See* End-oriented research
Origin of language, 96–97

Paleolithic cave art, 122–28; Abri
 Blanchard calendar bone, 137–38,
 140–41; *art mobilier*, 124, 125,
 133–34; calendrical objects, 137–41;
 chronological typologies, 144–45;
 dating of images, 124; Gontzi tusk
 calendar, 138–41; Lascaux bison,
 131–32; Pech Merle cave, 135;
 portable objects, 124, 125, 133–34;
 representational image making,
 130–33; style evolution, 146–48;
 Terra Amata huts, 129–30; *See also*
 Marking in Paleolithic art
Panofsky, Erwin, 7, 56, 111–21;
 Mukařovský compared to, 116–18
Panoptic instrumentalism, 36
Panopticon, Bentham's. *See* Bentham's
 · Panopticon
Parergon, 210n95
Parietal art. *See* Paleolithic cave art
Pascal, Blaise, 104, 108
Pasteur, Louis, 89
Pech Merle cave, 135
Peirce, Charles Sanders, 95, 113, 116
Peloponnesian Wars, 177
Penitentiary Panopticon, 36
Periodicization, 43
Perspectival art of Renaissance, 56–57
Philosophy of language, 97–101
Photography, 72, 192n30
Picasso, Pablo, 32
Pluralism of methodologies, 34–35
Pollitt, Jerome J., 178
Port-Royal grammarians, 39, 102–04,
 189n14
Portable objects, 124, 125, 133–34
Poussin, Nicolas, 4
Power: in Bentham's Panopticon,
 64–65; royal, 104
Prague Circle, 116–17, 223n161
Pratt, Mary Louise, 81–82
Propylaia, in Athenian akropolis,
 173–78
Psychology, Gestalt. *See* Gestalt
 psychology

Reader-response criticism, 81–82
Reception, artistic production and,
 81–82
Reconstruction, art historical, 21–22
Reik, Theodor, 94
Reintegration, contextual, 37
Reiss, Timothy, 55–56, 58, 107
Renaissance: perspectival art of, 56–57;
 See also Alberti's Window
Representation, 103–04, 107–09
Representational image making,
 130–33, 134
Riegl, Alois, 7
Ripa, Cesare, 117, 119
Rousseau, Jean-Jacques, 64
Royal power, 104

Said, Edward, 143
Saint-Hilaire, Isidore Geoffroy, 88
Sanity, madness and, 22–23
Sanskrit, 41
Saussure, Ferdinand de, 87–88, 89–90,
 98, 105, 108–09, 113, 115–16,
 214nn38–39
Scientificity, conditions for, 28–29
Self-identity: authorial, 32–33; national,
 33
Semiology, 31, 87–90, 114–19, 198n70
Semiotics, history of term, 217n83
Serendipity, 92–93
Shape grammars, 195n48
Sign: artwork as, 116–18; cultural, 90;
 indexes as, 95; linguistic, 89–90,
 108–09, 220n138; types of, 94–95
Sign theory. *See* Semiology
Signification, 50, 95–96, 102–04,
 106–08, 110
Simon, Claude, 68
Smith, Cyril S., 188n10
Snyder, Joel, 119
Social history of art, 159–68
Speech, meaningful entities in, 131
Speech act, aesthetic activity as, 44–49
Stafford, Barbara Maria, 42
Stevens, Wallace, 34
Styka, Jan, 55, 79
Style, concept of, 146–48
Subject, in Alberti's Window, 67–68, 69
Symmetry, 172–77

Tagg, John, 167
Taine, Hippolyte, 88–90, 94, 95, 99, 105, 115–16, 215*n*45
Telescope metaphor, 55–56
Terra Amata huts, 129–30
Textbooks, 197*n*61
Tompkins, Jane P., 217*n*90
Travlos, John D., 243*n*80
Trumbull Collection (Yale University), 73

Valesio, Paolo, 165
Van Gogh, Vincent, 21–26, 29–30
Vasari, Giorgio, 21, 28
Viglius, 59–60
Visual environment, codification of, 154
Visual language, art as, 48
Voltaire, 93
von Glasersfeld, Ernst, 130

von Humboldt, Wilhelm, 98
Voyage of discovery metaphor, 55

Walpole, Horace, 92
Warren, Robert Penn, 85
Washington Post, 2–4
Wedgwood, Josiah, 100
Whewell, William, 101–02, 106–07
White, Hayden, 82, 163–65
Wilhelm, Kaiser, 210*n*98
Williams, Raymond, 81
Wind, Edgar, 94
Wobst, Martin, 132, 146, 148
Wölfflin, Heinrich, 7, 75, 209*n*83

Yates, Frances, 60, 79

Zadig's Method, 91–93, 101
Zerner, Henri, 1–2, 7, 94